D1153821

FOR LOVE OR MONEY

FOR LOVE OR MONEY

Confronting the State of Museum Salaries

Edited by Dawn E Salerno

Mark S Gold and Kristina L Durocher

MUSEUMSETC | EDINBURGH & BOSTON

CONTENTS

FOREWORD

Melody Kanschat
Executive Director
Getty Leadership Institute

THE INVITATION TO WRITE the Foreword for this book came at an opportune time in my career at the Getty Leadership Institute at Claremont Graduate University (GLI@CGU). We had just wrapped up GLI 2019, an executive education program for museum leaders in its 40th year of serving our field. I have been contemplating my "exit strategy" into full retirement in the next few years, and I'd begun reflecting on both the changes I've seen and the changes that have been too slow to come to the museum industry as a whole. I had also been in touch with several CGU graduate students who were in the midst of job searches and several GLI graduates in the final stages of job changes and salary negotiations. Salaries, benefits, equity, gig work, wealth gap, and the worth of our work as museum professionals has been occupying a great deal of my thinking time.

This thoughtful book has helped me consider these broad issues in a progressive and clear way. It begins by painting a picture of where our field is in terms of salaries and internal and external equity within job descriptions and special expertise. It moves logically into a study of why the field is where it is and it presents cogent arguments for why our approach to salaries and equity must change – now! I am most impressed with the concluding section of the book as it both demands action and presents a toolkit for addressing salary equity as a means to the end of increasing benefit to the audiences that our museums serve.

I am ashamed to confess those moments in my museum work when my own decisions and actions enabled salary or hiring inequities. In my 22 year career at the Los Angeles County Museum of Art, I accepted positions with increased

responsibilities at lesser pay than previous candidates had received. As a young manager, I solved budget gaps and performance issues with new job titles and reorganization schemes, and I relied too heavily on managing our departmental workload with contractors, volunteers, and interns. As my role shifted from manager to leader, I redeemed myself a bit by addressing entry level base pay increases, maintaining health and retirement benefits, and increasing salaries via internal/external equity review and a merit-based salary matrix. But still, in balancing our programmatic aspirations with our income realities, I frequently would allow us to do more with less (and for less) as we prioritized our audiences (or programs) over our workforce.

At GLI, I review applications from museum professionals around the world, and am astounded to see salaries for mid-level museum managers with eighteen-plus years of education and seven years of work experience below $30,000. At the executive level, we see applicants with over 23 years' education and ten years' experience paid below $50,000. Each cohort over the past five years has noted increased reliance on gig workers at their institutions (guest curators, temporary conservators, campaign fundraisers, and artist educators), and museum educators remain the most undervalued (lowest-paid) sector in the professional workforce.

In my work on the arts management faculty at Claremont Graduate University, I am in contact with Masters' recipients whose search for jobs in mid-to-large market museums is frustrating and less than fruitful. Low pay, the number of competing applicants, and temporary hiring status top the list of issues faced by these up-and-coming museum professionals.

Clearly, something at the field-wide leadership level needs to happen. This book could be the beginning of leading that change.

I could not be prouder that two Getty Leadership Institute alumni, Dawn Salerno and Kristina Durocher, took it upon themselves to embrace their leadership and join with Mark Gold to produce this book. The three editors and the authors presented here have demonstrated that true leadership is nurtured through practice and accelerated through necessity. Every chapter reveals how the author's approach has shifted from managing personal and institutional challenges to leading change across an entire field. Their efforts remind us that in our toughest leadership moments we must not lose focus on reiterating a vision for change that will inspire others to take these important ideas forward.

INTRODUCTION

IN JANUARY OF 2016, Dawn Salerno was writing her essays in application to the Getty Leadership Institute. In response to the question asking her to identify the top one or two issues in the field that concerned her as a leader, she chose the issue of systemic under-compensation and salary inequities and the effect it was having on individuals, institutions, and the field.

Dawn ran her idea by Mark Gold who urged her to improve her chances of acceptance by embracing a more traditional concern such as financial stability or making museums more relevant to their audiences. She ignored the advice.

Dawn was right. Mark was wrong. Not only did Dawn get admitted to Getty, but her concerns were shared by other professionals in the museum community, and the discussion that was underway became more robust over time. Dawn and Mark collaborated on an essay on systemic under-compensation that was published in 2018. They believed that the field would benefit from a more comprehensive resource in which the best current thinking on as many of the related issues as possible could be aggregated and where their relationships could be explored. Their colleague and friend Kristina Durocher, who identified a different priority in her successful essay for Getty, shares their passion for the subject matter and agreed to co-edit this volume.

Our vision for this volume was aspirational and bold. We hoped to examine both the causes of the condition and its effect on staff, institutions, and the profession. We hoped to identify internal and external factors that suppress salaries, to consider the impact of present practices and paradigms on the field as a whole, to articulate the benefits that fair and equitable compensation would achieve, and to develop solutions and strategies – all with the goal of strengthening our institutions and

allowing committed museum staff to advance in careers that are both financially and personally rewarding.

We were delighted to receive proposals for chapters that addressed essentially all of the relevant issues from authors who had done considerable research and thinking – from recent graduates to retirees. As written, the chapters realized the promise of the proposals, and each is a deep dive into its topic.

We discharged our responsibilities as editors of this collection in the same way a curator might curate an exhibition. Except for the chapters we wrote ourselves, we did not create the art. We afforded our individual authors great latitude so that their research and their thoughts could be shared in their own words. We felt that the benefits of authenticity and integrity of authorship were critical. As a result, there is a diversity of voice that we hope adds to the collection.

We offer our sincere thanks to the authors who have so generously contributed their time and expertise in this effort. Their contributions have resulted in a resource that exceeds our wildest expectations in scope, depth, and quality.

Finally, we acknowledge the courage and conviction of those who raise these important issues in the field and in their own institutions and advocate for change. They include those who have shared their thoughts in this volume. We were moved by the following tweet from someone involved in the unionization effort at the New Museum:

It's cool that everyone in the art world loves congratulating me on the union and also will never hire me for an art world job again!

This volume is respectfully dedicated to those who are willing to take personal and professional risk to speak truth to power for the benefit of their colleagues – present and future – and the field they love.

Dawn Salerno
Mark Gold
Kristina Durocher

1

THE STATE
OF MUSEUM
SALARIES

CHAPTER ONE

MUSEUM PAY:
THE MORE THINGS
CHANGE
THE MORE THEY
STAY THE SAME?

———

Steven Miller

IN 1971 I WAS HIRED for my first full-time museum job. The starting salary was $6,000 per year. That would be about $37,000 in today's dollars. I was Assistant to the Senior Curator at the Museum of the City of New York. It was a new position. There was a package of benefits including health care, retirement, holidays and vacation time (four weeks a year). The museum had about eighty employees. Most were full-time and included security, maintenance, curatorial, marketing, image reproduction, sales shop and office workers. The museum is a private 501(c)3 nonprofit entity though the building and property are owned by the City of New York. The security and maintenance staff were city employees while all others were employed by the private museum operation. These divisions were a common arrangement for older cultural organizations on New York City property in municipal buildings.

If I were 23 today and were offered the same job at the same museum and at the chronologically adjusted salary would I take it? In a nanosecond. I would then, of course, figure out my domestic logistics as I did many years ago. These principally involve housing and food costs. Other expenses such as commuting, entertainment, clothing and personal incidentals would be factored in as they unfolded. My daughter has now addressed this same scenario. She decided to also work in a museum. She is with visitor services at a New York City Smithsonian Institution museum. Her salary is $28,000. The benefit package is excellent and they cover monthly commuting costs up to a certain amount. She lives in an apartment with three roommates and gets no underwriting from other income sources, though she does also work one day a week in visitor services at another museum. She loves her job. I am appalled at her salary.

Employment realities such as low pay are common in lots of jobs. For the purposes of this chapter, however, we are discussing museum work. The focus is on private tax-exempt entities such as the Museum of the City of New York. Because the majority of museums fall into the 501(c)3 Internal Revenue Service profile, the chapter will reflect those. Some of what is mentioned relates to museums owned by governments, universities, corporations and individuals but these occupy different museum work-a-day realms.

Museum pay inequity conversations have tended to focus on, for lack of a better term, what we will call the "professional" staff. These are people who define their livelihoods as careers. The jobs require academic and resume credentials tailored to a designated category of employment. Their work calls for specific training, abilities, and skills unique to a particular set of responsibilities. In the museum world, professional staff includes curators, marketing managers, directors, educators, conservators, exhibit designers, and fundraisers, to name some of the most obvious positions. Many of these employees have graduate degrees, some at the PhD level.

Fortunately, other low income positions are now part of the compensation conversation. Pay for guards, housekeepers, docents, maintenance, and visitor services staff is coming to light for its often paltry sums. Previously this would occasionally be referenced in salary budget deliberations. Improvements would at best happen in a token manner. Increases would be part of annual across-the-board compensation adjustments, or change when a new person was hired.

Circling back to the start of my museum career, when I arrived at the Museum of the City of New York there were five

curatorial departments. Each had a curator and an assistant curator. The academic and experience profiles of these people reflected the end of a museum era in America. There were three male and two female curators. They had been in their positions for a long time. None had trained specifically for their work. Some only had an undergraduate degree. Their knowledge of the collections under their care was considerable. They learned on the job about the subject these things embodied. The curators were quite bright and diligent. The collections in each department were (and remain) fabulous. Temporary exhibitions were done with some regularity but long-term installations were the rule. Little was published by collection-based staff. There was no expectation for anyone to be a leader or even participate outside the museum in aspects of the subjects or objects for which they were responsible. There was certainly no pressure to increase attendance through the mechanism of the popular exhibition. All were white. Two men were gay. One was a leader in the gay community of New York. He married his partner who was a bishop in a gay New York City church in the early 1970s, which attracted considerable press attention at the time.

Regardless of the backgrounds and experience of the museum's curators, what was apparent was the fact that none had to work for a living. They either had private means or were married to wealth. This was also the case for three of the curatorial assistants. Only two of those employees (I being one) lived on his or her income alone. The comfortable finances in the curatorial ranks no doubt caused minimal pressure to improve our salaries in any meaningful regular manner. In fact, I don't recall any such conversations occurring formally or informally until

well into my career there when I mentioned it to the director. Overt complaints about pay were scant.

A related fact of museum leadership jobs at the time revealed that positions throughout the country were invariably held by so-called "upper class" white males who either inherited or married wealth. They were dilletants and amateurs in the field. Many had Ivy League undergraduate educations and attended elite private schools before college. The early years of the Museum of Modern Art (MoMA) illustrates this reality. It is clearly explained by Russell Lynes in his wonderful history of the founding and first decades of the museum.[1] The nature of the aforementioned employee profiles has not entirely disappeared when it comes to museum hiring and its influence on pay. Being independently wealthy reduces effective interest in seriously promoting staff compensation improvements.

I believe a key factor influencing museum pay problems stems from justifying a museum's existence. Why on earth do we have these places? Heck, in the grand sweep of history they are not very old. The museum as we know it dates back only a few centuries. What do they mean and why? Isn't it odd to have repositories dedicated to collecting, preserving and studying all manner of natural and humanly created objects which will be retained in perpetuity? Defining a museum is often at the core of internal fiscal decisions. Are they worth what they cost – especially when we consider the largest annual budget expense is for employee compensation?

From the outside it appears museums know why they are and what they are. In fact this is not always the case. While a mission may sound good in print, those who have to realize it in practice can often be at odds or even confused. Like the five

blind men describing an elephant, trustees and staff may have very different definitions of "their" museum. This confused state will have an impact on pay. What jobs are required and why? Will they be full-time, part-time, temporary, contractual or seasonal? What qualifications should employees have? Can work be done by volunteers?

Because few people in museum governance positions in particular know how these entities really operate and what employees do, they have little understanding of acceptable pay levels. A colleague who was recently forced to step down by ignorant trustees was a stellar curator at an art museum. She was asked by a trustee, "What do you do all day?"

Museums are places of explanation. They accomplish this for the public with diverse programming including exhibitions, publications, scholarship, collecting, and events. Internally one of the most important explanation requirements is to consistently explain the museum to trustees and supporters.

Directors must be lead explainers. It is a ceaseless task. The more decision-makers know about who does what and why in an organization, the better prepared they should be if they are setting compensation. However, I have witnessed trustees thinking certain employees were exemplary when in fact they were duds. I wanted them removed but that option was blocked. Naturally, when it was time for annual budget reviews these sacred workers were recommended for totally inappropriate raises. Fortunately this only happened twice in my long career but in both cases I clearly failed as a personnel explainer.

When it comes to setting pay levels in private museums the final deciders are its trustees. They approve annual operating budgets. Those budgets are initially put together by designated

staff and perhaps board committees that might have advisory oversight for financial matters, personnel, programs, collections, and buildings and grounds. Personnel committees are the ones to watch when it comes to salaries. They can support the recommendations made by knowledgeable staff or wander totally off track.

Once a draft budget is determined it is submitted to either the executive committee of the board or the full board itself for review and final approval, which may be subject to changes before acceptance. Budget retention of positions and what they are paid will vary according to several criteria. Some will correspond with generally accepted ideas about a position's worth, as might be the case with guards or a sales clerk. Other criteria too often reflect personal prejudices or ignorance. A trustee might like one staff person more than another. Those in the world of finance may think accountants deserve better pay than curators. Reconciling awkward and prejudicial input can be difficult for directors in particular.

And, speaking of directors, one of the most egregious affronts in the museum world is the often wide chasm between what directors are paid and what other employees earn. The difference percentage does not reflect museum size. Why is there such a salary discrepancy? Boards of trustees set the chief executive's pay. Their approach often parallels that of the corporate sector they understand or hold as a personnel model.

The role of trustees in setting budgets for private museums is critical to understand and accept. When they volunteer for these leadership roles they assume the position of fiduciaries for the nonprofit entity. This is a legal designation and one every trustee should take seriously. Most do. The outcome of

this duty means they can be extremely cautious when it comes to containing operating costs. Because staff pay is always the largest part of every museum's budget, those numbers are watched carefully. This is why pay is often below par.

We live in a capitalist society. Return on investment, profit margins, expense measures, and other customary operating metrics drawn from the business sector are increasingly influencing how museums conduct their work. The approach is rife on the governance level when trustees think museums should be profitable commercial endeavors. This is a fallacy for certain, yet the idea infuses compensation. Those who appear to bring in money get better pay while those who do not get less.

Complicating museum salary matters are suggestions – implied or actual – that prevent improving salaries and benefits:

- If you don't like the pay leave the job.
- No one forces anyone to work in museums. No judge has sentenced anyone to museum employment.
- Why do people take jobs knowing the salary, then complain about it?
- Museums pay what they can afford.
- Presumably museum work has meaning that goes beyond mere personal income concerns.
- People should be grateful for a museum job as they are fun and easy places to work.
- We can always find good employees at cheap rates.

These thoughts are never spelled out in any documented manner but believe me they lurk behind all personnel decisions, be they made by those seeking work or those offering work.

We read that the current strong economy is making it diffi-
cult to find employees. Clearly that depends on the work sector
being analyzed. Museums seem to be immune to any lack of
potential employees. Supply and demand is on their side: adver-
tise a job opening and plenty of good applicants will surface.
Obviously response factors depend on location, the particular
job, and the museum seeking an employee.

For the most part museum hiring is a more disciplined and
structured process than it once was, especially in large urban
institutions. To start with, there are written job descriptions.
Unless a position is being filled from within by a pre-designated
candidate most openings are advertised in some manner. The
ads list work duties, qualifications and application procedures.
This employment professionalization reflects the profession-
alization of the museum field in general. Some applaud the
development as a welcome improvement but some would
note it lacks compensation improvements that would usually
accompany the rise of a field's status. Salaries are often absent
in job listings. Exceptions would be for government museums
such as those owned and operated on the federal, state, county,
city or local level.

With the marked increase in museum studies and related
graduate programs has come a plethora of job seekers into
the field. This means there is more competition to find work.
Many of the candidates are highly qualified. It appears to be
an employer's market. In fact that may only be true for certain
positions in certain institutions. A small historical society in
a rural community far from urban centers or health and other
services can have difficulty attracting good director job appli-
cants. A curatorial position at a major urban art museum, on

the other hand, will probably have a host of impressive candidates seeking to fill a vacancy for which they are clearly well-trained.

The challenges museum job seekers face today, by the way, are hardly new. In 1939, Laurence Vail Coleman, when he was director of the American Association of Museums, referred to it in his three volume series, *The Museum in America*:

> It is difficult to enter the museum field. Not only is the number of openings during any year quite small, but there are many experienced people seeking museum employment or reemployment.[2]

If the past is any indication, even the most sincere efforts to improve museum pay may be disjointed and scattered. To begin with, who will organize initiatives and on what scale? How will pressure be sustained and maintained? Who will monitor and report on progress? How will acceptable pay levels be updated and, again, by whom?

Over the years occasional one-off corrective measures have happened to improve museum compensation. We saw this when some unionized staff at MoMA went on strike in 2000. The issues then and in subsequent contract negotiations were about pay, health and other benefits as well as protections against unwarranted dismissal or abrupt layoffs. MoMA is a large institution and staff can organize protests, join unions, and otherwise fight for personnel improvements. Staff in smaller museums can feel insecure when contemplating or suggesting corrective actions. Indeed, their employment may be threatened. Protective recourse can be absent unless they can

make a case that a job loss was retaliatory or reflected racial, age, or gender bias if there are defensive legal measures covering these employment categories.

Several variables go into deciding museum compensation. Pay and benefits depend on what the institution's leaders decide it can afford. Their judgments are influenced by a wide range of realities such as museum size, mission, location, professional competency, personal preferences and prejudices, budget, endowment (if any), and operational priorities. The realities trustees accept regarding the museum they govern when it comes to compensation can be briefly described.

Museum budgets are built from existing ones. The annual exercise of creating next year's operating budget starts with an analysis of how the income and expense projections and realities unfolded in the current year. Did the numbers meet, exceed or fail projections? The three outcomes will determine what to do going forward, and, what positions will be retained, jettisoned, added to, given raises or bonuses, or have compensation reduced.

Museums fortunate enough to have endowments will examine these to see how well they are performing and what impact that performance may have going forward – positive, neutral or negative. Most museum endowments are never sufficient to meet operating costs. Additional fundraising is always required. These hopes have to be factored into what trustees think can be raised philanthropically and with earned income. Operating track records will determine annual budget numbers.

The following factors will influence museum budgets and thus pay levels.

Institution size usually, but not always, suggests museum pay levels. Large institutions may have meager salaries while smaller ones could be quite generous. Trustees will use museum size as a reason for deciding pay levels. Boards responsible for large museums will note that their directors should be paid more than might be the case in small museums because they have more responsibility. Responsibility magnitude is defined by the number of staff to be managed, the scope of an annual budget, the physical size of a museum, and the breadth and expectations of the public served.

Location can have a severe impact on museum pay if earned income is of importance to annual budgets. Remote organizations with low visitation are often unable to provide comfortable salaries and will have limited staffing options. This will not be the case, however, if the entity is well-endowed or enjoys the generous support of wealthy governing leadership. The historic properties owned by Classical American Homes, and partly open to the public, offer a good example as the organization was created by a very rich individual. It subsists on his largesse. Though perhaps an exaggerated example, conversely the Metropolitan Museum of Art in New York City is ideally poised to attract millions of visitors annually. Having recently set a new admission fee for non-city residents its income has skyrocketed. Next to the Broadway theaters as a group, it is the most popular tourist attraction in the city. The impact of income accrued annually has a positive effect on staff compensation.

Annual budgets are discussed elsewhere in this chapter. They are key foundational documents when pay is being decided. However, they are always adjustable. Alterations will unfold

FOR LOVE OR MONEY

if a new programming initiative is set, or a museum adjusts or changes its mission.

The number of employees involved in setting job titles, salaries, hours, benefits or bonuses will vary widely. It is important for staff to know who the players are and how much authority and influence they have.

Professional competency can have a positive effect on museum pay, or at least provide a sound basis to argue for better compensation. The attainment of a relevant graduate degree during employment might lead to a raise. An impressive list of publications can be presented as a valuable museum asset. Efforts that increase revenue for the museum are always appreciated. Sometimes this can lead to a raise. Of course, the absence of professional competency can work against pay improvements.

Governance and management *personal preferences and prejudices* influence salaries to a larger degree than might be realized. These are implemented by decision makers who may feel an individual is more worthy of a raise than his or her work warrants.

Operational preferences will impact salaries. Certain high priority programs, capital expenses, and fundraising initiatives will result in less money for some staff and more for others.

Long-term unrestricted endowments must be more of a priority for museums. The larger these funds are, the less precarious a museum's financial position might be. When looking for work, prospective employees are encouraged to examine an institution's financials carefully, noting especially its endowment circumstances.

The idea of generally accepted updated pay scales for

museum jobs that budget developers could refer to is a nice concept but in fact there is no consistent reliable neutral source of this information applicable for every sort of museum. Interpretations of institutional needs and realities and aspirations vary. Trustees act independently and privately in setting their museum budgets. However, improvements are unfolding on this front. The American Alliance of Museums' 2017 *National Museum Salary Survey* offers a good framework to build upon.

Museums can be seen as luxury hobbies established by the rich and largely sustained through their generosity over the years. Given the history of most nonprofit private museums in America the notion is valid. Just about every museum was either founded or otherwise significantly funded by wealthy individuals. The 1% continue to be the principal museum supporters when it comes to significant financial donations. The magnitude of their giving will vary with the institution. Evidence of the importance and impact of private money on museums is often emblazoned on buildings and parts thereof and scattered throughout galleries on plaques and in other customary public recognition ways.

The financial prominence of those who significantly support museums can suggest that those who work in them do so for personal pleasure rather than livelihood necessity. It can be assumed that employees like being associated with powerful movers and shakers. To a degree this is sometimes the case, especially for directors. More than a few see the job as a way to advance their social status, in addition to earning significant salaries and benefits. A retired director of a large urban history museum I know enjoys an annual annuity far higher than most of the staff working at that museum now, in spite of the fact

that in nearly two decades running the institution he nearly destroyed it.

There are several myths about how museums get the lion's share of their funding. It is not from generous corporate underwriting, government largesse or sizable grant awards. To be sure, there are exceptions such as the municipal budget support which older New York City museums receive, and occasionally a sizable contribution can materialize through a significant grant or corporate donation. But for the most part, the lion's share of big money gifts to museums come from individuals.

So, what impact does major giving by individuals have on museum salaries? Good question. In the past, donations for such things as buildings, new wings, or important acquisitions had either no direct effect on staff compensation, or else connectivity was an accounting reality difficult to unravel. It was hard to quantify an actual numerical connection. Recently the old sort of individual giving has expanded to include museum jobs. It is quite common now to have museum directors and curatorial positions named for a donor. My first place of employment has the Ronay Menschel Director of the Museum of the City of New York. I am unaware of any "lowly positions" in the staffing chart hierarchies underwritten with donor support. Perhaps someday there will be financial contributions for maintenance, security, and docent jobs.

The idea of supporting individual museum positions with major contributions is welcome but how these are structured and what, if any, compensation requirements accompany them is usually private information. There are two reasons for this: first, museums rarely divulge actual details of what they consider confidential financial gifts (donors too may insist on

privacy); and second, museums hope to retain as much flexibility as possible in applying these sorts of endowments. It would be interesting to know if donors set salary levels for their contributions, or even what the magnitude of their support is. The vast majority of people I have worked with over the years have a sense of pride both in their jobs and the institutions employing them. This is important. I have always said I work because I have to but I do museum work because I want to. This attitude might be admirable but it can be self-defeating when it comes to demanding a living wage, meaningful benefits, and professional respect. It suggests staff should do their jobs for intrinsic rewards rather than extrinsic returns. Ideally museum work is a calling – however, that calling should be properly rewarded in one's pay check.

Conclusion

The title of this chapter is worded as a question. The answer is yes and no. Many museum salaries remain low in spite of a welcome increase in the professionalism of the field since I started. To complicate matters, museums have all sorts of employment for all sorts of timeframes. They can be full-time, part-time, hourly, and seasonal. Add to this the fact that there are so many different sorts of museum in so many different parts of the country and pay levels are widely divergent. Moreover, they have and will continue to fluctuate dramatically in response to institutional fortunes or misfortune as well as the capricious nature of governing boards.

Museums are more popular than ever but they remain precarious financial operations. From a board of trustees' perspective this means watching the bottom line. Because personnel

costs are the largest part of any museum expense line, pay and benefits are always targets for scrimping. To be sure, some progress has been made but much remains to be accomplished if the reality of "the more things change the more they stay the same" is to be corrected.

There is still a lack of acceptance that all museum jobs require specific training, knowledge, and abilities accompanied by commensurate pay! The concept that anyone can be a director, curator, sales shop manager, guard, educator, exhibit designer or receptionist persists in some circles. This hobby mentality results in meager compensation. Boards of trustees and enthusiastic founders of new museums who are woefully ignorant about them often succumb to this syndrome.

There are several ways to build on present salary improvements in private museums:

- Encourage unions for museum positions that qualify. Rank and file staff at the New Museum, New York City did this in January 2019.
- Foster museum mergers or take-overs if they will provide institutional financial stability and increase compensation.
- Require job ads to include a set salary or pay range.
- Consider listing museum personnel pay on websites, in an annual report, or in some other easily accessible document.
- Encourage museum profession membership organizations to insist compensation be commensurate with reasonable living wages for a location.
- Make staff pay a primary topic of importance for the

Museum Trustees Association.

- Establish an independent desired ambitious pay roster for the variety of customary museum jobs.

This could be an adjusted rolling calculation program of the American Alliance of Museums (AAM). It would need to be monitored and updated as local, regional and national economies ebb and flow. The undertaking should reflect cost of living adjustments as well as disasters like the 2008 recession which hit most museums heavily, especially when it came to pay and job retention. The AAM would be the ideal entity to establish the program and track pay as it serves a wide range of cultural institutions throughout the nation. The organization already defines a long list of positions, as well as understands hourly, part-time, and seasonal jobs. Benefits, including their value and extent, would also need to be considered in the program. Requirements to meet optimum compensation levels could be linked to the AAM's museum accreditation program. Both museums already accredited and those wishing to be would have to adhere to the pay program. The leadership provided by the AAM can be built upon the documentation of its 2017 *National Museum Salary Survey*.

Museum jobs can and will be subject to change. Consequently, how compensation is set will change. The AAM would, presumably, be the most knowledgeable party to effectively keep track of current employment circumstances, hence this recommendation. For example, the salary level for a scientist in a large natural history museum may not correspond to that of a curator in a small history museum – or, it may. That assessment would need to be understood and explained.

Because the AAM hosts an employment classified service on its website, the pay report could be linked to that. How informative would it be for job seekers to compare compensation noted in a job ad with what might be listed by the AAM for a similar position. Public disclosure of museum pay is essential for future improvements:

> Here's what we know about salary transparency: Workers are more motivated when salaries are transparent. They work harder, they're more productive, and they're better at collaborating with colleagues. Across the board, pay transparency seems to be a good thing. Transparency isn't just about business bottom line, however. Researchers say transparency is important because keeping salaries secret reinforces discrimination.[3]

If low wages and inequities are to be taken seriously and acted upon positively, leading voices in the profession need to speak out and speak up about the issue. While efforts can unfold on a grassroots level, those in positions of museum responsibility – trustees in particular – will have to embrace an all-out coordinated effort to strengthen compensation across the board. The work has to be accepted by governing bodies, with the guidance of directors and other executives as well as museum profession organizations. The conversation has begun. It cannot succeed without due diligence and constant pressure for reform.

NOTES

1. Lynes, R., 1973. *Good Old Modern*. New York: Athenaeum.

2. Coleman, L. V., 1939. *The Museum in America, A Critical Study, Volume 2*. Washington, DC: American Association of Museums. (398)

3. Wong, K., 2019. Want to Close the Pay Gap? Try Transparency, *The New York Times*, 21 Jan, B8.

CHAPTER TWO

SETTING SALARIES: A PERSPECTIVE ON PRACTICE

Purvi Patwari

THE DEFINITION OF THE WORD "salary" in the Merriam Webster online dictionary is straightforward: fixed compensation paid regularly for services. Sounds simple, but in reality, the planning and structure that must be in place before a salary is established requires careful consideration. These decisions often rest on the financial constraints of operating budgets and how the organization regards total compensation for employees.

During the budget process and throughout the year, the topic of pay is debated between staff and supervisor, HR and Finance, senior staff members and executive director, and executive director and the board. The negotiations bring to light the friction between the need to ensure the required funds to provide mission-critical programming to visitors, funds to maintain the physical infrastructure of the museum's building, as well as funds for a healthy salary pool to recruit and retain talent for the organization.

In organizations that maintain static staffing numbers and low turnover, the impetus to re-evaluate internal salary structures may be low. If and when an incumbent needs to be replaced, the same budgeted salary is typically provided, often with a nominal adjustment based on the change in cost-of-living rates. These situations provide a gradual growth in salary over time. Additionally, lack of flexibility in the budget keeps a position's salary at the lower end of market rates. When external influences like low unemployment rates, competition for skills, and wage policy changes manifest in the labor pool, recruiting and retaining employees based on outdated salary levels impact the execution of the museum's mission. The inability to fill open positions quickly and keep engagement

and productivity high becomes costly.

Museums must determine their own compensation and communication practices to support the effective execution of their mission and to allow for growth or contraction. Setting the groundwork to provide healthy and equitable salaries requires research, planning, collaboration and commitment from the head of the organization, finance, human resources and department managers.

There are many aspects to consider when creating the foundation for salary structures. An organization must determine department configuration and the responsibilities needed to align with organizational goals. Each department must have current and accurate job descriptions which reflect the responsibilities, skills and education level required to optimize performance and to find, hire and keep talented and productive employees. In addition, the museum must have access to comparative salary data and the institutional agreement to implement competitive and equitable pay standards.

Accurate job descriptions are vital for recruiting the best qualified candidate for a position and managing the employee to be a high performer. Precise job descriptions also play a fundamental role in gathering industry data on similar pay for skills and responsibilities across various metrics, such as budget size, museum type, geographic location, staff size and/or staff type (full-time, part-time, exempt, or non-exempt).

Industry-focused salary surveys and job descriptions from other similar organizations provide valuable guidance to gauge competitive salary. When using these tools, be mindful to match job responsibilities rather than job title. Deciding on a consistent measurement for benchmarking the alignment

of responsibilities, such as a specific percentage, is important in making fair comparisons to surveys or other museums' job descriptions.

The budget process is the key place where valuable input for salaries is negotiated and established. Throughout the year, supervisors should be advocating for increasing staff salary based on the individual's responsibilities, accomplishments, leadership and professional growth, especially when employees have attained new certifications or attended trainings. Supervisors and management should be aware of the monetary and non-monetary cost of turnover and the effects of losing a key member of the department when shaping salary increases.

Additionally, forecasting for the expected or unexpected changes during the fiscal year must be considered. Creating a discretionary fund based on a percentage of total salaries to be used for unexpected changes in staffing during the fiscal year is helpful. Advance knowledge of staffing situations is not always predictable: an employee may need to use family or medical leave, or a unforeseen senior level position vacancy may require an interim replacement while a permanent search is conducted. However, having a discretionary fund in case of staff emergencies enables an organization to remain agile to adjust salaries to new, unanticipated needs.

A strategic method for setting salaries for individuals and departments is by developing the organization's compensation philosophy. The compensation philosophy (SHRM, 2019) sets the guidelines for how salaries are determined. It establishes pay and metrics for salary increases while maintaining equity throughout the organization.

Here are some questions to consider when developing your

organization's compensation philosophy:

- What percentage of operating budget will be used for employee salaries and benefits?
- Will a discretionary fund be established in the budget to be used for unplanned changes to staffing? What percentage of the total salary budget or flat amount will be allotted?
- What type of increase(s) will be used for annual raises: across the board; merit/performance based; cost of living; length of services?
- When will annual raises be given to employees: anniversary date; during performance review; fiscal year; calendar year?
- Are out of cycle increases for promotions allowable?
- What are the sources used to compile salary data for internal use?
- What criterion is used from the salary data sources: location; budget size; type/industry?
- What percentage of skills and responsibilities should match a position title and salary?
- What level will salaries be targeted (25%, 50% 75%) for the organization based on industry data?
- How do you keep employee evaluations and compensation equitable?
- How will market changes for high demand skills influence the salary of a new hire?
- How do you communicate the compensation philosophy internally for transparency and equity?

Creating an effective compensation philosophy requires collaboration and buy-in from all stakeholders to uphold equitable pay practices. It provides a platform to uniformly value and manage salaries across the organization. Ideally, position titles, regardless of department association, are paid within the same pay band. This eliminates the opportunity for one department manager to influence the pay of their specific staff in comparison to another department with similar job titles, years of experience and supervisory experience.

Apart from salary, the organization's compensation philosophy may include the availability of intangible benefits like workplace amenities, flex-time, and a supportive culture. In addition to these, an important benefit is providing a path for career mobility and advancement. Small organizations may not be able to offer a ladder for promotion. In such cases, perceiving the length of time an employee should remain in a position before moving on allows the organization to closely manage and develop the employee's skill set to position them for the next role.

The compensation philosophy must be communicated to promote transparency for the process. Advocating for transparency does not mean the organization must reveal all salaries, even with regulations allowing employees to share salary data. Providing employees with information about how the organization determines salaries, and when and why promotions and increases are provided, are important elements of the process for employees and managers to know and set their own expectations. Sharing the compensation philosophy also keeps the museum accountable to its own practices.

With new wage policies now influencing equal pay, overtime

pay, minimum wage standards, and redirecting salary negotiation conversations in favor of the employee, museums must be prepared to pay for talent. They have the opportunity to be leaders in compensation practices rather than merely matching salaries in their peer organizations. The talent is available in the marketplace to hire high producers and reduce turnover to meet and exceed organizational objectives. Look inward to establish your museum's unique compensation philosophy to show employees you value their talent, their skills and their dedication to your organization.

REFERENCES

SHRM, 2017. *Introduction to the Human Resources Discipline of Compensation.* Retrieved from https://www.shrm.org/resourcesandtools/tools-and-samples/toolkits/pages/introcompensation.aspx

SHRM, 2019. *What is a compensation philosophy? What should be included in a compensation philosophy?* Retrieved from https://www.shrm.org/resourcesandtools/tools-and-samples/hrqa/pages/compensationphilosophy.aspx

HOW TO ENHANCE YOUR VALUE

Micah Styles and Ian Duckworth

THE NOTION OF VALUE is, and always has been, inextricably linked with museums and in particular the arts. In late 1870s London, American-born artist James Whistler began work on a series of paintings he called his *Nocturnes* – dark, moody, misty landscapes and riverscapes composed of browns, blues, greens and blacks, with occasional flashes of brightness. He exhibited them at the Grosvenor Gallery in 1877, asking a considerable 200 guineas for each (about $16,000 or £12,500 in today's money). John Ruskin, the respected critic who had championed Turner and the Pre-Raphaelites, was unimpressed and wrote a particularly scathing review. The artist responded by suing him for libel. Under cross-examination at the Old Bailey, Whistler was asked whether he could really demand such a high figure for a painting that had only taken two days to paint. He replied, "No, I ask it for the knowledge of a lifetime."

He explained, "You are not paying for what I have just done, you are paying for what, through my knowledge, experience and expertise, how I know how to do it best." And the value proposition was born.

The debate surrounding the value of employees in the eyes of an employer should follow a similar argument, but often doesn't. Staff costs are usually the largest single item recorded on an organization's income statement (or in the UK a profit-and-loss account), and therefore inherently and perhaps often subconsciously, employees are more likely to be viewed as an "overhead" rather than a resource that can and should add value. The debate over classifying "human assets" on the balance sheet in the same way as one would classify other tangible and intangible assets has raged on for decades (Mieczyslaw, 1998) but the museum sector is unlikely to trailblaze where the likes

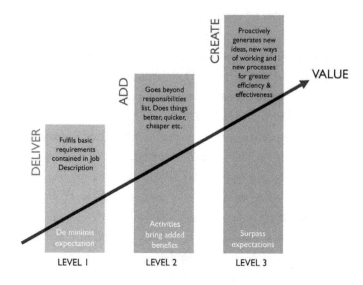

FIG.1: Levels of the Employee Value Proposition (EeVP).

of Google and Apple fear to tread. The mantra *People are your greatest asset* rings hollow in this context and remains a slogan rather than an ethos. However, the museum sector should be well placed to better understand the concept of the Employee Value Proposition (EeVP) than other sectors, as within the trans-disciplinary, multi-sensorial environments of museums, the currency is intelligence. An employee's intelligence modalities, for example the nine defined by American developmental psychologist Howard Gardner in his book *Frames of Mind* (Gardner, 1983) should therefore be relatively easy to correlate to a museum's vision, mission and objectives, with employee and employer perspectives also aligning with regard to value.

Personalizing value in this way is the beginning of the journey for realizing better compensation within the sector. Intelligent, innovative, creative, committed and energized employees create better organizations; however, their value contribution is often qualitative rather than quantitative in nature, usually increasing performance and reputation as opposed to commercial value. What needs to be made clear is the way this first type of value add is equal to the second type of commercial value and no different in the way it adds to overall value.

As is shown in Figure 1, employees need to bridge this gap in perception and understanding, and go beyond their job description to demonstrate that they not only do their job (deliver value); they also need to itemize how the museum benefits from employing them beyond a responsibilities list (adding value); and they need to show how – and here is the key – they look for and proactively generate new ideas, new ways of working, and new optimized processes for greater efficiency and effectiveness (creating value). Employees in such

a scenario, who have developed a clear EeVP, are more like entrepreneurs than simply "staff" in the way they create value for themselves and for others. These are people who know that any organization chart, chain of command, or well-established process is either a simplification of how things really work or else a transient form in a changing world. By regularly asking about the why of operations and deliverables they are capable of creating an environment of improvement.

How value is created

The prime way an employee can create value is through alignment of their skills, experience and capabilities with their museum's vision, mission, and needs. The closer the match to the fundamentals of the organization, the greater the value being created. Conversely, dissonance to the museum's core, whether its main objectives or wider institutional aims, will devalue the employee's contribution in the eyes of the employer. An employee, therefore, should be looking to demonstrate their alignment with the museum, and the value this creates. If the alignment supports the wider business objectives in this way, how the museum benefits from paying them is more easily understood, and the rationale for how they would benefit more by paying them more becomes clear.

Another important way that value is created is by the employee's connection with the museum and their co-workers. Connection is an essential human need, ranking just above basic needs on Maslow's Hierarchy of Needs. The papyrus record of the first documented labor strike (by the Egyptian artisans hired to build the necropolis for Pharaoh Ramses III in the twelfth century BC) illustrates how employees have

organically connected for at least 3,200 years, and likely longer. Connected employees are engaged employees, and engaged employees are better employees, not just in an individual area of specialty but across the value chain. Therefore, if you can demonstrate in your EeVP an ability to support and contribute to a range of projects and specific instances of fostering, promoting and facilitating connectivity within your museum that should be seen as a really valuable asset.

A third element of value is created by being current, and one obvious way to demonstrate this is by keeping up-to-date. This is vital if the employee works in a technical position, of course. But it's not just ensuring things work, or even about Continuing Professional Development (CPD). It's how this translates to tangible impacts and improvements in the museum's live environment. Other skills may not need to be as technically up-to-date, but all knowledge needs to be refreshed and alive to contemporary ideas. Any employee needs to be knowledgeable if they are to add value. Their employer can then easily make the link between current, refreshed and relevant knowledge and value.

A final factor to feed into the value matrix is creativity. Creativity is recognized as one of the most critical skills for the next generation and its value reaches well beyond the arts to affect every discipline and industry. A survey conducted of 1,500 CEOs from 60 countries and 33 industries identified creativity as the "most crucial factor for future success" (IBM Institute for Business Value, 2010) and creativity and innovation as a core competency has been identified by over 17 countries as so valuable for the next generation that it has required the major restructuring of national educational programs and priorities

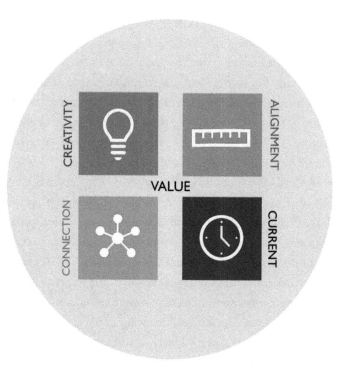

FIG. 2: What creates employee value in the eyes of an employer.

(OECD, 2009). In a world that is increasingly demanding and valuing the skills of entrepreneurs, innovators and change makers, the demonstration of creativity, idea generation and future-thinking will enhance EeVP.

In summary, the EeVP categories should be prioritized (Figure 2) as those that are aligned, connected, current and creative.

How value is communicated

It is one thing for an employee to actively think about, define, develop and enhance their EeVP – and to some extent this is already done by many informally, or within formal CDP, career pathways, or when asked to think specifically about training needs. The value of such exercises, though, is more often than not perceived as "personal" (i.e. Continued *Personal* Development) rather than any value that is being added for the museum. This illustrates the gap in value understanding and exacerbates the under-remuneration seen in the sector. The challenge is how the employee value is conveyed to the employer. Given the present gap in value understanding, employees need to show that this added value actually exists and how it contributes to the organization. This gap in added value understanding is ready to be filled by the newly skilled museum employee who – adapted to the fourth industrial revolution and with a greater range of multi-disciplinary skills applicable across museum activities – is able to articulate and demonstrate their EeVP clearly. Communication of value is key, and this can be achieved by the EeVP being recognizable, measurable and benchmarkable (Figure 3).

"A value proposition represents the psychological framework

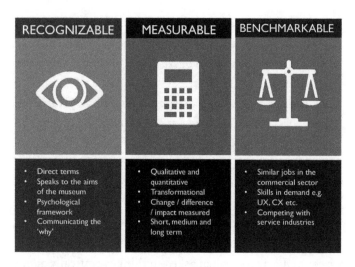

RECOGNIZABLE	MEASURABLE	BENCHMARKABLE
• Direct terms • Speaks to the aims of the museum • Psychological framework • Communicating the 'why'	• Qualitative and quantitative • Transformational • Change / difference / impact measured • Short, medium and long term	• Similar jobs in the commercial sector • Skills in demand e.g. UX, CX etc. • Competing with service industries

FIG. 3: The framework for communicating value.

human beings use to make decisions," said University of Louisville Associate Professor Brad Shuck, "It is the why of the relationship." The museum employee's value must therefore first and foremost be recognizable, translated in very direct terms which speak to the aims of the museum and the objectives of a specific role, and the psychological framework that this sits within. This is especially true when applying for a new position, either internally or for an advertised job vacancy. All too often, candidates will submit an application along with a generic resume, and perhaps a slightly tweaked cover letter for each post they apply for. In today's competitive markets this is not enough, and much more thought needs to be put into communicating the *why* of your proposition to prospective employers.

Museums are measured on their impact (and if they are not, if they are just there to "exist" then they should be). Increasingly the measuring of knowledge, learning, participation and engagement is just as important to monitor for a museum as are its visitor numbers and audience reach. Broader social, economic, environmental and even political impacts can also be stimulated by employees, as can a museum's reputation and influence. Categorized over the short, medium, long and super-long term, both qualitative and quantitative measurement should be included in this equation, with the emphasis on what the employee has done that is transformational. Activity cannot be considered as a value-adding impact if it would have happened anyway. But if something has happened quicker, better or cheaper, then that can be classified as a tangible and measurable impact. Measuring the change or difference made by an employee is therefore a fundamental aspect to communicate clearly.

For the first time much of the workforce in the museum sector will have a benchmarkable value to their job in the commercial sector. Commercial companies will be competing directly with museums to find good employees with the same skills. The museum sector is going from siloed specialism without comparable value, to having employees with skills in demand by the commercial and industrial world. For example, the skills required to satisfy the demand of increased visitor expectation can be benchmarked against user experience (UX) or customer experience (CX) specialists across a range of service industries. Communicating such benchmarks, in a recognizable and measurable way, will provide the framework for more useful employer/employee discussions about recognizing and rewarding value.

The evolving value context
The landscape within which museums operate is ever-changing, and they must, through necessity and the application of best-practice, continue to evolve. These structural shifts began in 1990s with the breaking down of siloes and the blurring of curatorial/engagement roles. The democratization of knowledge, the demanding expectations of the wider experience economy and the debate as to whether museums are "neutral" (and have ever been so) all mean that the role and the authority of a 21st century museum and its staff is up for grabs. The impact of this is both broad and shifting, but we can consider three main areas that have most effect on the value proposition: changes to organizational structures, changes to types of roles and changes to forms of employment (Figure 4).

Over the last 30 years museums have added a number of

areas onto the core work of collections, exhibitions, interpretation and education, and their organization design has dramatically changed as a result, shifting focus and balance to less traditional functions. These areas include the commercial elements of the museum, such as retail and catering, although often these are outsourced. Development and fundraising are also an integral part of many museums due to constant budget pressures. In Europe, raising money from individuals, and from businesses through sponsorship, has become a vital addition to institutions previously covered by public funding. With the odd exception, this has always been the case for US institutions – nevertheless this area of museum activity has become even more vital over time.

Accessibility has become another area of focus for the sector. Increasing the social diversity of the museum audience, as well as its size, is important, with the social range and age of the audience considered an indicator of the general health of the organization. Sensitivity to accessibility rolls through into outreach, community, partnership, networking and marketing. Accessibility is the gateway to networking. Converting visitors into members is one way of creating a social network of individuals who endorse the organization's activity and act as the basis of the museum's social network. The multi-channel ways in which our sector's organizations can reach their active (as well as their potential) audience have never been more powerful, and structures are evolving to accommodate this.

The staff who work in museums increasingly work as teams to deliver projects. They interconnect, separate and re-interconnect as and when needed. The only section that arguably stands alone in this is collections, but the trend is

	OLD	NEW
STRUCTURES	• Siloed • Care and collections heavy • Traditional departments	Visitor experience, accessibility focused Networks + engagement + influence Multi-channel audiences
ROLES	• Hierarchical • Management layers • Specialized functions	Interconnected + collaborative Project focused Self-managing teams
FORMS OF EMPLOYMENT	• Full time • Long term careers • Low no. of volunteers	More flexibility Contract, contingent and 'gig' workers High no. of volunteers (or no volunteers)

FIG. 4: New and evolving contexts that impact value.

for collections teams (with specialist curators separated from each other by academic criteria) becoming a smaller part of an expanding range of staff skills. It is happening, but perhaps not happening enough and in some way marks a return to the idea of curator as anthropologist and presenter alongside classifier. The current challenge is to integrate academic staff back into this larger picture through broader use of their academic skills. A look at most museum organizational charts will show how small the collections section has become compared to the rest of the skills needed.

With these additional functions to the traditional museum we can see how the idea of the collection is changing. Can it be argued that collections are no longer the core of such an organization? Maybe, but certainly their role in the organization has shifted. Given all the new functions added over the last 30 years, collections – by simply staying in the same position – have taken up less of the organization's activity, and the speed of this change is now more noticeable because of greater audience expectations about the technological augmentation of the object during their visitor experience.

The object is still the source of the visitor experience but has broken out of the glass case it was confined to, the place on the wall it was fixed to, and the storage space it was returned to. Objects can convey much more to their audience than they could before. The skills now required by staff are often about how best to do this, which requires empathy and communication, bringing such "soft skills" on a par with scholarship. It is through these skills – which adapt to new technologies, new attitudes to scholarship, new commercial imperatives and the new positioning of museums in society – that value is added to

the museum in a way that has not been possible before.

As well as the expansion of museums beyond the care and maintenance of collections, there is the disappearance of management layers. As more senior managers retire, they are being replaced with staff with specialist and technical skills who have a flexible approach to team working. Many management posts may well be going the way of the typist (remember them?) as employees become more autonomous yet more inter-connected and self-managing within the institution.

Forms of employment are also evolving. Contract and contingent workers form large parts of many museums' workforce. However, most notable and perhaps most directly related to the topic under consideration, is the fact that the use of volunteers has increased over the last 25 years. Volunteers tend to fill two roles – either front-of-house support or collections documentation, such as imputing data into management systems. Volunteers in this scenario add value to the organization, but chiefly by lowering theoretical costs. So far there is no proven argument about how volunteers offer intrinsic values and efficiencies to a museum and there is debate about whether they are actually contributing to the creation of an un-diverse, unrepresentative and affluent workforce. The widespread use of volunteers in this way may well encourage a "love or money" approach to pay by eliminating pay altogether from some areas of museum activity, allowing the museum to keep within set budgets that are inadequate to do the job.

A counter argument is offered by Lath Carlson, who has recently been appointed by Barker Langham Recruitment to the position of Director of The Museum of the Future in Dubai (and was ex-Director of Living Computers: Museums + Labs

and a Leadership Fellow of Noyce Leadership Institute (NLI). It's a vision within which museums don't have volunteers, and everyone is paid for the work they do. Where employees have entry points into the organization that don't require a degree. Where Interns are paid a living wage. Where there are flexible employment options and viable career ladders. Where there is a non-hierarchical, or at least a very flat, top-to-bottom hierarchy. Where there is skills training and development. In such an environment, described by Lath and others as Museums 3.0, all employees contribute a clear and understood added value to the organization (Carlson, 2014).

Museum staff will increasingly no longer work as a line management, command and control, entity with stop and go signs, but will more resemble an interconnected hive of continuous activity. Maybe the sector has yet to properly recognize this trend, but it seems set to continue until the sector does understand the change.

Why recognizing employee value is essential

So far, we have considered what value is, how it is created and communicated, and how it is evolving within the museum sector. On this basis, any proper assessment of the value of museums' staff would lead to extra-pay, and with a robust platform of understanding of what value from staff means, the institution should be in a better position to add the resources to fund such pay. Alongside the appreciation of such employee value should come a more rigorous way of quantifying the added value of volunteers as a team which adds value to an institution, doing more than just saving on costs and paid head count.

FIG. 5: The value journey.

With the concept of staff value at its heart, an institution can potentially set up a virtuous circle, attracting, engaging and retaining "better" staff which in turn leverages employee value and job satisfaction. Happier employees with rewards, recognition and career pathways are perfectly positioned to take advantage of the new skills and ways of working required in a museum of today (Figure 5).

An institution which invests in their employees in this way is better equipped to get the most out of the way museum staff structures have changed, are changing and will change further to create inclusiveness, accessibility, social networking, partnerships and community benefit. All these functions change the institution from one which primarily preserves and displays into one that actively engages with its public to transform through a whole experience.

Museums will have to come to terms with needing people with skill sets that are in demand by the commercial world and they will have to pay them accordingly. The change in the skills of the employee will require museums to invest in their staff to retain them against competition. There will need to be a commercial rate paid, with rewards and a career track to create a positive environment of achievement, otherwise a vicious circle of under-achievement will develop until the institution's offer lags behind its audience's expectations.

Maybe the ultimate added value for museums comes from the recognition that all the staff within the institution add value. With this buy-in, the larger added value that only museums are equipped to deliver is revealed – to put a set of experiences into a visitor's head they didn't know were possible – and then get them to come back for more of something completely different.

Conclusion

The true value proposition of museum employees is an under-developed component of the debate about low salaries, but one we feel needs to be addressed as part of an holistic solution for next-gen museums and their staff.

Employee value needs to be more clearly defined, articulated, communicated and understood by both parties. But the onus falls largely on the employee to instigate this. Rather than passively complain about low salaries, employees should proactively seize the opportunity to demonstrate how they contribute to the big picture, how they can bring greater benefit, and how they can solve or resolve problems. The case should be made for the value that employees deliver, add and create and the commensurate benefit that will come from recognizing and rewarding that contribution in the ever-evolving context of museums today and in the future.

We suggest that the positive results of a virtuous circle of rewards and recognition, through understanding and acceptance of value, can and should be based on an employee value proposition that is aligned, connected, current and creative, and communicated within a recognizable, measurable and benchmarkable framework.

For museums to remain relevant and engaging experiences in the next decade and beyond, the importance of their acknowledging the fact that people are indeed their greatest asset is imperative, and the necessity to invest more fully in their employees cannot be over-stated.

REFERENCES

Carlson, L., 2014. *Museums 3.0 – Museum as Resource*. Retrieved from: https://youtu.be/pnnaXO5tYcQ

Gardner, H., 1983. *Frames of Mind: The Theory of Multiple Intelligences*. Michigan: University of Michigan.

IBM Institute for Business Value, 2010. *IBM Global C-suite Study*. Retrieved from: https://www.ibm.com/downloads/cas/NJYY0ZVG

Mieczyslaw, D., 1998. How to Place Human Resources into the Balance Sheet? *Journal of Human Resource Costing & Accounting*, Vol. 3, Issue: 1, 83-92.

Organization for Economic Cooperation and Development, 2009. *21st Century Skills and Competences for New Millennium Learners in OECD Countries*. Paris: OECD Publishing.

COUNTER-INTUITIONS FOR MUSEUM COMPENSATION

John Wetenhall

OVER THE DECADES, as museums have become ever more "professionalized" and "businesslike," the management of "human resources" has increasingly come to resemble that of any profit-seeking local company. Museum administrators establish HR policies and hiring processes, job descriptions and annual goals, performance reviews and budgeted merit raises. Once established, the machinery of personnel management grinds on, year after year, superficially smoothly, until such time as people may, quite possibly, notice that it also seems to grind down upon the dedicated staff for whom the "incentives" of human resource sciences have done anything but inspire. To businesspersons in the boardroom, it can be difficult to perceive that the "best practices" of their corporate cultures may be undermining the creative ecosystems that good museums nurture to fulfill their potential. There is a simple reason: the people who dedicate their lives to museums are not businesspersons. They have chosen careers apart from the values of the corporate world and so carry with them innate immunities to the charms of HR rewards. But even if museum workers shared every ideal and ambition of the corporate employee, the motivational system that HR management has so refined in the corporate world would likely underperform anyway because the wage scales themselves are set too low for the incentives to work. This is but one of the means by which well-intentioned practices from the for-profit world run counter to the values of a non-profit culture. Allow me to explain.

Annual "merit raises" may cause more harm than good

The annual ritual goes something like this: the board approves a salary increase of one or two or three percent as a "merit raise"

for the fiscal year. This sum is set aside to elevate annual wages in recognition of "exceptional work," "outstanding service," or "inspired contributions" to the lofty mission of the beloved museum. Board members glow in their generosity to the hardworking souls whose labors they oversee among their fiduciary responsibilities. Congratulations circulate around the boardroom. Smiles and maybe even a round of applause. Job well done! Little would anyone guess how such a gesture of largesse could possibly meet with such grudging acceptance, apathy, or even a tinge of resentment by the intended beneficiaries, whose occupational mind-sets exist significantly further than may first appear.

If museum professionals viewed their worlds from the vantage-point of a budget or boardroom, all would likely be fine. But they live in communities of flowing information. They know the annual inflation rate and the fiscal capabilities of their institution. They hear what people make at other museums or comparable non-profits in town. They have access to salary surveys conducted by museum associations. They may also know what colleagues make in-house.

They also understand math. For instance, 1% of a $40,000 annual salary is $400. Take away a quarter for taxes and other deductions and that leaves about $300 per year, or $25 per monthly paycheck, or about $6 a week. Double or triple that and it gets better, but hardly by life-changing amounts. Those percentages that motivate the middle and top of a corporate pay scale – where workers already make tens or hundreds of thousands more in annual salary and whose merit raises could fund a home entertainment system, club membership or Mediterranean cruise – do not function effectively with lower

baseline numbers. And, by the way, many museum profession-
als make less than this example, rendering their "incentive
packages" the monthly equivalent of a paltry tip that, if left on
the table at a modestly-priced restaurant, may not constitute
an acceptable gratuity. But there is more.

Employees come to learn that a substantial percentage of
their "merit raise" goes to every employee regardless of achieve-
ment, so what poses as a reward for accomplishment is little
more than a cost of living adjustment in disguise. For instance,
if the "merit raise" pool spans from 2% to 3% (some workers
receiving 2%, others 2.5%, and the "best" 3%), then everyone
sees the 2% baseline as an automatic adjustment, having noth-
ing to do with their worth or contribution. More discouraging,
the remaining percentage differences that span mere fractions
between the absolute worst employee, the average worker, and
the most inspired contributor are too small to matter. They
separate the museum team by labeling some people as "better"
than others for sums of bi-weekly pay that are, in terms of qual-
ity of life, effectively meaningless. So, museums differentiate
their employees for an inconsequential rate of a few dollars per
paycheck, and then expect to unify everyone around the value
of teamwork toward a common mission.

There is another standard between merit and cost-of-living
that matters deeply to museum employees: fairness. Across
hiring cycles and over the years, it is not uncommon for cer-
tain staff members to be paid less than others of lower rank,
accomplishment, or tenure. Biases of race, ethnicity and gender
have long histories of contaminating wage scales even in well-
meaning institutions. Long-time employees sometimes find
their relative salaries lower than the wages dangled to recruit

new hires, realizing that their loyalty has been taken for granted by leadership that undervalues their institutional memory and the efficiency of not having to fill frequently-vacated positions. We museum professionals are especially sensitive to inequities, as so many of us entered the field to pursue ideals such as access to education, cultural equity, social justice and a faith in human goodness. It is the ethical duty of institutions of all kinds – especially such idealistic and aspirational entities as museums – to review comparative salaries for fairness among the existing staff and the field at large according to whatever standards may best apply. "Merit raises" without periodic fairness reviews can do nothing but perpetuate inequity and heighten the resentment of those on the wrong end of a raw deal.

"Merit raises" are structured on the well-meaning intuition that rewards are worthwhile, without recognizing the demotivating damage they can sometimes impart in the not-for-profit world. This counter-intuition requires unbundling salary adjustments into three separate pools, according to different processes. Annual cost-of-living adjustments can communicate to everyone in a team-based organization that leadership cares about each person's quality of life. Individual merit recognition, be it as a raise or bonus, sabbatical or perk, should be specific to the job well done, personal to the exceptional performer, and large enough to impact quality of life. Fairness reviews require examining the entire pay scale with a commitment to adjust salaries that are out-of-line relative to other museum employees or peers at comparable institutions. True, the museum may save a few dollars by avoiding the expense of such adjustments, but probably at a cost of employee unrest, or worse, undermining its own institutional values.

There is more to salary than money

The best salary I was ever paid was among the lowest. Years ago, when negotiating the terms for my first museum director-ship, it became clear that the institution's limited resources were bound to disappoint. As a combined botanical garden, art museum and historic house, Cheekwood was hoping to expand its fortunes through a major renovation funded by a capital campaign – an aspiration made promising by the vibrancy and economic growth of its soon-to-boom home in Music City – Nashville, Tennessee. The problem was that Cheeekwood's operating revenues were so tight that they could only offer a salary little more than the curatorial wages I was already earn-ing – a poor precedent were I to agree. So, attempting to find a path between an unacceptably low salary and a potentially career-making opportunity, I proposed this: if Cheekwood would allow me more creative work rules, I would work for its below-rate annual salary. Deal. I accepted an eleven-month con-tract on the annual salary that Cheekwood could then afford, accepting a requirement to go on unpaid leave for one month each year. In hindsight, these annual sabbaticals benefitted the institution probably more than had I labored behind the direc-torial desk. The arrangement forced me out of the daily grind and allowed for reading and reflection, usually inspired by sun-rises and sunsets over the gently lapping waters of Pensacola Beach.

While languishing in my unpaid idleness, I thought through the project I had joined the museum to pursue and came to realize that it might be a bad idea. The trustees wanted me to oversee construction of a stand-alone art museum to expand the historic Cheek Mansion at a time when another group in

town was exploring building its own art museum. From the fine white sand of the Gulf Shore came this idea: we could fulfill the entirety of Cheekwood's twenty-year master plan in only four or five years if we deferred building the art museum. We would instead invest in the botanical gardens, plus a modest conversion of existing stable stalls into spaces for contemporary art, joined by a mile-long woodland path for outdoor sculpture. By not competing with the proposed downtown museum, our capital campaign eventually tripled its original goal.

One of our campaign co-chairs, the late Monroe Carrell (funder of the sculpture trail), commented to me once, as we shifted our campaign strategy, "John, you sacrificed the project you came to us to pursue – we owe you one, so come see me when I can help." So a few months later I meekly entered the executive offices of the Central Parking Corporation and asked Mr. Carrell if he would help me go to business school. He rounded up fifteen other Cheekwood donors and convinced each to chip in for my two years of Vanderbilt tuition, generously offered with golden handcuffs that I would have to stay for two more years after graduation or else pay it all back. That deal made my directing career, refining my knowledge of management and leadership skills to the benefit of my sponsor museum and, in time, leading toward major museum positions for me. This would have been utterly impossible had not a modest non-profit had the courage and creativity to modify its standard conditions of employment.

We, as museum administrators, coming from backgrounds of academic study and non-profit management, sometimes try too hard to project ourselves as businesslike. Not quite sure about the mechanics of accounting, the leverages of

finance, and fiduciary nuances of the annual audit, we adapt to the look and language of the for-profit world, occasionally subordinating our indisputable credentials as experts in our mission-related fields to personas modeled on climbers of the corporate ladder. Reticent to expose our weakness, we hesitate to unleash the creative spirit that lies within our workforce. Notwithstanding our commitment to creativity in our galleries and innovative educational programs, we find it difficult to promote imaginative work rules or untraditional arrangements for fear of appearing administratively weak or not quite professional enough to manage our enterprise. We escort our boards along a workplace philosophy with all the imagination of a nineteenth-century factory owner, dedicated to keep workers on-site and occupied for as many hours and as many days as human decency and labor law will allow. We confuse attendance with productivity, input with impact, and so sell our creative instincts short. No, of course, not all of us all the time, but this can be our tendency as a field.

There are many ways to expand the menu of workday obligations. When the old Cheek Mansion had to close for renovation, the plan was to rent an expensive trailer to provide a year or two of temporary office space. For a fraction of the cost, we bought new computers for every staff member and set them up with home offices, using neighborhood cafes as conference rooms for weekly meetings. Productivity rose, as did morale and teamwork. I have spent summers on four-day weeks of ten hours each, with no diminution of work product among grateful museum colleagues who enjoyed longer weekends with friends and family. Some institutions of higher learning close between Christmas and New Year. Certain museums

shut down for a week or two each year to refurbish galleries and
maintain facilities, often allowing administrators, research-
ers, and visitor services employees some valued time away. We
tend to be a bit stingy offering sabbaticals, family leave, and
flexible arrangements for research and reflection. As we come
to terms with the limitations that may constrain our annual
salary structures, we should always remember our access to
the value of time.

Confusing expenses and investments

In the eyes of accountants, a museum's professional staff
constitutes an expense. Efficient enterprises compete by their
ability to do more with less: lower administrative overhead;
deliver service with fewer employees; automate factory lines;
and answer the phone with digital voices. Labor equals cost;
decreasing labor raises profit margin. But in a museum, cura-
tors, educators, and their professional peers are the instru-
ments that drive value; they not only contribute to the mission
of the museum, they amplify it. Curators make dormant collec-
tions come alive through scholarship, exhibitions and simply
by talking about collections to museum attendees and at public
gatherings. Educators energize museums through tours, lec-
tures, discussions and other programs. Conservators resus-
citate objects back to life from a state that may be otherwise
unfit for display. These are the mediators between museum col-
lections and their audiences. Employing more of them means
more mission – a better, stronger, more effective museum.
Fewer, simply, means less.

If we can agree that mission-driving staff members are
valuable assets for a museum, then funds spent on travel,

training, and other morale-building incentives are really investments. I had only just joined George Washington University to help navigate a merger with The Textile Museum (TM) of Washington, DC., when a long-time supporter inquired how we might make the most impactful use of her five-year campaign pledge. Finances at the old TM had been tight and staff restricted to basic duties, primarily packing for the move to a new facility. The museum had launched a Founding Patrons campaign to support the transition, anticipating new funding for start-up costs, initial exhibitions, educational programs, and the like. In my judgement, however, what we desperately needed was a means to look beyond our own logistical obligations. I wanted to send museum professionals to national conferences, symposia, and specialty training to engage with colleagues and think about possibilities and aspirations for our new museum. So, when this wonderfully generous donor asked how her gift might provide the most impactful benefit, I responded with conviction, "travel and training." Thanks to her gift, our people participated in association annual meetings, regional conferences, a week-long course on rare books, a three-week study of historic houses abroad, and a year-long leadership training program for emerging professionals. One year later, the following text came across my email:

> Today we received probably the warmest and most specific thank you for a donation we have ever received in all these years of supporting organizations – your letter. Forwarding to us the appreciative comments of the TM's participants in the AAM conference was heartwarming. Congratulations.

My letter had been nothing more than an assembly of three-sentence paragraphs, each by a recipient of staff-designated travel support to attend the annual meeting of the American Alliance of Museums (AAM). One attended several sessions on digitization. Another met vendors "to find... cost-saving solutions for the museum's exhibition spaces." An educator participated in sessions that helped her to "think about the museum's overall interpretive plan and how to best communicate our big ideas to visitors." Others learned about gender equity, diversity, inclusion, and how to create welcoming spaces for all. They thought through such concepts as "intersectionality," caught up on the latest technology, explored museums' role in environmental sustainability, and even probed "culture as a lens into what it means to be an American." This is not the stuff of weekly staff meetings nor on-site HR training. It is the kind of expansive, inclusionary dialogue that makes museum employees more thoughtful about their work and helps them deliver a fundamentally better experience to museum visitors. Museum leaders should want more of this. So should donors, because their museums benefit from it far more than the paltry savings that withholding such experiences might accrue.

The challenge of our status quo is that institutions dedicated to education – when it comes to their own inner circle of employees – do not always value learning. At least, they do not wish to pay for it. The financial reports that museum boards scrutinize would have us believe that the costs we incur for travel and training are "expenses" when, in substance, they invest in morale, sharpen individual skills, build teamwork, broaden the museum's collaborative network, and enhance the reputation of our beloved institutions. Yes, we have all heard

about corporate "junkets" to Vegas or golf resorts or Caribbean islands, but rest assured that the annual meetings of most non-profit organizations are more "businesslike" than those of most businesses. They enhance individuals' knowledge, skills and abilities, paying dividends to the museum by inspiring professionals to follow their passions beyond the quantifiable reach of recognized standards of public accounting.

If you set aside the financial reports, there is one more place to look for healthy investments in the professional staff: the weekly calendar of events. Beyond meetings and email and public programs, exceptional non-profits encourage teamwork and boost morale simply by setting aside time for group projects and learning activities. Two or three times a year, my current colleagues gather for a staff work day, when everyone goes to our storage facility to move large objects, clean out cluttered spaces, or reconfigure workrooms as current needs demand. We also visit other museums as a group, on occasion, for special VIP tours to admire the work of nearby colleagues. Once a month, we celebrate "cake day" which is nothing more than a pot-luck party of sweets to bring people together outside of agenda-structured meetings. I have been to bowling nights, baby showers, brown-bag lunch talks, happy hours, the annual Solstice Party, and was once taken to a "business" meeting at the Talladega Motor Speedway. These examples are not intended as a menu of options, but a license to empower the creative energies of museum professionals to develop lists of their own. A vibrant and healthy workplace culture is the lubricant that keeps the machinery of non-profits running smoothly. We all possess the means to compensate for pecuniary shortfalls with just a bit of imagination and commitment,

to generate a wealth of comradery, companionship, and mutual goodwill. The HR manual will tell you little about *esprit de corps*, but I would rather sacrifice a strategic plan than try to run a museum without it.

Accomplices to the scarcity of resources

I remember a conversation, at one of the many meet-and-mingle receptions that Miami's *Art Basel* orchestrates each year, with a recently-appointed art museum director about the ravages caused by the recession of 2008. He described layoffs, salary freezes and even some pay cuts that had been unavoidable to maintain pre-recession levels of educational programs and exhibitions. He praised his dedicated staff members who toiled to deliver as many lectures, exhibitions, and school tours as prior years, but with fewer people to help – images of heroic labor, tinged with declining morale, threadbare resources, and fretful concern for the future. The more he spoke about dedication and sacrifice, the more I realized that something was deeply wrong: why were museums so desperate to deliver the same programming on a fraction of the budget? What message were we sending? By absorbing the added labor that austerity measures had imposed, it seemed to me that staff members had become enablers of budget cuts without consequence, undermining their own welfare by suggesting to board members and public alike that they really did not need the resources they formerly had – staff, funding, and other help. Their own selflessness and dedication was undermining their self-interest.

I asked my director friend what he planned to do when times improved. "Hire back more staff," he reflexively responded, "we need to get back what we lost." Really? What about those

wonderful people who took pay cuts and reduced benefits to keep the museum going? What would they get? Not much, I learned – the topic had not come up. But before dismissing this as the indifference of a callous leader (he is not), consider that among professionals in our field, he was merely showing the same selflessness as had his dedicated staff: invest in the program before the people.

There exists no museum education department without another program worth funding. No exhibition cannot be improved with a few more loaned objects, a more richly illustrated catalogue, or more advertising and promotion. Digital resources can be expanded *ad infinitum*, as can collections, strengthened by just a few more "important" pieces. Museums are places of ambition, imagination, and passion for perfection that drives museum professionals beyond the boundaries of their own self-interest. They are infinite springs of deserving audiences, innovative ideas, and worthy programs. We need to hire just one more educator, another curator, a fund-raising guru or a master of public relations. We, in museums, always see a more impactful future if only we can stretch a little further.

This thinking undermines our interests. As we slowly emerge from fiscal crises or financial recessions, our first gestures should be for the loyal professionals who stood with us through hard times: perhaps a raise, bonus, or extra time off. Maybe an increase in the 401k matching program or augmenting the travel and training budget for the common good. Even in better times, we should remember that low wages may depress participation by people from different backgrounds or burdened by student debt, unintentionally diminishing

our commitment to diversity and an inclusive workplace. If this means delaying the new hire, then maybe patience can be our friend. The reason that this is so important for museum leadership to understand is that our employees may be too conflicted to ask – caught between their own idealist passions for the museum and their obligation to provide for themselves and their families. We museum directors exacerbate this conflict through our own ambitions, even though they be wholly directed toward the mission of our beloved museum. This is our blind spot. It is the business of museum leadership to understand the altruistic nature of the human souls in their charge and to care for them with all the fiduciary zeal that they dedicate to balancing their budgets and filing their 501(c)(3) forms.

The duty of care

There is a special group of people for whom this care is most in need: those at the lowest end of museum wage scales. Everyone understands that museums can afford less than the for-profit sector, but a living wage seems a minimum standard below which public entities should not operate if they purport to work toward the common good. We know and deeply value the contribution that volunteers make to museums. Some museums cannot operate without them and virtually any museum would be better served to dedicate more benefits, perks and other forms of appreciation to those wonderful, generous people. Interns are not volunteers. They work with museum employees on the understanding that they will gain sufficient pragmatic, hands-on learning experiences to compensate for the absence of a wage (the simple test for this is that when the museum employee spends more time hosting an intern than

would be required just to do the work itself, that signals a genuine internship). For the sake of opening museums to people of less advantaged means, some people wish to eliminate unpaid internships. Others differ, but most people would agree that hiring students is a worthy initiative. In the year I write, our university museum has hired as many part-time, paid students as we count full-time employees. Their contributions of energy, enthusiasm, and fresh ideas are vast; the satisfaction of supporting a student's early career is magnificent. There are many more ways to augment museum resources without leaning upon sub-standard wages and miserly benefits.

Much of my directing career has been spent in large institutions, requiring a substantial service staff of custodians, security attendants, gardeners, facilities engineers, salespersons, receptionists, food service workers, and many more. While working in smaller museums, I often chipped in by assisting colleagues in various tasks (that is how we all manage in smaller museums). Once in charge of larger sites, I set aside single eight-hour days to work in specific support roles and to understand those who perform such duties daily (an idea inspired by Florida US Senator Bob Graham's monthly "workdays"). So, on my first week of work at the John & Mable Ringling Museum of Art, I stood guard duty for a day and soon after trimmed the hedges on the 60-acre estate. I have carried heavy bags of mulch in 90 degree heat; cleaned toilets and sinks and dirty floors; pressure-washed plazas and spray-cleaned boilers; parked cars and directed traffic; welcomed visitors and driven a tram; stood idle on guard in empty galleries and watched vigilantly once crowds arrived; worked on roofs and in basements, in the cold, rain and searing heat; and I have learned a lot about the

dignity and dedication of museum workers. The people who make our museums function – be they public-facing or behind-the-scenes – contribute remarkable pride, commitment and often-unrecognized quality to the institutions we all love. I can write with certainty that there is nothing minimum about their roles to justify a minimum wage. If we value the people who visit our galleries, we cannot take for granted those who make them accessible.

One simple way to support museum professionals is to provide the basic resources they need to do their jobs. The hedges at the Ringling Museum (at least on the day I endeavored to trim them) are higher than a person can reach. I was paired with a co-worker so that one of us could wield the electric trimmer while the other held the ladder. After a few minutes of this worthy labor, I inquired whether there might be a more efficient process we might employ. No, I learned, we had no money to buy an extension for the trimmer. So to save less than $100 for a simple metal pole, we wasted one person's day of labor to stand idly by a ladder. While the penny-wise, pound foolishness of these economics are thankfully not normal, this underutilization of human capacity happens all too often. The computers and software and equipment and tools and books and subscriptions that museum workers use to leverage their knowledge and skills are not only vital for fiscal efficiency, they represent symbols of their users' institutional importance. Museum professionals are hard-wired with passion and ambition to make meaningful impact in their specialized fields and in the lives of people with whom they engage. Their incentive system is joy, fulfillment, and creative expression. Underinvestment slows them down. Micro-management constrains their contribution.

Encouragement and trust are the motivational means to maximize their "productivity." This is a remuneration beyond pecuniary controls, supported by the faith, freedom and opportunity that a museum bestows upon its people to fulfill their professional potential and personal influence.

A great deal is made these days about the so-called "three duties" of board governance: the duty of obedience, duty of loyalty, and duty of care. Obedience is about legal regulations, ethical guidelines and adherence to mission. Loyalty places the museum's interests ahead of the personal or professional advancement of individual board members. Care recognizes each member's responsibility to contribute the judgement and due diligence that important decisions require. But I submit that it is not enough to care only for the institution and its mission. This duty must mean caring for people, the people who labor in these wonderful museums because they care so much that they do not fully and competently advocate for themselves – even if such care means doing less or serving fewer. This duty is not simply caring as in empathy or understanding, but a care resembling that of doctors for their patients. A not-for-profit board cannot fulfill its fiduciary duties without fulfilling its responsibility to care for the people it employs.

The patrons absent from your donor wall

Allow me to conclude with a simple principle: an organization built around a mission of giving to others cannot be successfully administered by a staff from whom most benefits are taken. This is a matter beyond resources, reaching to the very identity of the people museums employ. There can emerge a tendency these days, in at least some boardrooms filled with

the titans of regional commerce and the scions of local phi-
lanthropy, to consider the professionals who conduct the
business of their museum's noble mission as essentially hired
help: "employees" or members of the museum's "staff." This
may come to resemble an upstairs/downstairs viewpoint that
would have the board dispense wages to workers as would the
members of a private club set the pay-scale of their service
workers. Where and when this happens, I insist to you that it
is wrong, not just from my point of view, but from a perspec-
tive articulated by the United States Secretary of Labor nearly
60 years ago.

In 1961, President John F. Kennedy asked Labor Secretary
Arthur Goldberg to arbitrate a strike by musicians of New
York's Metropolitan Opera – the first such intervention of the
federal government in the arts that anyone then could remem-
ber. Considering it "unthinkable" that the season might be can-
celled, President Kennedy forced both sides to the bargaining
table. The Labor Secretary convened the parties for argument
and debate, resulting in an eventual award of only a modest
pay raise for the musicians. There was simply not enough to
do better. More important for posterity, though, Secretary
Goldberg authored a 60-page landmark opinion that expanded
his decision into an exposé on the state of America's cultural
institutions and the people upon whom they rely. In the Age
of Camelot, performing arts institutions, like many museums
today, operated under financial pressures that limited their
ability to compensate performers as their talents demanded.
Musicians themselves, like museum professionals today,
brought exceptional talent, dedication, and life-long train-
ing to institutions whose wage scales "would not attract even

mediocre talent in other infinitely less skilled occupations."
Those musicians who delivered the magic of the Metropolitan
Opera, Goldberg concluded, ultimately, "subsidize the Met."
This principle persists today in our museums, where profes-
sionals endure early careers of unpaid internships and part-
time work, often after years of post-graduate academic study,
to achieve full-time salaries that pale in comparison to their
peers in the for-profit world. These pay scales articulate the
extent of their philanthropy, contributed by the acceptance of a
lower wage. Like any other museum patron, these contributors
deserve – at the very least – the acknowledgement, recognition,
and appreciation of their institution's leaders. Museum profes-
sionals are philanthropists. They deserve, most of all, respect.

CHAPTER FIVE

TOUGH LOVE: MUSEUM SALARIES AND THE WORKING CLASS

Mathew Britten and Kerry Grist

IN THE LAST THIRTY YEARS my salary has gone up and down regardless of location and job title. In fact, this year, I've been earning less than I did when I first started out. *Manager/Curator, South East England.*

This brief chapter aims to bring together some experiences of working-class museum staff and to draw attention to the struggles which working class individuals can face within museums. The authors carried out a critical assessment of currently advertised salaries for an early career position, Collections Assistant, and also surveyed a sample of 100 museum workers.

A sample of six Collection Assistant roles advertised between early 2018 and early 2019 reflects the lack of standardization and expectation which exists in the advertising of museum jobs.

The six roles examined had wildly varying job descriptions, contract lengths and levels of pay. The core job descriptions ranged from curatorial support, conservation support, and a focus on inventory and collection audits. Collection Assistant roles are generally entry-level and provide a useful guideline for what experience is needed to enter the sector. All six posts had different contract lengths, none being more than two years long. If, for example, an individual could obtain two of these jobs, one with a six month contract and one with a one year contract, they would have gained completely different experience from both roles (one is collection-audit focused, the other exhibition focused), yet they would still fall short of the requirements for another of the Collection Assistant roles, which has a completely different job specification and asks for two years' experience.

Interestingly, the latter role was the lowest paid of the six, despite asking for the most experience from candidates: a degree, a professional qualification and project management skills – a very great deal for an entry-level role that only just meets the lower end of the UK Museums Association's 2017 pay guideline for jobs at "assistant" level.

The situation highlights another problem in the sector: our theoretical candidate would have hopped from two short-term contracts, with their pay decreasing as they gained experience – from a £24,000-£28,000 range ($30,000-$35,500), down to the £18,000 ($23,000) mark – while their job title remained the same.

The authors also surveyed a sample of 100 museum professionals on their experiences of class, salaries and working in the sector. The survey produced a number of interesting insights:

- 57% of respondents identified as working class, defined by Museum as Muck,[1] as coming from a background with low social, economic and cultural capital.
- 48% provided the main financial income for their household.

Interestingly, 30% of the respondents identified *both* as working class *and* providing the main financial income. Location and salary were highlighted as the main factors when searching for work in museums. Twenty-three percent of working-class museum professionals identified salary as their main consideration when applying for a new job. The authors were shocked to discover that 75% of respondents said they had considered leaving the sector due to salary.

Respondents to the survey were encouraged to share their

CONFRONTING THE STATE OF MUSEUM SALARIES

experiences of salaries and working in the sector. We have selected four for reflection since they raise topics of repeated concern:

The higher up the ladder, the higher the class.

Working class (and other groups) are under-represented in senior positions in the arts and culture sector. In 2016, Arts Council England found that an individual's socio-economic background was one of the major driving forces behind their engagement with museums (Consilium Research & Consultancy, 2016). Museums are aware of this, and diversity in collections and display have helped to encourage more inclusive practice. However, museums need to do more to encourage class diversity within their workforce. For this to be effective, salaries must improve.

> Entry point seems a big issue - in my experience, working class professionals that perhaps transfer from other industries and enter at senior levels appear to be fine...

The inconsistency of employment requirements often leaves early career professionals in a catch-22 situation where they need experience, but struggle to obtain it, or simply cannot afford to work and not earn. In the authors' survey, 44% of respondents were unaware of schemes or initiatives to support entry for individuals from low-income backgrounds.

> I work part-time and am a single parent. We are constantly living on the edge of what's manageable.

I see jobs in other fields with starting salaries on a par with my twenty year experience salary, but fear stops me moving.

Sixty-seven percent of survey respondents admitted to experiencing "imposter syndrome," the feeling that you do not fit in, or are "faking it" no matter what your experience or qualifications. Often this feeling is rooted in a lack of understanding between different class experiences. If senior positions in museums are dominated by higher classes who are perceived not to understand the financial struggles of working class members of staff, then there is a risk of further alienating this section of the workforce.

The authors hope that this chapter has helped bring into focus an understudied, yet increasingly important, area of concern. The sector needs to change, to be inclusive and champion the diversity of its workforce. Currently, the insecurity and instability of salaries threatens to prevent the recruitment and retention of talented museum professionals.

To quote Freddie Mercury, "Too much love will kill you every time..." Financially at least in this case.

NOTES

1. Museum as Muck is a network for working class museum and gallery professionals.
 https://www.facebook.com/groups/museumasmuck/

REFERENCES

Consilium Research & Consultancy, 2016. *Equality and Diversity within the Arts and Cultural Sector in England.* Retrieved from: https://www.artscouncil.org.uk/sites/default/files/download-file/Equality_and_diversity_within_the_arts_and_cultural_sector_in_England.pdf

SERVICE OR SERVITUDE? WAGE POLICIES IN MEXICAN MUSEUMS

Amelia Taracena

IN MARCH 2018, Mexico City's museum employees went on strike, launching a movement they called *#YaPágameINBA*.' The Tamayo Museum was the first to tweet, on March 24, reporting that its workshops and guided tours would be suspended until further notice. A couple of days later, the National Museum of Art tweeted: "A love of art should not imply working three months without pay." The workers who lifted their voices and waved banners in front of the Palace of Fine Arts and other government-funded museums that are part of the National Institute of Fine Arts and Literature (INBAL, often referred to as INBA for short), were the so-called Chapter 3000 workers. These independent contractors, who tend to be university graduates in their twenties and thirties, said they had not been paid for three months.

Soon after, workers from the National Institute of Anthropology and History (INAH) joined the movement (Amador, 2018). Together, the INAH and INBAL employees handed out flyers and created a Twitter account called @capitulo_3000. Some of them met the media to draw attention to the movement. The news soon went viral, and INBA also responded quickly: on March 28, it issued a statement announcing that Chapter 3000 employees would be paid (Secretaría de Cultura, 2018). For several weeks, the authorities issued press releases and met with workers from the movement to talk about their demands for better labor conditions and a fair contract – demands which have still not been met.

Although INBA's independent contractors were paid in full by June 2018, payment and contract irregularities have persisted into the new presidential administration, which began last December: INAH failed to renew 650 workers' contracts

this year, saying it will no longer be "requiring their services" (Mateos-Vega, 2019). This has prompted INAH's Chapter 3000 employees to remain active on social media.

How did the situation become so serious? In fact, the payment issue is only the tip of the iceberg. In order to understand this complex institutional system, it is necessary to examine the political and economic history of cultural funding in Mexico. Since the Mexican Revolution in 1910, culture has been a fundamental part of the construction of a national identity, resulting in a state which – through its public museums – is the main driving force behind cultural activities in the country. Moreover, each presidential administration allocates a budget for cultural institutions, which is centralized, approved by the Lower House of Congress and managed through the Ministry of Finance. The budget covers the expenses of all the cultural entities under the Ministry of Culture's purview, including INBAL and INAH. It should also be noted that the Ministry of Culture has the smallest budget of all the federal government agencies and that cultural officials are paid less than public officials in other ministries.

That said, there are three different types of contracts for cultural workers: the *plaza* employees, who are full-time with a fixed position, a fixed salary, and benefits (bonus, retirement, social security, overtime) and who can unionize; *Chapter 1000* workers, who are hired at the director's discretion and do not have a fixed position but do have benefits; and *Chapter 3000* workers, independent contractors (freelancers) who do not accumulate benefits or seniority since their contract is renewed every two or three months.

Despite the various contracting schemes, all of these

employees perform similar tasks. In other words, they work in the administration, research, curation, communications, publications, design, museography, education, libraries, collections and conservation departments. Workers who are responsible for security and cleaning, however, are usually hired through private companies.

This is where it gets complicated: the Acquisitions, Leases and Services Law of the Public Sector applies to workers employed as independent contractors, not the Federal Labor Law (Morales, 2018). In theory, independent contractors have no obligation to be present at the facilities, to have a fixed schedule, or to be considered museum staff, although in practice they are treated as such; they perform the same tasks as formal employees in the museum and they have an identification card from the institution. Therefore, many (Buen, 2006: 67-84) have denounced a "lack of clarity in the rules that makes it difficult to differentiate between justified and unjustified informality" (Farías, 2014).

Since the Federal Labor Law does not apply to independent contractors, their jobs are unstable, depending entirely on the annual budget, which is distributed according to each museum or cultural project's perceived importance. In other words, although they play a vital role in museum operations, their services are "dispensable" – and since they are not legally state officials they are the first to lose their jobs when budgets are cut. This trend was clear in the budget cuts of 2017: the first to be affected were the Chapter 1000 workers, who were reduced to independent contractor status; and subsequently, Chapter 3000 workers were laid off.

What factors have led to the normalization of these

contractual practices?

Before the 1940s, the modernization of Mexico was based on the economic benefactor model, in which the state stimulated the economy through public investment; President Lázaro Cárdenas (1934-1940), for example, espoused this model. Then, under Miguel Alemán (1940-1946), a mixed economy scheme was established, in a period of reconciliation and cooperation with the United States after the 1938 oil expropriation (Loyola, Martínez: 23-41). With the 1976 devaluation, President Luis Echeverría (1970-1976) and President José López Portillo (1976-1982) tried to keep the economy afloat by increasing public spending, with the petrolization of the economy and the bank nationalization of 1982 (Servín, 2010: 18). This led, in the 1980s, to a change in Mexico's economic regime. The government of Miguel de la Madrid (1982-1988) began to adopt new neo-liberal practices that were in vogue around the world. De la Madrid's administration reduced public spending through the privatization of state enterprises and the opening up of international trade (Gollás, 2003: 33).

It was under this economic regime that Mexico's employment model began to conform to labor laws around the world and, at the same time, the state started to extricate itself from the cultural sector.

During Carlos Salinas de Gortari's administration (1988-1994), culture took a new turn with the creation of the National Council for Arts and Culture (CONACULTA) in 1988, which absorbed INAH and INBAL under its auspices. His government reduced state involvement in the arts and culture by promoting the opening up of the private sector to cultural managers, collectors and gallerists, fostering close ties between the private

and public sectors. For some specialists it meant a "redefinition of the state's relationship with culture"; the state became a "normative entity and promoter of initiatives by organizing a diverse set of actors and encouraging them to participate" (Del Río, 2008: 138). This management scheme resembled that of some public museums in other countries: like Britain in the 1980s under the influence of Thatcherism (Gómez, 2006: 287). This scheme was not merely financial – it drew upon companies' logic of economic power (Wu, 2007: 183).

In Mexico, this new private capital in the cultural sector led to the emergence of private museums and organizations (private foundations, galleries and private collections, art and cinema festivals), large-scale projects, as well as the introduction of new marketing practices in the public sector. At the same time, paradoxically, the number of government jobs in the cultural sector declined. The number of authorized positions (*plazas*) peaked during the transition between the governments of Vicente Fox (2000-2006) and Felipe Calderón (2006-2012), and then began to fall during the economic crisis of 2008-2009. To meet their labor needs, museums turned to independent contractors, whose wages and precarious contracts make them much less expensive than salaried employees.

As government bureaucracy has grown in recent years, *plaza* employees have specialized in administrative or technical positions, resulting in very few posts for research and conservation. Some researchers complained about this situation in 2009 (Proceso, 2009), when the budget for culture was cut during the financial crisis. More recently, others have argued that INAH has strayed from its initial mission and that there is a dire need for both security and research positions in archaeological

centers, some of which have had to close due to a lack of protection and looting (AN/HG, 2019b).

So, what kind of solutions have been proposed to improve the labor conditions and the situation of independent contractors in Mexican museums?

The current administration made an initial attempt, organizing a Rethinking the Museum roundtable with museologists, museum directors, artists, curators and researchers. All specified what must happen in order for museums to operate properly: a budget expansion; a review of Chapter 3000 contracts; a change of policy so that museums can manage and spend the revenue they generate (e.g. through ticket sales) instead of having to transfer the money to the Ministry of Finance; a review of preventive maintenance; decentralization of training, and the professionalization of training beyond Mexico City; management and administrative autonomy; and, finally, a specific federal legislative proposal to decentralize museums and streamline bureaucracy (Vargas, 2018).

The new government of Andrés Manuel López Obrador has the difficult task of establishing a new labor structure within the Ministry of Culture, which supplanted CONACULTA in 2015; the resulting changes will affect the contracts within INBA and INAH. In fact, the government has said it will conduct a thorough review of INAH jobs due to budget cuts. Some researchers point out that museums would suffer if independent contractors are dismissed or reduced in number, as they have a wealth of experience and institutional knowledge (AN/HG, 2019a).

There is no doubt that the management of the budget and the definition of what each new government understands as

culture – as well as whether culture is considered a priority in each president's six-year plan – is critical to solving of Mexican museums' problems. For example, the way the budget is currently managed – on a year-to-year basis – does not allow for the implementation of essential long-term operations, research and conservation programs. According to some observers, a national review of the current state of museums is needed in order to plan a total restructuring, as in 1960-1964 (Garduño, 2014: 5). Other experts see the potential for culture to drive economic development within public-private model, with the Ministry of Culture collaborating with cultural companies and international organizations (Cruz, 2016).

New museum reform is urgently needed. And it must take into account the need for labor equity, professionalization, and a structured program for managing museums according to the local, regional and national needs of the country.

NOTE

1. Translated as #PayMeNowINBA.

ACKNOWLEDGEMENT

I would like to thank David Gutiérrez Castañeda, Nathael Cano Baca, Juan Pablo Medina del Campo, Rodrigo Villa and Joanna Zuckerman Bernstein for their feedback on this chapter.

REFERENCES

Amador, J., 2018. Trabajadores del INBA e INAH van contra impagos y condiciones laborales. *Proceso,*. March 24. Retrieved from https://www.proceso.com.mx/527832/trabajadores-del-inba-e-inah-van-contra-impagos-y-condiciones-laborales

AN/HG., 2019a. El INAH, en estado de alarma por la situación laboral: Eduardo Matos Moctezuma. Aristegui noticias. February 2. Retrieved from https://aristeguinoticias.com/1002/kiosko/el-inah-en-situacion-de-alarma-por-la-situacion-laboral-eduardo-matos-moctezuma/

AN/HG., 2019b. El INAH a punto de perder el 20% de su personal contratado. Aristegui noticias. February 6. Retrieved from https://aristeguinoticias.com/0602/kiosko/el-inah-en-riesgo-de-perder-al-20-de-su-personal-contratado-bolfy-cottom/

Boletín No. 561., 2018. Secretaría de Cultura, March 27. Retrieved from https://www.inba.gob.mx/prensa/8658

Buen, C. de., 2006. El contrato de prestación de servicios profesionales, vía de fraude laboral. *Revista Latinoamericana de Derecho*, año III, no. 5: 67-84.

Cruz, E.,2016. *Sector cultural. Claves de acceso.* Universidad Autónoma de Nuevo León, Editarte Publicaciones.

Del Río, L., 2018. *Las vitrinas de la nación: Los museos del Instituto Nacional de Antropología e .Historia. Contexto, desarrollo y gestión, 1936-2006.* México: INAH

Diario Oficial de la Federación, 1985. Ley de Prestaciones de Servicios relacionados con Bienes Muebles, February 2. Retrieved from http://dof.gob.mx/nota_detalle.php?codigo=4718237&fecha=08/02/1985

Farías, A., 2014. El doble rasero de la informalidad. *Nexos*, February 1. Retrieved from https://www.nexos.com. mx/?p=18370

Garduño, A., 2014. ¿Qué hacer con los museos mexicanos? *Milenio*, September 27, pp. 4-5.

Gollás, M., 2003. México. Crecimiento con desigualdad y pobreza (de la sustitución de importaciones a los tratados de libre comercio con quien se deje). COLMEX.

Gómez, J., 2006. *Dos museologías. Las tradiciones anglosajona y mediterránea: diferencias y contactos.* España: Ediciones Trea. Retrieved from: https://cee.colmex.mx/documentos/ documentos-de-trabajo/2003/dt20033.pdf

Loyola, R. and Martínez, A., 2010. Guerra, moderación y desarrollismo. In Servín, E., (Ed.) *Del nacionalismo al neoliberalismo, 1940-1994.* México: Fondo de Cultura Económica, pp. 23-41.

Mateos-Vega, M., 2019. Se quedaron sin empleo más de mil en INAH e INBA. *La Jornada*, March 8. Retrieved from: https:// www.jornada.com.mx/ultimas/2019/03/08/se-quedaron-sin-empleo-mas-de-mil-en-cultura-inah-e-inbal-3946. html

Morales, F., 2018. No está en nuestras manos. INBA. *Reforma*, April 14. Retrieved from: https://www.reforma.com/aplicacioneslibre/articulo/default.aspx?id=1362130&md5=9c7e36 af4119ddd353a51c32c87a4889&ta=0dfdbac11765226904c16c b9ad1b2efe&lcmd5=e4b4bba586e0f4ce19d301f1ab9a5def

Proceso, 2009, Crisis económica, crisis laboral, ¿qué más en el INBA? *Proceso*: September 21. Retrieved from https://www.proceso.com.mx/118843/ crisis-economica-crisis-laboral-que-mas-en-el-inba

Servín, E., 2010. *Del nacionalismo al liberalismo, 1940-1994*. México: Fondo de Cultura Económica.

Vargas, A., 2018. Autonomía de gestión para museos acuerdan en Foro cultural. *La Jornada*, November 23. Retrieved from: https://www.jornada.com.mx/ultimas/2018/11/23/autonomia-de-gestion-para-museos-acuerdan-en-foro-cultural-1170.html

Wu, Chin-Tao, 2007. *Privatizar la cultura*. Madrid: Ediciones Akal.

CAUSES
AND
EFFECTS

2

PASSION AS PAY: THE WIDESPREAD EFFECTS OF STAFF TURNOVER

Michelle Friedman

IT IS A FACT THAT ACROSS both the museum field and the job market at large, staff turnover is increasing. Gone are the days when someone started at an entry level position and throughout their career worked their way up at one single institution. In December 2018 alone, over 5.5 million positions were vacated across all fields in the United States (Bureau of Labor Statistics, 2019b). Now, millennials are moving from institution to institution at a rapidly-increasing pace – occasionally moving to a higher-level position but often moving laterally. Simultaneously, many of these changes cross career lines – moving from one field to another. Since beginning my career in the museums over a decade ago, I have seen the rate of staff turnover snowball. In my ten years at The Aldrich Contemporary Art Museum in Ridgefield, Connecticut, the three to four-person education and public programs department has seen thirteen staff members come and 10 go. Rather than staying at an institution for long stretches and growing within one specific organization, there seems to be a revolving door with staff committing to shorter stints, gaining just enough experience to take elsewhere. The reasons that staff may leave are many; lack of advancement, limited or nonexistent raises, a deficit in work-life balance (an issue becoming more and more important to the workforce) and departmental downsizing.

Across institutions the memo is consistent: you are lucky to have a job in your field, in the museum world, in the arts, in a non-profit organization. There were nearly 12.3 million jobs in nonprofit organizations in 2016, totalling 10.2% of total U.S. private sector employment (Bureau of Labor Statistics, 2018). In the museum field specifically, there were only approximately

174,000 jobs across the country (Bureau of Labor Statistics, 2019a). The sentiment is consistent: there are few jobs compared to other fields, so you should feel privileged to work at a museum. Yes, the pay is not as high as other fields, but you get to do what you love. You should feel blessed to be working at a museum even if the hours are long, the workload is heavy, and the pay is light – positions in the arts and/or museum world are few and far between, so count your lucky stars! And, if you choose to leave, there will be a line of people waiting to take your position.

Museums capitalize on this mentality and count on the passion of its employees: they love what they do, they are dedicated, and they will work hard, regardless of the salary or benefits. Often, when someone does choose to leave, their position is filled with young professionals looking to gain a foothold in the institution, while higher positions are frequently left unfilled to save money. Emerging professionals, more than previous generations, are looking for personal and career growth or job security (Altman, 2017). Why invest in a high-level staff member (and the salary that comes with it) when institutions can label it as a "learning experience" and market it to young professionals for a much lower price tag? In many of these situations, employees are promised perks and opportunities to offset heavy workloads, only to be overwhelmed to the point where there is no room for growth and burnout is inevitable. As part of a research study, both supervisory and non-supervisory employees were asked to rate their stress levels: both populations reported stress in a typical week approximately 50% of the time. When these same employees were asked how likely they were to leave their current position, only 30% said between somewhat likely and

extremely likely (Maulhardt and Smith, 2015: 2).

But what happens to the public programs, and in turn the participants, when passion is simply no longer enough to keep the stewards of those programs in place?

Programs, and by extension the audience they serve, suffer when staff turnover is this high. In a 2018 survey of UK museum and cultural leaders, audiences and employees rank as the most important constituents over trustees, foundations, major donors and corporate sponsors; it is, therefore, all the more problematic that the highest ranked constituents are most negatively impacted by staff attrition. (Smets et al., 2018: 16). How can any institution prioritize an audience when the staffing structure doesn't adequately support the programs that serve them? The equation is simple: the quality of services suffers when there is an increase in demand (from program participants, members, potential funders) but a decrease in resources (experienced staff and budget) (Phillips and Hernandez, 2008: 3). Many museum programs are developed based on the institution's mission, its strategic goals and the expertise of the staff, who create programs to fill educational gaps they perceive, reach diverse populations and communities, and develop new relationships. These offerings are thoughtfully developed, find a successful stride, gain traction, and build a devoted following – in short, the programs become part of the identity of an institution as well a staple of the community. This is a common goal among so many programmers, to create a program that gains momentum and becomes a known offering within the community. In a way, it becomes self-sufficient and an important part of the department's pedagogical approach. Then, inevitably, the staff member who fostered the audiences'

experiences leaves – passing the torch to the next person in line who in many cases is responsible for more work than the person before them. That program adds to an ever-growing workload of the new staff member, which then includes their own responsibilities and the work from the now-departed colleague. And so the program, and its audience, cannot possibly receive the same level of focus or budget.

Audiences need to be cultivated. Now, visitors to museums are looking for more individualized, innovative, and engaging experiences. No longer is the public seeking simply to absorb the content by wandering through galleries or exhibits, they are looking to an institution to serve their individual needs. And in order to understand and respond to these needs, museums must connect with their audiences and make them feel valued – which requires key staffing: "Visitors are no longer passive receptacles for the curator's knowledge, but rather active, engaged participants." (Rodney, 2016).

In today's cultural setting, there are so many options to choose from. In 2013 within a thirty minute radius of Ridgefield, CT alone (where The Aldrich is located), there were over 55 summer camps, with over 20 focusing on, or including, the arts according to research undertaken by Aldrich staff. The arts camps all offered hands-on art-making, access to professional and/or teaching artists, and skill building. So how does an institution set itself apart? One of the most important and impactful differences is the priority placed on human connection. Audiences are more invested in programs that they feel connected to, communities that they feel a part of, and institutions that prioritize audiences. Without that human relationship, audiences will choose to align with another institution or join

a program where they feel their presence matters, where they are valued, where they are not just another number coming through the doors.

However, a program cannot be maintained at the highest level when there is a gap in staffing, knowledge or experience. How can one person tackle two positions' workloads while giving 100% across the board? Priorities have to be re-evaluated when there is a transition and often programs are put on the back-burner or done on a smaller scale. Resources and time have to be reallocated to focus on onboarding the new staff, often to the detriment of the audience. Budgets may be decreased, time to spend on program development and implementation may be lost, and the experiential knowledge about the program and its loyal audience may evaporate with the now-exiting staff member. A once strong and innovative program may suffer from dwindling time and resources, solely due to the fact that the team is down a staff person.

All the while, this consistent turnover puts the young professionals in a catch-22 situation – learn to be as effective, organized, and successful as your now-departed, highly-experienced predecessor; continue to provide existing program initiatives of the highest quality; and create innovative visitor experiences – all with less experience and for significantly less pay. Be the best of the best with the smallest paycheck.

This is not to say that young professionals do not add value to an institution – on the contrary, they are the future of a museum and the field at large – they bring original ideas, a diverse perspective, and enthusiasm that is palpable and infectious. Where they lack, appropriately, is the experience to harness that passion, to use it to create a successful program,

event, or opportunity for engagement. This is when mentorship and a balance of knowledge and experience is key – senior staff educate young professionals and help them grow in an institution. In turn, these young professionals may one day mentor another young professional. They offer guidance and encourage risk-taking in younger staff, who know that their mentors are there to support them and help with any course-correction. The young professionals are able to learn through their successes and their mistakes, all while the audience is cultivated and introduced to new staff. Without key mentorship from senior staff, they are, for lack of a better term, thrown to the wolves. Often, other staff, who are taking on additional work during a transition, don't have time to train or assist, and these employees must figure it out on their own. It all adds up to a continuing spiral that is not unique to any one institution – less money means less staff, which means fewer programs, which means less money, and on and on it goes.

This turnover is the perfect example of being between a rock and a hard place. How can an institution prioritize its staff and audience if one or both isn't consistent? How can an organization offer opportunities to both experienced and young professionals, for proper wages, and encourage them to focus on audience and program development? How do we invest unilaterally in our programs as well as in our staff – through compensation and professional development. How does this investment in staff lead to the development and retention of the audience that the institution serves?

The equation is simple – focus on investing in (and retaining) staff and the dividend will be audience development and community building. That solution is key to creating a

dedicated programs team that will in turn continue to build strong, engaged audiences. In order to offer a roster of programs that are relevant to the intended audience – that serve the community and the institution's mission, that grow a following steadily – the staff need to feel valued. Staff that feel pride in their work, who feel that their contributions have a place in their organization and who believe in their museum will undoubtedly work harder. Things as simple as brainstorming meetings with young professionals so their voices are heard, inclusion in (or access to) information about decision making across the institution, and access to staff across departments – tactics that have little or no cost at all – show staff at all levels that they are valued members of a team. Opportunities to develop their skills, attend professional development workshops, sit in on webinars, or meet with peers in the field, will create better museum professionals – this only benefits the institution, and will continues to inspire and motivate them to work hard. Preventing burnout, even with a high workload and high demands, will ensure that the amount, and quality, of the work – and morale – will continue to be above average. All of this, by extension, also prioritizes the institution's audience, the people that frequent the museum, both throughout transitions and during business as usual.

This work is never done. Transition is inevitable, whether at a modest or rapid pace. In my tenure, I am the only person who is still in the education department from ten years ago. The education department has prioritized staff growth, finding its stride while building a new departmental mission, program roster, and focus on audience, all while advocating for more professional development, opportunities for growth, and fair

pay for both young and experienced professionals. With each turnover that comes, we have to reorient, shifting focus internally while keeping a strong and invested face towards the audience. But our mission remains the same: focus on our staff and our audience; create opportunities for learning, engagement, and discussion at all levels for everyone who works for and/or visits the museum; provide access to resources and training; prioritize people just as highly as budget.

This work isn't easy, but it is important. All people seek human connections and the fewer positions filled within museums means less engagement with and for the audience, all to reduce costs and make budget savings. Sometimes saving money comes at too high a cost.

REFERENCES

Altman, J., 2017. How Much Does Employee Turnover Really Cost? *Huffington Post*, 18 January 2017.

Bureau of Labor Statistics, 2018. *The Economics Daily*, 31 August 2018.

Bureau of Labor Statistics, 2019a. *Industries at a Glance: Museums, Historical Sites, and Similar Institutions: NAICS 712*. Washington, D.C.: U.S. Department of Labor.

Bureau of Labor Statistics, 2019b. *Job Openings and Labor Turnover Summary*. Washington, D.C.: U.S. Department of Labor.

Maulhardt, M., and Smith, J., 2015. *2015 UST Nonprofit Employee Engagement & Retention Report*. Santa Barbara: US Trust.

Phillips, Y., and Hernandez, J., 2018. *The Impact of Low Retention of Nonprofit Organizations*. California State University San Bernadino: Electronic Theses, Projects, and Dissertations. 731.

Rodney, S., 2016. The Evolution of the Museum Visit, from Privilege to Personalized Experience. *Hyperallergic*, 22 January 2016.

Smets, M., et al., 2018. *Museum Leaders' Report: Challenges and Responses for Leading with Purpose*. Oxford: Oxford University.

FAR TOO FEMALE: MUSEUMS ON THE EDGE OF A PINK COLLAR PROFESSION

Taryn R Nie

WHY ARE MUSEUM STAFF SALARIES traditionally low? It is not purely because the sector is strapped for cash, as is so often suggested. Low salaries, often not even representing a living wage, are in large part due to the fact that the field is dominated by women.

"You are far too young and far too female to have a curator ever report to you" (Feldman, 2016). This overtly sexist statement was made to Kaywin Feldman, Director of the Minneapolis Institute of Art, during an interview for a position at a large art museum in Texas when she was 31 years old. She felt the need to reiterate this belittling sentiment, which she has encountered repeatedly throughout her 22-year museum career, at the American Alliance of Museum's (AAM) 2016 Annual Meeting because implicit sexism and gender disparity still dominate the profession.

Museums, like all institutions and individuals, face the choice of compliance with or resistance to society's wrongs. At face value, they seem to be doing the latter. *Inclusivity, equality,* and *diversity* have become buzzwords that define the future of museums. The terms are cropping up at conferences, on blogs, and in strategic plans internationally – but nearly always in reference to audience. All the talk of equality by change-makers and visionaries in the field rarely turns the lens inward to address one glaring inconsistency – the treatment of museum staff. In this area, equality – particularly of pay – is hard to find. Women make up two-thirds of the art museum workforce, and not only are entry- and mid-level staff salaries lower than those of counterparts in other fields with the same educational background that do similar work (such as librarians or teachers), but in many museums a vast gender pay gap exists when it comes

to remuneration at director levels.

The relationship between museums and femininity is a fraught one, and the idea of gender bias within museums' walls is not new. By now, the under-representation of female artists and feminine histories within museum collections and exhibitions is a widely accepted fact that most art museums are still struggling to amend. But before the Guerrilla Girls came together in 1985 to give voice to gender discrimination in the art world – from representation in museums, to opportunities, to funding – the issue was largely hush-hush. It is only recently that minor attention is starting to be given to how the societal biases and femmephobia that have shaped museum narratives throughout history have been playing out in the museum work-force for equally long.

Just as the Guerilla Girls gave a voice to female artists, it is important now that a voice be given to female art museum staff members who continue to face hiring biases and menial sala-ries. In order to do so, long entrenched gender-biased practices in the field must be addressed and reevaluated.

While liberal attitudes and socially progressive discourse envelop a museum's exterior, such high ideals seem disingenu-ous when poor salaries reflect an internal patriarchal hierarchy. Unfortunately, museums have thus far turned a blind eye to their ethical obligation to pay a living wage. True change must come from within. Museums have the chance to become lead-ers in workplace pay equity. Yet, if historical trends continue, museums are poised to cement their status as a pink-collar profession with large armies of women in the underpaid lower rungs of the ladder, and a handful of (white) men in the highly-paid upper tiers. Employees are a museum's most valuable

asset, and wage equity – at all levels – should be at the heart of museum discourse. However, even as comprehensive salary studies by AAM and the Association of Art Museum Directors (AAMD) have become more regular, and a coalition of museum professionals has recently organized to thoroughly address the issue, it is still mired in myth, and an aversion to the topic at the highest – and most influential – levels persists.

This chapter seeks to unpack the intricate cycle of gender discrimination and pay inequity that plague the field, and calls for top-down solutions that will effect systemic change.

Myth No. 1: The gender pay gap does not exist
Putting museum practice in context through a social science lens
While sub-standard salaries can be found throughout the museum field, research has shown that gender negatively affects the careers of women in museums to an acute degree. A glass ceiling is compounded by a sector built on a model of "sweat equity:" low pay for labors of love, or what Elizabeth Merritt calls the "museum sacrifice measure" (Merritt, 2016: 46-51). The top six institutions' net assets total $18 billion – with operating budgets between $63 and $315 million – and while senior staff members reap the benefits of such fiscal prestige, predominantly female entry- and mid-level employee salaries remain stagnant and substandard according to the Resources for Financial Data listed at Appendix A. Compensation expenditure as a percentage of operating budget for these institutions is provided at Figure 1.

Take the example of Museum of Modern Art's Director, Glenn Lowry, who raked in $2.2 million in 2016 while an entry-level museum shop worker scraped by with a paltry $29,000

	PERCENTAGE OF BUDGET SPENT ON COMPENSATION
J PAUL GETTY TRUST	52.5%
CLEVELAND MUSEUM OF ART	30.4%
MUSEUM OF MODERN ART	30.4%
MINNEAPOLIS INSTITUTE OF ART	35.9%
ART INSTITUTE OF CHICAGO	36.3%
PHILADELPHIA MUSEUM OF ART	38.3%
METROPOLITAN MUSEUM OF ART	41.5%
MUSEUM OF FINE ARTS, HOUSTON	29.6%
NATIONAL GALLERY OF ART	43.7%
MUSEUM OF FINE ARTS, BOSTON	65.1%

FIG. 1: Compensation expenditure as a percentage of Operating Budget.
All annual operating budgets are from FY16, and compiled from a combination of institutional 2015-16 Annual Reports, FY16 Audited Financial Statements, FY17 Budget Requests, 2016 Consolidated Statements of Activities, and FY15 Form 990s.

– before taxes. A senior visitor services assistant kept barely afloat, just $48 between her and the poverty line on a monthly basis. One MoMA bookstore employee minced no words when describing her feelings towards low pay, slim maternity leave, and weakening healthcare benefits:

> It feels like a direct attack on our ability to do our job. Upper management is skewed heavily towards men. Women are the lower-paid workers, and have to take on these costs during childbearing years. (Whitford, 2015)

But with upper management dominated by men, and women filling out the lower-paid ranks, MoMA's employee gender distribution is sadly representative of the field.

The majority of art museum workers are gravely underpaid, to the point of not earning a living wage, due to implicit gender bias and discrimination. The 2015 Andrew W. Mellon Foundation's *Art Museum Staff Demographic Survey* found that females make up 60% of museum staff. In some institutions, that number rises as high as 94% (Schonfeld *et al.*, 2015: 10). Furthermore, it appears the field will continue to become more female-dominated over time based on the gender of its younger employees – what the Mellon Foundation refers to as the "youth bulge" (we will avoid the sexist connotations of that very phrase).

A sector that overwhelmingly consists of underpaid women is termed a "pink-collar profession," and with that disparaging designation come a number of issues. Because a high number of women are employed in museums, it seems that gender equality has been achieved and the field can move on to other

	MEMBERSHIP ASSISTANT	CURATORIAL ASSISTANT	VOLUNTEER COORDINATOR	EDUCATION ASSISTANT	ASSISTANT REGISTRAR
MALE	13.9%	19.4%	12.5%	11.2%	7.5%
FEMALE	86.1%	78.6%	86.8%	88.8%	92.5%

FIG. 2: Gender ratio by position.
Compiled from AAM's 2017 National Museum Salary Survey: percentage of female vs. male respondents per position.

hot-button issues. Right? Wrong. One cannot associate gender equality with sheer employment numbers; rather one must look at the quality of employment, particularly when it comes to fair salaries. Simply put, pink-collar professions – a politically correct way of saying "women's work" (a term popularized by Louise Kapp Howe, *Pink Collar Workers: Inside the World of Women's Work*, 1977) – have been devalued by the American labor market and see lower salaries on the whole. Museums have become a woman's profession in numbers and, if widespread sub-standard salaries persist, the field will soon solidly join the pink-collar ranks. What must be unpacked, then, is why woman have come to dominate the field and accept the low salaries offered. In order to do so, one must step back and view the museum as part of the broader social context in which it exists – one in which underlying sexism collides with a "do what you love" (DWYL) labor culture to economically exploit the female worker. Only through this social science lens can museum-specific practices be thoroughly understood.

As with any issue, there is debate. Some economists staunchly disagree with the idea that salary discrepancy is due to the "smoking gun" of discrimination and instead assert that the chief contributors to the pay gap are the different choices men and women make throughout their careers. Men value income growth while women value "temporal flexibility" – pursuing jobs that give them the latitude to be caregivers – leading to a gender divide when it comes to job selection. Their lower salaries simply reflect these choices over time, while men who have chosen jobs with longer, less flexible hours are duly rewarded for their dedication. In other words, the oft-cited statistic that women earn 80 cents for every dollar a man does is

	AAM DISCIPLINE: ART	AAMD OVERALL	NATIONAL AVERAGE LIVING SALARY
CURATORIAL ASSISTANT	$29,825	$36,483	$32,947
EDUCATION ASSISTANT	$30,250	$30,675	$32,947
ASSISTANT REGISTRAR	$35,571	36,041	$32,947
MEMBERSHIP ASSISTANT	$35,360	$35,000	$32,947
VOLUNTEER COORDINATOR	unavailable	$35,361	$32,947
DIRECTOR/CEO/PRESIDENT	$75,705	$180,250	$32,947

FIG. 3: National Average Living Salary vs. AAM/AAMD 25th Percentile Salary.
2016 national average living salary metrics calculated using MIT's Living Wage Calculator based on their definition of a typical family of four. Museum salaries compiled from AAMD's 2017 Salary Survey overall 25th percentiles per position, and AAM's 2017 National Museum Salary Survey 25th percentiles per position in the art discipline. All salaries based on a 40-hour work week.

misleading – females are just choosing jobs that pay less, such as museum work (Dubner, 2016).[1]

Is this assessment correct? It seems "choice" and "option" are very different things, and the scenario above seems to be riddled with gender bias and societal expectations – nuances hard to quantify from an economics standpoint. The Department of Labor equally seems to confuse and conflate choice and option:

> The differences in raw wages may be almost entirely the result of the individual *choices* being made by both male and female workers [emphasis added]. (U.S Department of Labor, 2009: 2)

While a less official source than the Department of Labor, a Twitter exchange that erupted during a 2016 AAM Annual Meeting panel presentation, *What We Talk About When We (Don't) Talk About Women in Museums*, echoed a very similar misconception concerning female choice:[2]

Gracie Astrove: Talk about money!!! #payequity #feminism #AAM2016

$ilvius Br4bo: @GracieAstrove and or choose different career choices

Diana Does Museums: @PaulShikari @GracieAstrove I'll work where I want & deserve to be paid exact as much as any other human (man or woman) w/same qualification

$ilvius Br4bo: @DianaDoesMuseums @GracieAstrove
Work the same hours with the same experience as your
male counterpart and you will.

$ilvius Br4bo: @rkassman @DianaDoesMuseums
@GracieAstrove Its called the earnings gap and that
because women CHOOSE not to make as much as men.

Investigating the idea of female "choice" is critical to under-
standing economic gender discrimination in the United States,
and thus within the museum field. Yes, in part, the pay gap
reflects choices. It would be ingenuous to say otherwise. But, as
evidenced in this Twitter feed, commonly held misconceptions
about the gap are disconcertingly prevalent. The fact is, if a field
becomes dominated by women taking on the same exact jobs
men were doing before, the pay literally drops. How's that for
a splash of cold, gender-biased water in the face? This decline
persists even when controlling for such factors as education
(women are now better educated than men overall), work expe-
rience, skills, race, and location. Why? The reason is simple,
but sobering. Once a woman starts doing a job, it appears to
require less skill and thus is not as important to an organiza-
tion's net earnings (Levanon *et al.*, 2009: 865-891). Women are
not picking positions of lesser skill or value, according to Paula
England, a sociology professor at New York University: "It's just
that the employers are deciding to pay it less." The inverse is
also true – when men begin to outnumber women in a field or
position, pay increases because the work is perceived to have
a higher value (Miller, 2016). A recent Cornell study poses that
sheer discrimination may be to blame, finding that it alone may

be responsible for 38% of the gender pay gap (Blau and Kahn, 2016: 8).

These studies stand in stark contrast to the theory of "temporal flexibility" and the conclusion that discrimination is no longer a primary agent of pay equity. More importantly, they shed much-needed light on the discriminatory culture that exists within museums. It is a culture in which males dominate upper-tier positions and, as slow progress is made and women ascend to leadership roles, the salaries afforded those roles decrease; meanwhile, positions further down the hierarchy (such as education and collections management) are dominated by women and the sub-standard salaries reflect that very clearly. Museum work has become devalued because it is a woman's profession (Figure 4).

Which leads us to the second half of the question – why are women more willing to accept lower salaries?

From a social science perspective, gender norms and expectations begin affecting the subconscious at a young age. One such assumption that is imprinted early on the female psyche, and with which the "temporal flexibility" supposition aligns, is that females achieve for the satisfaction of others while males achieve for tangible rewards. Thus, based purely on social constructs of accepted gender roles, girls are funneled toward "nurturing" sectors that affect public good – in which "eager to please" is an unspoken prerequisite – while boys are propelled toward corporations and the sciences. This segregation denies the fact that women, as humans, desire the "basic satisfaction of seeing their work rewarded with money" (Hunt and Colander, 2013: 242, 244). Over time, it is such siphoning that has created entire pink-collar professions in which women

	AVERAGE SALARY OF NON-EXECUTIVE EMPLOYEE	AVERAGE SALARY OF OFFICERS, DIRECTORS, TRUSTEES, AND KEY EMPLOYEES	TOTAL COMPENSATION PAID TO DIRECTOR OR PRESIDENT
MUSEUM OF MODERN ART	$47,912	$586,285	$2,187,311
ART INSTITUTE OF CHICAGO	$22,792	$447,922	$1,379,213
METROPOLITAN MUSEUM OF ART	$47,880	$507,664	$1,358,196
MUSEUM OF FINE ARTS, BOSTON	$25,549.35	$611,697	$1,190,137
NATIONAL GALLERY OF ART	$65,679	$501,663	$1,171,463
J PAUL GETTY TRUST	$67,879	$339,379	$1,159,420
MUSEUM OF FINE ARTS, HOUSTON	$33,104	$662,919	$823,364
MINNEAPOLIS INSTITUTE OF ART	$34,375	$334,591	$576,782
PHILADELPHIA MUSEUM OF ART	$30,446	$234,146	$556,796
CLEVELAND MUSEUM OF ART*	$30,361	$317,112	$265,677

FIG. 4: Compensation distribution across the museum workforce.
All compensation is from FY15, based on Form 990s.
*The Cleveland Museum of Art Director began midway through the fiscal year, thus reflecting a lower comparative compensation.

are expected to work primarily for the benefit of others rather than remuneration.

It is this socio-historically constructed mindset that allows women to more easily accept and museums to more easily offer – with a clear conscience – salaries that do not represent a living wage. Female work for little (or no) pay has become normalized over centuries – and the underlying attitude of this gender discrimination has become entangled with the American workforce's current "do what you love" (DWYL) phase. But Miya Tokumitsu, the author of *Do What You Love: And Other Lies About Success and Happiness*, argues that this emphasis on DWYL is crippling the American worker in mental, social, and economic ways:

> It leads not to salvation, but to the devaluation of actual work, including the very work it pretends to elevate – and more importantly, the dehumanization of the vast majority of laborers. (Tokumitsu, 2014)

With a largely female base that has been socially conditioned to such labor dehumanization, museums have supremely exploited the DWYL trend. How many times are museum professionals told to accept the barely-living-wage fate and just be thankful to have a meaningful job in a field they are genuinely passionate about? To be satisfied with the conviction that they are helping the museum fulfill its altruistic ambitions? Which aligns neatly with the selflessness women are socially expected to espouse. In museums, as in other sectors, DWYL prompts workers to believe their labor is disconnected from the marketplace and reduced compensation is for the greater

organizational good, not due to broader management biases. Thus, wages are depressed since an oversupply of highly qualified (female) individuals are "willing to underbid each other to secure the non-financial benefits of museum work" (Merritt, 2016).

Museums across the country require personal passion from all employees while their commensurate compensation remains an afterthought. And each time female workers decide not to leave for higher-paying jobs outside the field, or ask for a decent wage for a current position, the museum has conditioned them to reaffirm to themselves that their choice to stay is the ethical one, upholding personal values as well as that of the institution. An ironic twist, when it is the art museum that refuses to confront its own ethical underbelly.

Myth No. 2: Museums do not discriminate
The vicious cycle of gender discriminatory practices:
Unpaid internships, advanced degrees, and predominantly male boards

> Compliant, silent and mostly female, interns have become the happy housewives of the working world. (Schwartz, 2013).

Unpaid internships: fraught and feminized
A majority of art museums rely on primarily unpaid internships – in line with the rest of the nonprofit sector, the top provider of unpaid internships at 57% of those offered (Gardner, 2011: 6). The ethics of unpaid internships in museums are prickly, bringing forth the charged issues of class privilege, economic status,

diversity, and even institutionalized wage theft. Contestably at the root, though, is the gender-salary link, an issue on which the field is far less aggressive and largely silent. Is it a coincidence that a field which perpetuates unpaid interns also happens to have a predominantly underpaid female staff?

Think of the words and phrases that pop up repeatedly in internship postings – "enthusiastic," "flexible," "positive attitude," and "capable of taking direction." These qualities align with historically female labor traits, whether at home or in the workplace. They imply unfailing pleasantness, obedience, malleability, and outward displays of gratitude – for any task, for no pay. A 2015 study in the *International Journal of Arts Management* found that 40% of female students, compared to only 13% of males, "disagreed that they would work harder during a paid as opposed to an unpaid internship" (Cuyler and Hodges, 2015: 68-79, 94). In other words, females have been socialized to work just as hard at a job with no external reward as one with (salary, benefits, promotion, etc.) because of an unspoken belief in largely intangible benefits. A satisfied husband – or boss – is all the reward a woman needs. The mere opportunity of an internship at a big name art museum, just like the opportunity to cook her family dinner, is what the female intern is expected to be visibly grateful for.

Thus, it is of little surprise that "peripheral, part-time, lowly paid, flexible work with limited benefits has been associated historically with women," and this proves drastically true when it comes to unpaid internships (Broadbridge and Fielden, 2015: 39). Year-to-year, approximately 75% of unpaid interns are women (across nonprofit, for-profit, and government sectors) – in part, because employers expect to get away with this

	MEMBERSHIP ASSISTANT	CURATORIAL ASSISTANT	VOLUNTEER COORDINATOR	EDUCATION ASSISTANT	ASSISTANT REGISTRAR
MALE	$48,242	$43,280	$40,470	$34,700	$35,400
FEMALE	$38,881	$34,900	$40,000	$33,712	$39,968
NATIONAL AVERAGE LIVING SALARY	$32,947	$32,947	$32,947	$32,947	$32,947

FIG. 5: Male vs. Female AAM median salary.
Salaries compiled from AAM's 2017 National Museum Salary Survey: Overall median salaries by gender per position.

exploitative, unethical behavior with little legal fuss (Elmer, 2013). And although rigorous internship data is minimal, the National Association of Colleges and Employers (NACE) conducted a survey in 2015 which provided statistical evidence that paid internships are more likely to lead to offers of full-time job employment, with higher salaries, than unpaid ones. In the nonprofit sector, 51.7% of paid interns received offers compared to only 41.5% of unpaid interns, and the formers' median salary offer was $41,876 versus the latters' $31,443 (National Association of Colleges and Employers, 2016).

In this way, the gender imbalance in pay inequity translates from intern to staff (Figure 5). Many industries that rely on unpaid internships, such as the arts, have a predominantly feminized workforce (Broadbridge and Fielden, 2015: 39). The cultural and economic feminization of unpaid internships – the deeply entrenched, often unconscious belief that when women do work it is less financially valuable – long ago seeped into the veins of the museum field.

Advanced degrees for entry-level
Why does the museum field require masters' degrees for entry-level positions – which pay as much, if not less, than a shift manager at Walmart earning $45,720-$78,777 (Glassdoor, 2017) – just to offer salaries that belittle the very prestige that degree is supposed to evoke? Again, gender bias in educational, professional, and career path expectations.

There is a noticeable gender imbalance in museum profession/studies and arts graduate programs, with most skewing heavily female. There is a need, as directors and senior faculty members of these programs have identified, for women to

gain "intellectual legitimization through study" in order to be considered qualified and prepared for their museum careers. In other words, they need hard proof – a degree and rigorous past experience, printed on resume quality paper stock – that they are capable of meeting the job expectations (Malik, 2012). On the other hand, male peers do not need the validation of a degree to the same extent because, instead, they are evaluated on their confidence, *joie de vivre*, and untapped future potential. Helena Reckitt (MFA Curating, Goldsmiths, University of London) aptly described this scenario when asked if there were different professional expectations between men and women curators:

> ...the field has been much more receptive to maverick male curators, to those who come from non-art or non–art-historical backgrounds but who have something of the impresario about them. Very few female curators have risen to prominent positions without solid professional or academic credentials. In the case of maverick, mostly male figures, their lack of traditional training seems not to work against them. Quite the opposite: it enables them to accrue some of the charisma and star power of the artist. Despite the evidence of women in key curatorial and directorial positions, women working in public institutions still often get stuck at the level of assisting... on the basis of stereotypically female traits of diplomacy, hospitality, and charm... (Malik, 2012)

If a woman's natural professional instincts beyond

CONFRONTING THE STATE OF MUSEUM SALARIES

"diplomacy, hospitality, and charm" cannot be trusted, she is forced to self-legitimize with a degree even for poorly paid entry-level positions. This, in turn, devalues the degree (a financial burden which essentially takes a poor salary to pathetic) and contributes to the decreased authority of that female staff member throughout her museum career. If the salary bargaining power of an advanced degree is removed from the outset, there is little to use as leverage for pay increases in the future. No wonder, then, women working in the museum field find it impossible to progress through the ranks as easily as men – and sometimes even find it necessary to earn yet another degree to ascend to that next professional rung.

The three Ms: Mostly male museum boards and directors
Compensation is a controversial topic. This may be even truer in the nonprofit sector than the for-profit sector. Often donors feel that money paid to employees takes away from money that could be spent on the charitable purpose of an organization. It is important to remember that the most important asset of any organization is its people (Guidestar, 1999).

This describes the dangerous mentality of many museum boards. They look out upon a sea of female faces and see them "doing what they love," "lucky to be there at all," "satisfied fulfilling the museum's mission." If that sea of faces became male, no doubt the inner dialogue would change drastically – and, perhaps, the salaries.

A 2017 survey of museum board demographics conducted by AAM found that board composition is 55% male – primarily older, white males between 50 and 64. But the respondents to this survey, *Museum Board Leadership 2017: A National Report*,

were predominately history museums, homes or sites (48%) with budgets of less than $1 million (58%) and only one to nine paid full-time employees (52%). The board gender imbalance is more drastic when one considers art museums, particularly the country's wealthiest, most influential institutions. While they may no longer be the old boys clubs of yesterday, the gender ratios remain starkly uneven. At the USA's top five art institutions (based on 2016 operating budgets greater than $100 million) males compose 62% to 80% of a given board. And not one has a female director (see Appendix A).

It is, sadly, not surprising that a male-dominated board at a wealthy institution is more likely to hire a male director. And if they do hire a female, they will pay her less – "at museums with operating budgets of $15 million or more, female directors earned 75 cents on average for every dollar earned by male directors" (Treviño *et al.*, 2017). Elizabeth Easton, director of the Center for Curatorial Leadership, sharply observed:

> Everyone just claps their hands and says that it's getting better. But with boards full of men and search committees gravitating to men, it's not going to get better. (Sheets, 2014)

The "it" she refers to is this gender gap and pay inequity within art museum directorships, rather than substandard salaries due to a female dominated field, but the sentiment still rings true for the latter. After examining AAM's 2014 *National Comparative Museum Salary Survey*, a perhaps even more interesting trend was identified. As operating budgets increase, the average salaries for several staff positions actually decrease. Not only

is a primarily male board more likely to hire a male director, but in turn that director seems less likely to be an ethical voice amidst trustees and donors, an advocate for living wages on a predominantly female staff's behalf (according to the same survey, two-thirds of all full-time paid museum professionals are women, and women outnumber men in 41 of the 52 full-time positions).

So, unfortunately, the rare female directors at larger art museums – the Kaywin Feldmans and Karol Wights of the world – are not going to solve the gender-salary problem. Strategically replacing a member of a museum's leadership team with a female may be good for optics, and even lead to change within that particular institution, but is ultimately a band-aid mentality of "gender-fixing" that has, thus far, not forced the field to seriously consider the ethical dimensions of sub-standard salaries. Small individual steps are nothing to be sneezed at, but they cannot effect the systemic, sustained change this traditionally patriarchal, hierarchical field needs.

The museum board plays a key role in improving salaries and pay equity – wages and benefits are primarily negotiated and established by the director, HR director (if one exists), and the board committee that oversees budget decisions. A very small, principally male pool is charged with representing a large, predominantly female workforce: not quite a recipe for gender-pay equity. As a governing force responsible for the integrity of their institution, directors should be leveraging their relationship to advocate on behalf of their staff. They are in the position to impress upon the board that employees are indeed a museum's most valuable asset and that ethical standards museums profess to adhere to demand that those

employees be paid a wage commensurate with their education, skills, experience, and cost of living.

"It is time to go to battle differently." Those were the sentiments of a director of one of the nation's most affluent Ivy League university art museums. "One of my first actions as director was to fight for living wages." He saw adjustments in compensation that needed to be made across the rungs, and acted accordingly. And, sitting on other art museum boards himself, he is typically the lone trustee advocating for wage review. "Boards don't see employees as an asset, so directors need to lobby." In his opinion, the art museum field not only fails to be a leader in gender-pay equity, it fails to even reflect the sea change toward parity happening in American society at large (Remarks by museum director who preferred to remain anonymous, 2017).

In short, a director can be a museum worker's most powerful ally or greatest source of resentment.

There is also, as we know, a gender imbalance within museum boards themselves. Increasing female representation on boards not only increases the likelihood of hiring women into leadership positions and, consequently, has a trickle down effect on the economic prosperity of women in lower level positions – boards with more women are statistically proven to experience higher financial performance (Semuels, 2016). Substantially higher. Companies with the "highest percentages of women board directors" outperformed those with the least in the areas of equity, sales, and invested capital by 53%, 42%, and 66% respectively (Joy et al., 2007). However, according to the U.S. Government Accountability Office, gender balance within board rooms could take more than four decades to achieve with

equal proportions of women and men joining boards each year
(U.S. Government Accountability Office, 2015). Thus, just as in
areas like programming and audience outreach, the nation's
most influential museums should be bunking trends, setting
standards, and emerging as role models for institutions across
the country that look to them for best practices – not waiting
passively for vague "society" to right itself. Gender parity within
museum trustees is both an ethical and economic imperative.
And what museum board can argue with solid business sense?

Myth No. 4: Gender-salary equity is beyond a museum's control
Institutional and individual approaches to addressing the issue
Too often the tendency is to talk about gender-salary inequity
not as a macro issue but as an individual responsibility, two
modes of thought comically at odds. Somehow the bias is one
that ambiguous "society" must grapple with, too entrenched
to solve within the cubicles of a single office – but, simulta-
neously, every woman is told she must "lean in" and grab her
career by the proverbial horns.

When work is not work, but abstract fulfillment of per-
sonal passion and public service, workers are less likely to
fight for workers' rights. Thus, the very expectation that
women confront salary discrimination at an individual level
is perhaps more difficult within the museum field than many
other sectors. For this reason, it is even more incumbent upon
institutions to implement standard procedures that combat
gender-salary bias.

Identity-blind hiring and the paradox of meritocracy
Identity-blind hiring allows the interviewer to purely assess

skills, without scooping through the foggy bias and precon-
ceived notions of gender, race, or age. And the method could
be particularly effective in museums, where an ironic direct
relationship exists: the greater a field's identity aligns with
objectivity and equality, the greater the gender bias.

Known as the "paradox of meritocracy," research conducted
in 2010 by researchers at Indiana University and MIT found that:

> When an organization is explicitly presented as
> meritocratic, individuals in managerial positions favor
> a male employee over an equally qualified female
> employee by awarding him a larger monetary reward.
> (Castilla and Benard, 2010: 543-676)

The underlying mechanisms responsible for this ironic twist
manifest themselves clearly within museums.

When a field publicly prides itself, even relies, on being
unbiased – equitable, inclusive, accessible, or any other buzz-
word presently resounding through the museumsphere – it has
an effect on their senior level management. Managers are less
likely to scrutinize their own personal behaviors for prejudice
because the ethical credibility established by their institution's
brand begins conflating with their self-perceived moral com-
pass. In other words, they are convinced they are gender-blind,
above bias, because their institution professes to be. How else
could they hold the position they do, if their personal beliefs
and actions were not somehow intertwined with the museum's
mission? They are unwilling or unable to confront their sub-
conscious gender stereotypes – which are "common and auto-
matic" (ibid: 543-676) – because it would require a daunting

confrontation with their sense of self and fundamental beliefs about their work. Fairly and neutrally presenting information to the public is the cornerstone of most museum philosophies, making it the perfect breeding ground for senior level staff to feel fair and neutral by extension. Thus, they are more likely to discriminate against women because these implicit biases seep into their decisions unquestioned and unchecked:

> People given a chance to disagree with a set of sexist statements or primed to feel objective have been found to be more likely to recommend a male over a female candidate in experimental hiring scenarios. (Monin and Miller, 2001: 33-43) (Uhlmann and Cohen, 2007: 207-223)

Following this reasoning, it would seem those most suscep-tible to these mechanisms would be a group in power which has never personally experienced pervasive bias – white males, which just happen to dominate the upper museum echelons. These cause-and-effect scenarios are so sociologically and psychologically entrenched it is no wonder the museum field has been largely silent about the ethical dimensions of their gender discriminatory salary practices. But whether ignorant or intentional, the blissful silence must end at some point – if not by changing unconscious behaviors, than by changing how the field hires.

Enter again identity-blind hiring. The idea of identity-blind hiring may seem like a moot point in a field that is already predominately women. Yet, consider that removing gender from the equation not only increases the number of women hired – which is not the issue at hand in entry- and mid-level

positions – but increases the salary offered – which is (Castilla and Bernard, 2010: 543-676).

The takeaway? Gender and merit are persistently and pervasively conflated. And sub-standard salaries are the most visible manifestation of this bias within museums. So, hand-in-hand with identity-blind hiring must be salary-history-blind hiring as well as salary transparency for the job at hand. Transparency in job postings would reveal the living wage underbelly many museums would rather ignore, and thus may force the boards and directors responsible for setting salaries to publicly address the ethical dimension of their decisions.

The gender equity in museums movement
As with most social issues involving inequality, there are rumblings at the grassroots level long before those in power commit to change. The topics of gender and salary in museums have both gained traction over the past few years, although largely as disconnected conversations (unless discussing the specific issue of pay gaps among directors). Nevertheless, a consistent vocal presence – online, in text, and at conferences – is precisely what is needed to make these intrinsically connected topics become agenda items at future board meetings. Such museum staff observations illustrate – and necessarily complicate – a discussion that must go much further, regarding not only the gendering of museum salaries but also what this issue conveys about the sociology of the museum field.

The three most vocal advocates for social change within museum workplace practices and culture are the individuals behind Joyful Museums (2014), Museum Workers Speak (2015), and the Gender Equity in Museums Movement (GEMM) (2017).

Together, they provide an environment for emerging, current, and former museum professionals to converse about, collaborate around, and challenge the status quo. As Museum Workers Speak so aptly put it, "Our goals are to provide a forum to begin this conversation, to counteract the silence/taboo around discussing labor in museums."

Through regular surveys, monthly tweet chats, and AAM conference sessions, these coalitions have certainly built the stage and directed the spotlight. By raising awareness and developing resources, they are flipping the script. But not in its traditional sense. Instead of displaying the myriad perspectives of the museum community, an outward lens the field has always been more comfortable with, they are putting on display the museum worker – in all her passions, struggles, obstacles, insecurities, and achievements. An entity the average museum board is surprisingly unfamiliar with when it comes to daily accommodations and operations.

However, a recent study released by the AAMD implies far more action is needed. The AAMD's 2017 *Salary Survey* found the average median salary increased by 3% in 2016. Though this sounds encouraging, it only mirrors the country's economic growth rate of an average annual 2% to 3%. Furthermore, the positions that saw the most salary growth were Chief Operating Officers (5.5% – double the average rate across other museum positions), curatorial staff (4.6%), and directors (1.6%) (Association of Art Museum Directors, 2017: 4-5).

If anything, this salary growth only perpetuates what has already been introduced here – that those few male-dominated senior positions continue to receive a disproportionate distribution of financial reward (Figure 6).

	EXECUTIVES AS PERCENTAGE OF TOTAL EMPLOYEES	COMPENSATION OF EXECUTIVES AS PERCENTAGE OF TOTAL EMPLOYEES
MUSEUM OF MODERN ART	1.29%	6.59%
ART INSTITUTE OF CHICAGO	0.38%	6.99%
METROPOLITAN MUSEUM OF ART	0.66	6.59%
MUSEUM OF FINE ARTS, BOSTON	0.33%	7.41%
NATIONAL GALLERY OF ART	0.90%	6.48%
J PAUL GETTY TRUST	1.20%	5.71%
MUSEUM OF FINE ARTS, HOUSTON	0.26%	4.89%
MINNEAPOLIS INSTITUTE OF ART	1.24%	10.90%
PHILADELPHIA MUSEUM OF ART	1.01%	7.29%
CLEVELAND MUSEUM OF ART	0.95%	9.13%

FIG. 6: Percentage of executive employees vs. Percentage of total compensation.
Number of employees and compensation compiled primarily from FY15 Form 990s.

Myth No. 5: Gender-salary equity is not an ethical issue
Calling for change from the top
All the measures just outlined are steps that can be taken at
individual and institutional levels. Implementing change one
museum, one activist, one employee at a time. But are dispa-
rate, fractured pockets of progress across the country enough?
Or will such efforts continue to make headlines once in a while,
but soon fade into white noise to those not directly impacted?
As with civil rights, gay marriage, and countless other social
movements, state-by-state laws may change – but not until
the gavel falls at a Supreme Court ruling is the mission seen
as accomplished. So, what equivalent is necessary to achieve
better salaries and pay equity in museums across the nation?
Acknowledgment and advocating must come from those who
govern the field – the AAM.

In nearly every regard, museums adhere to an ethical con-
duct that exceeds the minimum behavior required by local,
state and federal laws. When it comes to collecting, deacces-
sioning, programming, fundraising, audiences – all are guided
by a moral compass fundamental to the identity and integrity
of the field.

And yet, when it comes to gender pay equity, both the
AAM and the museums it represents are not following their
own directives. Do the salaries currently being paid meet
legal minimums? Yes. Do the salaries reflect a museum taking
"affirmative steps to maintain their integrity" and thus set-
ting an ethical model for other sectors? (American Alliance of
Museums, 1991/2000). Absolutely not.

Why, in this particular area, are museums across the board
falling short? The answer, it would seem, is disappointingly

simple. Those in power do not see staff as the most important asset held or value shared. Those labels, according to the Code of Ethics, are held by collections and public service, respectively. While no one would argue those two entities are paramount, it would be equally hard to argue they could continue exist at all, let alone flourish, without devoted – but financially undervalued – female staff.

On this front, the Code of Ethics is largely silent. While a section on Governance does exist, it merely states in ambiguous and idealistic language that:

> The governing authority ensures that the museum's collections and programs and its physical, human and financial resources are protected, maintained and developed in support of the museum's mission.

What does it mean to protect, maintain, and develop human resources in support of the mission? The answers are infinite, open to interpretation by each and every museum board and director. Such relative criteria and subjective implementation have allowed substandard salaries based upon implicit gender biases to become normalized in the field. Thus, it is precisely here, with AAM and the Code of Ethics, that the tides must turn.

It is better late than never, and strides have been made. Their 2017 Annual Meeting and MuseumExpo held a session titled *Workplace Confidential: Museum Women Talk Gender Equity* (led by the founders of GEMM) (American Alliance of Museums, 2017: 57). While it wasn't exclusively about salary, there was extensive discussion about salary inequity – a commendable

move by AAM, although the use of the word "confidential" in the session title does slightly reinforce the aura of taboo and guilt around the subject.

The ultimate goal, however, must be incorporating salary standard language as an amendment to the Code of Ethics (which hasn't been updated since the turn of the millennium). Both actions, though, would require the AAM to overcome what seems like their greatest obstacle – eschewing their vague and dispassionate language in order to advocate with precision, clarity, and focused intent.

A refreshing example of such an approach was taken by colleagues at the library-equivalent umbrella organization, American Library Association (ALA), in 2003. In their *Campaign for America's Librarians: Advocating for Better Salaries and Pay Equity Toolkit* they minced no words, with an introduction to a 58-page manifesto that is as biting and impassioned as the issue demands:

> We librarians have a well-deserved reputation for being outspoken when it comes to intellectual freedom and other issues that affect library users. We have not been nearly as vocal on our own behalf. Statistics show that our profession, along with others that are pre-dominantly female, are underpaid relative to the education required and the complexity of the service we provide. Our challenge is clear:
>
> • We must overcome the stereotype of the librarian as the selfless, dedicated, and devoted worker, who is in the profession to do good and who will accept any pittance of pay.

- We must promote a better understanding of what the librarian does. No one will want to pay us more money if they have no idea what education, experience, judgment, and special skills it takes for us to do our jobs.

- We must contribute substantively to the fight for pay equity – it is our fight, too. Women have been discriminated against in a variety of ways, a primary one being compensation (American Library Association – Allied Professional Association, 2003: 3).

Where is this straight-shooting vigor at AAM? A small but striking difference between the two organizations' vocabulary is the use of *we*. AAM speaks of *museums* as an external party, while ALA fuses their organization with the librarians it represents by using a first-person *we*. The implication is that AAM does not identify as part of the body it serves. Lacking such embedded unity, it is no wonder the organization has not felt compelled to become a platform for pay equity.

But AAM cannot continue to profess to champion museums without championing museum workers.

Conclusion
The AAM's Code of Ethics clearly emphasizes that a museum's foremost priority is the community it serves. That should include the community within its own walls. What better way for an institution to make a positive social impact on the public than by providing a living wage to the underpaid and under-recognized women who make the museum hum, day in and day

out, with their education, skills, and tireless devotion.

There will never be a "good" time to address gender-pay inequity. As nonprofits, museums will always be under financial pressure. But neither workers nor the field itself can afford to continue this complicit behavior – signing the unspoken contract of DWYL, self-sacrifice, and entrenched gender-biased practices – that implies a real or perceived lack of funds is a valid reason to discriminate with compensation that fails to reflect a living wage. To do so would be to accept becoming an established pink-collar profession.

It is time. The field has openly discussed qualms about unpaid internships, unneeded degrees, board ratios, and directorship gender-pay gaps – but when it comes to the ethics of substandard salaries at entry- and mid-levels, there is an absence of shame. And shame, unfortunately, is what motivates change within the rungs of power. Museums cannot truly be the upstanding, ethical institutions they profess to be until they acknowledge the inequitable treatment of their own employees. Paying museum staff decent wages encourages the continued professionalization of the field, which in turn leads to higher quality programs and exhibitions, and ultimately brings every museum closer to their holy grail of a larger, more engaged, and diversified audience.

The field is ready and anxious to embrace the virtue of equity, accessibility, diversity, and inclusion when it comes to audience – but it is quite a different matter when it comes to the woman sitting at a computer cataloguing the collection, or the one leading third graders through the galleries, or the one greeting visitors with a wide smile as they enter the gift shop. It is time to value these unsung heroines.

It is time to go to battle differently.

NOTES

1. The national pay ratio between men and women reached 80/100 cents in 2015 (Hill, 2017: 4), while female art museum directors, on average, earned 73/100 in 2016 (Treviño *et al.*, 2017: 5).

2. Transcribed from an actual Twitter conversation.

REFERENCES

#MuseumWorkersSpeak, 2015. Retrieved from http://museumworksspeak.weebly.com/

American Alliance of Museums, 2017. Workplace Confidential: Museum Women Talk Gender Equity. *Annual Meeting & MuseumExpo Program Book*. Washington DC: American Alliance of Museums.

American Alliance of Museums, 1991/2000. *Code of Ethics for Museums*. Retrieved from http://aam-us.org/resources/ethics-standards-and-best-practices/code-of-ethics

American Alliance of Museums, 2012. *2012 National Comparative Museum Salary Study*. Washington, DC: American Alliance of Museums.

American Alliance of Museums and New Knowledge Organization Ltd., 2014. *2014 National Comparative Museum Salary Survey*. Washington, DC: American Alliance of Museums.

American Alliance of Museums and New Knowledge Organization Ltd., 2017. *2017 National Museum Salary Survey*. Washington, DC: American Alliance of Museums.

American Library Association-Allied Professional Association, 2003. *Campaign for America's Librarians: Advocating for Better Salaries and Pay Equity Toolkit*. Chicago, IL: American Library Association-Allied Professional Association. Retrieved from https://www.ala.org/ala/hrdr/libraryempresources/toolkit.pdf

Association of Art Museum Directors, 2017. *From the Field: Salary Survey*. Retrieved from https://www.aamd.org/our-members/from-the-field/salary-survey

Association of Art Museum Directors, 2017. *2017 Salary Survey*. New York, NY: Association of Art Museum Directors.

Blau, F., & Kahn, L., 2016. The Gender Wage Gap: Extent, Trends, and Explanations. *IZA Institute of Labor Economics*, 9656, 8. Retrieved from http://ftp.iza.org/dp9656.pdf

Broadbridge, A., & Fielden, S., (eds.), 2015. Handbook of Gendered Careers in *Management: Getting In, Getting On, Getting Out*. Northampton, MA: Edward Elgar Publishing.

Castilla, E., & Benard, S., 2010. The Paradox of Meritocracy in Organizations. *Administrative Science Quarterly*, 55(4), 543-676. Retrieved from http://dx.doi.org/doi:10.2189/asqu.2010.55.4.543

Cuyler, A., & Hodges, A., 2015. From the Student Side of the Ivory Tower: An Empirical Study of Student Expectations of Internships in Arts and Cultural Management. *International Journal of Arts Management*, 17(3), 68-79, 94. Retrieved from https://fsu.digital.flvc.org/islandora/object/fsu%3A330448

Dubner, S., 2016. The True Story of the Gender Pay Gap. [Podcast]. *Freakonomics Radio*, January 7. Retrieved from http://freakonomics.com/podcast/the-true-story-of-the-gender-pay-gap-a-new-freakonomics-radio-podcast/

Elmer, V., 2013. Women are 'Leaning In' – and Not Getting Paid for It. *The Atlantic*. Retrieved from https://www.theatlantic.com/sexes/archive/2013/08/women-are-leaning-in-and-not-getting-paid-for-it/278765/

Feldman, K., 2016. Power, Influence and Responsibility: Kaywin Feldman at the 2016 AAM Annual Meeting. [YouTube video]. American Alliance of Museums,

July 5. Retrieved from https://www.youtube.com/watch?v=aMCJU8IoIUM&t=5s

Gardner, P., 2011. The Debate Over Unpaid College Internships. *Intern Bridge*. Retrieved from http://www.ceri.msu.edu/wp-content/uploads/2010/01/Intern-Bridge-Unpaid-College-Internship-Report-FINAL.pdf

Gender Equity in Museums Movement, 2017. Retrieved from https://www.genderequitymuseums.com

Glassdoor, 2017. Walmart Shift Manager Salaries. *Glassdoor*, July 20. Retrieved from https://www.glassdoor.com/Salary/Walmart-Shift-Manager-Salaries-E715_D_KO8,21.htm

GuideStar, 1999. *Understanding the IRS Form 990*. Retrieved from https://www.guidestar.org/Articles.aspx?path=/rxa/news/articles/2001-older/understanding-the-irs-form-990.aspx

Hill, C., 2017. The Simple Truth about the Gender Pay Gap. *American Association of University Women*, Spring 2017. Retrieved from http://www.aauw.org/aauw_check/pdf_download/show_pdf.php?file=The-Simple-Truth

Hunt, E., & Colander, D., 2013. *Social Science: An Introduction to the Study of Society*. UK: Routledge (15th ed.)

Joy, L., et al., 2007. The Bottom Line: Corporate Performance and Women's Representation on Boards. *Catalyst*. Retrieved from http://www.catalyst.org/system/files/The_Bottom_Line_Corporate_Performance_and_Womens_Representation_on_Boards.pdf

Joyful Museums, 2014. Retrieved from http://www.joyfulmuseums.com/

Levanon, A., et al., 2009. Occupational Feminization and Pay: Assessing Casual Dynamics Using 1950-2000 U.S. Census

Data. *Social Forces*, 88(2), 865-891. Retrieved from https://doi.org/10.1353/sof.0.0264

Malik, S., 2012. *Survey on Gender Ratios in Curating Programs*. Center for Curatorial Studies, Bard College. Retrieved from http://www.bard.edu/ccs/redhook/survey-on-gender-ratios-in-curating-programs/

Merritt, E., 2016. The Museum Sacrifice Measure. *Museum*. Retrieved from http://www.aam-us.org/docs/default-source/resource-library/the-museum-sacrifice-measure.pdf?sfvrsn=0

Miller, C., 2016. As Women Take Over a Male-Dominated Field, the Pay Drops. *New York Times*. Retrieved from https://www.nytimes.com/2016/03/20/upshot/as-women-take-over-a-male-dominated-field-the-pay-drops.html

Monin, B., & Miller, D., 2001. Moral Credentials and the Expression of Prejudice. *Journal of Personality and Social Psychology*, 81(1), 33-43. Retrieved from http://dx.doi.org/10.1037/0022-3514.81.1.33

National Association of Colleges and Employers, 2016. *Paid Interns/Co-Ops See Greater Offer Rates and Salary Offers than their Unpaid Classmates*. Retrieved from http://www.naceweb.org/job-market/internships/paid-interns-co-ops-see-greater-offer-rates-and-salary-offers-than-their-unpaid-classmates/

Schonfeld, R., et al., 2015. *The Andrew W. Mellon Foundation: Art Museum Staff Demographic Survey*. Retrieved from https://mellon.org/media/filer_public/ba/99/ba99e53a-48d5-4038-80e1-66f9ba1c020e/awmf_museum_diversity_report_aamd_7-28-15.pdf

Schwartz, M., 2013. Opportunity Costs: The True

Price of Internships. *Dissent Magazine*. Retrieved
from https://www.dissentmagazine.org/article/
opportunity-costs-the-true-price-of-internships

Semuels, A, 2016. When Women Run Companies. *The Atlantic*.
Retrieved from https://www.theatlantic.com/business/
archive/2016/12/female-bosses-in-the-workplace/506690/

Sheets, H., 2014. Study Finds a Gender Gap at the Top
Museums. *New York Times*. Retrieved from https://www.
nytimes.com/2014/03/08/arts/design/study-finds-a-gen-
der-gap-at-the-top-museums.html?_r=0

Tokumitsu, M., 2014. In the Name of Love. *Jacobin*.
Retrieved from https://www.jacobinmag.com/2014/01/
in-the-name-of-love/

Treviño, V., *et al.*, 2017. The Ongoing Gender Gap in Art
Museum Directorships. *Association of Art Museum
Directors*. Retrieved from https://aamd.org/sites/default/
files/document/ AAMD%20NCAR%20Gender%20Gap%20
2017.pdf

Twitter, 2016, May 28. Retrieved from https://twitter.com/
GracieAstrove/status/736542296305324033

Uhlmann, E., & Cohen, G., 2007. 'I Think It, Therefore It's
True': Effects of Self-Perceived Objectivity on Hiring
Discrimination. *Organizational Behavior and Human
Decision Processes*, 104, 207–223. Retrieved from http://
www.socialjudgments.com/docs/Uhlmann%20and%20
Cohen%202007.pdf

U.S. Department of Labor, 2009. *Foreword to An Analysis
of Reasons for the Disparity in Wages Between Men and
Women*. CONSAD Research Corporation. Retrieved
from https://www.shrm.org/hr-today/public-policy/

hr-public-policy-issues/Documents/Gender%20Wage%20
Gap%20Final%20Report.pdf

U.S. Government Accountability Office, 2015. *GAO-16-30:
Corporate Boards: Strategies to Address Representation of
Women Include Federal Disclosure Requirements. Report to
the Ranking Member, Subcommittee on Capital Markets and
Government Sponsored Enterprises, Committee on Financial
Services, House of Representatives.* Retrieved from http://
www.gao.gov/assets/680/674008.pdf

Whitford, E., 2015. MoMA Employees Protest "Modern
Art, Ancient Wages." *Gothamist.* Retrieved from http://
gothamist.com/2015/06/03/moma_employees_protest.php

APPENDIX A: RESOURCES FOR FINANCIAL DATA FOR THE TOP TEN WEALTHIEST ART MUSEUMS IN THE USA, BY OPERATING BUDGET

International Revenue Service Form 990/990PF
(Accessed May 2017, GuideStar.org)
Metropolitan Museum of Art, 2014 (FY15)
J. Paul Getty Trust, 2014 (FY15)
Art Institute of Chicago, 2014 (FY15)
Museum of Modern Art, 2014 (FY15)
National Gallery of Art, 2014 (FY15)
Museum of Fine Arts, Boston, 2014 (FY15)
Museum of Fine Arts, Houston, 2014 (FY15)
Philadelphia Museum of Art, 2014 (FY15)
Cleveland Museum of Art, 2014 (FY15)
Minneapolis Institute of Art, 2014 (FY15)

Annual Reports, Audited Financial Statements, Statements of Activities, and Budget Requests
(Accessed May 2017)
Metropolitan Museum of Art, *2015-16 Report of the Chief Financial Officer.* (FY16)
 http://www.metmuseum.org/-/media/Files/About%20
 The%20Met/Annual%20Reports/2015-2016/Annual%20
 Report%202015-16%20Report%20of%20the%20Chief%20
 Financial%20Officer.pdf
J. Paul Getty Trust, *J. Paul Getty Trust Report 2016: Culture at Risk.* (FY16)
 http://www.getty.edu/about/governance/trustreport/
 trust_report_16.pdf

The Art Institute of Chicago. *FY16 Audited Financial Statements.*
http://www.artic.edu/sites/default/files/The_Art_Institute_of_Chicago_FY2016_Audited_Financial_Statements.pdf

Museum of Modern Art. *FY16 Consolidated Financial Statements.*
https://www.moma.org/momaorg/shared/pdfs/docs/about/MoMAFY_16.pdf

National Gallery of Art. *FY17 Congressional Budget Request.*
https://www.nga.gov/content/dam/ngaweb/notices/Financial%20Reports/fy2017-budget-request-national-gallery-of-art.pdf

Museum of Fine Arts, Boston. *FY16 Consolidated Statement of Activities.*
http://www.mfa.org/annual-report-2016/downloads/Consolidated_Statement_of_Activities_2016.pdf

Museum of Fine Arts, Houston. *FY16 Audited Financial Statements.*
https://www.mfah.org/downloads/c379716a-0cc6-e611-80c8-0050569125fe/view

Philadelphia Museum of Art. *FY16 Audited Financial Statements.*
https://www.philamuseum.org/doc_downloads/annualReports/PhiladelphiaMuseumofArtAuditedFinancialStatement2016.pdf

Cleveland Museum of Art. *FY16 Audited Financial Statements.*
https://www.clevelandart.org/sites/default/files/documents/annual-report/The%20Cleveland%20Museum%20of%20Art_16-15_final_secured.pdf

Boards of Trustees (elected trustees only)
(Accessed May 2017)

Metropolitan Museum of Art
 http://www.metmuseum.org/-/media/Files/About%20
 The%20Met/Annual%20Reports/2015-2016/Annual%20
 Report%202015-16%20The%20Board%20of%20Trustees.pdf
J. Paul Getty Trust
 http://www.getty.edu/about/governance/trustees.html
Art Institute of Chicago
 http://www.artic.edu/about/board-trustees
Museum of Modern Art
 https://www.moma.org/about/trustees
National Gallery of Art
 https://www.nga.gov/content/ngaweb/about/board-of-
 trustees.html
Museum of Fine Arts, Boston
 http://www.mfa.org/annual-report-2016/trustees.html
Museum of Fine Arts, Houston
 https://www.mfah.org/downloads/
 b5eb9d86-c856-4c87-8043-91e81298638d/view/
Philadelphia Museum of Art
 http://www.philamuseum.org/information/43-323.
 html?page=2
Cleveland Museum of Art
 http://www.clevelandart.org/about/museum-leadership/
 board-of-trustees
Minneapolis Institute of Art
 https://new.artsmia.org/about/museum-info/
 board-of-trustees/

WHAT'S GOING ON IN THIS PICTURE? MUSEUM EDUCATION AS UNDERVALUED LABOR

Emily Turner

WHEN EVALUATING MUSEUM WORK across the sector we see a high cost of entry coupled with low compensation that creates barriers to cultivating a diverse workforce equipped to properly address the needs of its communities. However, the extent to which we see these trends depends on what area of museum work and institutional discipline, location, structure, or size we are looking at. Museum education is one of the areas in which we see many of the tensions regarding museum pay vividly on display. As one of the most female forms of museum labor, both in terms of who performs it and how people perceive it, and as one of the field's lowest-paid areas of expertise, museum education provides a unique opportunity to observe deeply entrenched contradictions and assumptions about museum labor, and the ways in which these contribute to unsustainable working conditions.

Let's take a moment to look closely at the current state of museum education salaries. When compared to other categories on the 2017 *AAM Salary Survey*, Educational Assistants have the lowest median salaries at $33,962 (AAM, 2017). The survey, admittedly, does not cover common part-time or hourly roles like tour guides, front desk staff, and security, but when ranking the results of the American Art Museum Directors salary survey, Educational Assistants have the second-lowest average salaries above Security Officer/Guard (Halperin, 2017).

In looking at salaries, it's important to focus on entry-level work because in a system where pay increases both with seniority and based on what someone makes in a previous position, entry-level pay is where it all begins. The low pay for entry-level full-time educator positions is particularly striking because of the high visibility of education within most museum missions

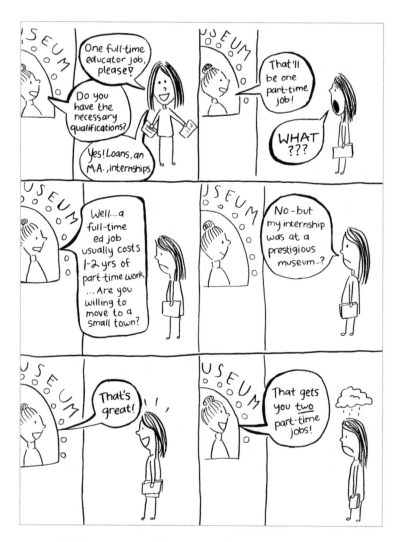

FIG. 1: The price of entry to full-time museum education work.

and self-promotion. This positioning has grown rapidly over the past 40 years, marked by the publishing of *Excellence in Equity* by AAM in 1992, which outlined a strategic plan to make education the primary purpose and function of the museum (Roberts, 1997: 150-51). As museums continue to become more education- and visitor-centered, it's important to look at how education staff are faring in this transition.

This chapter will focus on the youth-driven front-of-house work of museum educators, for this is the archetype of the museum educator from which perceptions that contribute to the devaluation of educational labor within the museum stem. I have included some comic illustrations to illuminate the many ways educational labor is undervalued and why. After all, when you work in museum education a sense of humor is paramount.

So what's going on in this picture (Figure 1)? A hopeful emerging museum educator in search of a job believes she has completed the necessary prerequisites to gain full-time employment – a graduate degree, an unpaid internship, and volunteer experience – only to find that it's not enough. She's still expected to start her employment journey by taking on part-time work. Welcome to the museum education hustle! As with most informal education jobs, the bulk of entry-level educator positions are part-time, temporary, and/or freelance in nature. The *AAM Salary Survey* suggests close to a third of Educational Assistants are part-time workers, but this is likely an underestimation due to the fact that the position definition was not focused on direct facilitation of programs (AAM, 2017). By comparison, a 2015 NEMA (New England Museum Association) study of museum education found that 70% of organizations use paid part-time staff to deliver educational

programming (NEMA, 2015: 12). A survey of New York City cultural organizations also found that half of all museum education jobs are part-time (Schonfeld, 2016). This shift towards employing part-time and contractual labor has been caused by a number of factors, including hiring freezes and budget cuts during the 2008 great recession, and the rise of the so-called "gig economy" (Migdal, 2018). In cutting costs by reserving teaching time for part-time and temporary workers, particularly during peak seasons, many education departments have effectively separated the labor of program development and administrative work from the labor of program facilitation.

As one can imagine, relying on part-time work places educators in unstable work environments that require them to juggle multiple positions in or outside the museum field if they are to make the equivalent of a full-time salary with benefits. This leaves them open to greater exploitation and lower pay compared to their full-time counterparts. These jobs are unpredictable and competitive; folks burn out. Hyperallergic recently reported that in New York City, pay rates for freelance educators have been stagnant, a financial hardship for workers who must buy their own health insurance and create their own makeshift retirement funds (Rodney, 2015). This kind of work is untenable for people trying to start a family, those with dependents, or those do not have family resources to fall back on. It exacerbates the common financial barriers for anyone wishing to work in a museum, a field that already insists on maintaining a highly qualified and underpaid workforce.

This division of labor is also untenable for an education team. If teaching staff are constantly moving through a revolving door in search of the next paycheck and a more

stable position, full-time developers must spend a significant portion of their time training and re-training staff to deliver programs. Not to mention that it inhibits building the institutional memory necessary for long-term strategic planning and growth. Program growth in this divided structure also requires a healthy amount of respect and communication between part-time and full-time staff in order for those with delivery expertise to shape and influence programming. How much respect can really come from a hierarchy where those with more prestige, higher pay, and greater expertise have gained their position by slowly moving up a ladder that distances them from the actual labor of teaching? We will also see later the many ways in which floor staff are devalued, and departments are strapped for time and resources.

Here we have a snapshot of who is performing educational labor within institutions – both the demographic makeup of education workers, and how it is cared for depending on the size, organization, and budget of a museum (Figure 2). The majority of museums in the United States are very small both in budget and staff size (Ingraham, 2014). Many museums thus operate with "departments of one" and/or combine seemingly disparate staff roles. Sometimes, this means educational programming is overseen by someone who was hired with a completely different specialty, or someone who has other duties that demand the majority of their time. In the NEMA area, in the 75% of museums that do not have dedicated education staff, education falls under the responsibilities of the museum director – a person likely juggling too many responsibilities (NEMA, 2015). What museums cannot do with paid staff alone, they will turn to volunteer labor for. In fact, the majority of

FIG. 2: A museum education hall of portraits.

people working in museums are volunteers, with small museums depending on them the most (Merritt, 2016). Arguably the most visible volunteers in a museum are those that work directly with audiences: docents.

Who is responsible for education has also changed as education has moved from the periphery to the center of museums. Many museum education writers and researchers point to AAM's *Excellence and Equity* (1992) as a watershed publication that marked this shift. *Excellence in Equity* called for all parts of the museum to see themselves as active participants in the sculpting of museums as places of learning. In a rush to both professionalize the field and support the centering of education within the museum, the ensuing decades were marked by calls to establish new professional organizations and journals, develop a body of research and evaluation to give legitimacy to museum learning, and create new technologies for reaching audiences (Rasmussen and Winterrowd, 2012). In this process, the expertise of educators was distributed elsewhere in the museum (Nolan, 2009). New types of positions have opened up in museums experimenting with what institution-wide educational priorities look like. We can see in Figure 2 that the Director of Education has recently had a title change to Curator, perhaps to reflect a more formal integration of various types of interpretation in their museum. Other new hybrid jobs include positions like the Gallery Guides at the Guggenheim Museum, who serve education and security roles simultaneously (Solomon R. Guggenheim Foundation, 2019). This kind of redistribution can be tricky. Due to recessionary budget cuts and an analysis of visitor satisfaction with staff, the Rubin Museum decided to layoff all but one member of its admissions staff and

wrap all front desk duties under the purview of Education, rebranded as Visitor Experience (Stafne, 2010). Although this case study presents only positive impacts of the transition, one has to wonder about the long-term effects of decisions like these on the perceived value of educators and the impact on visitor services positions. This kind of shift ultimately forced educators to spend half their time in a service-oriented role, more closely aligning it with positions that are *actually* the lowest paid in museums. It also resulted in the elimination of a large number of visitor services and security roles in the museum – positions that usually have higher proportions of workers of color (Schonfeld *et al.*, 2015). In aligning visitor services with education, museums could perhaps be slowly chipping away at access to entry level wage work in museums.

Belonging to a marginalized group often comes with financial consequences due to the ways forms of oppression such as racism, sexism, and class are systematically and inextricably linked. This is one reason the high cost of entry to museum work results in effects like low racial diversity among museum workers. In Figure 2, most of the people in the portraits appear to be white women, and most workers of color are in the group portraits representing entry level workers. There are very few men, though notably one seems to have been promoted to a coordinator position. The teaching staff are primarily young adults, whereas the docents are in their sixties and upwards. While other low-paying museum jobs have relatively high proportions of workers who identify as racial and/or ethnic minorities, museum educators are overwhelmingly white and women. In art museums, they are close to 80% female and near 75% white – significantly higher rates

than the U.S. population as a whole (Ibid.). The AAM salary survey, which covers multiple museum disciplines, reported education positions ranging from 77%-88% female, with the highest proportion of men in mid-level positions (AAM, 2017). It's telling that in such a female-dominated workforce, male educators are clustered in mid-level positions within a department. Perhaps this is because of the "glass escalator," which promotes men with less experience faster than their female colleagues (Schwarzer, 2006: 24). It may also be a reflection of what are considered appropriate educational roles for men. We see this in K-12 classroom education where men are more likely to be teachers at older grade levels, and/or administrators (Rich, 2014).

This may all seem at odds with the idea that education is arguably one of the more accessible entry points for leadership-track museum work. Due to the multi-disciplinary nature of informal museum-based education, facilitators are often hired from a wide variety of backgrounds like theatre, community organizing, and high school internship programs. Entry-level education workers are less likely to have graduate degrees than comparable positions in other areas of the museum (AAM, 2017). Depending on where you live, such as large urban areas with a preponderance of museums, there may also simply be more education jobs available than others. In a study of New York City cultural organizations, education was not only found to be the largest job type in museums (followed by security), but the largest area of growth in number of jobs across all organizational disciplines (Schonfeld, 2016). Education is also where intellectual leadership roles in art museums are seeing the most growth in non-white hires (Westermann et al., 2018).

FIG 3: Museum educator warm-ups.

Despite these accomplishments, across all previously refer-
enced surveys, racial, gender, and educational diversity are
still not reflective of national demographics, and their repre-
sentation decreases as position seniority increases. This should
not be surprising given how exhausting and precarious it is for
educators to not only get their foot in the door but walk all the
way in and stay there.

Once you make it past all the hurdles to entry, what kind of
work does museum education actually entail? Turns out, it's
really hard to define! It can seem like a near impossible task
because education work is so many things at once (Figure 3).
This conundrum has given educators grief for decades, and is
part of why they struggle to be taken seriously as specialists. In
their widely-discussed report, *The Uncertain Profession*, Dobbs
and Eisner controversially described museum education as a
field with "unarticulated basic aims," inadequate formal train-
ing, and lacking a scholarly foundation (Dobbs and Eisner, 1987).
Despite the establishment of several professional organizations,
and subsequent influential publications such as *Excellence in
Equity* (AAM, 1992), *From Periphery to Center* (NAEA, 2007), or
the research of John Falk and Lynn Dierking that outlined stan-
dards and theories which lay foundations for museum educa-
tion, educators continue to confront skepticism and confusion
as to their purpose, skills, and validity. In 2006, issues of the
Journal of Museum Education explored such topics as Are Museum
Educators Still Necessary? and The Professional Relevance of
Museum Educators. More recently, on the blog *Museum Questions*,
Rebecca Herz posited that the recent variety in new educator job
titles (as discussed earlier) reflects not only growing differences
in the responsibilities themselves but a struggle for vocabulary

to define what it is museum educators do (Herz, 2014).

So what is it? In taking a look at Figure 3, we see that there are many aspects to museum education. Firstly, it is visitor-focused work, and has been since day one. In establishing museum educational activities as a distinct part of museum work in the 1920s and 1930s, mission-aligned work was effectively split between scholarly and popular or public pursuits (Roberts, 1997: 65). Curators have traditionally focused on collections, while educators focused on interpreting collections for the public. Although several institutions are working to reunite these two aspects of interpretation, the distinction lingers. Being visitor-centered, museum educators are often directly in contact with museum audiences and are thus front-of-house roles – even when not formally structured as blended positions. In the case of front-of-house museum workers, they become avatars for the institution in the eyes of the visitor. Customer service-oriented positions, broadly speaking, are open to criticism and harassment from both the general public and colleagues. The National Gallery of Art has recently come under fire for what security guards, retail workers, and others have described as a hostile work environment characterized by sexual harassment, discrimination, and retaliation that has resulted in formal complaints to the Equal Employment Opportunity Commission (EEOC) and a handful of lawsuits (McGlone, 2018). Early investigations by trivedi and Wittman into the sexual harassment which museum workers face link the rise of a female majority staff to high rates of sexual harassment in the workplace, though they do not make a distinction between harassment from colleagues versus visitors (trivedi and Wittman, 2018). Museum education is also manual labor.

On-the-floor teaching often requires educators to be on their feet for hours at a time, constantly moving, sitting on the floor, navigating small gallery spaces, and setting up and maintaining teaching supplies. Coupled with burnout culture, the physical nature of education work tends towards educators being young and able-bodied.

As discussed previously, the only positions paid less than floor educators in a museum are the other service-oriented positions like retail, security, and facilities (AAM, 2017). What perhaps distinguishes education from these other front-of-house roles, however, is the remaining association with the scholarly and intellectual aspects of museum missions. In a thoughtful essay about the work of gallery technicians, Jaclyn Bruneau describes ways in which the technician is sometimes seen as a service worker, sometimes an expert, depending on which staff they are interacting with, and she insists there is an invisibility to both (Bruneau, 2018). Museum education has a similar dual role. Although much of education work is service-oriented, core educator functions like designing programs, facilitating lessons, writing educational materials, and serving on exhibition development teams are intellectual tasks that require specialized knowledge (Munlay and Roberts, 2006: 35-36). Depending on the museum and position, teaching staff may need to be certified in Visual Thinking Strategies, have archival research experience, understand species classification, or be a practicing studio artist. Although educators often need to have specialized knowledge, use of a diversity of engagement techniques along with the wide variety of institutional approaches to education means educators also often build their expertise largely "within the context of their practice" (Bailey, 2006).

FIG. 4: The gap in understanding.

The preponderance of on-the-job learning, a seeming lack of formalized routes to educator positions, and a wealth of subject areas has supported a perception of educators as generalists rather than specialists.

In the vignette at Figure 4, we see a large gap between the passing staff member's understanding of what educational work entails and the actual complexities of informal learning. Being seen as a generalist has dire consequences for the perceived value of educational labor, for if work does not require formalized expertise, perhaps anyone can do it. This is particularly true of labor that has been historically categorized as women's work, such as teaching. Macuschla Robinson, in exploring the unpaid labor of the art world, reminds us that historically in Euro-centric cultures a gender essentialism has persisted in which women are aligned with nature and caregiving (Robinson, 2016). As a natural resource, women's labor is seen as naturally occurring and thus freely available for extraction and undeserving of compensation (Robinson, 2016). It is for this reason that women were identified as being the perfect candidates to fill U.S. classrooms as teachers in the mid-1800s (Boyle, 2004). Although museum educators have fought hard through professionalization efforts to distinguish museum learning as distinct from K-12 classroom education, the structural and associative bonds remain. Since the beginning, museum education has been tied to classroom learning; the first dedicated education staff in U.S. museums were schoolteachers (Roberts, 1997: 33). To this day, K-12 learners remain the biggest audiences for education departments (NEMA, 2015). Frustratingly, because museum learning does not occur in a classroom but in a space of leisure, educators must also combat

prejudices and misconceptions that undervalue informal learn-ing in particular. Without the formal benchmarks or consistent long-term relationships characteristic of classroom learning, and with an emphasis on constructivist, personal meaning-making experiences, museum educators have struggled to find appropriate and sufficient research-based methods of measuring outcomes, especially in a quickly changing field. Within half a century, museum learning moved from hierar-chical, unidirectional models of learning, through entertain-ment and empowerment models, to arrive at current models of navigating and creating narratives (Roberts, 1997: 131-133). These engaged pedagogical techniques are not often seen as intellec-tually rigorous because they aren't serious enough, emphasize "soft" skills, and are perceived as lacking structure.

Educators argue that the field is an intellectually and finan-cially undervalued area of museum work because of "inherited biases" surrounding feminine labor (Davis et al., 2018). Museum education is indeed a female-dominated profession. Where education is the focus, there you will find women. Although women make up approximately half the museum workforce (depending on the study), certain types of museum work are largely segregated along a gender binary, with men concen-trated in departments like IT, exhibit installation, and secu-rity (Baldwin and Ackerson, 2017: 47-52). These patterns emerge cross-institutionally as well, with women more likely to be found in museums more closely aligned with youth audiences and education. Science centers, which serve a predominantly youth audience and use collections primarily for teaching, are predominantly run by women, whereas natural history muse-ums, with similar content but a scholarship and research focus,

are predominantly run by men (Baldwin and Ackerson, 2017: 18).

A preponderance of women workers does not automatically result in an equitable work environment. As women take over a field, pay drops (Miller, 2016). Definitions of feminine labor have also historically been drawn around economic and racial lines; during the Jim Crow era, Black women were both thrust into the workforce at higher rates (out of economic necessity), and were largely excluded from jobs white women held (Bremner, 1992). In *Women in the Museum*, surveys, interviews, and historical research illuminate several ways in which women museum workers, despite being in the majority, feel pressured to perform certain aspects of femininity like being soft spoken and playing the "cute little girl card" (Baldwin and Ackerson, 2017: 100-109). These too are normative notions of femininity rooted in whiteness, and which have historically been denied women of color (Cole and Zucker, 2007). Nationwide studies also show that transgender workers regularly face discrimination based on their gender identity, and trans women in particular receive significantly less pay compared to their cis female and male counterparts (Burns, 2012). Without making space for expressions of womanhood that de-center whiteness and gender essentialism, museum education departments can become hostile and exhausting work environments for women of color as well as genderqueer and trans women.

It would be remiss not to explore the impacts of the prevalence of docent labor on museum education, for its use both displaces actual staff positions and makes it difficult for educators to advocate for the value of their work within their institutions (Figure 5). For one, the docent-led stop-and-talk tour has maintained a strong hold on staff and visitor imaginations,

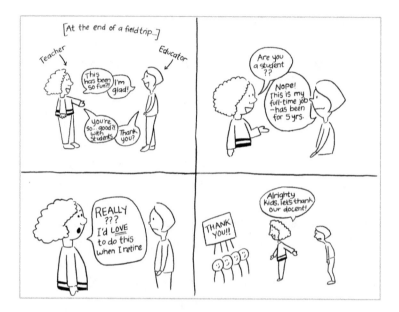

FIG. 5: Let's thank our docent – a case of mistaken identity.

with wide-sweeping impacts. Although current literature on best practices in museum engagement and education focus on dialogic, hands-on, and visitor-driven learning, it is taking a long time for these methods to become standard across the board in museums. Additionally, museum education departments still rely heavily on volunteer labor regardless of what methods of engagement they employ. Museums with small budgets (as you may recall, the majority of U.S. museums) rely most heavily on volunteers to deliver school programs, though the vast majority of large museums have volunteers to facilitate these programs as well (NEMA, 2015). Because museum education relies heavily on volunteers, it is doubly deemed feminine labor; volunteerism has historically fallen into the realm of "women's work" (and leisurely women's work at that). In the 1940s and 1950s, as museum women were pushed out of staff roles and volunteerism boomed nationally, women moved full steam ahead into heading up museum volunteer programs, responsible for leading tours, running membership drives, and throwing galas – common volunteer roles to this day (Schwarzer, 2009:19). It's important to remember that although volunteers provide invaluable support to keep museums going, volunteering is still something people do for free, for fun, and in the case of docents, regardless of whether they were teachers in past lives.

On-the-floor teaching staff encounter interactions like the one in Figure 5 on a regular basis. The backhanded compliments come from a good place, they really do. Most people don't realize how rude they are being when doling out praise in a surprised tone. Assuming that you must be a volunteer, visitors seem confused or surprised when confronted with an

education staff member who is both young and skilled. There is a myriad of other surprised reactions that occur depending on what kind of "other" they perceive the educator to be – a well-spoken person of color, male, a white person working at a culturally specific institution, etc. Not understanding that this may be a full-time job, acquired with qualifications and training, they also assume the reason you must have time to be here is because you are a student. Of course, the fact that this educator is also likely a young woman presents her with a challenge to be taken seriously. Even after being told this is your career, it does not fit with this visitor's notions of museum education work. They insist that what you do for work would make a perfect part-time hobby.

Because docents are very visible volunteers, sometimes the clash between shifting educational trends and long-standing traditions of volunteer-led programs plays out with dramatic results. Sensationalist news stories and conference sessions tell tale of "docents gone wild," – offending visitors and staff, touching art, providing inaccurate information – that some say is a result of decreased resource allocation to volunteer management and a culture of resistance to staff changes to programming (Cohen, 2015). These behaviors are subsequent fuel for other dramatic stories like the Hirshorn suddenly can-celling its docent program and replacing them with what are essentially interns (McGlone, 2014). Because docents are typi-cally seniors and the educators or interns coming to replace them young women, these stories are chock-full of age-ism and sexism in both directions. One recent report of rogue vol-unteers vs. hostile staff at the Phoenix Art Museum included several accounts of sexist remarks targeted at incoming staff

and staff being rude or dismissive to docents who want to keep giving tours the way they are used to (Pela, 2019).

Although news about cancelled docent programs paints a picture in which the field, increasingly professionalized, is doing away with volunteer labor in hopes of providing consistent, full-time, high quality educational work, this is not resulting in more paid work for dedicated education staff. Often, as in the case of the Hirshorn, docents are instead replaced with unpaid interns. By providing museums with free or below minimum wage labor but with a higher time commitment, unpaid internships both displace paid positions and decrease the affordability of gaining the experience needed for full-time museum employment. In addition to being displaced by unpaid interns, a study by Ron Kley suggests that educators were the most impacted by lay-offs following the 2008 recession (Kley, 2009). Although concrete data is minimal, the narratives in news articles containing interviews with museum executives are telling. When the Getty Museum laid off 34 staff members in 2012, the education department was the hardest hit and museum officials insisted programming wouldn't suffer because volunteers would be able to pick up the slack (Boehm, 2012). Other museum layoff news stories (*Metropolitan Museum of Art Lays Off 34 Employees*) are less informative about the fates of educators, but reassurances that core mission work won't suffer because no curators or conservators were let go illuminate deeply-held beliefs that the work most central to museums is that of collections and curatorial departments (Pogrebin, 2016). Education is simply a (free) cherry on top.

When educators aren't seen as leaders and specialists essential to the core mission of the museum, they aren't given the

proper resources or support to do their jobs well and keep up with audience and community needs. Educators do a lot with very little. Although all respondents of the NEMA education survey said their museums had education written into their mission, nearly half didn't have any dedicated full-time education staff (NEMA, 2015). When departments are strapped for people power and relying heavily on part-time, freelance, and/ or unpaid labor, people burn out and quality is inconsistent. Educators are also often bound by content set by curatorial staff, which means they may be working with objects that have high value as part of a traditional canon, but are not the most effective objects or artworks for teaching (Prottas, 2017). Paths to curatorship (positions that in art museums are 84% white) have been identified as a top area of priority for museum diversity and inclusion initiatives, specifically because of their primary role in establishing museum interpretive narratives and canon (Pogrebin, 2018). A curatorial workforce with little resemblance to the American public as a whole, or to their community, leaves many educators potentially scrambling to mitigate exhibits lacking proper representation or ill-designed for young people with tack-on programming and gallery guides. The traditional group tour is also a relatively standardized experience, but market research in the tourism industry indicates that people's preferences are moving more towards what feel like personalized experiences (Dilenschneider, 2015). A growing third-party museum tour industry has steadily been filling in the gaps for education departments that can't keep up with demands for boutique experiences that offer a niche interpretive lens (Glusac, 2018).

So far we have described an ecosystem in which education

work has ostensibly been placed at the center of the museum, but the work of education specialists is devalued as feminine, low-skill, and unworthy of compensation. In looking to save money, museums divvy up the work of educators to other departments of the museum, provide them with minimal resources, and avoid employing full-time employees when possible. Yet people still flock to education because it markets itself as welcoming of diverse backgrounds, at the heart of an institution's mission, and therefore a potential path to leadership. However, the financial and emotional impacts of building and maintaining a career as a museum educator are only realistically manageable by a select few, creating monolithic teams likely ill-equipped to create programming that is truly affirming and supportive of all learners.

In Figure 6, we see that a museum has chosen to sing high praises of a particular program by describing its effectiveness at changing the lives of others. The description of the program clearly does not match the experience of the students themselves, who exchange looks of exasperation as this white educator attempts to forge connections between their identity as immigrants and the artwork in a superficial way. In *Knowledge to Narrative*, Lisa Roberts poignantly notes that while museum educators have done wonderful work advocating for the needs of audiences, to such a degree that the interpretive nature of museums has fundamentally changed, they have only made the museum friendlier for those for whom it was already designed to be friendly (Roberts, 1997: 73). This is why who designs and facilitates programs matters. Tiya Miles, in her exploration of Southern ghost tourism found by and large that although ghost tours offered unique opportunities to discuss histories

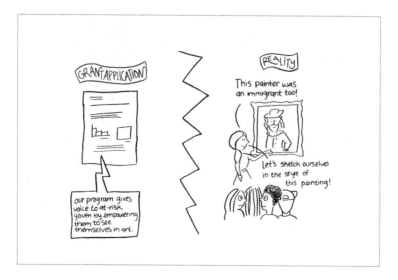

FIG. 6: The grant application vs. reality.

of American slavery largely absent elsewhere at Southern historical sites, they consistently perpetuate harmful stereotypes and inaccurate representations of the lived experiences of the enslaved (Miles, 2015). It wasn't until encountering Tommy, a queer Black man who gave tours at the Myrtle plantation, that she encountered a guide who creatively managed to subvert typical sensationalist and uncritical ghost narratives (Miles, 2015: 114). Hannah Heller, in a study of whiteness in art museum education, similarly found that educators of color often bear the responsibility of addressing race in conversations with students on tours (Heller, 2018). White educators, by contrast, perpetuate systems of oppression in small but powerful ways by centering white comfort through use of euphemistic language, describing violence passively, and avoiding the topic of race altogether in conversations with students (Heller, 2018). Since educators are disproportionately white, this bodes ill for museum learning.

How we prove the value of educational programming also matters. Initially, American museums relied on a belief that their "mere presence in a community would somehow enhance [its] well-being" (Weil, 2000: 10). Nowadays, museums are constantly asked to prove their good to their communities. Grantors and government funding agencies ask nonprofits to prove their good by measuring where they see positive change and difference in the recipients of their services (Weil, 2000: 9). On the national level, AAM spends hefty resources commissioning research and drafting reports like such as *Museums as Economic Engines* (2017), *Museums and Public Opinion* (2017), and *Museum Financial Information Survey* (2009) that outline the ways museums contribute to the economy and have widespread

reach and appeal, as demonstrated by high attendance and the number of non-traditional visitors who participate in programs (AAM, 2018). At the same time that museums have been attempting to transform themselves into educational institutions, museum business strategies have placed an emphasis on money-making ventures like attracting large audiences, special ticketed programming, retail, cafés, and event rentals (Munley and Roberts, 2006).This transactional, numbers-driven framing of impact perpetuates language that separates the museum from the "others" they serve, and pushes aside the content of the interactions themselves. Community outreach programs become a box to tick rather than a two-way relationship foundational to the purpose of an institution, and can result in disingenuous engagement.

It can be frustrating to imagine a way out or forward when everything is so intertwined.

There have been several calls to combat racism and decenter whiteness in museum education as a path towards museum relevance and meaningful visitor-centered engagement. But without institutional prioritization of equity and inclusion, and without an increase in the monetary and perceived value of museum learning and those who facilitate it, museums are likely to uphold systems of exclusion in ways that stymie any progress educators may try to make on their own. Rather than emptily referring to education as "the heart of the museum", we need a more expansive vision of the central function of museums that works for the visitor, museum staff, and the health of the field. Although the educational model of museums has been transformative, it has allowed for the continued upholding of a system in which museums hold knowledge and distribute

it to others. We see this in the way that the keepers of that knowledge (curators) are at the top of a hierarchy, and those who distribute, popularize, and complicate it (educators) are at the bottom. It's important to remember that attitudes towards feminized labor are not simply a matter of prejudice for malice's sake; their systematic effect is to prevent access to power, which in a capitalist society is often accessed with wealth.

Because the problem is so multi-headed and, at a foundational level, beyond the simple matter of pay differentials, ways forward must be similarly transformational. One such way to redistribute power could be through concept of museums as places where knowledge and narratives are collectively constructed. In the context of anti-oppressive pedagogy and facilitation techniques, Marit Dewhurst and Keonna Hendrick point to educators' "ability to hold multiple truths in the same moment [as] incredibly powerful in disrupting the idea [of] a singular, white-dominated and constructed narrative" in museum spaces (Dewhurst and Hendrik, 2016). As Lisa Roberts explores in her part-ethnography, part-history of museum education, *Knowledge to Narrative*, museum educators have a long history of bringing voices and views into the museum that challenge hierarchies of meaning and authority (Roberts, 1997: 151). She argues that museums, impacted by educators, have the potential to become forums for the negotiation and renegotiation of meaning and ideas (Roberts, 1997: 147). Rather than everyone competing to control what an education-centered museum mission really entails or getting left out when they are not considered mission-work, a narrative model of museums makes room for museums to be several things at once. As experts in helping others critically construct

narratives, educators still have a space in this model along with other marginalized areas of museum work. When museums can be many things at once, facility-based revenue streams can be recognized as supporting community gathering, and thus mission-based work in their own right as opposed to wholly separate financial support for educational activities. Generating knowledge about your audience's wants and needs becomes a collaboration between visitors, educators, front-desk staff, and marketing. Exhibits are co-created with developers, curators, educators, and community members. In collaboratively constructing what it means to be a museum, all staff have the potential to be valued for the knowledge they bring to the table.

REFERENCES

American Alliance of Museums, 2018. *Museum Facts & Data.* Retrieved from https://www.aam-us.org/programs/about-museums/museum-facts-data/

American Alliance of Museums and New Knowledge Organization Ltd., 2017. *2017 National Museum Salary Survey.* Washington, DC: American Alliance of Museums.

Boehm, M., 2012. Getty to cut 34 at museum unit. *Los Angeles Times,* 1 May. Retrieved from http://www.latimes.com

Boyle, E., 2004. *The Feminization of Teaching in America* [from MIT Program in Women's and Gender Studies – Kampf Prize]. Retrieved from https://stuff.mit.edu/afs/athena.mit.edu/org/w/wgs/prize/ebo4html

Bruneau, J., 2018. *Dirty words: labour.* Retrieved from https://www.jacbruneau.net/dirty-words-labour/

Burns, C., 2012. The gay and transgender wage gap. *Center for American Progress,* April 16. Retrieved from https://www.americanprogress.org/issues/lgbt/news

Cohen, R., 2015. Boomers 'gone wild' as museum docents: nightmare or real life? *Non Profit Quarterly,* July 21. Retrieved from https://nonprofitquarterly.org/category/nonprofit-news/

Cole, E. and Zucker, A., 2007. Black and white women's perspectives on femininity. *Cultural Diversity and Ethnic Minority Psychology,* 13(1), 1-9. doi: 10.1037/1099-9809.13.1.1

Davis, A. *et al.,* 2018. Inherited Bias: Thinking Critically about Female Labor and the Value of Museum Education. *Viewfinder,* 8. Retrieved from https://medium.com/viewfinder-reflecting-on-museum-education

Dewhurst, M. and Hendrick, K., 2016. Dismantling racism in museum education. *Journal of Folklore and Education*, 3, 25-30.

Dilenschneider, C., 2015. Group tour interest in decline: why museums should invest elsewhere (data). *Know your bone*, May 8. Retrieved from https://colleendilen.com

Dobbs, S. and Eisner, E., 1987. The uncertain profession: educators in American art museums. *Journal of Aesthetic Education*, 21(4). 77-86. doi: 10.2307/3332832

Eid, H., 2018. Connecting the dots: the impact of diversity in the museum workforce on innovation, relevance, and audience engagement. *Museums and the Web*. Retrieved from https://mw18.mwconf.org/paper/connecting-the-dots-the-impact-of-diversity-in-the-museum-workforce-on-innovation-relevance-and-audience-engagement/

Glusac, E., 2018. Museum tours for people who don't like museum tours. *New York Times*, July 20. Retrieved from www.nytimes.com

Halperin, J., 2017. How much money museum employees really make. *artnet News*, June 29. Retrieved from https://news.artnet.com/art-world

Heller, H., 2018. Whiteness and museum education. *Incluseum*, December 14. Retrieved from https://incluseum.com/2017/12/14/whiteness-and-museum-eduction/

Herz, R., 2014. What does a museum educator do? (and do we need them?). *Museum Questions*, July 23. Retrieved from https://museumquestions.com/2014/07/23/what-does-a-museum-educator-do-and-do-we-need-them/

Ingraham, C., 2014. . There are more museums in the U.S. than there are Starbucks and McDonalds – combined.

The Washington Post, June 13. Retrieved from https://www.washingtonpost.com

Jennings, G. and Jones-Rizzi, J., 2017. Museums, White Privilege, and Diversity: A Systemic Perspective. *Dimensions*, June 13. Retrieved from https://nemanet.org/files/9615/0228/7672/Dimensions-Diversity-Special-Edition-JenningsJonesRizzi.pdf

Kai-Kee, E., 2012. Professional organizations and the professionalizing of practice. *Journal of Museum Education*, 37(2), 13-23. doi: 10.1080/10598650.2012.11510727

Kley, R., 2009. Recessionary layoffs in museum education. *Journal of Museum Education*, 34(2), 123-128. doi: 10.1080/10598650.2009.11510625

McGlone, P., 2014. Hirshhorn ends docent program, telling volunteers that they are no longer needed. *The Washington Post*, October 30. Retrieved from https://www.washingtonpost.com

McGlone, P., 2018. Guards at National Gallery of Art complain of hostile environment. *The Washington Post*, March 13. Retrieved from https://www.washingtonpost.com

Merritt, E., 2016. Volunteers and museum labor [from *Center for the Future of Museums Blog*, October 18]. Retrieved from https://www.aam-us.org/2016/10/18/volunteers-and-museum-labor/

Migdal, R., 2018. Freelancing and the future of museum work. *Theory and Practice*, 1. Retrieved from https://www.themuseumscholar.org/theory-practice

Miles, T., 2015. *Tales from the haunted south: dark tourism and memories of slavery from the civil war era*. Chapel Hill, NC: The University of North Carolina Press.

Munley, M.E., and Roberts, R., 2006. Are museum educators still necessary? *Journal of Museum Education*, 31(1), 29-39. doi: 10.1080/10598650.2006.11510527

Nolan, T., 2009. The museum educator crisis. *Journal of Museum Education*, 34(2), 117-121. doi: 10.1080/10598650.2009.11510624

Pela, R., 2019. Nightmare at the Phoenix Art Museum: docents are fleeing, donors drying up. *Phoenix New Times*, March 6. Retrieved from https://www.phoenixnewtimes.com

Pogrebin, R., 2016. Metropolitan Museum of Art lays off 34 employees. *The New York Times*, September 28. Retrieved from https://www.nytimes.com

Pogrebin, R., 2018. With new urgency, museums cultivate curators of color. *The New York Times*, August 8. Retrieved from https://www.nytimes.com

Prottas, N, 2017. Does museum education have a canon? *Journal of Museum Education*, 42(3), 195–201. doi: 10.1080/10598650.2017.1343018

Rasmussen, B., and Winterrowd, S., 2012. Professionalizing practice. *Journal of Museum Education*, 37(2), 7-11. doi: 10.1080/10598650.2012.11510726

Rich, M., 2014. Why don't more men go into teaching? *The New York Times*, April 11. Retrieved from http://www.nytimes.com

Roberts, L., 1997. *From knowledge to narrative: educators and the changing museum*. Washington and London: Smithsonian Institution Press.

Robinson, M., 2016. *Labours of love: women's labour as the culture sector's invisible dark matter*. Retrieved from http://

runway.org/au/labours-of-love-womens-labour-as-the-culture-sectors-invisible-dark-matter/

Rodney, S., 2015. The precarious lives of freelance museum educators. *Hyperallergic*, November 27. Retrieved from https://hyperallergic.com

Schonfeld, R., and Westermann, M., 2015). *Art museum demographic survey*. New York City: The Andrew W. Mellon Foundation. Retrieved from https://mel-long.org/programs/arts-and-cultural-heritage/art-history-conseration-museums/demographic-survey/

Schonfeld, R., and Sweeney, L., 2016. *Diversity in the New York City Department of Cultural Affairs Community*. Ithaka S+R. https://doi.org/10.18665/sr.276381

Schwarzer, M., 2006. *Riches, rivals, and radicals: 100 years of museums in America*. Washington, DC: American Association of Museums.

trivedi, n., and Wittman, A., 2018. Facing sexual harassment and abuse in the feminizing museum. *Journal of Museum Education*, 43(3), 209-218. doi: 10.1080/10598650.2018.1488126

Westermann, M., et al., 2019. *Art museum staff demographic survey 2018*. Ithaka S+R. doi: 10.18665/sr.310935

Weil, S., 2000. Transformed from a cemetery of bric-a-brac. In *Perspectives on outcome-based evaluation for libraries and Museums*. Washington, DC: Institute for Libraries and Museum Sciences, 4-15.

CHAPTER TEN

GENDER, EQUITY AND MUSEUM TECHNOLOGIES

Kelly Cannon, Liam Sweeney and Seema Rao

MUSEUM TECHNOLOGY offers a useful lens through which to explore the complex issue of salaries, due both to the complexity of roles and comparisons with outside sectors. Museum technologists are in the unique position of holding significantly overlapping skill sets with the for-profit technology sector, one of the highest paid industries worldwide with fast-growing salaries (Barrett, 2017). In this chapter, we document and outline some salary concerns from our peers in the museum technology field at a time of increasing financial incentives to encourage moves into the private sector.[1] In a recent online post, co-author Seema Rao described the opportunities and challenges of this moment:

> Museum professionals were never highly paid, so is the current situation any different than at other times? [...] Technology has transformed museum work, so many museum professionals now find themselves in possession of transferable skills. With more job options, museum professionals can be more critical about workload and salary. (Rao, 2018)

Our research stems from Rao's and co-author Kelly Cannon's pairing in the 2018 Museum Computer Network (MCN) Mentorship program, which provided an opportunity to connect with another woman technologist and discuss candidly many of the issues described here, and particularly their enhanced impact on women.[2] As described in the methods section below, our approach included expanding these discussions with our peers, who generously shared with us their personal experiences, fears, and details about life transitions. We

thank them and the editors of this book for their willingness to engage in difficult conversations in the spirit of problem-solving, equity, and hope for the present and future of museums. With interviews undertaken among a small circle of peers, this essay is not comprehensive, but does offer first-hand insights into the major issues facing this labor force, as well as avenues for further research and advocacy.

Methods

Our approach to gathering evidence involved three phases: desk research, unstructured interviews and a follow-up survey. We interviewed sixteen people, drawing on MCN annual conference attendance and personal networks.[3] In selecting the interview population we sought a variety of experiences, including those who currently work in the art museum field, as well as those who have previously worked within art museums and now are in a different sector. We defined museum technology roles as those in which the primary tasks involve planning, producing, maintaining, and/or supporting multimedia and digital interfaces, content, and/or infrastructure in support of museum exhibitions, collections, or programs. This could include but is not limited to roles in social media, digital learning, information technology, digital publishing, digital product management, designers, developers, and others. This gave us a cross-section of work experiences and museum professionals to draw from.

Interviewees were subsequently surveyed to provide details on their work history, including former job titles, compensation, and duration of time in position. We also collected demographic variables such as gender, race/ethnicity, class and

education. We received a 31% response rate from participants.

Challenges facing museum technologists

We were not surprised to find in the interviews that each individual with whom we spoke had negotiated a complex, personal balance between commitment to a mission, desire to be part of a community of shared values, and salary considerations. They often framed these as trade-offs, and when they spoke about salary, the conversations quickly led into discussions about their museums' missions, as though the two factors were necessarily interrelated.[4] However, the responses also critiqued how museums' organizational culture may undermine mission-related ambitions, in part due to their labor practices. While the latter half of this chapter will consider salary more closely, we begin by teasing apart nuances in how the interviewees relate to the cultural, organizational, and social aspects of working in museum technology.

Many of the benefits most prized by respondents are unquantifiable and intangible. Those with whom we spoke often noted that their job met their wish to be in a personally or culturally enriching environment. One respondent described how she chose the museum she currently works in: "[This museum] feels like they are participating in a dialogue and hosting a conversation that I want to be part of." Another described the community of workers that formed around the shared dialogue as, "the museum is where my tribe is." For many, the opportunity to contribute to the mission was a significant factor in accepting a lower salary, with some framing it as a temporary sacrifice: "I thought of it as, 'I'm going to do my service for a little bit.'" While most spoke about the importance

of work that resonated with their personal values, their awareness of the trade-off between salary and mission led them to be vigilant about how the mission is manifested in the workplace. As one respondent described, "Having institutional mission that resonates with you is important, [and] seeing how an institution translates that mission into action is equally important to salary."

When asked how museums could better attract and retain workers with digital skills, many respondents drew attention to organizational culture, underscoring a need for greater digital maturity in organizations to support internal and external demands. Several respondents cited a disconnect between the processes and values of digital work, such as being agile, innovative, and collaborative, and the traditional, hierarchical structure of museums. As one explained, "My managers didn't understand what I did… [it's important] to understand and decide what is needed and then dedicate the resources or decide that we cannot." Others felt similarly, explaining, "digital is hard if there are no ways to manage up in a museum," leading to a "level of distrust," inefficiencies, and repeated project failures. Nesta UK's *Digital Culture 2017* report supported this, demonstrating that, of institutions reporting minor positive impact from digital technology, 32% characterized senior management as knowledgeable about digital technologies, in comparison with 52% for institutions that reported major positive impact from digital technology (Ellis *et al.*, 2017).

Museums' slow and unsteady embrace of digital processes and projects contrasted with how museum technology workers describe their own work values. One respondent described a digitally-aligned workplace as having, "a culture that finds

ways to support elastic thinking, prototyping, [and] encouraging employees to learn/unlearn/relearn." Many of those interviewed described themselves as self-taught, continuous learners who felt that ongoing professional development was essential to helping their museum remain current and competitive in a rapidly changing technological environment. One explained:

> Digital skills are being able to Google things and get a decision. Saying that I have expertise in any platform will be meaningless in three months. [It's about] reassessing what I've been doing and not getting too attached to it.

Another respondent agreed, arguing that this was a requirement of the role: "I was hired not because of specific skills... everyone is expected to be a generalist and adapt really quickly and learn new things." Many explained that they had little formal training related to technology, but had learned most of their skills in their own time or on the job through trial and error and through peer networks.

However, while many of the interviewees sought opportunities for continued learning, they encountered a lack of formal recognition of their efforts through promotions and raises. One respondent who is a board member for an international museum technology organization pointed to the discrepancy between her leadership role in the field and her compensation: "It was disappointing to [realize] that as a leader in museum tech and with a big network, I was woefully underpaid." A respondent who left museums for a role in a for-profit

technology startup described opportunities for development
that were not available in her previous museum role:

> [The company] moves people around every three years or
> so. You can come in as an engineer and move to social
> media based on aptitude. It reduces burnout and gives
> you a chance to switch jobs but stay in the organization.

Another respondent pointed to the lack of a formalized review
system at her former museum as reducing room for growth
and personal investment: "Not only is your base pay so much
lower, but because there are no performance reviews, there's
no pathway to make more."

These stories suggest that museum technology workers,
like their colleagues in other museum departments, are often
drawn to the field through a passion for the mission and the
communities within and around the institutions. Their desire
for creative satisfaction and experimentation, however, can
run up against museums' traditional organizational culture.
The gap between that culture and contemporary expectations
of a workplace that values learning, adaptability, innovation,
and experimentation, at both the institutional and individual
employee level, threatens museums' ability to attract and retain
workers with digital skills, and diminishes their potential for
growth in an increasingly digital experience economy.

Considering salary

Museum technologists face trade-offs as they chart their
careers, whether they are choosing between remaining in the
sector or determining their role within an institution. The

satisfaction of contributing to the operations of cultural spaces is weighed in relation to one's financial security. Museum leaders increasingly recognize the importance of improving their technological capacities as the digital continues to transform the information sector. The ways in which these changes are implemented cut across departments and manifest in a variety of roles. The challenges of determining compensation are made even more complex when digital skills transferable to the for-profit sector are adopted in positions that historically have not been associated with information technology. To better understand these complexities, we consider how participants in this study responded to trade-offs between the museum sector and the broader technology industry, as well as to their evolving roles within the museum.

Comparing sectors
Overall, our interviews confirmed that low museum salaries exert significant pressure on museum workers and their families, despite their passion for museum technology work, and have pushed some to leave the field. Several respondents who left museum technology roles mentioned that the salary was not tenable as it barely met the cost of living, while another described the stress of working in multiple part-time jobs in the field to make ends meet. Another respondent discussed how low salaries are particularly challenging when raising a family:

> At the museum, my wife got cancer, and we couldn't afford the medical bill. So I found a new job. Then we had an extra kid, when we had budgeted for two. So, I had to find another job with a higher earning potential.

For many, leaving the museum field offered the opportunity to attain financial security. One respondent who recently made the transition to a for-profit technology company described her relief at earning a higher salary: "I'm thinking about buying a house in [my city]. I never would have been able to do that on a museum salary, but now I can consider it and that's a really nice thing." The opportunity to gain financial stability has become even more urgent for those who are starting, or in the middle of, their careers. The pressure of home ownership, a traditional sign of entering the middle class, is particularly marked; as generational progress has diminished, millennials now have lower living standards than their parents due to a lack of growth in salaries paired with higher housing prices (O'Connor, 2018).

Salaries in the museum field

Salary disparity within museum technology positions can also be a source of dissatisfaction among staff.[5] More than one respondent suggested that technology roles in departments other than information technology have lower salaries. For instance, we heard from a respondent who began her career in the education department well below a rate of $15 per hour, and remained at that low pay grade for several years. Meanwhile, some interviewees who had experience working in the information technology side of the museum were earning close to or above $100,000 per year.

These findings are not a surprise. In fact, they confirm findings from other studies which indicate pay disparities within museums. The 2017 Association of Art Museum Directors (AAMD) salary survey reveals that museum educators earn substantially less than museum technologists. This finding is

complicated by the reality that many museum education roles increasingly require technology skills. Audience engagement has evolved considerably in the last twenty years, such that digital engagement is central to attracting and keeping new audiences: in-gallery, mobile, and online digital interpretation have become the norm. Education staff have evolved their skills to meet these new needs, though their salaries often do not reflect this change. The increasing blurring of technology and non-technology roles might necessitate a reconfiguration of compensation for digital roles outside IT departments, such as in marketing or education, to acknowledge the shifts in required competencies and the salaries that those competencies command in other sectors.

The following table (Figure 1) shows a comparison of salaries as well as compound annual growth for each position in education and technology departments tracked in the AAMD Salary Survey.[6] While these education and technology positions are not necessarily comparable with one another, the salary survey does hierarchically track four positions in each of these departments.[7]

As the table shows, there are significant disparities in salary between the comparable tiers of the information technology department and the education department.[8] Considering the growth rate of these positions also helps us understand the trajectories of these salaries. For instance, comparing the second most senior position in these departments shows a significant disparity in the average salary growth. Associate Educators have seen only a 1% increase in median salary since 2011, while the Systems Manager role has seen an average increase in median income of 3.1%. This suggests not only that salaries are low in

EDUCATION	MEDIAN SALARY	CAGR	TECHNOLOGY	SALARY	CAGR
Director of Education	$77,000	2.3%	Director of Information Systems	$106,000	2.6%
Associate Educator	$52,000	1.2%	Systems Manager	$79,000	3.1%
Assistant Educator	$43,000	2.5%	Web Manager	$60,000	2.6%
Education Assistant	$36,000	2.5%	New Media Manager	$50,000	2.1%

FIG. 1: AAMD Salary Survey – Education and Technology roles.

these roles, but also that they are stagnant.

Research from the Andrew W. Mellon Foundation, Ithaka S+R and AAMD has also found that these departments are highly gendered. In 2015, Information Technology staff identified roughly 30% as female and 70% as male, while education staff identified as roughly 79% female and 21% male. In this sense, we see a correlation of income along gender lines.

The departmental and gender issues described in the research aligned with our respondents' remarks. Our interviews confirmed that staff were aware of these disparities. One respondent described learning that she was paid less than men in the same role and the lack of proactive response from her institution. Salary growth challenges were discussed by a number of women who entered a job at a low pay rate, based on a previous salary, hampering their future earning potential. The issue of salary disparity by gender is exacerbated by a lack of salary negotiation training. One respondent explained that a male manager helped her advocate for a higher salary and several others agreed with one respondent who said, "I don't think women are taught to advocate for their salaries. I had to learn to do that [on my own]."

Conclusion

Our study suggests that salary concerns are interwoven with questions facing the larger field of museum technology. While mission is a powerful motivator for working in museums, low salaries and organizational culture may lead workers to look outside the field. Other sectors have embraced innovation and experimentation, while many museums have remained bureaucratic organizations. Inequity in institutions, such as between

different departments within a single organization, have a detrimental effect on worker engagement. As technology becomes integral to most functions, the movement of museum technology staff outside the field has particular impact on operations and future growth.

It is incumbent on museums to attract and retain this talent to remain relevant in the twenty-first century. As baby-boomers begin to retire, will there be workers available to fill those roles, or will millennials have responded to financial pressure and left for positions with more secure salaries? The future of our field depends on solving these questions. Without continuing to invest in our employees, museums will not have the stability to meet today's visitor needs, let alone evolve to meet the needs of the future.

NOTES

1. This was also an undercurrent of the panel *Should I Stay or Should I Go?* at the 2018 Museum Computer Network (MCN) conference, pointing to the increased visibility and urgency of these conversations.

2. The issues of people of color in museum technology is an important area for further research. This sample included 13% people of color. The issues of race did not explicitly figure in the conversations, but the protocol also did not probe for these topics.

3. Museum Computer Network draws museum professionals from a variety of tech-related departments as well as vendors. The 2018 annual meeting attracted 588 people. Some of our interviewees were chosen because their role had changed between the 2011 meeting (our earliest records of meeting attendees) and the 2018 meeting. As an aside, comparison of the 2011 and 2018 attendance overall offers some interesting reflections on the field. The conference attendance grew 60% between the two benchmarks. Ten percent of the attendees in 2018 had attended the 2011 conference. Of those attendees, 63% were employed at museums during both conferences, and 81% of those employed at museums were at the same museum. Overall, the comparison of the MCN conferences indicates a surprising amount of stability in the museum technology field.

4. For an excellent critique on the "inverse relationship between the social value of work and the amount of money one is likely to be paid for it," see David Graeber's *Bullshit Jobs: A Theory*. (New York: Simon & Schuster, 2018).

5. Non-IT technology positions are defined by the scope of responsibilities rather than department, as mentioned in the methods section.

6. Compounded Annual Growth Rate (CAGR) is a measure of growth. It is the mean (geometric) annual growth rate of salaries considering multiple periods. It is calculated by considering the beginning and ending values of a data set. Unlike YOY (Year on Year) growth, CAGR considers the compounding values (i.e. considers salary increments and cuts overtime).

7. It is important to note that while museums have very different staffing structures across the field, they conform these roles to the survey instrument for the purposes of participating in the AAMD salary survey.

8. Technology departments are considerably younger than museum education departments, which were often created at the founding of the museum. The relationship between department age and salaries would be an interesting area for further research. Additionally, roles in education and technology departments differ widely in terms of responsibility. A comparison of salary and responsibility between departments could be a useful research area.

REFERENCES

Barrett, H., 2017. When technology specialists earn "scary salaries". *Financial Times*, 13 December. Retrieved April 11 2019 from https://www.ft.com/content/c844079c-c3e3-11e7-b30e-a7c1c7c13aab

Ellis, R. *et al.*, 2017. *Digital Culture*, 26 September. Retrieved April 11, 2019, from Nesta UK website: https://www.arts-council.org.uk/sites/default/files/download-file/Digital Culture 2017_0.pdf

O'Connor, S., 2018. Millennials poorer than previous generations, data show. *Financial Times*, 23 February. Retrieved April 11, 2019, from https://www.ft.com/content/81343d9e-187b-11e8-9e9c-25c814761640

Rao, S., 2018. Giving Tuesday & Low Salaries in Museums. *Medium*, 26 November. Retrieved April 11, 2019, from https://medium.com/@artlust/giving-tuesday-low-salaries-in-museums-b4080566c81b

3

ADDRESSING
THE ISSUE

HOW TO FIX MUSEUM SECTOR RECRUITMENT IN 15 EASY STEPS

Tom Hopkins

THE FOLLOWING IS A THREAD posted on Twitter by @TMPHopkins1 on 29 June 2019.[1]

Thread: How to fix museum sector recruitment in 15 easy steps.

1/15 Entry level jobs should mean entry level, don't ask for prior experience. Let people learn on the job, and provide ongoing training and development opportunities.

2/15 If you want someone with prior experience, then *pay them accordingly*. I mean at least a number of thousands of £ over the Living Wage. (That's the Living Wage that you are, at least, paying to all you entry-level staff).

3/15 Museum Studies PGs are great! The skills and thinking they impart are really useful for the sector, but academia isn't the only place these can be developed. Give candidates the freedom to express how they might have gained them from other places.

4/15 While we're at it, why not consider looking at if you really need those undergrad degrees you all seem to insist on. Hell, going to uni is GREAT! But the skills uni imparts *can* be gained outside of it and meaningfully evidenced. Please open your eyes to this fact.

5/15 (Clue to points 3 and 4 above: Just making PG requirements "Desirable" rather than "Essential" will *not* fix this).

6/15 Not everyone knows how to actually *apply* for jobs. Recruiters should offer clear and concise instructions to

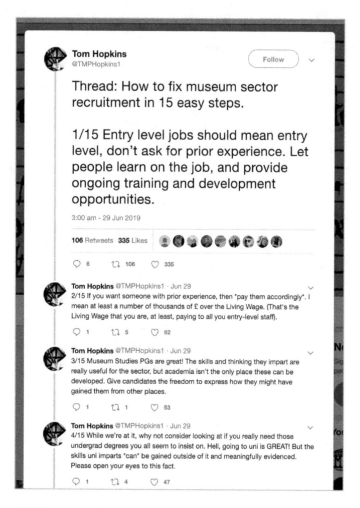

FIG. 1: The opening of the author's thread on Twitter

candidates. If you don't have time to develop these in house, just link to Mark Carnall's blog here: Museum Careers Advice – How to apply for jobs.[2]

7/15 Graduate traineeships are not ok. Traineeships should be open to all. Until you fix point number 4) above, graduates already have a head start. Which is in no way to say that graduates should be disbarred from traineeships. This is about opening doors, not shutting them.

8/15 So how to differentiate between candidates for entry level positions/traineeships if we're not going to use prior experience or qualifications as discriminating factors? We could try making personal specs that focus on values and qualities and transferable "soft" skills.

9/15 Ban unpaid internships. Volunteering is great – but it's not fair to ask people to commit huge amounts of their time. Volunteering should be as flexible as practicable, not replace paid jobs, and expenses paid.

10/15 Yes, some museums are fighting for their very survival. Others are not. We must not use "there's no money in the sector" as an excuse to keep wages depressed. If a decent wage cannot be paid for a role, Trustees should not sign-off on it. People > museums.

11/15 We all have different financial needs and outgoings. Congratulations if you survived living in central London on £12k a year. Not everyone can. Please stop contributing to the

normalisation of low wages in our sector and SHUT THE HELL UP.

12/15 Funding bodies need to consider implications of capital project employment. Short-term contracts not sustainable. Keep project staff in post before, during and after project runs. Short term contracts = high attrition = re-recruitment = £££ = poor team dynamics.

13/15 Funding bodies should also take more responsibility that their projects are hiring in an inclusive, fair, sustainable and appropriately salaried fashion.

14/15 Advertise your salaries. Expect people to be angry with you if you don't, because non-disclosure is a really awful thing to do.

15/15 Recruitment. Give good feedback. Let unsuccessful candidates grow. Don't waste applicants' time with your terrible app software. Have clear and concise JD's and specs. Have contact details and answer questions. Pay reasonable interview expenses.

NOTES

1. The original posts can be found at: https://twitter.com/TMPHopkins1/
 status/1144908496137314304

2. https://advisor.museumsandheritage.com/blogs/museum-careers-advice-apply-
 jobs/

DECENT WORKING CONDITIONS ARE ESSENTIAL FOR DECENT COMPENSATION

Paul C Thistle

ENDEMIC LOW PAY in the museum sector is one significant circumstance unquestionably worth the critical study presented in this book. However, the culture of overwork that exists in museum workplaces gravely exacerbates the enormity, unethical nature, and destructive outcomes of under-compensation. I firmly believe it is absolutely essential to take a step back from the important question of unfair – and in many cases unsustainable – museum pay rates (Milldrum, 2017; Tyson, 2013: 92, passim). My aim in this chapter, therefore, is to provide necessary perspective on the structure, management, and experience of work in the museum field that undeniably make low wages more reprehensible – and, in hourly-rated terms at least, illegal in many jurisdictions. Dictionary.com defines the noun overwork as "excessive work." The verb means to "exhaust with too much work" or "make excessive use of." Synonyms listed include: "exploit, drive (too hard), overtax, and overburden."

In my view, intense pressures to overwork in the museum industry are generated by rising expectations in a context of limited or declining resources. Love for what we do and commitment to excellence drive museum workers to fill the growing gap between rising expectations and the available resources. In the wider world of work, such circumstances result in personnel being confronted with related "work intensification" (Bunting 2004: 28), resulting "task saturation" (Murphy, 2018), and "excessive workloads/insufficient staff resources" (McIsaac, 2013: 21, 22) leading to eventual push-out from the job (ibid: 3, 22-23, 47). We will see that such workplace problems are identical in the museum sector.

The origins of concern

My earliest forebodings about this issue arose during the mid- to

late-1980s as I worked in my first long-term museum job as the sole staff member of a small museum looking forward to what eventually became a $1.7 million capital project. Having failed to persuade my municipal employer to hire more staff to help prepare for this major expansion into a physical plant approximately six times larger, I applied for and was granted provincial (i.e. state-level government in Canada) funding to hire one additional staff position. In return, I carried out training and advisory services for museums located in the northern half of the province of Manitoba. To begin my new responsibilities, I called on museums in the region to pinpoint needs for support.

Returning from six of these visits, I was struck by one worrying characteristic recognized among the paid staff and volunteers working at every one of these rather diverse heritage operations. That similarity can be summed up in one word: burnout. Burnout is defined as emotional exhaustion, depression, and a variety of other negative symptoms such as loss of job performance due to job stresses that result from work overload. Typically, burnout strikes workers who are committed to their work and, significantly, "physical and psychological problems" occur (Schultz and Schultz, 2006: 370-2).

If you could see directly into the eyes of the volunteers pictured at Figure 1, understand their hearts, and hear the despair about the failure to recruit new volunteers and the resulting uncertain future of the museum, you would be as acutely aware of their weariness and discouragement as I was. According to the last Canadian study that provides relevant data, in concert with the decline in both the number of volunteers and the total number of volunteer hours during the three-year period studied, the average number of hours contributed per volunteer

actually rose by nearly 9% (Statistics Canada, 2001: 31).

On returning, I wrote an editorial in the newsletter of The Sam Waller Museum. It focused on the burnout discovered among the museum workers I had met (Thistle, 1990: 1). So, at the time of writing this chapter, I have been thinking, researching, speaking, and writing about the poor Quality of Working Lives (QWL) problem in museums for nearly three decades. Sadly, to date, there has been little or no progress made on addressing these issues. Arguably, the museum QWL situation has worsened in the last 30 years, for example, with the incursion of "work enhancing technologies" (cf. Towers *et al.*, 2005: 14-18) in our field.

The museum folks in the picture were soon to be challenged by the introduction of a program of Standards for Manitoba Museums (Association of Manitoba Museums, 1995). In the following, I make no argument against the ultimate value of professional museum standards to advance museum practice. However, I do insist that the negative impact of standards regimes on museums and their workers – given the lack of necessary resources to implement them effectively – requires critical museology. At the time, my analysis of the new standards regime proposed during its development (1993-1994) was that it imposed many unrealistic – if not impossible – standards for this and other small and mid-sized museums (Thistle, 1994: 11, passim).

Research related to this question that focused on museums in Quebec identified widespread problems of insufficient financing, a "general state of fatigue," and "burnout" among museum workers. Research project leader Professor Philippe Dubé, from Université Laval, concluded that this state of affairs

FIG. 1: Hospitable volunteers Gertie, Mary and Dorothy wait for their peer Bruce to finish one more task before starting lunch put on for the author at the Ole Johnson Museum, Big Woody, Manitoba, Canada in June 1990. Photograph: Paul C Thistle.

is due in large measure to an ideal operational framework defined from outside the institution that is based on "an official definition that small and medium-sized museums simply cannot meet." This conception of a professional standard museum creates "a trap that makes museum work increasingly complex, and even *absurd*" (Dubé, 2001: 8-9) [emphasis added]. Similar conclusions about the damage to museum operations imposed by unresourced expectations introduced by standards regimes have been reached by other museum analysts (Janes, 2009: 19; Tivy, 2006: 32, 43; Kurylo, 1984: 10).

Indeed, museum standards regimes have resulted in some museums becoming unsustainable and forced to shut their doors. I am sad to report, when seeking to learn the fate of the volunteer-run Ole Johnson Museum many years later, I found it had closed and been lost to the memories of my contacts in Manitoba. I recently discovered that its collection was passed on to the Swan Valley Historical Museum – another volunteer operation in the area that currently is desperate for new volunteers. It should be noted here that the Canadian Museums Association (CMA) (1986: 3) identified the main concerns for small museums with respect to the impact of professional standards at the time as being:

- the failure to take into account the lack of resources available to small museums;
- the tendency for standards to be based on "ivory tower" ideals which do not address the real needs of small museums;
- and the potential for setting up invidious comparisons with richer museums.

Citing Stephen Weil (1988: 8, 24 passim), Professor Dubé (2001) recommended that museum practitioners should develop an alternate model of what professional standards small and medium-sized museums can, could, and should be expected to achieve.

To close this section, my overall summary of the human resource crisis in the museum field generated by overwork is captured by the aphorism "the straw that broke the camel's back." My experience, observation, and research leads me to describe museum workers as already fully-loaded camels working in a constant rain of straws – read unresourced expectations. As they often do, when resources fail to keep pace with continually rising expectations from all stakeholders – government and other funders, professional museum organizations, and visitors – museum workers choose to step up to close this ever-widening gap. In practice, we meet these unresourced expectations by self-sacrificially overworking longer and harder than we are paid to do. As a result, museum workers find themselves impacted by chronic circumstances identified by research in the wider world of work as: "task saturation" (Murphy, 2018), "time poverty" (Schor, 1991: xx, 5), and workplace stress (Posen, 2013: 2, passim). Thus, when museum practitioners habitually overwork, they are in danger of breaking their backs – if not physically, then, as outlined below, in mental, family, and social health terms.

Why museum practitioners tend to overwork
To start, we love what we do. Here, we must look to the sociology of work that identifies museum workers among a class referred to as "occupational devotees." In short, such individuals have

CONFRONTING THE STATE OF MUSEUM SALARIES

"profound love for the job," and "a set of deeply felt values" sig-
nificantly regarded as "socially important, highly challenging,
intensely absorbing, and immensely appealing" creating "deep
involvement and attachment" and "rewarded by self-actualiza-
tion or self-development" (Stebbins, 2004: ix, 10, 17, 76). Not
only are we devoted to our vocation, museum workers are com-
mitted to excellence – and expected to be so by professional
ideals (e.g. American Alliance of Museums, 2017; cf. Tyson,
2013: 64, 88). What is the upshot here? When expectations
increase above available resources – person-power, time, money
– museum practitioners voluntarily work longer, harder, and
faster than we are paid to do (Tyson, 2013: 16; cf. Posen, 2013: 13).
We sacrificially overwork regardless of the damage done to our
own QWL.

Occupational devotion is not the sole – and perhaps not even
the most significant – reason behind overwork. Clear evidence
of what I call the "unfunded expectation inflation" rampant in
the museum field is the fact that paid staff and volunteers often
are given no choice but to overwork.

At one point in my career, due to a supervisor's approval of
vacation time for colleagues and refusal to permit an upcom-
ing exhibition opening later than advertised, I found myself
in an unplanned situation with no option but to dismantle my
vacationing colleague's temporary exhibition as well as to pre-
pare and mount my own replacement displays on schedule. To
accomplish this, I worked 32 days in a row for between eight
and sixteen hours a day. Physician David Posen, who has been
treating stressed-out workers for more than a quarter century,
identifies the three biggest problems that cause workplace
stress like mine: the work's volume and velocity compounded

PAUL C THISTLE | **229**

by "abuse" of workers by management (Posen, 2013: 38, 247, passim). Posen observes, "an increasing amount of stress in recent years has been company-driven and organizations are doing precious little to own up to the damage they're causing on a daily basis" (2013: 32).

A remarkable corresponding declaration by a well-respected museum professional underlining the author's experience above was voiced during discussion of a conference presentation I made (Thistle, 2010). Another panelist, the late Barry Lord – then President of Lord Cultural Resources – firmly asserted that, as "information workers," we in the museum field should expect "fifteen-hour work days".

I disagree in the strongest possible terms with Lord and others who maintain that eight hours of work a day are never enough (cf. 80-hour weeks in Matousek, 2018; [but this is "stupid" Posen, 2013: 116]). Museum professionals of this opinion should attend to a comprehensive review of labour standards in Canada that recommended the eight-hour work day be maintained and that no worker should "be subject to coercion, or... be required to work so many hours that he or she is effectively denied a personal or civic life" (Arthurs, 2006: x, 47). In parallel, I suggest that those of us in the heritage business must not forget the history of struggle to bring about the eight hour working day (Golden, 2006). This is to say nothing about internationally recognized human rights to health and safety at work under the Universal Declaration of Human Rights and the International Covenant on Economic, Social and Cultural Rights (Spieler, 2003: 86-87, 101, 104). While laboring fifteen hours a day, we must ask, what is the QWL under such circumstances?

The overwork all too often expected of museum occupational devotees can be understood as nothing less than default – or deliberate – abuse of our love for the work. This exploitation is short-sighted in the extreme, since overwork not only harms the mental, physical, family, and social health of workers, it also demonstrably undermines productivity (Kuroda and Yamamoto, 2018; Posen, 2013: 5, 45, 58-9, 136, passim; Higgins *et al.* 2008: 6-11, 160, 199-200; Duxbury and Higgins, 2012a: 6, 9, 13-14 passim).

Research data on overwork outside and inside museums
Large longitudinal studies on samples of 25,000 Canadian workers carried out in 1991, 2001, and 2011 have identified significant increases in stress levels at work and sharp declines in life satisfaction (Duxbury and Higgins, 2012b: 12; Duxbury and Higgins, 2012a: 6, 9, 13-14 passim). Half of the participants in these studies match the professional, well-educated characteristics of museum workers.

In the museum sector specifically, the rather rare research on working conditions from 1983 through 2019 has identified the following related problems:

- "role overload" (Newlands, 1983: 20);
- "dysfunctional burnout" (Lord and Lord, 1986: 116);
- "little or no attention... paid to the need to support museum workers, to attempt to reduce the mounting stresses in their lives, nor to treat the rampant burnout" (Thistle, 1990: 1);
- increased "occupational stress," "job dissatisfaction, mental ill-health ... hypertension, heart disease... absenteeism, and high turnover" (Kahn and Garden, 1994: 193-4, 202);

- "general state of fatigue" and "burnout" (Dubé, 2001: 8-9);
- museum executive directors "hopelessly overburdened" (Janes, 2009, 64);
- "over half of respondents agreed... life has been too rushed" and – at the same time as showing markedly higher or equal happiness scores in all ten other measures – museum workers reported statistically significant discontent compared to the very large Happiness Alliance (happycounts. org) data sample in only one well-being factor: that being "time balance" (Michelbach, 2013: 3, 34-35, 42);
- due to funding cuts "greater demands have been placed on me" and "I take on more because I care for my organisation" by 65% & 56% respectively in a museum workplace stress survey (Sullivan, 2015);
- 47% of respondents to an informal survey of museum workers reported leaving the field is a consideration and 33% of those who actually have quit museum work cite "poor work/life balance" (Ocello, 2017, 8);
- the most recent Center for the Future of Museums' *TrendsWatch* reports "workers often feel overworked and that their productivity drops when the workweek reaches 50 hours or more. Museums... pay a high if hidden price for stress. Turnover results in a loss of knowledge, experience, and institutional memory" (Merritt, 2019: 40, 43, 44).

The do more with less culture in museums

One particular management trend forms part of the strong pressures on museum workers to overwork. There exists a prevalent frame of mind in the museum sector that often seeks to "do more with less." This idea was evidenced by officials of

the Art Gallery of Ontario (AGO) who said exactly that when announcing layoffs of 23 permanent staff and decisions not to renew 47 contract positions (Bradshaw, 2009). In the real world, such irrational deceits can be put into practice only by further exploiting museum workers' willingness to overwork self-sacrificially in order to meet expectations that lack sufficient resources. With 70 fewer workers, AGO officials seemingly continued to expect that its remaining demoralized staff could "do more with less." It is not difficult to see why management is acknowledged as the major cause of stress and related burnout, according to author of the book *Is Work Killing You?*, medical doctor David Posen (2013: 321, passim; cf. Higgins *et al.*, 2008: 160, 199-200).

In summary, I am convinced that museum practitioners must apply the available evidence detailing the indefensible Quality of Working Lives in our field to the question of under-compensating museum workers. If we fail to do so, we will never be able to effectively address unsustainably low wages in museums.

Increasing pay alone is no solution to wage slavery

Without any doubt, pervasive overwork in the museum industry makes the nominal low rates of pay much worse than the raw figures reveal. As occupational devotees, museum workers have a tendency to become "willing slaves" to our jobs. Madeleine Bunting, *Guardian* columnist and Director of the London-based think tank Demos, reporting on a major study of workers in the UK in her book *Willing Slaves: How the Overwork Culture is Ruling Our Lives*, introduced the concept of "willing slaves" overburdened with work. The study found dystopian

increases of workloads, more hours worked, "work intensification," "stress levels soared," "rising incidence of depression," and, rather than short sprints, work became "an endless marathon" (Bunting, 2004: xix, xxii, xxv, xxvii, 7, 187-8, passim).

Personally, I rate myself as a willing slave. Although I have been blessed to spend the majority of my 26 years of employment in the museum field working for municipal museums that are unionized and, along with higher levels of government heritage operations, typically boast wages that are above the problematic norm. On the other hand, important research by participant observer Amy Tyson identified problematic low wages even for state-funded living history site interpreters and this had been the case since the outset (Tyson 2013: 4, 6, 15, 91-92, 172, passim;) in this "poverty-ridden field" (Phillips and Hogan 1984: xi, 9 ff.). Despite the well-documented evidence of low pay – markedly poorer for women – I argue that, even if museum workers find ways to get paid more, no pay raise – no matter how large – can improve the QWL deficit if we do not escape from excessive work. Overworked willing slave employees need to be emancipated from the proven stress-related ill-effects.

I now return to my own case to demonstrate this problem. After surviving my 32 straight days of unpaid overtime, I calculated the effective rate of my hourly pay. My comparatively high $32 (CAD) an hour curatorial department head wage rate at the time actually ended up being $8.88 (CAD) per hour for the duration of my month-long marathon. This amounted to a pay cut of 72.25% relative to my nominal wage rate. I believe that I am not the only museum practitioner to be exploited for my devotion to the job. It is both a pervasive and a perverse

situation. Many employees in this field exhibit total investment in the emotional and intellectual labor that is entailed in the museum enterprise that we love and for which we sacrifice so much (Tyson, 2013:18-21, 104, 115, 176, passim).

Self-evidently, the under-resourced expectations under which many museum workers toil – without, or even with, continuous overtime pay – can never adequately compensate museum workers for the negative QWL, stress, and ill-health outcomes of constant overwork. Museum worker burnout from excessive work is driving committed and experienced people out of our field.

Let's be brutally realistic here. High or increased museum pay cannot prevent – or even ameliorate – burnout. There is empirical evidence that bigger paychecks do not buy life satisfaction, especially in the face of stress at work (Kasser and Sheldon, 2009: 243; Posen, 2013: 6). Witness the case of physicians whose labor is comparatively highly-paid compared to museum work. Medical personnel also are occupational devotees. Recent research on doctors finds that between half in Canada and two-thirds in the USA report overwork and burnout (Goldman, 2018; Larkin, 2018). Newly-trained doctors in residence – who in the museum field would be called "emerging professionals" (cf. Milldrum, 2017) – are deliberately forced to work punishingly long hours, mainly as a right of initiation. In one American study, suicide is the second most common cause of death for all resident doctors and the most common cause among males in the cohort (Yaghmour et al., 2017: 1). Thus, high pay is no protection from the debilitating damage that overwork and burnout cause to even well-paid workers' mental and physical health.

In light of the above, even if my museum pay had been increased to equal a top lawyer's billing rate per hour, or to the salary of a large private sector corporate CEO – which Google searches report make between 200 to 400 times above his/her firm's line workers (cf. Posen 2013: 131) – my willingness to over-work, and the professional opinion that 15-hour work days are *de rigeur*, wouldn't ever allow improvement to the quality of my working life. I will simply continue to be task-saturated, debilitatingly overworked, stressed, and burned out regardless of my pay rate (cf. Posen, 2013: 26, 182).

Conclusion

There is a strong case to be made that constantly rising, yet unresourced expectations, and poor Quality of Working Lives, combined with museum human resources practices, must not be exempt from critical museology. Continually attempting to do "more with less" cannot be accomplished in any business supposedly following professional ethics standards that obli-gate museums to "protect" their staff members on the same level of importance as collections (International Council of Museums, 2017: 2; American Association of Museums, 2000: 2) and to treat workers fairly (Museums Association, 2019: 19). In the end analysis, the serious problems of worker overload and under-compensation must therefore be addressed at the same time if we are ever to attain pay in the museum field that actually can be considered decent and sustainable.

I maintain that it is critical to act now to change the cul-ture of overwork and resulting burnout in our vocation. Amy Tyson (2013: 84), author of *The Wages of History*, asserts that museum practitioners do possess collective agency. Among

the many philosophical, organizational, and individual functional competencies that museum workers possess are skills that analyze, create alternatives, act to minimise problems, and value original approaches to problem-solving (Canadian Museums Human Resource Planning Committee, 1997: 15). I urge museum workers in the strongest possible terms to initiate change in the museum industry that – by default or deliberate intent – preys upon museum practitioners' love for our work.

In considering the potential effectiveness of such a necessary lobbying effort, I point to the much-needed and extensive efforts among North American professional museum organizations currently aimed at improving diversity in our field (American Alliance of Museums, 2019; Canadian Museums Association, 2019). By all means, let's diversify the museum workforce. We can succeed in such social activism and must do so (Janes and Sandell, 2019). However, I believe it is imperative that we work equally hard to ensure that increasing numbers of diverse museum employees are not forced to labor in an unreasonably low wage ghetto, nor to continue "business as usual," expecting them to carry out museum work unethically and/or illegally as is distressingly commonplace in our industry today.

With regard to addressing exploitative employment, Tyson advises her living history interpreter colleagues – and, by extension, I believe the entire museum workforce – "Above all, fight it now so it doesn't plague you the rest of your working life" (Tyson, 2013: 70-71).

REFERENCES

American Alliance of Museums, 2017. *Pledge of Excellence and Core Standards*, September 17. Retrieved from https://www.aam-us.org/programs/accreditation-excellence-programs/pledge-of-excellence/

American Alliance of Museums, 2019. *Diversity, Equity, Accessibility, and Inclusion*, April 2. Retrieved from https://www.aam-us.org/?s=diversity

American Association of Museums [now Alliance], 2000. *Code of Ethics for Museums*. Washington: American Association of Museums. Unpagenated versio retrieved from http://www.aam-us.org/resources/ethics-standards-and-best-practices/code-of-ethics

Association of Manitoba Museums, 1995. *Standards for Manitoba Museums*. Winnipeg, MB: Association of Manitoba Museums.

Arthurs, H., 2006. *Fairness at Work: Federal Labour Standards for the 21st Century*. Ottawa, ON: Human Resources and Skills Development Canada. Retrieved from https://www.google.com/url?sa=t&rct=j&q=&esrc=s&source=web&cd=1&cad=rja&uact=8&ved=2ahUKEwiz-oXX6K_hAhVHlKwKHf3uBUcQFjAAegQIBhAC&url=http%3A%2F%2Fdigitalcommons.osgoode.yorku.ca%2Fcgi%2Fviewcontent.cgi%3Farticle%3D1166%26context%3Dreports&usg=AOvVaw3xepTxO8AaFUjyWM3jmiBz

Bradshaw, J., 2009. AGO cuts 23 permanent staff. *The Globe and Mail*, April 4, updated April 28 2018. Retrieved from http://www.theglobeandmailcom/news/national/ago-cuts-23-permanent-staff/article1156582/

Bunting, M., 2004. *Willing Slaves: How the Overwork Culture is Ruling Our Lives*. London: HarperCollins Publishers.

Canadian Museums Association, 1986. *Final Report: Feasibility Study National Standards for Museums*. Ottawa: Canadian Museums Association.

Canadian Museums Association, 2019. *Cultural Diversity Publications*, April 2. Canadian Museums Association. Retrieved from https://www.museums.ca/site/reports

Canadian Museums Human Resource Planning Committee, 1997. *The Workforce of the Future: Competencies for the Canadian Museum Community*. Ottawa: Canadian Museums Association.

Dubé, P., 2001. View: Towards a New Generic Model for Small and Medium-Sized Museums. *Muse* [Canadian Museums Association] 19(1), 8-9.

Duxbury, L. and Higgins, C., 2012a. *Revisiting Work-Life Issues in Canada: The 2012 National Study on Balancing Work and Caregiving in Canada*. Ottawa: Carleton University and the University of Western Ontario. Retrieved from https://www.google.ca/url?sa=t&rct=j&q=&esrc=s&source=web&cd=1&cad=rja&uact=8&ved=2ahUKEwir6f7g-9rgAhWQ2YMKHUznCooQFjAAegQICRAC&url=https%3A%2F%2Fnewsroom.carleton.ca%2Fwp-content%2Ffiles%2F2012-National-Work-Long-Summary.pdf&usg=AOvVaw1I4j-xdUU6KBXsKivrgU58

Duxbury, L. and Higgins, C., 2012b. *Key Findings. Revisiting Work-Life Issues in Canada: The 2012 National Study on Balancing Work and Caregiving in Canada*. Ottawa: Carleton University & the University of Western Ontario. Retrieved from https://www.google.com/

url?sa=t&rct=j&q=&esrc=s&source=web&cd=1&ved=2ah
UKEwjTitDT4tfgAhUEmoMKHf-tCmoQFjAAegQIABA
B&url=https%3A%2F%2Fnewsroom.carleton.ca%2Fwp-
content%2Ffiles%2F2012-National-Work-Key-Findings.
pdf&usg=AOvVaw06ph9rcCJk_02PcbFMCS9R

Golden, L., 2006. How Long? The Historical, Economic and Cultural Factors Behind Working Long Hours and Overwork. In R. Burke (Ed.), *Research Companion to Working Time and Work Addiction*. Cheltenham, UK & Northampton, MA: Edward Elgar.

Goldman, B., 2018. Getting help for burned-out doctors. [Blog post]. *Dr. Goldman's Blog*, April 8. Retrieved from https://www.cbc.ca/radio/whitecoat/blog/getting-help-for-burned-out-doctors-1.4610808

Higgins, C., et al., 2008. *Reducing Work-Life Conflict: What Works? What Doesn't. Report 5*. Ottawa: Health Canada. Retrieved from https://www.canada.ca/en/health-canada/services/environmental-workplace-health/reports-publications/occupational-health-safety/reducing-work-life-conflict-what-works-what-doesn.html

International Council of Museums, 2017. *ICOM Code of Ethics for Museums*. Paris, FR: International Council of Museums. Retrieved from https://icom.museum/wp-content/uploads/2018/07/ICOM-code-En-web.pdf

Janes, R., 2009. *Museums in a Troubled World: Renewal, Irrelevance or Collapse?* New York, NY: Routledge.

Janes, R. and Sandell, R., 2019. *Museum Activism*. London & New York: Routledge.

Kahn, H. and Garden, S., 1994 [original 1993]. Job Attitudes and Occupational Stress in the United Kingdom Museum

Sector. In K. Moore (Ed.), *Museum Management*. New York, NY: Routledge.

Kasser, T. and Sheldon K., 2009.Time Affluence as a Path Toward Personal Happiness and Ethical Business Practice: Evidence from Four Studies. *Journal of Business Ethics*. Special Issue Working to Live or Living to Work. 84(Supplement 2), 243-255.

Kuroda, S., and Yamamoto, I., 2018. Why do People Overwork at the Risk of Impairing Mental Health? *Journal of Happiness Studies*, 19(1), 1-20. Retrieved from https://doi.org/10.1007/s10902-018-0008-x [unpagenated].

Kurylo, L., 1984. The Ministry of Citizenship and Culture's Standards: Better Museums for Ontario or Re-arranging the Deck Chairs on the Titanic. *Museum Quarterly* [Ontario Museum Association] 13(3):9-13.

Larkin, M., 2018. Physician burnout takes a toll on U.S. patients. *Reuters Health News*. Retrieved from https://www.reuters.com/article/us-health-physicians-burnout/physician-burnout-takes-a-toll-on-u-s-patients-idUSK-BN1F621U

McIsaac, E. *et al.*, 2013. *Shaping the Future: Leadership in Ontario's Nonprofit Labour force. Final Report*. ONN Human Capital Renewal Strategy: Phase One. Toronto, ON: Ontario Nonprofit Network & The Mowat Centre. Retrieved from http://theonn.ca/wp-content/uploads/2011/06/Shaping-the-Future.Leadership.pdf.

Merritt, E., 2019. *TrendsWatch. (2019)*. Washington: Center for the Future of Museums, American Alliance of Museums. Retrieved from https://www.aam-us.org/programs/center-for-the-future-of-museums/trendswatch-2019/

Matousek, M., 2018. Elon Musk says people need to work around 80 hours per week to change the world. *Business Insider*, November 26. Retrieved from https://www.businessinsider.com/elon-musk-says-80-hours-per-week-needed-change-the-world-2018-11

Milldrum, C., 2017. Why I Left the Museum Field: A Guest Post by Claire Milldrum. *ExhibiTricks: A Museum/Exhibit/Design Blog*, September 11. [Blog post]. Retrieved from http://blog.orselli.net/2017/09/why-i-left-museum-field-guest-post-by.html

Murphy, J., 2018. Increase Team Productivity by Decreasing Task Saturation: Too Much to Do and Not Enough Time to Do It [Podcast and transcript]. *Afterburner*: August 14. Retrieved from https://www.afterburner.com/fighting-task-saturation-04/

Museums Association, 2019. *Code of Ethics for Museums*. London, UK: Museums Association. Retrieved from https://www.museumsassociation.org/download?id=1155827

Ocello, C. et al., 2017. *Why are Great Museum Workers Leaving the Field? Survey by Claudia Ocello, Dawn Salerno, Sarah Erdman, & Marieke Van Damme*. Retrieved from https://docs.google.com/presentation/d/1_aHdxmGoJdb4deqsjy-hH9eoDUIPXz_EdkU-7gWuXDwE/edit#slide=id.p3

Schor, J., 1991. *The Overworked American: The Unexpected Decline of Leisure*. New York, NY: Basic Books.

Schultz, D. and Schultz, S., 2006. *Psychology and Work Today. An Introduction to Industrial and Organizational Psychology*. Ninth Edition. Upper Saddle River, NJ: Prentice Hall.

Spieler, E., 2003. Risks and rights: The Case for Occupational

Safety and Health as a Core Worker Right. In J. Gross (Ed.), *Workers' Rights as Human Rights*. Ithaca, NY: Cornell University Press.

Statistics Canada, 2001. *Caring Canadians, Involved Canadians: Highlights from the 2000 National Survey of Giving, Volunteering and Participating*. Ottawa, ON: Government of Canada.

Thistle, P. C., 1990. Editor's Scene. *Little Northern Museum Scene*. 38, 1, August. Retrieved from https://solvetasksaturation.files.wordpress.com/2013/09/littlenorthernmuseumeditorial.pdf

Thistle, P. C., 1994. Standards Critique Letter Highlighted. Retrieved from https://solvetasksaturation.files.wordpress.com/2013/09/standards-critique-letter-highlighted.pdf

Thistle, P. C., 2010. Fully Loaded Camels: Addressing Museum Worker Task Saturation presented at the University of Toronto Master of Museum Studies programme 40th anniversary conference Taking Stock: Museum Studies and Museum Practices in Canada, Toronto, April 24.

Thistle, P. C., 2018. About Critical Museology Miscellanea. *Critical Museology Miscellanea*, February 21 [Blog]. Retrieved from https://miscellaneousmuseology.wordpress.com/about-critical-museology-miscellanea/

Tivy, M., 2006. *The Local History Museum in Ontario: An Intellectual History 1851-1985*. [Thesis] Waterloo, ON: University of Waterloo. Retrieved from https://uwspace.uwaterloo.ca/handle/10012/2821

Towers, I., et al., 2005. *Time Thieves and Space Invaders: Technology, Work and the Organisation*. Paper presented to the 4th Annual Critical Management Studies Conference,

July. Cambridge. Retrieved from https://www.google.ca/
url?sa=t&rct=j&q=&esrc=s&source=web&cd=1&ved=0ahU
KEwiXspLmpb7XAhWXoYMKHe6mDpwQFggmMAA&ur
l=http%3A%2F%2Fciteseerx.ist.psu.edu%2Fviewdoc%2Fd
ownload%3Fdoi%3D10.1.1.98.9879%26rep%3Drep1%26type
%3Dpdf&usg=AOvVaw1zR6kwdxu9gAkQ6jveETRx

Tyson, A., 2013. *The Wages of History: Emotional Labor on Public
History's Front Lines*. Amherst and Boston: University of
Massachusetts Press.

Weil, S., 1988. The Ongoing Pursuit of Professional Status:
The Progress of Museum Work in America. *Museum News*
67(2): 30-4.

Yaghmour, N., *et al.*, 2017. Causes of Death of Residents
in ACGME-Accredited Programs 2000 Through 2014:
Implications for the Learning Environment. *Academic
Medicine*, 92(7), 976-983. Retrieved from https://journals.
lww.com/academicmedicine/Fulltext/2017/07000/Causes_
of_Death_of_Residents_in_ACGME_Accredited.41.aspx

CREATING A MORE EQUITABLE EXPERIENCE FOR MUSEUM INTERNS

Natalie Sandstrom

EACH OF US HELD our imaginary water glasses full of our own knowledge. One person began by pouring some of their knowledge into the glasses of the others, moving slowly and deliberately, while the rest of us stayed silent as the weight of wisdom seemed to become real in our hands. We took turns sharing and receiving understanding with each of our peers by pouring, until our glasses were overflowing. By the end of the exercise, everyone had taken from and given to each member of the group, setting a precedent for openly sharing insight that should persist throughout museum education. One way we can realize this goal is by supporting emerging museum educators through experiences such as internships.[1]

For three years I worked as a paid Student Museum Educator (SME) at the Smith College Museum of Art (SCMA), and had the opportunity to embody this water glass activity – learning from my colleagues, and sharing my own wisdom and experiences. The SME program incorporates a theoretical framework but is primarily experiential, and focuses on giving undergraduate students gallery teaching experience. In this chapter I will explore how the SME program models an ideal museum education work environment, and argue that it includes components of compensation, experiential learning, mentorship, and transparency – elements that we should advocate for in student internships and beyond to fulfill institutional and individual goals. While each of these components is crucial, I focus on compensation and experiential learning because I believe them to be most critical in preparing students to understand and take on the labor involved in museum education. On the institutional level, paying student workers allows a museum to achieve its goals by expanding opportunities to create a diverse

FIG. 1: Five of the six Fall 2018 SMEs with Gina Hall. (Left to right: Tiv Hay-Rubin, Libby Keller, Isabel Beeman, Cassandra Gonzalez, Natalie Sandstrom, Gina Hall). Photograph: Lynne Graves.

team of paid interns who do real, mission-aligned work. For students, being paid creates opportunities to build the experience, skills, and network to succeed, while setting the expectation of a fair and supportive workplace in their full-fledged careers (Figure 1).

Equity, internships and pay

Today, with the help of projects like MASS Action,[2] institutions are thinking about what it means to create an equitable workplace through gender, race, [3,4] and sexuality, as well as considering economic diversity and fair compensation for labor.[5] Specifically, more and more museums are starting conversations about unpaid internships.[6] Major institutions such as the Metropolitan Museum of Art and the Whitney now offer some paid summer opportunities. However, many internship programs, both inside the art world and out, are unpaid. In a 2017 study conducted by MuseumNext,[7] of 420 museum professionals interviewed, only 8% received a living wage during their time as interns, while 48% had not been paid at all (Richardson, 2017). At first thought, one might argue that unpaid internships are still better than nothing. However, on further consideration, in the context of equity (the just and impartial treatment of all people) this stance breaks down. Those who cannot afford to work for free are unable to access careers which have high expectations of educational background and previous professional experience. Perhaps students can be creative in finding ways to support themselves while trying to build a resume, but this should not have to be the case, as the division of time and labor across multiple commitments can lead to overwhelming stress, and lower quality work.

By relieving the strain of taking additional jobs to subsidize unpaid museum labor, paid internships may encourage a wider range of candidates to enter the museum field. This kind of inclusive consideration encourages a greater number of perspectives when it comes to problem solving, and creates empathy in the field. At SCMA, paying student workers creates this kind of space. For example, in the fall 2018 cohort, the six SMEs came from both work-study and non-work-study backgrounds, from more than five areas of study, and three class years. Two of us were returning staff members, while the other four were new hires. Over the semester we had opportunities to become a team, to understand each other's unique perspectives, and to draw on those experiences when we needed support. I was in my third year as an SME, coming from an English and Art History background, and a non-work-study student. I would have still been an SME if the position were unpaid, though would have devoted less time to it. Due to being paid, I was able to dedicate myself to my work, I experienced an equitable first workplace, and I amassed skills that proved to be valuable as I entered the museum field.

The transition to paid internships

The Student Museum Educator program has flourished since transitioning from volunteer to paid in 2014. With SMEs, the education department at SCMA gives fledgling student educators the responsibility and recognition of part-time staff members, under the guidance of Gina Hall, Associate Educator for School and Family Programs. SMEs primarily design and lead responsive, inquiry- and object-based tours for K-12 audiences. Additionally, SMEs assist with implementing interpretive

materials, and facilitating community programs such as the annual student gala and monthly drop-in artmaking activities. SMEs are expected to interface with the public in a professional manner, adapting to the needs of visitors of all ages and abilities (Figure 2).

When Hall turned the program from volunteer to paid, the goal was to provide real experience to undergrad students. Hall says that, "as an academic museum we have a mandate to pay our students" (Gina Hall, personal communication, October 2018). At Smith she found this particularly true, because the museum was eligible to receive part of the college's federal work-study funding, and there were also areas where SCMA could redirect funds toward a paid internship program. Hall had previously worked at an institution that paid its student educators, and she knew that she needed to implement change to the compensation structure at Smith, both for the benefit of students, and of the program itself. She felt that the existing volunteer model was giving students pedagogical background, but not enough opportunities to apply the knowledge they were gaining. Many students were unable to allocate the full time that the position required because of the pressures of work and school, so the programmatic goal of SMEs working directly with K-12 audiences was not being met.

To make the transition from a volunteer corps to a small group of part-time student educators, SCMA had to redirect its work-study funds, and they also chose to put internal museum funds toward the new SME directive. Before 2014, the museum's portion of the work-study funding was allocated to paying a student assistant for each member of the education department. The assistant positions shifted to become the Student

FIG. 2: The author with a group of second graders on a recycled materials tour, discussing Betye Saar's *Ancestral Spirit Chair* (1992). Photograph: Lynne Graves.

Museum Educators, responsible for leading gallery tours and helping with administrative tasks. Today, the museum has no unpaid interns, though there is a separate volunteer program which requires only four hours per month from participants.

Reflecting on the changes that have come from the switch to a paid student program, Jessica Nicoll, SCMA's Director and Chief Curator, says:

> The shift in recent years to a smaller corps of paid SMEs has had a number of benefits including allowing us to deepen training, giving students more opportunities to develop content and teaching strategies, and compensating them for the significant time they contribute to this work. Paying students is also an issue of equity, making this valuable learning experience possible for all interested students. (Jessica Nicoll, personal email communication, October 2018)

Gina Hall echoes this sentiment. In addition to being able to accommodate more tours, Hall believes:

> With our current model, SMEs have time and guidance for planning, researching, prototyping and reflection, all of which has hugely increased the quality of the learning experiences for our visitors, and the learning experience of the SMEs as well, to contribute to their growth as professional educators. (Gina Hall, personal communication, October 2018)

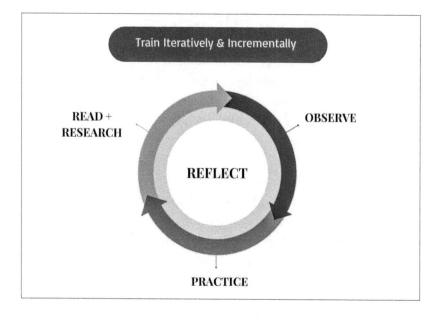

FIG. 3: Associate Educator Gina Hall's learning flow chart for SMEs.

Fulfilling individual goals

Because the positions are paid, SMEs are expected to devote ten hours a week to work. The program is scaffolded with trainings and readings on best practices, which supports work with visitors. Tours are planned collaboratively, and reflective writing and conversation exercises are conducted after each group visit. This not only gives students the tools and vocabulary to teach, but also the skills to reflect and grow. A 2005 study on experiential learning found that "making space for students to take control of and responsibility for their learning can greatly enhance their ability to learn from experience" (Kolb and Kolb, 2005: 209). This study also stressed the importance of "the creation of learning spaces that promote growth-producing experiences for learners," rather than simply focusing on measured outcomes (Ibid: 205). In my time as an SME, I was part of three different cohorts, each of which had a range of student educators with different teaching expertise in terms of subject and age group, providing a dynamic and supportive work environment that celebrates highs and learns from stumbles.

For most of us, being an SME is our first time working in a museum, and may also be the first teaching experience, so students arrive with excitement and eagerness to grow. This necessitates hands-on leadership from SCMA education staff, as well as from older and more experienced members of the SME cohort. As the program leader, Gina Hall understands how harnessing new educators' enthusiasm can benefit all parties involved:

The energy and perspective that student educators infuse into their time in the office makes them an

invaluable voice within the institution, helping us to be more relevant and accountable, thoughtful and purposeful in the education work that we do for all audiences. (Gina Hall, personal communication, October 2018)

Accordingly, Hall actively promotes the informal mentorship component of the SME program, encouraging students to not only engage with her, but also with museum staff both inside and outside of the education department. In my time at SCMA, I was on both sides of the mentorship: I received advice from Gina when applying to internships; and I gave new SMEs tips on office workflow, or insight on classes who return to the museum annually. This not only helps the SMEs feel like valued and included staff, but also helps them understand what keeps a museum running. SMEs see not only visitor engagement, but also the paperwork for scheduling groups, and the discussions across departments about how to make the museum inviting and accessible. For example, when the curatorial staff works with education to plan physical accessibility in a new exhibition, SMEs can be privy to those talks. And, because students are paid, they spend more focused time working, which leads to a fuller mentorship experience, through which the real labor of the field becomes clear.

I loved these interdependent aspects of being a paid student educator. Throughout my time at Smith, my colleagues and I talked about things such as how to engage students who have special needs, and how to have a range of group management strategies ready to go. I learned how to appropriately redirect language surrounding artworks that depict minorities or represent problematic historical events. The museum allowed me

to have difficult conversations, and I came away with a toolkit of strategies that helped me face hard teaching moments. At Smith I also learned to harness my background and share my passions with visitors, such as when I brought my English (British Romanticism) and art history knowledge together to deliver my best tour ever: sublime landscapes with a group of high schoolers (Figure 4). I also experienced the less glamorous desk work, like spending hours researching the most economical art materials to buy in bulk for public programs. These experiences prepared me for success as I transitioned to the "real world" – within three months of my graduation I landed a full-time, education-based position in a museum.

The Smith College Museum of Art takes pride in knowing that, through its immersive and challenging work environment, Smithies are set up for success. SMEs have gone on to work in such places as MoMA, the Nelson Atkins Museum, the MFA Boston, and the Denver Children's Museum. Jessie Magyar, Community Outreach Coordinator at the ICA in Boston, believes that:

As an SME, I learned how to facilitate meaningful conversations and help people form personal connections with art objects. That has absolutely inspired every career aspiration and choice I've made as an artist, educator, and art therapist. (Jessie Magyar, personal email communication, October 2018)

While Jessie's SME cohort was unpaid, she still gained skills that she could take away. Kate Hanks (Class of 2018) feels that being a paid SME not only gave her confidence and experience,

FIG. 4: The author with a group of elementary school students reviewing the museum's rules before entering the gallery. Rule 2 (accompanied by walking motions with two fingers): use walking feet while in the museum. Photograph: Lynne Graves.

but also helped her realize her value: "If I can be paid for my labor as a college student, then I should be paid for my labor as a post-grad member of the workforce" (Kate Hanks, personal email communication, October 2018). These alumnae quotes demonstrate how compensation amplifies the other three components of a great work environment for young educators: mentorship, transparency, and experiential learning.

Conclusion

When I left Smith and SCMA, I had many takeaways. First and foremost, I knew that my teaching toolbox had been lined with a foundation of techniques backed up with theory. Thanks to the mentorship I received, I felt confident that I had something to offer to my future employers; and because of the experiential aspect of this program, I had a sense of what to expect. Finally, by working with a range of peers who brought diverse backgrounds to the office in so many ways, I learned the importance of listening, and of cultivating a compassionate and empathetic workplace, which transfers into working with the public.

In this chapter, I have used this lens of my experience to explore the work of SMEs in relation to the institution, demonstrating the value the student can bring to the museum, and the ways in which fair work experience can set students up for success. This should be thought of a case study that acts as a model work environment for other institutions. Paying interns and creating a space where experiential learning, mentorship, and transparency can take place ought to be replicated in other museums across the field, and across all departments. While finding the means to make this change happen is a large hurdle, resources do exist. Finding ways to reallocate internal

funding, applying for grants, or (for academic museums) using work study funds has powerful implications across the field. Taking steps toward creating more accessible and equitable internships and jobs could impact museum education from the ground up, helping to embolden the next generation of educators through early work experiences.

To conclude, let's revisit the glass activity,[8] this time considering those future museum educators. Imagine again a room of people with their water glasses of knowledge. Imagine that each of them is different – whether that be their economic, social, racial, mental, physical, or educational background. Imagine the immense potential that lies within each of their cups, waiting to be shared to help their peers' glasses overflow. Think of the steps we could make toward equity and deeper empathy. As educators, we support visitors as we challenge them to see what more they can find in our museums. I invite us to task ourselves with that same process of discovery, and to welcome others to share that experience. I believe that the field of museum education is a bottomless glass – we can always learn and grow from each other, which strengthens everyone.

NOTES

1. A version of this chapter appeared with a different title in the online edition of

 Viewfinder: Reflecting on Museum Education (National Arts Education Association

 Museum Education Division, Editor), December 16, 2018):

 Sandstrom, N. (2018). Compensation and compassion: Creating a more equitable

 field for emerging museum educators. *Viewfinder, 8*. Retrieved from

 https://medium.com/viewfinder-reflecting-on-museum-education

2. https://www.museumaction.org/resources/

3. https://www.locallearningnetwork.org/journal-of-folklore-and-education/current-

 and-past-issues/journal-of-folklore-and-education-volume-3-2016/dismantling-

 racism-in-museum-education/

4. Some organizations, like the Getty Foundation, Mellon Foundation, Walton Family

 & Ford Foundation, and AAMD, support goals to add racial diversity to the field

 through offering scholarships or grants to young people of color so that they are

 able to gain experience.

5. https://www.aam-us.org/programs/resource-library/deai-human-

 resources/#StaffDiversity

6. https://www.aam-us.org/programs/resource-library/resources-for-the-museum-

 industry-to-discuss-the-issue-of-unpaid-internships/

7. https://www.museumnext.com/2017/07/stats-on-museum-internships/

8. https://www.trainingforchange.org/training_tools/water-glasses-exercise/

9. https://beyondart.wordpress.com/

REFERENCES

Kolb, A., and Kolb, D. (2005). Learning Styles and Learning
Spaces: Enhancing Experiential Learning in Higher
Education. *Academy of Management Learning & Education*,
4(2), 193–212. Retrieved from http://www.jstor.org/
stable/40214287

Richardson, J. (2017). *Eye Opening Stats on Museum Internships*.
MuseumNext. Retrieved from https://www.museumnext.
com/2017/07/stats-on-museum-internships/

WHY MUSEUMS MUST STOP USING VOLUNTEER DOCENTS AND START PAYING THEIR EDUCATORS

Tara Young

IN THE LAST FEW DECADES, museums have evolved from repositories of objects to community catalysts. More recently, museums are increasingly considering their role in promoting equity, taking stands on issues related to the inclusion of multiple voices and the representation of previously underrepresented groups, and are even making difficult decisions about whether to accept funds from sources that are incompatible with their values. Given museums' awareness of responding to societal and political issues that affect them and their constituencies, it is completely nonsensical that they still rely so heavily on volunteers to deliver their primary educational offerings. Not only does this practice shortchange audiences, it also creates a less diverse front line, depresses salaries, and degrades the professionalism of our field.

If museums want to invest in an excellent visitor experience, honor high standards of professionalism, and acknowledge the training and skill of their education staff – which is on the whole underpaid and underappreciated – they must stop using volunteers to conduct the educational experiences that are the primary mission-critical activity of the museum's daily operations. Before I go further, a disclaimer: I have nothing but admiration for the volunteers who currently do this work. The problem is structural within the field, not personal with the volunteers. In my twenty-plus years in the museum field, I have worked with hundreds of volunteers, and have relied on them to give tours and carry out other essential duties. Overwhelmingly, I have found them to be smart, generous, selfless individuals who have pride in their institutions and who want to share that pride with visitors. Given the strong feelings I have about the ways that museums should and should not

use volunteers – and what I believe are compelling arguments to support those feelings – volunteers who read this essay may take offense. I acknowledge that, but I will still make the case for the imperative to pay educators rather than use volunteers, an imperative that is long overdue and that I believe is crucial to the health of the museum field.

For clarity, I want to define some terms that I'll use; some of these are imprecise, but because they're widely employed, they serve as useful shorthand. First, to describe facilitated educational experiences in which visitors explore the museum with a guide, I'll use the word *tour*. Here, *tour* suggests a sustained activity for a significant amount of time (typically around an hour) rather than a casual encounter. To describe the role of the facilitator of such experiences, I'll use the term *docent* for an unpaid individual, and *educator* to indicate a paid staff person. In some settings these terms are interchangeable, or are replaced with other terms entirely (for example, *interpreter*), but I'll use these definitions going forward.

Clearly, the *tour* as defined above is only one method of delivering educational experiences to visitors, and in the context of a busy education department that offers many other programs, dwelling on the tour may seem to give it disproportionate attention. As museum professionals, we see our education programs holistically. Remember, though, that for many visitors – especially first-time visitors – the tour may be the only sustained encounter they have with a museum representative. For these visitors, the breadth of the other educational offerings is unimportant because they'll never experience them. Also, it's safe to assume that casual visitors don't distinguish between volunteer and paid educators. Any nuances

that museum professionals may appreciate, or, to state it more frankly, the different standards to which we may hold docents and educators, are likely not apparent to visitors.

There are five main arguments for why I believe museums should – indeed must – stop using volunteer docents to facilitate tours: first, the reliance on volunteers devalues the work of educators, literally and figuratively; second, this devaluation of the educator role perpetuates a lack of diversity in the field; third, volunteers are not – and cannot be – held to the same standards as paid staff; fourth, visitors' experiences with paid educators are likely to be more successful than those with docents; and fifth, though volunteers may be seen as "free" labor, the resources museums devote to their oversight are significant.

The benefits of shifting from docents to paid educators are many: educators are paid a wage that reflects the importance of their work; as a group, educators are likely to be more diverse than docents (who are overwhelmingly white women over the age of 40, especially at large art museums);[1] training and evaluation of paid staff can be more rigorous; the visitor experience with more highly trained educators is more positive; and resources currently used to manage docents can be redeployed elsewhere.

Historically, many museum education departments, or even entire museums (such as children's museums) were founded on a grass-roots basis by volunteers. We owe volunteers a huge debt of gratitude for their essential role in creating the museum education field. When education initiatives were volunteer-led, the museum field was firmly rooted in a belief that museums should serve primarily as depositories for objects, and that

therefore, curators should be at the apex of the museum field. Clearly, the field as a whole has moved so far away from that paradigm that it now seems old-fashioned. Today's museums are continuing on a trajectory towards being community- and visitor-centered, with education at the heart of their missions and functions. Indeed, the majority of museum mission statements mention education as central to what they do.

Since the time of volunteer-run education departments, museum education has become a distinct professional field. Beginning in the 1970s, museum studies programs were established and began to offer specialized degrees in museum education. By continuing to use volunteers as docents, museums are essentially refusing to acknowledge that facilitating tours is a skill that requires specialized training, rigorous practice, an understanding of pedagogy and andragogy, and customer service, to name only some of the areas one must master. The absurdity of thinking that a volunteer, even one with teaching experience, is interchangeable with a trained professional comes into relief when we look at an analogy in another field. Imagine, for instance, that there were two candidates for a position as a dental hygienist. One has completed two years of a training program and has had experience in an apprenticeship or internship model. The other has not had specialized training, but is smart, passionate, and willing to learn (how hard could it be, really?), and – the best part – is willing to work for free. Which person would you want to clean your teeth?

Depressing salaries and limiting diversity

Though the assumption that facilitating educational experiences is not a specialized skill worth paying for is problematic enough, the effect that that assumption has on salaries within

the museum education profession is truly lamentable. In the simplest terms, if docents – per our definition – earn no money, than the value of the task they perform is literally $0. In situations where educators are paid to give tours exclusively – as distinct from other education staff who do this work as only one part of a larger set of responsibilities – these educators are likely to work part-time, without benefits or any job security, at a pay rate that may be equal to, or just above, minimum wage. Essentially, the role of educator is treated as an entry-level, unskilled role, paid at the same rate or even less than what one might earn at Starbucks, where even part-time staff are eligible for some benefits. If museums are paying so-called "entry level" employees unconscionably low hourly rates, then that's the floor upon which the entire compensation structure in the department is based. Therefore, a program manager who makes $18 an hour (less than $33,000 for a 35-hour workweek) is perceived as being paid a reasonable salary. Though it's barely a livable wage in a major city, especially if one has student loans, the program manager may accept this salary uncomplainingly because she knows she's so much better off than her fellow educators making $11 per hour.

Not only does the reliance on unpaid docents for a crucial visitor-facing role depress education department salaries, it also contributes to a lack of diversity in the museum profession. Over the last few years, the field has increasingly questioned the ethics of unpaid internships, partly because they present a barrier to entering the field.[2] However, the same conversations have not been happening about how the reliance on volunteer docents does the same. The schedule requirements of many docent programs reflect the fact that they have been built

around retirees or people who otherwise don't hold a full-time job; it's not uncommon for docent training to occur during weekdays and for programs to require hundreds of hours of volunteer service per year. These terms make the docent role at many museums untenable for people with full-time jobs or demanding school schedules; explicit or implicit membership or donation requirements may further deter lower-income individuals from pursuing a role as a docent. These factors contribute to a lack of diversity among educators in two ways: first, if the docent corps is not diverse, then many of our visitors do not see themselves reflected in the role, which could stifle their future interest in the field. Second, because, as discussed above, the reliance on docents keeps entry-level salaries low, anyone who can't afford to live on an educator's salary is effectively shut out, especially given that many front line educator positions are part-time or seasonal.

Passion is not a substitute for skill and accountability

Regardless of how dedicated and passionate a group of volunteers may be, there is simply no way to hold them to the same standards as paid staff. These lower standards are evident before docents even apply, evidenced by position descriptions that emphasize the fact that no experience is required. Imagine how ridiculous it would seem for a job listing for a paid educator to promote a lack of experience or specialized training as a selling point. While the docent role may be competitive in large museums, or in ones considered to have especially prestigious docent corps, in many smaller museums the process of becoming a docent is not competitive, because of the simple need for personnel.

The difference in standards between volunteers and staff continues after the onboarding process. By definition, volunteers are engaged in their work for personal enrichment; they're giving a great deal to the institution, but they're also getting a lot: learning and social opportunities, skill development, and even enhanced social status. A major perk of volunteering is flexibility; not only is it inevitable that volunteers take advantage of this flexibility, but it's assumed to be part of the unwritten agreement between the individual and the institution. Simply put, volunteers usually do not prioritize their work to the same extent that paid employees prioritize their jobs. This is understandable, but it still means that on the whole docents are less reliable than paid educators. In my many years of working with volunteers, I've had them call out for any number of completely valid reasons: family obligations with children, grandchildren, or elderly parents; travel; medical appointments; inclement weather; having visitors in town; the list goes on and on. These are all things that a paid educator would have to do on his own time or take paid time off to do.

The performance review – and remediation of any problems – is also completely different with docents and with paid educators. In my experience, evaluation of docents has to be approached delicately. I've had docents outright refuse to be evaluated; one memorable response to a request for a docent to allow a staff observer on her tour was, "This is supposed to be fun, not work." While large museums with a deep pool of docents may have more flexibility, the truth is that often subpar performance is tolerated because there is a perceived need for the volunteer's labor. The logic may be that it's better to have a mediocre tour than no tour at all. Other complicating

factors may be that the docent is also a donor, has prominent standing in the community, or is a personal friend of the director or a board member. Though certainly docents are "fired," the tolerance for less-than-ideal performance is much higher for docents than for paid staff.

Volunteer docents often do not get the same level of training as paid staff. There are many examples of museums where docents continue to be trained primarily in content, while educators who deliver other types of programs in those same institutions receive training in pedagogy and educational strategy. Reasons for this discrepancy are unclear: in some cases, the docent corps is an independent nonprofit organization that does not report to education staff. Docents may individually or collectively be major donors to the museum and thus receive special treatment. In other cases, the issue may be that it's simply easier to teach and learn content than pedagogy: content can be learned on one's own time, while teaching pedagogy is time-consuming and not a good investment if there is a risk that the docent won't stay at the institution long enough to make that investment worthwhile. Docents who are trained primarily in content are likely to give a tour in a lecture-based style rather than a dialogic style, even though our field as a whole has moved toward a dialogue-based model paid educators in an institution may use. Many of our institutions seem to be comfortable with docents continuing to use a model that the museum education profession has long considered to be outdated. Consider for a moment this description of the docent role at the Santa Barbara Museum of Art:

Docents act as tour guides for children and adults

visiting the Museum. They give curriculum-based slide talks at schools and follow-up classes in the Museum's galleries, and give gallery talks to adult visitors. Docents attend twice monthly meetings that include slide lectures and workshops as part of the program of ongoing professional development.[3]

Similarly, the Benton Museum at the University of Connecticut presents the following under the *What Do Docents Do?* heading of their website:

> **Touring**: Docents serve as tour guides to visitors, including school children, students, the university and local community. **Art lectures**: Docents may present talks at the museum to schools, community groups, and senior centers in the region. **Research**: Docents prepare background information on museum exhibitions and acquisitions for the use of docents who tour and give lectures.[4]

I'm using these two examples as representative of the field, not singling out these institutions. But clearly, neither of these statements – just two samples of many – exemplifies the best practices in the field of museum education, or what these same institutions are actively practicing elsewhere. Rather, these descriptions feel stuck in time, reminiscent of an era now long past when museum collections, rather than visitors, were an institution's *raison d'être*. Not only are these representative statements not in sync with current best practices, but they also stand in contrast to the American Alliance of Museum's

Core Standards for Education and Interpretation, the first point of which is, "The museum clearly states its overall educational goals, philosophy and messages, and demonstrates that its activities are in alignment with them."[5] I am confident that my colleagues in museum education would not define the activities excerpted above as being "in alignment" with their institutions' educational philosophy. Museums who perpetuate this disconnect are doing the field a disservice.

Is there really a difference in skill level?
To emphasize why this discrepancy in style and in adherence to best practices between docents and educators is important, remember that for many visitors, the experience they have on a tour is the only extended encounter with a museum representative. While we, as administrators, may think that overlooking less than perfect docent performance is not a big deal in the scheme of things, for individual visitors it *is* a big deal. In preparation for this chapter, on a recent visit to New York, I conducted a completely unscientific but illustrative test of the qualitative difference between volunteer and paid educators. I went on tours at two Manhattan museums that are nationally recognized for their excellent education departments, both of which are on the forefront of the field-wide conversation about visitor-centered learning. One, an art museum, uses volunteers to give general tours; the other, a history museum, uses paid staff. Both individuals whose tours I experienced were highly skilled at what they had been trained to do. It was clear, though, that they had trained to do two different things, and that the paid educator reflected the educational mission of his institution, while the volunteer docent did not.

First was the art museum, with a docent we'll call Vivian. She was friendly, poised, articulate, and welcoming. The tour was a thematic tour across time and culture, and she started by saying that the experience was going to be dialogue based. However, I did not see her actually implement a dialogue-based approach. At the second stop she asked the group for adjectives that described the object we were looking at, and while she seemed receptive to the terms people shared, the next part of her talk did not incorporate any of the provided adjectives, and she instead continued with ones that she told us "most people say" and which better served her concept for the tour. As someone with an art history background, I found the content she shared interesting, but it was not accessible to the large, diverse group of visitors, including a few young children, that made up the tour group. My notes include these examples of her language, none of which she defined or contextualized: "blending of abstraction and naturalism," "compositional element," "Cubism," "reinstallation," "fractured forms" and "Western tradition." She appeared to have nearly memorized the content and didn't create space for true dialogue or for visitors to make their own meaning.

At the history museum, the tour experience with an educator we'll call Sam was markedly different. The tour was rather traditional in that it followed a prescribed sequence, and it was not fully inquiry-based; quite a bit of the content was provided as a one-way conveyance of information. Unlike Vivian, however, Sam left room for discussion, and invited us to make personal connections with the content. As one example, he had asked us at the very beginning where we were all from; one young adult visiting with her parents shared that they had

come to New York to help her move. Later, when Sam was discussing a room in the historic building we were in, he asked the young woman how the size of the space compared to her new apartment. Those kinds of connections occurred throughout, and by the end of the tour we were all chatting as a group and, I think, feeling like we had experienced the tour together, a vibe that was not at all present in the tour with Vivian.

What I saw in these two examples was that while both educators said that the tour would be a discussion, only Sam, the paid educator, actually delivered on that promise. It seemed that Vivian, the volunteer docent, had perhaps had some training on dialogue-based tours but had not internalized it, either based on her own preference or on the fact that the staff educators didn't require its use. Volunteer docents may be allowed to choose an approach (that is, to decide whether or not they want to use it), whereas paid staff need to follow the strategy that the leadership has selected as a best practice.

It's about living our institutional values - not money
While we can perhaps understand the reasoning behind the discrepancies of training docents versus paid educators, when we flip the lens and look at the training issue from the point of view of the visitor rather than as administrators, it makes no sense at all. At many museums, we are peopling our front lines with volunteers whose training is less rigorous than we would require of paid staff. The visitors don't have different standards depending on the pay status of the facilitator; they expect a level of excellence that frankly they are not always getting from volunteer docents. If I were a novice museum visitor, Vivian's tour would not have helped me make a connection to the museum.

I probably would have been a little lost in the terminology, and I would likely not have felt that there was room for my input in the experience. Sam's tour, though, did make that personal connection – I could see it in people's faces – and I would bet that the people on that tour now look at that museum in a new way and feel a deeper relationship with it. If I were recommending one experience over the other, it would without question be Sam's tour at the history museum. Given the importance of word-of-mouth marketing in museums, a mediocre tour can have real repercussions as visitors share their experiences with friends and family and in online reviews.

Even if museum administrators support the idea that educators should all be paid, two major objections come up. First, what about all of our loyal volunteers, who are wonderful ambassadors for the museum, and who, in many cases, support the institution financially; and second, how do we afford to pay the educators?

The answers to both of these questions have more to do with institutional values than with practical concerns. But let's consider them at face value first. There are many ways that loyal volunteers can appropriately be redeployed across the museum: as greeters, program assistants taking tickets at an event, office assistants, researchers, community outreach volunteers, and so on. While there may be some hurt feelings or departures among a few volunteers during the transition of a volunteer docent program to a paid staff model, those problems – if they occur – will be short-lived and are outweighed by the benefits of the change for all parties involved: the visitors, who get a better experience; the educators who are adequately compensated; and the volunteers who are no longer given a

huge responsibility with inadequate resources. Stellar volunteer educators can apply for paid positions, if there are openings, so they can continue in that role. Making a parallel to a non-museum setting helps to illustrate the point: many parents and community members volunteer in public schools and find satisfaction in doing so. They may participate in the PTO, help in the library, or as a "mystery reader" in a classroom. My kids' school has a lobby greeter role that is filled by volunteers from the senior center. We would all be outraged, though, if volunteers assumed the role of classroom teachers. We acknowledge that teachers have a certain set of professional skills, and we clearly delineate between volunteer and educator roles in schools. The same should be true in museums.

In addition to worrying about losing volunteer support, administrators looking at a model of using only paid educators to deliver programs understandably think about cost. Certainly, expenses would increase if a museum stopped using volunteer docents and instead shifted their role to paid staff. But isn't excellence in education – and its positive effect on the visitor experience – a resource worth investing in? Extending the example above, teachers' salaries make up the majority of school departments' budgets, but because they're the most important resource in a school, districts invest in teachers and make cuts – or raise funds – elsewhere; again, the same should be true in museums. Practically speaking, I believe that museums looking at using paid educators where they have previously used volunteers can find ways to increase revenue and reduce expenses in moving from the old model to the new. In a scenario where paid educators receive more robust training and are more committed to their roles than volunteer educators

would be, it's likely that visitor satisfaction will increase. Increased satisfaction means more repeat visits, more visitors becoming members, and higher levels of support across the board. This isn't a quick fix, but I think the improvement in quality and accountability is one concrete answer to the money question.

The second part of the financial equation in moving from volunteer to paid staff is that as institutions we spend a significant amount of money administering volunteer programs. Assuming that we redeployed volunteers who had been docents into other areas of the museum, there would still be costs involved in administering the program, but they would be reduced. Many museums have at least one staff person who devotes a significant amount of time to overseeing volunteer docents. While paid educators would still need to be supervised and trained, they don't need the same amount of hands-on management. The turnover of fairly paid educators is likely to be less than that of docents, reducing the amount of time that an administrator would have to spend on recruiting, hiring, and orienting. Though restructuring one or more supervisory jobs may also not be an immediate solution, it presents several options in terms of how a coordinator role could be reassigned to better meet strategic initiatives or eliminated to offset the implementation of educator pay.

Some museums have adopted the strategy of having two types of interpreter roles, some that are paid and some that are volunteer. Often the paid educators work with school groups, because of the perception that facilitating experiences with school groups requires a more specialized set of skills, and more consistency across staff, than working with the general

public does. While this strategy may seem like a step in the right direction in terms of professionalizing the interpreter role, it has its own problems. For one, having two categories of interpretive staff limits flexibility and the ability to cross train. It can also create division and territoriality within the department. Such dual categories may even violate the Fair Labor Standards Act, if a volunteer and a paid educator are doing the exact same job.[6] More importantly, the "split" strategy sends a mixed message: education departments who use this model have essentially acknowledged that volunteer educators do not have the training or skill to meet the needs of a school program, but that the quality of their tours is good enough for the general public. The members of the general public are our community, and we should be giving them the same quality of experience that school groups receive. If the volunteer interpreters aren't able to deliver school programs at a high enough level, the solution is not to create a system that allows two different levels of quality, but to raise the quality of all visitor encounters.

Next steps

I believe that over time a reliance on volunteer docents to facilitate educational experiences in museums will be phased out, due to a lack of people available to fill the role, a growing disconnect between the demographic makeup of docents and visitors, and a moral conundrum similar to that surrounding unpaid interns. However, if museums really want to position themselves as catalysts of change and promoters of diversity, equity, accessibility, and inclusion, then I challenge those who still use volunteers to deliver mission-critical education programming to make a bold change according to their values,

rather than waiting for the tide to change gradually. Educators with demonstrated skill, experience, and training need to be paid at the market rate for professional educators. While most Americans seem to be in agreement that teachers in our public schools are underpaid, few people probably realize that to most museum educators, a public school teacher's salary and benefits seem like an unattainable luxury. Volunteers need to be redeployed to other areas of the museum, where they can be helpful in ancillary roles that do not take the place of paid staff. Visitors – including, but not limited to, schools and teachers – deserve to have the highest quality educational experiences possible at our institutions. Museums need to actively invest in attaining excellence in those experiences rather than cutting corners to save money or overlooking mediocrity to retain donors. Ultimately, museums couldn't exist without talented staff and loyal visitors; investment in these constituencies is the most fundamental, mission-critical obligation of museums. It's time for all museums to fulfil that responsibility by paying all front-line educators as the skilled professionals they are.

NOTES

1. Demographic studies of docents are not readily available. However, Halperin's article about the High Museum of Art's goal of diversifying its docent corps cites the group as having only 11% people of color in 2011, in a city that is 52.3% Black or African-American, according to the 2010 census.

 Halperin, J., 2017. How the High Museum in Atlanta tripled its nonwhite audience in two years. *Artnet*, December 27. Retrieved April 2, 2019, from https://news. artnet.com/art-world/high-museum-atlanta-tripled-nonwhite-audience-two-years-1187954

2. See: Ivy, N., 2016. The Labor of Diversity. Washington D.C., *American Affiliation of Museums*, January 1. Retrieved from: https://www.aam-us.org/2016/01/01/the-labor-of-diversity/

3. Santa Barbara Museum of Art Docent Programs. Retrieved April 2, 2019, from https://www.sbma.net/ support/getinvolved/docent

4. Docent programs. Retrieved April 2, 2019, from https://benton.uconn.edu/ education/docent-program/#

5. Ethics, standards, and professional practices education and interpretation standards, n.d. Retrieved April 2, 2019, from https://www.aam-us.org/programs/ ethics-standards-and-professional-practices/education-and-interpretation/

5. Fact Sheet #14A: Non-profit organizations and the Fair Labor Standards Act (FLSA). (2015, August). Retrieved April 3, 2019, from https://www.dol.gov/whd/regs/ compliance/whdfs14a.pdf

RE-ENGINEERING THE WAY MUSEUMS WORK

Jon Ingham

MANY MUSEUMS TRY TO MINIMIZE their staffing budgets by reducing headcount and keeping their employees' salaries low. But this strategy is not sustainable. It is a bit like trying to lose weight – you can focus on your diet and lose a few pounds, but are most likely to end up putting the extra weight back on. Instead of this, most people find the best way of losing weight is to change their lifestyle. The same type of thing is true in organizations too, so what museums really need to do if they want or need to "slim down" is to change the way they organize their work and their people. The supplementary effect of this approach is often that museums will need fewer people and, in most cases, they will also be able to pay their people more appropriately too. This chapter reviews the opportunity for this re-engineering, supported by digital technology, and its impact on the types and levels of staff rewards.

The changing context of work

Organizations across all sectors, not just museums, are currently undergoing major transformations due mainly to the impact of digital technologies. The museum sector itself has seen many instances of this, for example with the use of guides and apps to help people explore and learn about their collections. Devices such as multimedia guides allow visitors to walk at their own pace whilst accessing tour guide-like support (Van Gogh Museum, n.d.) and mobile games such as the V&A's *Secret Seekers* enable families to uncover facts about the V&A through a social gaming experience (Price, 2017). Even more innovative approaches include a pen which allows visitors to create and collect their own objects (Cooper Hewitt, 2014). Other institutions, such as Detroit (Detroit Institute of Arts, n.d.), Cleveland

(Moore, 2015) and elsewhere are using virtual and augmented reality to provide exciting new immersive ways of interacting with displays. Increasingly, museums are looking at the Internet of Things (IoT) and the better use of data to provide even more personalized, engaging and educational experiences.

However, digital transformation is rarely just about technology. All the above examples potentially disrupt a museum's business model and allow or require the development of new, broader organizational ecosystems. For example, many museums have partnered with Google Arts & Culture (Google, n.d.) to extend their audiences and allow people to view objects or access collections in different ways – a development which has direct potential impact (both positive and negative) on access, collections management, processes and staff.

Digital technologies are also allowing commercial organizations to get closer to their customers and other stakeholders in order to better understand and meet their needs. Likewise, many museums are also developing deeper, longer-term and more collaborative relationships with their own "customers" (i.e. both visitors and wider audiences), embedding themselves within the societies and communities in which, and for which, they exist. So, just like their commercial counterparts, museums increasingly need to become more customer-centric, which includes the use of human-centered design initiatives (such as journey mapping, personas, participatory design, user testing and prototyping) in the way they work.

These approaches are particularly important in museums which often find themselves in a rather unfortunate paradoxical position. The positive aspect of this is that the work museums do is increasingly recognized as lying at the center of culture,

knowledge, creative and tourist industries – all of which provide significant economic and social benefits. However, at the same time, we see that in many countries museums' outputs are often undervalued by both the public and governments, leading to reduced funding (and therefore greater pressure on sustainability), or even self-financing arrangements, which can force museums to reduce salary levels.

Dealing with such a situation requires museums to become ever more entrepreneurial, commercial, digital- and customer-focused in order to find new ways to provide compelling experiences for their customers. In turn, this requires re-engineering of the way museums work – with museum staff themselves at the center of this approach.

People have always been the basis for success in any organization. This is probably best explained in a classic *Harvard Business Review* article on the service profit chain, which demonstrates how satisfied employees lead to satisfied customers (Heskett *et al.*, 2008). These days, we tend to focus on employee experience, or the level of satisfaction provided by the nature of people's jobs, and the physical, cultural and digital environments in which they work (Morgan, 2016). We need to provide people with a compelling *employee* experience in order to provide the sort of compelling *customer* experience outlined above. Providing a compelling employee experience therefore requires deployment of the same kind of techniques (such as journey mapping), organizational and managerial activities as those which are customer-centric.

As shown in Figure 1, it is also useful to recognize that new opportunities for performing activities and changing the context of work are often best identified by people that are *near to* where

	Employee / Worker Experience / Satisfaction	Customer / Stakeholder Satisfaction	Museum Performance
DESCRIPTION	Satisfaction with overall integrated experience (design of job / gig plus digital, physical and cultural environments)	Satisfaction with omni channel access to museum	Increased revenues and margins Repeat visits Profitability and staffing budget to pay people appropriately in the new organization model
SOURCE OF INSIGHT	Employees / workers and employee / worker facing HR and other groups	Customers and customer facing employees and workers	
DESIGN APPROACHES	Journey mapping Personas User testing Prototyping		
NEW SOLUTIONS	Use of digital technologies and data Closer to employees / workers and customers New organization / business models Organizational networks and business ecosystems		

FIG. 1: The museum service profit chain in the digital age.

the work is done, rather than by those actually doing the work. For example, the source of insight for external opportunities should be customer-facing employees rather than customers, and the source of insight for internal opportunities should be HR generalists or business partners, rather than employees themselves.

Taking the retail sector (another sector in which organizations often aim to reduce staff costs) as a comparator, Harvard Professor Zeynep Ton promotes a good jobs strategy as the basis for an uncommonly employee-centric way of operating (Ton, 2014). This is based on an ongoing cycle in which good quality and quantity of labor leads to good operational execution, which then provides high sales and profits, which in turn allows higher staffing budgets to provide the required labor. In particular, a "good jobs" strategy allows organizations to maintain a certain level of slack resourcing, which enables them to respond to new requirements and opportunities.

Ton's research suggests this strategy provides significant business benefits over a "bad jobs" approach, and that the strategy works in other sectors too. For example, in manufacturing, Toyota has been more successful than many companies because its well-trained and empowered workers are able to implement standardized management processes which enable the company to deliver excellent quality.

In the museum sector, a good jobs strategy needs to involve quality employees working in a flexible way. This will often require moving away from the standard nine-to-five work day and a single location, to being more available when and how customers want access – for example with varied staffing patterns responding to peaks and troughs around exhibitions. Staffing also needs to respond to new and more quickly

changing skill requirements, which include a more commercial focus, customer service, partnership working, and the broader mindsets and abilities required to provide value. Increasingly, staff will also need to work in cross-functional teams and internal or external networks.

One current example is a transformation taking place across the seven museums run by Leicester City Council in the UK, where curator positions are being replaced by a new audience development and engagement team, aimed more tightly at attracting new and more diverse audiences (Adams, 2019). Whilst this is a controversial move, generating huge debate on social media channels, with museum professionals concerned about loss of scholarship and expertise, the move is designed to create a more nimble service that is more directly responsive to the needs and expectations of a twenty-first century audience. Today's audience development and engagement teams are yesterday's curators.

Therefore, the advancement of digital technologies, the adoption of increasing people-centricity and the promotion of good jobs strategies may reduce, and will certainly change, the demand for staff. This makes a museum's workforce even more important to its success. Museums need to invest in their core domains – but they need to invest in smarter and more tailored ways of managing their staff too.

Changing requirements of staff

Managing staff more smartly is also important because the expectations of the workforce have changed. People want, and increasingly demand, a sense of purpose and meaning from their employment as well as a connection with others in the

workforce. Employers in all sectors already need to respond to this demand, which will become an essential requirement if we see the widespread introduction of initiatives like Universal Basic Income (UBI). UBI will result in people having a realistic opportunity to work on what they *want* to do, rather than *have* to do, and could provide a significant opportunity for employers like museums in the creative economy.

People also want more flexibility, often including the need to work part- rather than full-time, to work at home, to work for multiple organizations as freelancers, or to develop "side hustles" on top of their main employment. Importantly, these expectations are not limited just to generation Y or Z (or their global equivalents such as China's post-80s) but are increasingly expressed by people of all ages. Organizations, therefore, need to focus on meeting these workforce needs as well as their business and customer ones. Sometimes this can be quite easy. For example, museums often need project-based staff to design exhibitions and this short-term focus often fits the aspirations of people who want to work in this role.

Similarly, museums' increasing need for flexibility often means they need to get work done by temporary employees, contract or "gig" workers, and consultants. This contingent workforce is an increasingly common addition to the traditional organization. For example, as shown in Figure 2, Charles Handy's shamrock organization model (Handy, 1995) now needs to be considered to have four constituent parts (or leaves) rather than just three:

- A **core** workforce with specific skills and a high alignment with a museum's mission who want a long-term relationship with the museum. The core workforce may

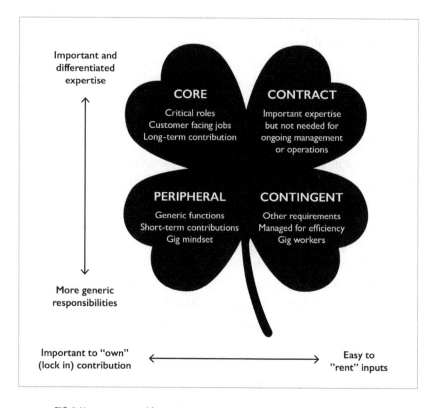

FIG. 2: New museum workforce segments.

include curators and conservators, but also front-of-house and visitor experience staff, whose excellent as opposed to average performance can make a huge difference to customer experience.

- A **contract** workforce of key talent who do not fit the above profile but are still really important for the museum's future. Handy suggests this may include people who have previously been employed by the organization. Web designers and other digital staff may also fall within this category, perhaps with part-time, often freelance, engagement contracts.

- A **peripheral** workforce who will probably be employees rather than gig workers, but who may bring a "gig mindset" (McConnell, 2018) to their work, meaning that they are more focused on their own development and career rather than loyalty to their current, short-term employment. This workforce segment will include staff working in generic functions such as finance and marketing, as well as areas like security and food and beverage (if these are not outsourced).

- The additional leaf provided by the **contingent** workforce of gig workers and other short-term contributors. This group could include people working in a range of different areas in which it is easier and more effective to rent rather than own capability. As opposed to the contract group, these staff will not generally provide a strategic differentiation and this means they may need to be managed with rather more focus on efficiency.

Each of these different workforce segments has different requirements and expectations and will need to be treated differently, though similarly in terms of the relative quality of the approach.

Meeting each of these segment's needs can be fairly easy since the flexibility required by an organization is often similar to the flexibility desired by individual staff members. However, the challenge is often in matching the two. For example, Glassdoor reviews from staff on zero-hour contracts in the UK show a significant difference in perspective depending on whether these arrangements have been designed to meet employees' as well as the employer's needs (Ingham, 2015). In addition, staff need to be participants in the design of any flexibility to ensure it really does meet their needs. Organizations also need to focus on providing suitable integration between these workforce categories in order to avoid tensions between them (McIlvane, 2019), as has been reported recently at Google (Wong, 2018).

Other ways of meeting the workforce's new expectations include providing more involvement in the core domain of the museum. For many staff, this will be a highly influential reason that they work in the sector and most museums could make much more of this alignment than they do, maximizing the opportunities for intrinsic as well as extrinsic motivation. For example, museums could develop internal communities which enable staff to contribute outside of their specific job areas, extending opportunities for their meaningful collaboration, activity and impact. Creating formal or informal forums within the museum to encourage and facilitate this begins to blur organizational lines and also creates more fluid, flow-to-the need teams.

The role of volunteers in many museums shows the potential provided by people who are naturally aligned to the core domain of the museum and want to contribute to a museum's cause, separate from any financial compensation for doing so. A good

example is the UK's London Transport Museum, which has a large volunteer workforce, including roles which might usually be considered standard paid positions, including research, IT, help desk analysts, curators, and event stewards. The museum takes this approach a stage further by using volunteering as a means to meet the museum's broader mission, providing volunteering experience as a means for people to grow into transport engineering careers with other employers through the museum's Enjoyment to Employment program (London Transport Museum, n.d.). However, it is important that this opportunity is not taken too far, as providing broader and more altruistic benefits can never be a good excuse not to pay people appropriately, and there is an argument that not paying volunteers and interns facilitates the idea that museums exclude people from poorer backgrounds, which is something that modern museums must seek to balance in their diversity strategies.

Opportunities for re-engineering

The changes required to support both customers and employees are often going to be very significant and may require radical re-engineering rather than more incremental change (although implementing these radical changes in an ongoing, agile manner is often the very best approach).

As shown in Figure 3, re-engineering means developing new processes and services to meet specific objectives, without being constrained by the way things are currently done. However, a key requirement is that these objectives now need to refer to employee expectations as well as business and customer needs. In addition, redeveloping processes and services to meet these needs will often benefit from including design thinking,

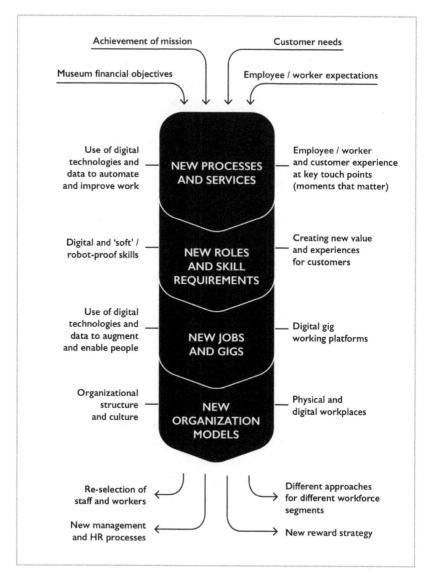

FIG. 3: Re-engineering museum work and staffing requirements.

personas and journey maps to help ensure interactions with employees at key touch points within or around the process are as positive as possible.

Once processes and services have been redeveloped it is possible to identify new roles and skill requirements to support these, allowing staff appropriate discretion to identify new ways of meeting customer needs in order to provide exceptional experiences.

These roles can then be grouped together to provide new jobs and gigs to be performed by people acting in the different segments of the workforce. These jobs and gigs will increasingly need to be supported by the use of digital technologies such as artificial intelligence, robotic process automation and robotics (Jesuthasan and Boudreau, 2018), as well as outsourcing, to ensure core, contract and peripheral staff can concentrate on the most valuable activities, as well as the digital gig working platforms required to support contingent workers.

These jobs and gigs can then be grouped together into an updated organization design. Whilst most organizations in the museum sector and elsewhere have traditionally organized themselves using functional and divisional structures, they are increasingly using new organization models (Ingham, 2017) based on project teams (the main opportunity for contract and especially contingent staff), and communities and networks (core, peripheral and contract staff). They are also increasingly using new approaches such as self-management. Museums should also look at using these more modern approaches, particularly as they tend to support people's sense of purpose and empowerment, helping them to add value to the institution and their customers.

Based on the above steps, museums can then check whether

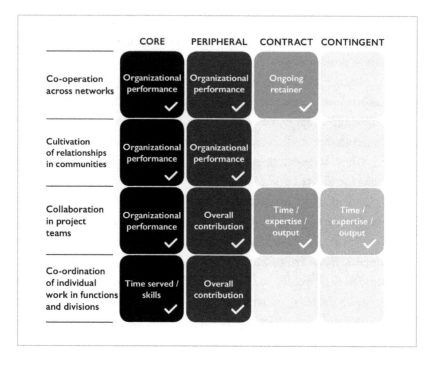

	CORE	PERIPHERAL	CONTRACT	CONTINGENT
Co-operation across networks	Organizational performance ✓	Organizational performance ✓	Ongoing retainer ✓	
Cultivation of relationships in communities	Organizational performance ✓	Organizational performance ✓		
Collaboration in project teams	Organizational performance ✓	Overall contribution ✓	Time / expertise / output ✓	Time / expertise / output ✓
Co-ordination of individual work in functions and divisions	Time served / skills ✓	Overall contribution ✓		

FIG. 4: Rewarding new workforce categories.

they have the right people working in these redesigned roles and reselect people into them as appropriate. Museums should also think more broadly about recruitment pools which may help them improve the diversity of their workforces. Museums also need to set up mechanisms to support changes in the workforce, such as the reformed HR and management processes required to support the various workforce segments. One particularly important requirement is to update the museum's reward strategy and practices.

Impacts on rewards

For many museums this type of re-engineering may mean a need for fewer core employees, but with these and other staff being more highly paid, as well as a need for looking new reward and recognition opportunities.

As shown in Figure 4, we increasingly expect to see museums adopting the following reward and recognition models:

- The **core** workforce receiving most of their pay through a higher base salary with progression being based on time served and the acquisition of skills to compensate this group for their ongoing commitment and involvement in a broad range of discretionary activities. They may also receive some variable reward linked to overall organizational performance to support their collaboration with other staff in projects, communities and networks, but this is likely to be quite limited since incentive pay is not generally a key motivator in the museum sector.
- **Peripheral** staff receiving a lower base than core employees, with pay progression based upon their overall contri-

bution in their jobs and on projects, with – where it makes sense – additional variable payments based on the performance of their departments or the whole organization.

- **Contract** staff being paid mainly on a project basis, either for their time if an employee, or for their outputs if a contractor, with pay in either approach reflecting the value of their accumulated experience and expertise. These staff may also be given additional retainers to keep them linked with the museum between projects.
- **Contingent** staff paid mainly for completing tasks and projects, as well as maybe some payments for ideas and innovations and other impacts. These staff may not be paid that much by any one museum but have the potential to generate higher levels of revenue from across their broader portfolio of work.

Museums also need to ensure that these different reward approaches are seen as fair by each of the different groups. This will be aided by greater pay transparency, enabling each group to understand the different reward approaches used for each group, if not the actual pay structures used within them.

To support collaboration across the workforce, we expect to see reducing pay differentials within museums so that, on an overall balance-sheet-based perspective, there is both a reasonable pay ratio between the most valuable core employee, and perhaps the lowest paid contingent worker (on a pro-rata basis), and that this ratio is also perceived as fair within each of these different categories. This will also respond to increasing shareholder and public concern about executive pay, and increasing pressure on both minimum wages and the immigration of

cheap labor in some areas, including the USA and UK.

However, as identified earlier on, pay is not the only motivator for people in any organization and museum staff in particular are motivated by a range of other factors. We therefore expect to see greater use of benefits and other personalized support, helping to meet the varied needs of a more diverse workforce, together with the increased use of recognition and perhaps other approaches like gamification to maintain levels of engagement, for at least as long as levels of pay remain low.

Summary

Re-engineering the work and staffing of museums aided by digital technologies and new approaches offers the potential for museums to find ways of moving from a focus on efficiency and saving money (a bad jobs strategy) to one focused on value and experience (a good jobs strategy). Whilst museums should follow this approach to ensure their own success and engage wider audiences positively in their domain, it would also support fairer rewards for the staff working in this sector.

REFERENCES

Adams, G. K., n.d. Leicester museums to restructure curato-
 rial team. *Museums Journal*. Retrieved March 12, 2019, from
 https://www.museumsassociation.org/museums-journal/
 news/27022019-curator-posts-face-the-axe-leicester-
 museums

Cooper Hewitt Museum, 2014. The new Cooper Hewitt
 experience. *Cooper Hewitt Museum*, June 13. Retrieved
 March 12, 2019, from https://www.cooperhewitt.org/
 new-experience/

Detroit Institute of Arts, n.d. *Lumin*. Retrieved March 12, 2019,
 from https://www.dia.org/lumin

Google, n.d. About the Google Cultural Institute. *Google*.
 Retrieved March 12, 2019, from https://www.google.com/
 culturalinstitute/about

Handy, C., 1995. *The Age of Unreason: New Thinking For A New
 World*. London: Random House Business.

Heskett, J. L. *et al*., 2008. Putting the service-profit
 chain to work. *Harvard Business Review*, July–August
 2008. Retrieved from https://hbr.org/2008/07/
 putting-the-service-profit-chain-to-work

Ingham, J., 2015. BBC Breakfast: zero hour contracts. *BBC*,
 September 2. Retrieved March 12, 2019, from http://
 strategic-hcm.blogspot.com/2015/09/bbc-breakfast-zero-
 hour-contracts-glassdoor.html

Ingham, J., 2017. *The Social Organization – Developing Employee
 Connections and Relationships for Improved Business
 Performance*. London: Kogan Page.

Jesuthasan, R. and Boudreau, J., 2018. *Reinventing jobs: a 4-step*

approach for applying automation to work. Boston, MA: Harvard Business Review Press.

London Transport Museum, n.d. Enjoyment to employment. Retrieved March 12, 2019, from https://www.ltmuseum. co.uk/support-us/enjoyment-to-employment

McConnell, J, 2018. The gig mindset is growing inside organizations. *NETJMC*, July 5. Retrieved March 12, 2019, from https://www.netjmc.com/ the-gig-mentality-is-growing-inside-organizations

McIlvane, A. R., 2019. Temp workers are angry – and HR needs to listen. *HR Executive*, January 23. Retrieved March 12, 2019, from http://hrexecutive.com/ temp-workers-are-angry-and-hr-needs-to-listen/

Moore, C., 2015. Artlens Studio. *Cleveland Museum of Art,* December 9. Retrieved March 12, 2019, from http://www. clevelandart.org/artlens-gallery/artlens-studio

Morgan, J., 2016. The employee experience equation. *Jacob Morgan Inc.*, February 25. Retrieved March 12, 2019, from https://thefutureorganization.com/ the-employee-experience-equation/

Price, K., 2017. V&A Secret Seekers – designing a new mobile game for family visitors. *V&A:* July 7. Retrieved March 12, 2019, from https://www.vam.ac.uk/blog/digital/va-secret- seekers-designing-a-new-mobile-game-for-family-visitors

Ton, Z., 2014. *The Good Jobs Strategy: How the Smartest Companies Invest in Employees to Lower Costs and Boost Profits.* New York: Houghton Mifflin Harcourt Publishing.

Van Gogh Museum, n.d. Multimedia guide. Retrieved March 12, 2019, from https://www.vangoghmuseum.nl/en/ plan-your-visit/multimedia-guide

Wong, J. C., 2018. Revealed: Google's "two-tier" workforce training document. *The Guardian*: December 12. Retrieved from https://www.theguardian.com/technology/2018/dec/11/google-tvc-full-time-employees-training-document

A CASE FOR SALARY TRANSPARENCY IN JOB POSTINGS

Charlotte Martin, Sarah Maldonado
and Anthea Song

ASSURING DIVERSITY AND EQUITY of museum and cultural institution employees is a necessary, but complex, issue that is paramount in our field. One relatively easy step toward this goal is to increase transparency in the hiring process, starting with job postings. Professional organizations and job boards can play an essential role in this process by requiring employers to include salaries in all postings.

This chapter follows the decision by the New York City Museum Educators Roundtable (NYCMER) to require salaries on all job postings and some of the initial effects, both anticipated and otherwise. Knowing that salary information is one factor in a large set of issues around equity in the workplace, the board moved forward with the policy change despite minor concerns about how this decision would impact an important revenue stream for the organization. Incidentally, the change coincided with an increase in revenue and we faced minimal resistance from job posters. Initial feedback on the policy includes improved transparency around pay within institutions and even improvements in wages, as both hiring managers and job seekers now have a way of comparing rates of different job types across the region.

This has been a successful policy change that can serve as a foundation for larger efforts in equity work. We encourage job boards and professional organizations to require salary details on all job postings.

Who we are

Since 1979, the New York City Museum Educators Roundtable has served to support informal educators in the tri-state area, through our mission statement to provide a forum for museum

education professionals to address meaningful issues relevant to our work and to exchange and disseminate current information. As a volunteer-run professional organization, NYCMER has long connected museum educators to accessible professional development and a community of peers.

Currently serving over 700 members, NYCMER offers monthly professional development and networking programs, an annual conference, peer groups, leadership opportunities, event postings, and a leading job board for our area in the field. These job listings, sent out via email to members and posted on our public website, enable museums and prospective employees to find one another in a field-specific forum. We see this as a benefit for our members, who can find relevant openings without having to wade through other listings, and for institutions, who have a pool of candidates with appropriate interests and experience. By charging job posters, NYCMER has an additional source of revenue to support the important work we do as a local museum organization.

Why salary information is important

By 2016, though, board members wondered about ways in which our job board could be perpetuating inequities in our field. In January of that year, the New York City Department of Cultural Affairs (DCLA), a major funder of cultural organizations, released the results of a year-long survey (City of New York, 2019) looking at diversity at all levels in the cultural sector, including museums. The survey found that though people of color make up 67% of New York City's population, they account for less than 39% of NYC nonprofit cultural staff. This discrepancy was even more apparent at the senior level,

in which only 26% of senior level positions were held by people of color. Meanwhile, education represented the fastest growing sector within cultural institutions, with the majority of positions (almost 89%) being part-time, and with a disproportionate number of white educators holding the relatively few full-time positions. Based on the report, the board recognized the high interest in entering museum education, but confirmed doubts that the field was not accessible to, or sustainable for, people of color and people lacking outside financial support.

At the same time, we were increasingly reading about how the process of salary negotiations and employers requiring candidates' salary histories negatively impact women (Kray, 2015) and people of color (Sturm, 2009). (New York City later made it illegal for employers to ask about an applicant's salary history during the hiring process, starting on October 31, 2017.) Without salary information up front, candidates are at a disadvantage walking into a job interview. We were also aware of the research noting that professions dominated by women tend to have lower wages (Claire Cain Miller, 2016), which concerned us, since the DCLA report listed that overall, women held 64% of education positions in cultural organizations. The 2017 American Alliance of Museums (AAM) National Museum Salary Survey (American Alliance of Museums, 2017) noted discrepancies in pay between men and women in many positions. The federal government also provided a compelling case study: federal jobs, including those in museums, have a transparent salary system (FEDweek, 2016). In 2016, people of color held 35.3% of federal jobs, as compared with 32.5% of civilian jobs.

In our field specifically, NYCMER board members also recognized that job titles and budgets vary wildly among

institutions. A museum educator at one organization could be another museum's coordinator, education specialist, freelancer, or manager depending on the size of the institution. Additionally, two people with the same title at differently sized museums could have vastly different responsibilities, hours, and salaries. Freelancers and part-time educators could also have varied contracts and expectations across institutions. Moreover, the AAM salary survey does not include part-time wages and needs to be purchased, as opposed to being an open resource. Aligning experience and expectations around pay could be incredibly challenging and frustrating for applicants across the board.

Lastly, bloggers and advocates like Vu Le and Paul Orselli, who respectively write the blogs *Nonprofit AF* (Le, 2015) and *ExhibiTricks: A Museum/Exhibit/Design Blog* (Orselli, 2017a), were calling on nonprofits and museums to increase transparency and list salaries for these very reasons. The NYCMER board wanted to take steps to actively address this issue. By requiring institutions to list salary ranges, we hoped to indirectly encourage organizations to offer more competitive pay. By increasing access to salary information, perhaps we could weaken barriers to entry and foster growth for professionals in our field, particularly people of color and women.

Concerns and anticipated outcomes
Although the board was committed to adding the salary requirement, we did have concerns related to the logistics of messaging this change and responding to pushback from museums. We also anticipated that this change could lead to a drop in revenue if museums decided to stop posting with us.

On the positive side, we felt that this requirement would improve the experience of our members by enabling them to focus their job searches, set their expectations, and negotiate existing salaries based on data from other museums. We also thought this change would help institutions by reducing the likelihood that an applicant might make it through the selection process, only to turn down the job due to the salary offer, since clarity at the start of the process often prevents misaligned expectations at the end of the interview process.

While we recognized that requiring salaries on all job postings would be a small step in addressing issues of equity in the field, it was one we could take quickly. In early summer 2017, the board, led by former President Kinneret Kohn, decided to move towards this new policy. It went into effect in August 2017, when we added a required field to NYCMER's online job posting form for a salary or salary range.

Implementing the new policy

Until July 2018, the board's Membership Coordinator, Sarah Maldonado, was responsible for all job and event postings. In the first year of implementing the new salary requirement, Maldonado often had to follow up with job posters to let them know of the policy change. She didn't meet any resistance until a month in, when a large institution initially declined to post salary information. However, within six days the museum reversed its policy and supplied salary details so the job could be posted. Success! After six months, a division inside another large institution declined to post salary information while a different division inside the same institution did post salary information. The third and final instance of an institution

declining to post salary details came from a mid-sized institution which posted salary information for a part-time job, but decided to remove additional language stating that there was a training rate to avoid having to list that rate. While an institution's size can sometimes play a role in these decisions, it's also worth noting that these three museums spanned three different content areas: history, art and science.

An important piece of our salary requirement is that we have worked to allow descriptive text, instead of insisting the job posters simply provide a number. This is sometimes vital in conveying the nature of a job. For instance, a small institution used the following language for the salary field:

> Base $250/day. Schedule to be determined with the candidate (see above re: FT/PT status) and pay is ultimately commensurate with fit and experience.

For a part-time event manager position, another small institution included:

> Monthly compensation based on event number by your team. Ex: 6 events/month – $1,250; 9+ events/month – $1,875. In addition, the [position] will earn 50% of profits on every event they lead.

To post a job on the NYCMER job board, the logistics require that the job must first be approved internally and then a link is automatically sent for payment. This is to help moderate any spam or incorrect postings that come in (such as listing multiple jobs in one submission). In general, there are always a certain number

of job posters who do not follow through with payment and thus their jobs are not posted to the job board. This can happen for a variety of supposed reasons – person who submitted the job doesn't see the payment link if it gets routed to their spam folder, their timeline for hiring has changed, the position was posted in error or is no longer available, their budget for recruiting has changed, or they simply forget to make the payment. While Maldonado made initial efforts to follow up with these disengaged job posters, many of these reasons are outside of NYCMER's control. There were some job posters who never responded to the request for salary information, and thus their jobs were not posted. After looking through our records, however, this potential reason for disengagement with the posting process was deemed less than all other instances. It is for this reason that we've only referenced exchanges where job posters explicitly declined to provide salary details.

The language used to prompt job posters for salary information was simple: "Can you please provide a salary range for this position? Transparent salary ranges is a new NYCMER job posting requirement." The follow up when a poster did not want to supply salary details was also straightforward and non-judgmental: "Unfortunately we won't be able to post the job without a range. We hope you understand why it's important that NYCMER support transparent hiring practices, and we hope you'll post with us if your museum policy changes." It has never been our intention to guilt or shame institutions into providing salary information, thus the point was not pushed further. We created a policy and it was up to the institution to oblige if they wanted to reach our member network. Our goal has always been to provide support to our members and be their voice in the informal education field.

Lindsey Steward
@Steward2Lindsey

I'm also glad that NYCMER is requiring salary information in job postings. It is important for us to show our support for equity and best practices in salary sharing and negotiations #NYCMER2018 #NYCMERsmj

♡ 7 9:23 AM - May 21, 2018

Margaret Middleton
@magmidd

Great news shared by @KinneretK: all job postings on the NYCMER website are now required to include salary! #NYCMER2018 #RaceWageGap #GenderPayGap

♡ 39 9:23 AM - May 21, 2018

JM Wasko
@jmwasko

What a great way for @KinneretK to kicked things off! Listing all of the ways @NYCMER is already 'reacting & responding' with what they've done this year (like requiring salaries on job listings! 💰) #NYCMER2018 #NYCMERsmj

♡ 6 9:22 AM - May 21, 2018

FIG. 1: Appreciation of the policy often came in the form of tweets.

CONFRONTING THE STATE OF MUSEUM SALARIES

Response from members and beyond

Our goal of supporting our members has been heard, as NYCMER continues to receive positive feedback from our members and others in the field. Anecdotally, job searchers appreciate the transparency which allows them to focus their job searches and approach salary discussions more confidently. Publicly, this often comes in the form of tweets directly praising the policy (Figure 1).

Advocates in the larger field have also pointed to NYCMER as a model for other professional organizations to add salary requirements to their job boards. Orselli, who praised NYCMER's policy in two of his posts (Orselli, 2017b and 2018), responded to our request for a comment:

> I still say the simplest starting point to moving museums toward paying ALL their employees a living wage is to require that salary ranges be included in every job ad. Professional museum groups that still refuse to institute that simple salary range requirement are derelict in their duties to their members and the broader museum field because of misplaced fears over lost museum job postings revenue.

We agree with Orselli's overall stance, and continue to encourage other professional organizations and job boards to require salary information on job postings.

Along with direct tweets, NYCMER and our salary policy is brought up in conversations and threads on Twitter. To see our organization openly mentioned, praised, and recommended for membership speaks to the support members feel (Figure 2).

Hannah Heller 🐦
@museum_matters

Replying to @LeahGolubchick and 2 others

Truth... so I originally found the listing on @NYCMER's job posting, which requires salary ranges (huzzah!)-- this one is for 30,000. Interestingly not included in the museum's own posting. So... yeah.

♡ 2 2:34 PM - Aug 31, 2018 ⓘ

Sara Lowenburg @slowenburg · Jan 26, 2018 🐦
Replying to @heyshaelyn
shout out to @nycmer for posting salaries now

shaelyn amaio
@heyshaelyn

Yes! So awesome! The field needs transparency around all of this!

♡ 1 2:56 PM - Jan 26, 2018 ⓘ

FIG. 2: The new salary policy was discussed in Twitter conversations and threads.

And we've seen this in our membership numbers, which continue to grow each year.

Revenue increase

Along with our member numbers growing, we saw an increase in job postings in the first year of implementing this policy. In our budget for the 2017-2018 fiscal year, we estimated our revenue from paid job postings based on 132 listings. We were pleasantly surprised to actually post 165 paid jobs throughout the year. In fact, this increase in postings put a strain on the Membership Coordinator's time to address her main responsibilities and led the board to create a new position to handle all postings. Anthea Song is the inaugural Event & Job Listings Coordinator. For the current 2018-2019 fiscal year, at the time of writing she has already processed 131 paid job listings and we are only nine months along. Out of those, only a handful of posters have required follow-up emails to list salaries, and none has explicitly declined to post based on the salary requirement

Additionally, in the first year of implementing the policy we posted three jobs with annual salary ranges between $60,000–$100,000. In this second year, again at the time of writing, we have posted sixteen jobs within the same range. Specifically, nine of those jobs had salaries listed between $60,000–$70,000, and seven of them listed salaries between $70,000–$100,000. Not only do our numbers of paid postings continue to increase, but we are receiving postings for higher salaried jobs. From this we can see that our policy does not cause employers to feel restricted to only submitting part-time or entry-level positions.

While our revenue has increased – and this helps make the business case for our decision – it is important to note that

we would not have rescinded our policy even if our revenue fell. Supporting our members and creating equity in our field is important! Including salaries in our job listings is an easy but powerful step toward that goal. By requiring salaries, we are helping to give our members the knowledge and tools to advocate for themselves and the teams they supervise.

Pushing institutional change

In addition to accolades from our membership base, implementing this policy has fostered tangible change in tri-state area museums and cultural institutions. The NYCMER job board has become a platform for both job seekers and hiring managers to compare wages across the area and job types.

At The Aldrich Contemporary Art Museum, in Ridgefield, CT, there have been more conversations around salaries, ultimately leading to a salary increase for *per diem* educators, beginning in 2019. According to Michelle Friedman, Head of Education and Academic Initiatives:

> NYCMER's push for salary transparency has led to many departments being up front with every *per diem* educator, teaching artist, guest speaker or consultant about the stipends or salaries offered.

On top of simply talking about the listed salaries for each position, Friedman adds:

> The education team and the visitor experience team have worked to ensure that all candidates have the opportunity to learn about and when possible negotiate the offered

salary with a clear understanding of how and why the number was determined as such and what room there is for discussion.

Even further, says Friedman, the Aldrich has "worked to open up conversations about salaries with other regional organizations to understand both where our offerings fall and where we should be."

Elsewhere, NYCMER's policy change "opened up promising conversations about how to share salaries at work," according to a hiring manager at a large institution:

> There was resistance that this could cause tension between other departments in education that don't publish salaries... Without NYCMER, we wouldn't have had the opportunity to talk about this issue. Seeing a major, heavily used job board require salaries gave those pushing for change an opportunity to move the conversation forward.

Beyond these two clear instances of forward progress, other hiring managers have reached out to us for advice on reasonable and competitive rates, based on the size of their institution and the type of job being posted. A director at a small institution who encountered a lower-than-anticipated response rate to an advertised position, contacted Song for support, in an effort to analyze the effectiveness of their post, including the listed salary. By cross-referencing other institutions in the area, they were able to contextualize the most up-to-date state of salaries in our field.

Strengthening the hiring process

Having access to salary details increases clarity at the start of the hiring process, which helps prevent misaligned expectations at the end. According to data from Glassdoor, surveyed across industries and fields, 67% of job seekers listed salary as a top piece of information when looking at a job posting (Glassdoor, 2018a). Julie Coucoules, Glassdoor's Global Head of Talent Acquisition, comments:

> Job seekers crave transparency on pay, not only to make an initial judgment about whether to consider applying for a job, but also to assess if an employer holds long-term potential for them.

In a second study, Glassdoor reported that during the interview process, 50% of individuals were frustrated by the lack of information about pay and benefits, showing that even once a candidate was selected for an interview, these details were not transparent enough (Glassdoor, 2018b). This frustration level was more common among the women in the survey than the men (57% and 44%, respectively).

While most museum professionals are drawn to the field because they love the work, we cannot overlook the impact of the salary on applicants' decision making. Take Maldonado's own experience, for example, where an employer did not want to discuss salary until the end of the hiring process. After three interviews, three reference checks, and a check-in call along the way, she finally discovered that the salary was extraordinarily low and that the small institution exhibited no interest in negotiating. While the job was exciting and a good fit, she knew that she

couldn't make the salary work. Had the salary information been provided at the beginning of the process, particularly in the job listing, the employer would have attracted candidates who found the offer suitable and would not have wasted an unnecessary amount of time for all parties involved. A director at a mid-sized institution shared a similar sentiment, saying they had come to realize "how important it is for applicants to be aware of the salary before they apply for positions. It's a fair practice that sets the right expectations and saves everyone time."

A manager at a mid-sized institution said they had initially found the request for salary information slightly surprising, "due to the fact a majority if not all of [the] job posting sites we post to do not require salary range." The hiring team, however, saw the requirement as an opportunity to reflect on their originally "somewhat wide" range and honed in on a set amount. By doing so, the manager acknowledged the advantage of "being able to filter out any candidates that feel that your salary range is too low for them." Additionally, according to Angela Agard, Manager of Administration at the New York Transit Museum:

[Including pay ranges] gives applicants a better understanding of the salary going into a job interview [instead of having] that awkward moment of having to ask... The advantages of salary transparency allow candidates to evaluate an institution not only on what it is paying for a particular position but also on social values, how it treats employees... The larger goal from an HR perspective is to be able to offer market value or more to attract exceptional candidates.

Already, applicants may use Glassdoor and other crowd-sourced sites to try to gather information about salary and workplace culture, but this information is piecemeal, potentially biased, and not necessarily specific to a particular job. Responding to this information gap, the National Emerging Museum Professionals Network (NEMPN) started a Salary Transparency Project which allows individuals to submit job postings that don't list salary information, and members of the NEMPN board "will reach out to the museum and start a conversation on the importance of salary transparency during the hiring process," according to the submission form. By being transparent about salaries, museums can reduce confusion and prevent further misleading expectations. Since some museums that post to NYCMER with a salary still do not list salaries on their own websites, the NYCMER job board is a particularly helpful tool for both job seekers and employers.

Looking ahead

We acknowledge that salary transparency is just one element in addressing issues of diversity and equity in the field. Other aspects include entry-level positions with strict education requirements, reliance on volunteers and unpaid interns, bottlenecks in departmental hierarchies, and implicit bias among existing staff and boards. Taking steps to continuously challenge and address these systematic roadblocks involves long-term work, but we are hopeful that we are moving in the right direction.

Within NYCMER, board members continually reassess policies around posting internships and volunteer opportunities and will work to use the organization's professional

development programs and collective voice to address these issues. For our own internship on the board, we have paid a stipend for the position since its creation in 2006, and we are committed to offering a fair amount.

As NYCMER maintains its policy of requiring salaries, we recognize the important contributions that other job boards and professional organizations have made by applying similar policies, including discipline-specific associations like the Association of Children's Museums and the Association of Science-Technology Centers, and regional networks like the Mid-Atlantic Association of Museums. Transparency on paid positions within the field provides anyone, including those considering entering the field, with a foundation of knowledge in regard to how their skills may be valued. We have been able to push forward with change because, as one hiring manager noted, "NYCMER has a niche in terms of reach in the museum arena."

As more organizations require salaries on postings, institutions will face increased pressure to amend their policies and increase transparency. All professional organizations and employers have a role to play, and we call on them to act by requiring salary transparency on all job postings.

REFERENCES

American Alliance of Museums and New Knowledge
 Organization Ltd., 2017. *2017 National Museum Salary
 Survey Snapshot: Education, Visitor Services & Research/
 Evaluation*. Washington, DC: American Alliance of
 Museums.

City of New York, 2019. *Diversity & Equity in New York City's
 Cultural Workforce*. Retrieved from https://www1.nyc.gov/
 site/diversity/index.page

FEDweek, 2016. *Demographic of Federal Workforce
 Summarized*. (February 24). Retrieved from
 https://www.fedweek.com/issue-briefs/
 demographics-of-federal-workforce-summarized/

Glassdoor.com, 2018a. *Salary and Benefits are Most Important
 for U.S. Workers and Job Seekers Looking at Job Ads, According
 to Glassdoor Survey*. Glassdoor, July 25. Retrieved from
 https://www.glassdoor.com/about-us/salary-and-benefits-
 are-most-important-for-u-s-workers-and-job-seekers-
 looking-at-job-ads-according-to-glassdoor-survey/

Glassdoor.com, 2018b. *Lack of Information about Compensation
 is the Biggest Frustration for U.S. Workers and Job Seekers,
 according to Glassdoor Survey*. Glassdoor, September 19.
 Retrieved from https://www.glassdoor.com/about-us/
 lack-of-information-about-compensation-is-the-biggest-
 frustration-for-u-s-workers-and-job-seekers-according-
 to-glassdoor-survey/

Kray, L. J., (2015). The best way to eliminate the gender pay
 gap? Ban salary negotiations. *The Washington Post*, May
 21. Retrieved from https://www.washingtonpostcom./

posteverything/wp/2015/05/21/the-best-way-to-
way-to-eliminate-the-gender-pay-gap-ban-salary-
negotiations/?noredirect=on&utm_term=.83b0b6abcdb1

Le, V., 2015. When you don't disclose salary range on a job
posting, a unicorn loses its wings. *Nonprofit AF*, June 1.
Retrieved from https://nonprofitaf.com/2015/06/when-
you-dont-disclose-salary-range-on-a-job-posting-a-
unicorn-loses-its-wings/

Miller, C. C., 2016. As Women take over a Male-Dominated
Field, the pay drops. *The New York Times*, March 20.
Retrieved from https://www.nytimes.com/2016/03/20/
upshot/as-women-take-over-a-male-dominated-field-the-
pay-drops.html

Orselli, P., 2017a. Is Your Museum Guilty of Weaselly Pay
Practices? Answer These 6 Questions to Find Out!
ExhibiTricks: A Museum/Exhibition/Design Blog, May 23.
Retrieved from https://blog.orselli.net/2017/05/is-your-
museum-guilty-of-weaselly-pay.html

Orselli, P., 2017b. One Way to Address the Museum "Pay
Problem" (Today!). *ExhibiTricks: A Museum/Exhibition/
Design Blog*, October 6. Retrieved from https://blog.orselli.
net/2017/10/one-way-to-address-museum-pay-problem.html

Orselli, P., 2018. Museums and Museum Groups – Stop
Covering Your A*s. *ExhibiTricks: A Museum/Exhibition/
Design Blog*, June 25. Retrieved from https://blog.orselli.
net/2018/06/museums-and-museum-groups-stop-cover-
ing.html

Strum, S., 2009. Negotiating Workplace Equality: A Systemic
Approach. *Negotiation and Conflict Management Research*.
Volume 2 (Number 1), 92–106.

TURNING TALK INTO ACTION

4

ACHIEVING SALARY TRANSPARENCY – JUST BY ASKING

Michelle Epps

AS MUSEUMS GRAPPLE with how to become more inclusive and equitable institutions for the public, museum professionals are struggling with the realization that their institutions are often not practicing the same care internally. It was this mounting frustration and heightened awareness of the conflicting priorities that prompted the National Emerging Museum Professionals Network (NEMPN) to mount a campaign aimed at identifying one issue we could actually work to change: salary transparency.

The National Emerging Museum Network was founded in November 2015 as an independent offshoot of the American Alliance of Museums' (AAM) Emerging Museum Professionals (EMP) initiative, which was launched in 2007. The initiative was initially created to service those in their museum career for less than ten years. Now, NEMPN defines "emerging" as a self-selective term and does not put a time restriction on the classification. The NEMPN separated from AAM in late 2014 after the Alliance determined it would no longer support the EMP initiative. At this point there were already 36 chapters established across the United States. Under the direction of Seattle EMP Chapter leader Laura Lantz and the author (as Cleveland EMP Chapter leader), the chapters met to develop a Leaders Network, which would eventually evolve into the National Emerging Museum Professionals Network. In 2016 NEMPN formed an Executive Committee for the purpose of governing the network. And in 2017 a board of directors was brought together for the purpose of becoming a 501(c)(3) organization. After a successful Go Fund Me campaign in 2017, NEMPN was able to file for 501(c)(3) status and became a tax-exempt nonprofit. Currently the NEMPN comprises 53 chapters across the

USA, Canada, and the UK.

In 2018 the Emerging Museum Professionals Facebook group was alive with posts, comments, and discussions from museum professionals repeatedly making it through an interview and being one of a few finalists for a position, only to find out that the position pays only $10 per hour or less. The commonality to all these threads was that had the individual known what the salary was they would have not bothered applying for the position and wasting their and the museum's time. It was also at this point that we saw a backlash from some museum professionals who lamented they would have happily accepted the position because it was more than they were currently making, and from others who felt they didn't have the luxury of turning down jobs because of low pay. The remedy seemed simple: include the salary in all job postings and allow individuals to self-select whether they want to work for the pay offered. We surmised that if we could convince museums to make this simple change to their hiring practice they could save themselves time and money by not interviewing people who will turn down the position when the salary is revealed; or worse still, be appointed only to quit six months later for a better paying position. We just needed to convince museums to make this switch.

According to the The Institute of Museum and Library Services the number of museums in the USA alone is 35,000 (2014). Since it would be impossible to have conversations with 35,000 institutions the next best thing would be to talk to the associations and organizations these museums use to advertise jobs. In August 2018 we launched our Salary Transparency Letter Writing Campaign. The game plan for our campaign was

to make a case for salary transparency, demonstrating over-whelming support for this change in the form of letters from museum professionals. We quickly identified 60 museum associations that hosted job boards. Of these eleven were nationally focused, six were regional museum organizations, three were international museum organizations, and the remaining 38 were state museum associations. Out of this list of 60 organizations, only two required salaries to be quoted prior to our campaign.

Before launching the campaign publicly, we reached out to Executive Directors or Board Presidents of each of these organizations to inform them of the campaign and that our intent was not to bully or coerce them to change their posting policies, but rather to convince them it was the right thing to do. Our letter is reproduced at Appendix 1.

We also followed up after these letters with a personal email from myself as Board President to make sure the communication was received. In cases where there wasn't an existing relationship with the organization the same text as above was sent.

Shortly after sending out these communications we started to receive requests to discuss the Letter Writing Campaign in more detail. I spoke to 25 organizations. These initial conversations were fruitful and resulted in a number switching over before we even launched the public call-to-action part of our campaign. Out of these 25 organizations, ten indicated that they would present the change in policy at their next board meeting; twelve switched to requiring or strongly encouraging salary inclusion, or expressed a commitment to do so; and three were unable to commit due to pressure from their board or other contributing factors.

We then turned to the public and asked for their help in writing letters and signing our online petition which we had created through Change.org. We were able to create one petition which would send our collected electronic signatures by email to the 46 museum associations from whom we had not yet received a commitment. Our Change.org petition was set to incrementally email all the museum associations based on signature milestones starting with ten signatures, then twenty, then 50, 100, and so on. The language of the petition was slightly different than the letter and email sent out from NEMPN to the museum associations, as we were also trying to make a case to our public audience about the importance of either writing a letter or signing the petition. The petition is still live (as there are still 36 museum associations not requiring salary on job boards) and is reproduced at Appendix 2.

We also provided the public with the addresses and contact person for each association, along with a sample letter.

We are unable to say with certainty how many people actually mailed physical letters, but as of 6 May 2019 there were 496 signatures on the Change.org petition. It is still an open petition as of that date.[1] After the petition became live and was widely shared on social media, we started to receive new responses to our initial letters and we spoke to an additional eight museum associations, three of which made the switch to requiring salary almost immediately. We also received commitments to require or strongly encourage salary transparency from seven of the ten organizations we initially spoke to after having the opportunity to speak with their boards.

We also requested endorsements from social media influencers who were also advocating salary transparency on job

postings. We reached out to POW! (Paul Orselli Workshop, Inc.), Vu Le (Nonprofit AF), and Museum Hack, all of whom responded by either sharing our petition or including it in their own calls to action for salary transparency. Paul Orselli wrote about our campaign in his November 2018 blog post, *Labor Pains: The 2018 NEMA Conference and the Museum World's Ongoing Wages and Workers Challenges.*

It was with these combined efforts we were able to successfully make the case for salary transparency. Out of the 35 museum associations NEMPN had spoken with, fifteen are now requiring salary to be listed when posting a job, and seven are opting to strongly encourage salary transparency for a set period of time and then revisit the policy after an education period with their institutional members. Additionally, three museum organizations which were not identified on our original list reached out to NEMPN informing us they had made the switch and requesting to be added to our list of museum associations making the change. Of those that switched to require or strongly encourage salary transparency, many provided encouraging endorsements:

> I think this is a positive step for the entire museum field, and I hope this requirement will help not only those seeking museum jobs know what their salary ranges might be, but will also help museums take stock at what their peers in the field are offering for positions in their organizations.

Of the thirteen museum associations that opted not to make the switch to salary transparency, we received a number of reasons,

all of which were valid. These included:

- An educational campaign on diversifying the hiring prac-
 tices of museums and promoting unbiased job postings
 would have a more positive impact than just looking at
 salary ranges.
- Individual museums have different policies for a vari-
 ety of reasons, and we aren't in a position to determine
 if those policies are right or wrong for the individual
 museum.

Though these arguments have merit, we felt having the dis-
cussion about pay transparency was a step in the direction of
unbiased job postings. We also want to address the issue of
"enforcing policies" on museums, which some have accused us
of. In fact, we want museums to come to the implementation
of salary transparency on their own and not through coercion.
But we also don't think it is wrong for a job board platform to
ask that museums adhere to a standard when sharing open job
positions.

Though the Salary Transparency Letter Writing Campaign
has concluded, we are still continuing our effort to promote
salary transparency on job postings. We will continue to reach
out to the 23 museum associations we were not able to connect
with to make our case, and we will circle back to the eleven
museum associations that needed more time and evidence.

A common complaint we received from museum associa-
tions during our campaign was that this should be a conver-
sation held directly with museums. As a response to this we
launched our Salary Transparency Alert form in March 2019,

providing a platform for job seekers to notify NEMPN when a job is posted without salary information. The job seeker fills out the Google form online and we follow up with the museum directly asking them to join us in our effort to make hiring practices in museums more equitable by including salary information. To date we have received over 70 alert submissions and one response from a museum agreeing to make the change. We hope this new effort will allow us to saturate the museum field with the conversation around salary transparency and will result in more museums seriously considering changing their job posting policies.

APPENDIX 1

Dear esteemed colleague

We appreciate the resource the (insert name of association) has made available to the museum community by hosting a "job board" on your website which saves employment-seeking museum professionals time and frustration during their job search. As you may know, museums also benefit from this arrangement by reaching a wider audience and attracting a larger talent pool than they otherwise would through their traditional means of communication. On the surface this arrangement seems an even trade; job announcements are brought to the attention of job seekers. Unfortunately, the issue is considerably more complex than it appears which is why we are writing today. In the next couple of weeks the National Emerging Museum Professionals Network will launch a letter writing campaign encouraging museum associations across the U.S. to change their jobs board requirements. We hope this campaign will demonstrate the overwhelming support for adopting a new best practice for job posting.

Currently, the common practice has been non-disclosure of salary ranges or hourly pay rates for museum jobs. There seems to exist a fear among museum hiring committees and executives that disclosing pay will scare off potential talent, or somehow compromise their ability to negotiate for a salary range they can fit into their budget, or worse, the current employees may become disgruntled if they find a new hire could potentially make as much, or even more, than themselves. Though we can sympathize with these concerns, change must happen.

Vu Le, Executive Director of Rainier Valley Corps, has pointed out in his widely read blog, nonprofitaf.com, the system of non-disclosure contributes to the lack of diversity in the nonprofit workforce, unfair compensation, and a high rate of burn out. As we strive to diversify the field and make museums and cultural institutions more equitable, we want to advocate for levelling the playing field for those who want to work in museums. We hope this campaign will help you demonstrate to your board that there is overwhelming support for this change in practice and join us and the growing number of associations now requiring salary ranges for job postings on their websites and through other communication channels. We look forward to seeing these requirements posted on the (insert name of association) job board in the near future.

Sincerely

**National Emerging Museum Professionals Network
Board of Directors**

APPENDIX 2

Currently the common practice has been non-disclosure of salary ranges or hourly rates for museum jobs. Many organizations believe disclosing pay will limit the submission of potential talent, compromise their ability to negotiate for a salary range they can fit into their budget, or cause distress among current employees regarding pay disclosure.

However, as Vu Le, Executive Director of Rainier Valley Corps, has pointed out in his widely read blog, nonprofitaf.com, the system of non-disclosure contributes to the lack of diversity in the nonprofit workforce, unfair compensation, and a high rate of burn out; all things that are harmful to museum operations. Because institutions have been slow to change their job posting format, we are reaching out to the Museum Associations that host job boards to adopt the following job posting requirements, along with the reasoning behind each one.

Require accurate salary range

The job hunt is time-consuming and expensive for both the employer and prospective employee. Posting an accurate salary range will help both sides avoid wasting time on jobs/candidates they cannot afford.

Paid positions only

Unpaid internships are only available to those who can afford to work for free, and disqualify many people without the means from getting experience in our field.

Strongly encourage to include the name and title of the person to whom candidates should address applications

This avoids any confusion for candidates submitting applications, resumes, and cover letters.

Strongly encourage to include interview format (group, panel, one-on-one, etc.)

This allows candidates to better prepare for an interview and reduce the stress of the unknown.

Strongly encourage to include a breakdown of the hiring process from application to training

This offers candidates a clear picture of what to expect and give them a better understanding of your timeline

There is a plethora of conversations happening within the field regarding diversity, equity, accessibility, and inclusion, but we would like to recognize the need for action. Disclosing salary ranges on a job posting may not solve all these problems, but it will be a step in the right direction. Please join the National Emerging Museum Professionals Network in requesting Museum Associations to consider changing their posting requirements for posting job openings.

Thank you!

Michelle Epps
Board President

NOTES

1. The Change.org petition is available at https://bit.ly/2DSdt7H

2. At the time of writing, the 27 museum associations requiring or strongly encouraging salary transparency are:

Michigan Museums Association, Ohio Museums Association, Mid-Atlantic Association of Museums, American Association for State & Local History (AASLH), Missouri Association for Museums & Archives, National Association for Interpretation, Museums Association of Montana, Maine Archives & Museums, Small Museum Association, Museums Alaska, Museum Association of Arizona, Greater Hudson Heritage Network, Mountain Plains Museums Association, Association of Science-Technology Centers (ACTC), Louisiana Association of Museums, Kansas Museums Association, New Mexico Association of Museums, Southeastern Registrars Association, Midwest Regional Conservation Guild, and New York City Museum Educators Roundtable (Required), Pennsylvania Federation of Museums and Historical Organizations, Southeastern Museums Conference, Virginia Association of Museums, Association of South Dakota Museums, Utah Museums Association, American Institute for Conservation of Historic and Artistic Works, The Association for Living History, Farm and Agricultural Museums (Strongly Encouraged).

PROFESSIONAL ASSOCIATIONS AND LABOR POLICIES

Jessica Brunecky

THE COLORADO-WYOMING Association of Museums (CWAM) is positioned to serve two states, a unique model among museum associations. The organization therefore covers an extensive geographic area and confronts the needs of museums on a continuum from urban to rural. Unpaid labor (i.e volunteer positions and unpaid interns) is an issue that exists across that continuum and its impact on the museums and their communities can be drastically different. While museums and cultural organizations have long relied on unpaid labor, the future of these labor practices is being questioned, especially by those concerned with equity and diversity. These issues are of central concern as the CWAM board debates how to create critically-needed dialog on unpaid labor at the state level, in both states.

Colorado is a prime study in contrast of urban and rural areas. Within the Denver metro area, which propels Colorado's economic growth, arts and cultural organizations recorded over two million volunteer hours in 2016 alone (Colorado Business Committee for the Arts, 2017). This is the equivalent of over $53 million in unpaid labor and equal to the labor of nearly 1,000 full time employees. Hours contributed by unpaid interns were not part of the calculations, but would undoubtedly be substantial as well. However, many museums served by CWAM operate outside of the metro area and currently no similar surveys of unpaid labor exist.

Despite its close proximity, Wyoming faces separate economic forces than Colorado's largest metropolitan area. Its main economic driver is the energy economy, which is prone to boom and bust cycles. Its second largest economy is tourism, driven in large part by the numerous National Monuments and Parks within its borders. Wyoming also has around 10% of the

population of Colorado in nearly 94% of the land, making it a sparsely populated state by comparison.

Methods

To better understand the labor challenges facing the museums we serve, the CWAM board convened a sub-committee on unpaid labor in December 2018. Our intent was to gather data to inform our analysis of how paid, under-paid, and unpaid labor vary between our states. In addition to background research into the economic and demographic differences between the two states, the committee agreed to pursue the following research strategies: an online survey of our members, follow-up interviews with those respondents who expressed willingness to answer more detailed and nuanced questions, and hosting an in-person town hall discussion on labor issues.

The online survey consisted of ten questions, ran for four weeks in February 2019 and resulted in 40 completed responses. Twelve follow-up interviews were guided by seven questions and were conducted over two weeks following initial analysis of the survey results. Additionally, eleven museum professionals discussed labor issues at an hour long in-person CWAM town hall discussion in March.

Survey responses

The 40 completed responses were well distributed, with an appropriate range of types of museums with varying governance, budget and staff sizes, and locations within both states. There was one shortcoming worth noting: despite outreach efforts, there were no responses from rural museums in either state (defined as serving areas with a population less than 1,500). Unsurprisingly,

institutions reporting more than 100 unpaid volunteers or interns were all located within the Denver metro area: 72% also reported 100-plus full time staff, and 64% reported annual operating budgets of $10 million or more (all reported annual operating budgets over $1 million). For institutions with annual operating budgets under $1 million, 86% reported fewer than ten full time staff and 50% reported fewer than ten volunteers or interns as well. Institutions with an annual operating budget of less than $50,000 reported fewer than ten individuals that fall into one of the following categories: full time staff, part-time staff, volunteers or interns, or were volunteer-run institutions.

One surprising result was that 40% of respondents indicated that their institutions always include salaries with job postings, and an additional 12.5% of respondents work for institutions that leave the choice with the hiring manager. 88% of these institutions have governance structures within a municipality or university, and may adhere to transparency guidelines as required by their parent organizations.

The survey also revealed that there is a strong desire to learn more about the estimated cost of living, with 66% of respondents indicating an interest in the topic. Respondents from museums of all sizes and governance types, from across both states expressed this interest. Cost of living, especially when compared with salaries for job postings, was also a topic in numerous interviews.

Key findings
Minimum wage and volunteering
One contrast identified in the background research was the minimum hourly wage for each state. Colorado's minimum wage increased to $11.10 per hour on January 1, 2019, while

Wyoming maintains the Federal minimum wage ($7.25 per hour). This disparity illustrates the differing economic conditions of the two states, and was referenced by a number of the interviewees from Wyoming as labor issue of concern in their area. For example, some cited a struggle to keep entry level workers when the museum could only pay slightly above Wyoming's minimum wage, while large chain stores in the area have increased entry level salaries to $11.00 and $12.00 an hour. Notably, the 2019 Wyoming legislature failed to pass a bill to increase the state's minimum wage to $10.00 by 2025 (Connolly et al., 2019). Respondents from both states expressed a fear that those entry level workers who choose to stay in museums are falling victim to the outdated philosophy that museum workers must sacrifice income for their passion and their field.

A 2010 economic analysis published in the *Journal of Economics and Business* may in part explain why Colorado's largest museums and cultural institutions rely so heavily on volunteers: volunteer labor at nonprofits increases as a substitute for lower paid labor when minimum wages increase (Simmons and Emanuele, 2010: 73). Our survey data confirmed that large institutions in Colorado's metro area rely most heavily on volunteer labor. This is especially concerning when viewed in conjunction with the 2005 analysis published in *Nonprofit Management and Leadership* which revealed that "nonprofit organizations engaging volunteers have significantly lower wages that nonprofits employing paid staff only" (Pennerstorfer and Trukeschitz, 2005: 187). Thirteen percent lower, according to their analysis (ibid). One could extrapolate that urban Colorado institutions are increasingly relying on volunteers in place of paid entry level workers because of the rising minimum wage, and as a

result of the increase in unpaid labor are paying workers less across the institution. Interviewees at institutions with very large volunteer pools in the Denver metro area were more likely than those in mid-sized cities in either state to cite "unlivable" wages as one of the biggest issues facing their area.

Internships

Another form of unpaid labor of great interest to the sub-committee was internships. Interviews provided the most insightful data regarding use of interns among institutions in both states. Unsurprisingly, large institutions with 100-plus full time employees reported the highest volume of interns. However, they were not necessarily the institutions with the most rigorous or defined internship programs. Numerous mid-sized museums (fewer than 50 full time staff) reported programs that had defined educational goals and stipulations regarding paid tasks vs unpaid tasks. Interviewees at smaller institutions (fewer than ten full time staff) also discussed the need to set limitations on the number of interns at their institution, how many hours interns were allowed to "work", and which departments were willing to take on interns. This may be because of a necessity to justify staff members' time to train and supervise interns when there are fewer staff at an institution.

Regardless of the size or location of the institution, many interviewees acknowledged a historically problematic relationship between their institutions and internship labor. But they also expressed optimism that their institution was reframing that relationship in positive ways. Some new directions included: diversity initiatives, effective messaging empowering boards to fund stipends for internships, cultivating

donor-funded internships or fellowships, focusing on mean-
ingful mentoring between each intern and a staff member,
and moving towards project-based contract work instead of
internships.

Pay inequities

Fifty-eight percent of interviewees identified pay inequity, or
disparity across departments and between levels of manage-
ment, as one of the biggest issues facing their area. This was
also a heated topic among town hall participants. However,
there was not one single disparity that dominated the discus-
sions. Rather, there was concern about the issue from many
angles. Some were concerned with implicit devaluing of depart-
ments that typically received lower salaries than others (educa-
tion or visitor services, for example). Others were concerned
with the ratio of pay between top-tier management and mid-
level management vs the responsibilities of the positions. Still
others cited the inequity of pay between museums and other
industries with educational requirements or skill sets (market-
ing and communications or project management, for example).
Many interviews also came around to the issue of turnover as a
result of transferable skills and better pay outside of museums.

Next steps

Promoting transparency and empowering employees

It is clear that interviewees and town hall participants are eager
for CWAM to advocate for labor and salary transparency in a
number of ways. The sub-committee initially anticipated a
key outcome would be advocating for salary information to be
included with job postings, as there had been great fanfare in

2018 when other organizations had announced similar require-ments. However, survey data showed that this particular tactic may be less useful than expected, since 40% of institutions already had policies requiring salaries with job postings. That said, this tactic was mentioned in 25% of interviews and there is clearly room for improvement on this issue. At the request of the sub-committee on labor, and with the full support of the executive committee, the CWAM board will take up the issue of requiring salaries for all postings submitted to our job board at a meeting later in 2019.

As previously discussed, 66% of respondents are interested in the estimated cost of living in their area. This is an issue CWAM can easily address by providing access to, and consulta-tion on, cost of living compared with salaries offered for posi-tions. As there is great economic variance between our two states, this would provide a valuable service to our members by promoting transparency.

It is also clear that one ongoing tactic CWAM can use is to facilitate complex conversations around labor and salary trans-parency. CWAM will continue to conduct sessions at our annual meeting, town halls, etc. around labor issues so that there are opportunities for museum employees to ask questions and seek guidance among peers.

Tangible outcomes

Interviews with employees of municipal and university institu-tions helped forge a plan to look to these types of institutions for benchmarks on salaries. Since their salary information is publicly available, CWAM could compile a report with this data to guide private nonprofits in setting salaries. Such a report

would empower job seekers to evaluate salaries listed for positions they may be considering. This report/resource aligns with the desire for greater transparency and will be prototyped at the 2019 CWAM Annual Meeting.

The sub-committee went into this research with the idea of creating a Museum Labor Toolkit. After reviewing the survey data and conducting interviews, it seems the toolkits should take two forms. One will focus on how to address museum labor internally with fellow staff and management, and will include "conversation starters" to guide conversations on negotiating salaries and raises, pay inequities, volunteer and intern policies. The second toolkit will focus on how to talk about museum labor externally, to city and county officials, state representatives, donors, and boards, and will include advocacy materials to communicate the value of museum labor to those who can do more to support the field. These toolkits will be prototyped at the 2019 CWAM Annual Meeting.

As these issues will evolve with the field and with the changing economic realities of both states, CWAM is committed to supporting dialog on unpaid labor (and museum labor more generally) at the state level, in both states.

REFERENCES

Colorado Business Committee for the Arts, 2017. *Economic Activity Study*. Retrieved from http://cbca.org/economic-activity-study/

Connolly, R. *et al.*, 2019. House Bill No. HB0273. State of Wyoming. Retrieved February 19, 2019, from https://www.wyoleg.gov/Legislation/2019/HB0273

Independent Sector, n.d. *The Value of Volunteer Time / State and Historical Data*. Washington, DC: Independent Sector. Retrieved April 8, 2019, from https://independentsector.org/resource/vovt_details/

Pennerstorfer, A., and Trukeschitz, B., 2012. Voluntary contributions and wages in nonprofit organizations. *Nonprofit Management and Leadership*, 23(2), 181–191.

Pho, Y. H., 2008. The Value of Volunteer Labor and the Factors Influencing Participation: Evidence for the United States from 2002 through 2005. *Review of Income and Wealth*, 54(2), 220–236.

Simmons, W. O., and Emanuele, R., 2010. Are volunteers substitute for paid labor in nonprofit organizations? *Journal of Economics and Business*, 62(1), 65–77.

CHAPTER NINETEEN

ADVANCING SALARY EQUITY THROUGH LEGISLATION

Kristina L Durocher

WHEN IT CAME TIME FOR ACTOR Michelle Williams to reshoot scenes for the 2017 film *All the Money In the World*, she was paid the standard $80 per diem, earning approximately $1,000. Later she learned her co-star Mark Wahlberg had received $1.5 million for the exact amount of work. She did not think to ask for more money, nor did her agent push for greater compensation, even though the two actors are represented by the same talent firm, William Morris Endeavor (Mandell, 2018). Testifying in Washington, DC on April 2, 2019 during a hearing about closing the gender wage gap, Williams said of the pay disparity:

> Guess what, no one cared. This came as no surprise to me, it simply reinforced my life-learned belief that equality is not an inalienable right and that women would always be working just as hard for less money while shouldering more responsibility at home.
> (Desta, 2019)

In the wake of the women's movement of the 1970s, governments and institutions adopted or passed legislation and polices to end workplace gender discrimination. Now, 50 years later in response to the Time's Up and #MeToo movements, governments in the U.S. and internationally are once again scrutinizing work place cultures and policies that consciously or unconsciously give preferential treatment to men. The result of these examinations are renewed efforts to close the lingering gender wage gap that exists worldwide, across all professions, and education levels.

This chapter looks at legislative initiatives adopted and

proposed in the United States and internationally to close the persistent gender wage gap. First, the chapter presents a brief summary of U.S. labor laws passed in the twentieth century. The second section presents a more nuanced look at recent research to account for the gender wage gap and the laws enacted and proposed during the past twenty years to address it, including recent international mandates, federal legislation and laws passed by individual states. Lastly, the chapter presents possible remedies for closing the remaining persistent gender wage gap.

US labor laws in the twentieth century

More than 50 years ago, President John Kennedy signed into law the Equal Pay Act (EPA) as an amendment to the Fair Labor Standard Act of 1938. The EPA prohibits gender-based wage discrimination between men and women who perform jobs with essentially the same skills and responsibilities, requiring the same effort under similar working conditions. The law includes several exemptions:

> ...except where such payment is made pursuant to (i) a seniority system; (ii) a merit system; (iii) a system which measures earnings by quantity or quality of production; or (iv) a differential based on any other factor other than sex. (EPA, 1963)

The law was an effort to correct gender-based wage discrimination and close the wage gap among blue-collar workers that, according to the U.S. Department of Labor statistics, resulted in women then earning approximately 59 cents for every dollar

a man earned. Subsequent laws have been passed with the goal of ending employment discrimination and closing the gender and race wage gaps. Title VII of the Civil Rights Act of 1964 protected workers from discrimination based on race, color, religion, gender, or national origin. Included in the bill was the creation of the Equal Employment Opportunity Commission (EEOC) that has the authority to investigate claims of workplace discrimination and enforce anti-discrimination employment practices. In the early 1970s, Congress passed the Higher Education Amendments Act of 1972 that is best known for its provisions under Title IX that ban discrimination based on sex in any education activity or program receiving federal funding. The Education Amendment also expanded the scope of the EPA to include white-collar managerial, executive, and professional jobs that had been exempt from the original law.

In 1979, the first year comparable data between salaried male and female full-time workers was available, women earned 62 cents to every dollar a man earned (Bureau of Labor and Statistics, 2015). Clearly since the passage of the EPA there was a slight improvement in closing the wage gap, but more was needed to reverse deeply-held societal biases facing women in the workplace. Contradictorily, while no new laws were passed in the 1980s, the gender-wage gap narrowed significantly. Researchers have determined that women's educational progress (partly because of Title IX, and partly though securing employment in male-dominant occupations) accounted for the majority of gains in closing the gender wage gap from 1980–2000 (Blau and Kahn, 1997, 2006, 2016). Despite the substantial educational gains, selection of high-wage majors, and making inroads in professions with high percentages of men,

women still earn less than men. In 2018, women earned 81 cents for every dollar earned by men (Bureau of Labor and Statistics, 2018).

Causes of the gender wage gap

To understand the laws enacted in the past twenty years, it is important to recognize factors identified to explain the gender wage gap. Researchers Blau and Kahn (2007) indicate that the wage gap which American women experience can be accounted for mainly through career choices, industry category, labor force experience, and union status.

In an analysis of the American labor market, data from the *Georgetown University Center on Education and the Workforce Report* (2018) shows that women's earnings have grown over time and the gender wage gap has declined across all levels of educational attainment since 1976, except for women who have earned graduate degrees. In high-paying white-collar jobs where one might expect greater pay parity, the reverse is true. Women with advanced degrees earn less than men with comparable experience and education levels at a higher rate than women with lower levels of educational attainment. In other words, the gap in earnings narrows the lower the educational attainment of men and women. The persistent wage gap for women with advanced degrees is symptomatic of a number of issues, including fewer hours worked and work experience differences (Blau & Kahn, 2007).

Through the glass ceiling

Researchers attribute a portion of the gender wage gap to inadequate representation of women among upper-level

management and supervisory positions in all employment sectors, including private and public corporations, government agencies, nonprofit organizations, institutes of higher learning, and start-up ventures (Cornwell and Kellough, 1994; Kerr et al., 2004; Robovsky and Lee, 2018). Research finds fewer American women become equity partners in law-firms, chief executives or tenured professors. The wage gap affects women executives in the nonprofit sector, too. Women who lead nonprofits are paid less then male CEOs. According to the *GuideStar Nonprofit Compensation Report* (2018), for nonprofits with budgets under $250,000 the wage gap is approximately eight percent, however, as the budget grows, so too does the wage disparity. For nonprofits with budgets of $25 million and up, the gap widens to 25 percent. When asked about the findings, GuideStar CEO Jacob Harold noted, "(i)t would be called hypocrisy," commenting that many nonprofits have human rights, social justice, and gender and racial equity central to their missions. Several years ago, the Association of Art Museum Directors undertook a study to examine the wage gap among its membership, finding that in 2016 women hold fewer than 50% of directorships (Gan et al., 2017). The report found that in AAMD member museums with budgets less than $15 million, female directors were paid 98 cents for every dollar earned by male directors. The study reported that the wage gap persists most dramatically at museums with budgets more than $15 million where female museum directors earn 75 cents on average for every dollar earned by their male counterparts (ibid.).

In response to the pay disparity between highly educated and experienced women and men occupying senior executive positions, gender diversification in the boardroom is gaining

global attention. Conventional wisdom holds that greater representation of women on boards of directors would create gender diversity among top executives, improve corporate performance (Farrell, 2015) and, one would expect, help close the wage gap. Research of Russell 3000 companies by Institutional Shareholder Services (ISS) shows that only 28% of corporate boards have 20% female directors (d'Hoop-Azar *et al.*, 2017). ISS found that support for greater gender diversification in the board room is growing, but differs among countries because of cultural and societal norms, for example Nordic countries have the greatest gender parity in the board room, with Norway enacting the most stringent regulations. In 2007 Norway passed a law requiring corporate boards to have at least 40% of the seats held by women or face penalties; other European countries followed with their own tough regulations or passed soft-law quotas without sanctions; the U.K. issued voluntary guidelines (Bertrand *et al.*, 2014).

Ten years after Norway enacted gender board quotas, there has been no discernable change in the number of women in the upper ranks of corporate executives, nor in the earnings disparity of women below the top five highest paid female employees (Bertrand *et al.*, 2014). While the regulations have not had the intended effect in diversifying senior executive ranks, they have resulted in greater representation of women in the boardroom, reducing the wage gap between male and female board members. The receptiveness to board gender diversification represents a change in corporate cultures and opinions and has led to other regulatory actions and voluntary efforts in the U.S. and globally to increase the percentage of women in the boardroom. California passed legislation in 2018 mandating

a hard quota on the number of women serving on boards of directors of companies headquartered in the state with severe penalties ranging from $100,000-$300,000 for non-compliance. It is the first state to pass regulations on board gender diversity and, as the home to some of the most profitable global tech firms, positions itself as a leader in gender equality of publicly held corporations (Kumar, 2018).

While the study of Norwegian firms found no discernable benefits to rank and file female employees from the increased number of women serving on boards, the span of time since the law was enacted (around 12 years) may not be enough to counteract years of pervasive and entrenched attitudes towards women in the upper echelons of male-dominated sectors of the labor market. Passage of the California law will give researchers an opportunity to study its impact on corporations in the U.S. where cultural attitudes towards women in the workplace differ widely from European countries which are considered more socially liberal. For museums, and other non-profits, voluntarily increasing board gender diversity may result in the hiring of more female executive directors at institutions with budgets greater than $15 million because board members play a significant role in the hiring process and in setting compensation.

What you don't know can hurt you

The gender wage gap begins as soon as men and women enter the workforce and widens substantially over time. Those who study the issue agree that occupational selection accounts for higher salaries for American men (Blau and Kahn, 2007) and yet, awareness of occupational selection and the gender wage gap remain low among new entrants to the American and

international labor markets. It is important to understand the corrosive effect a lack of awareness of the gender wage gap may play in setting the salary for workers' first forays into the labor market. This lack of awareness has far reaching consequences: A Gallup poll found that 53% of Americans believe men and women are treated equally in the workplace and that gender-discrimination has largely been eliminated (Jones, 2005).

Psychologist S. Beyer (2018) analyzed three studies conducted between 1996 and 2012 investigating the awareness of the gender wage gap among U.S. college students. Beyer reported that students, while aware of the gap, underestimated the magnitude of the discrepancy. Her team of researchers found college students consistently overestimated the pay of women in gender-balanced, majority-female, and majority-male occupations and simultaneously underestimated the pay of men. These misperceptions led to wide divergencies between the actual and estimated wage gap. In one study they reviewed, the difference between perceived and actual pay of men and women was more than $12,000. Beyer hypothesized that the lack of awareness of the size of the gender wage gap may affect college students' starting salary perceptions and negotiations, and lessen their ability to identify pay discrimination in the workplace, perpetuating the status quo of pay inequity.

The overestimation of women's compensation relative to men's within the same occupations, the underestimate of graduates' starting salaries, and the belief that gender discrimination is largely non-existent may, in fact, weaken legal protections against pay discrimination. Beyer points to the Wisconsin legislature's repeal of its 2009 Equal Pay Enforcement Act as evidence of the consequences of inaccurate estimates and lack

of awareness of the gender wage gap despite Wisconsin women earning 78 cents to every dollar earned by men (ibid.).

If college students underestimate the gender wage gap within occupations, and some employers erroneously believe it is non-existent, it may negatively affect recent graduates' salary negotiations and impact their potential cumulative earnings as the gender wage gap increases over time. Universum Global, an international human resources consulting firm, annually surveys business and STEM (Science, Technology, Engineering, Math) students and their perceptions of their worth in the global market place. Its 2018 *Cost of Talent* report presents responses of 533,351 students from 39 countries to the question, *What salary do you expect to earn in your first job after graduation?* American female business school students underestimate their earnings by $5,618 annually in comparison to male students and American female students studying STEM disciplines perceive their first-year earnings will be on average $7,682 less than their male counterparts. A study conducted by the American Association of University Women (AAUW) comparing the starting salaries of men and women in their first year of employment after graduating found men already earned more than women. Women working full-time earned $35,296 on average, while men working full time earned $42,918 (Corbett and Hill, 2012). Researchers at Georgetown University Center on Education and the Workforce came to the same conclusions and presented their findings in *Women Can't Win*, reporting that the average male with a bachelor's degree earns more annually than a female with the same educational experience. Not only does he earn more, he can expect his salary to increase 87% during his career, while a woman with a bachelor's degree will only see

her annual earnings climb by 51% during her time in the labor market (Carnevale *et al.*, 2018).

Knowledge is power

To shrink the gender wage gap there is a growing trend in the U.S. and internationally toward voluntary and mandated actions to lift the secrecy around wages and strengthen existing regulations. Innovative policy approaches to address the gender wage gap, include, but are not limited to, wage transparency, protecting workers' ability to discuss wages, increasing pay data collection and reporting, establishing clearer guidelines for equal pay for equal work, implementing gender-responsive budgeting, and increasing the penalties for companies engaged in wage discrimination as well as boosting the damages for its victims (Holmes and Corley, 2017).

The push for greater pay transparency in the U.S. initially grew out of the labor movement in the 1930s during the height of the great depression. During the early 1930s, labor unions in the U.S. received support from progressives within the Roosevelt administration and from legislation passed by Congress that included the 1935 National Labor Relations Act (NLRA) which protected workers' rights to organize, ask for improvements to working conditions, discuss wages, benefits and terms of employment, and prohibit employers from retaliating against them for doing so. The NLRA protects most private sector workers, but excludes independent contractors, public-sector employees, and those identified as supervisors; however, many U.S. non-supervisory private sector workers are unaware of their rights under the NLRA. More than 60% of private sector employees who participated in a study conducted

by the Institute for Women's Policy Research in 2011 reported that their employer either explicitly prohibits or overtly discourages employees from discussing or disclosing their wages. Pay secrecy and lack of transparency hurts women by making it difficult for them to determine if they are being paid equally for equal work. Prior to the 2009 passage of The Lilly Ledbetter Fair Pay Act (LLFPA), American employees charging their employers with wage discrimination had to file a complaint within 180 days of the first paycheck that contained unequal pay, even if the worker didn't learn about the discriminatory wages until much later. The law now considers each paycheck that includes unequal pay as a separate violation and allows employees the right to file a claim 180 days after the last discriminatory pay check and not 180 days after the first offense (EEOC, 2019). Following the signing of the LLFPA, some states passed legislation protecting the rights of employees, whom they have defined more broadly than the NRLB, and prohibited employers from limiting employees' ability to disclose and discuss their wages. California, Connecticut, Maryland, Minnesota, New Hampshire, New York, and Oregon have passed regulations protecting wage disclosure. In 2015, the Department of Labor also sought to expand protections for employees and passed regulations prohibiting federal contractors from restricting their employees' ability to inquire, disclose, or discuss their wages (U.S. Department of Labor, 2019).

Internationally, several countries have passed regulations in the past decade strengthening protection for workers who discuss or disclose their wages. Iceland, which consistently ranks as one of the best places to work for women according to the World Economic Forum's annual gender gap report (2018),

revised its Act on Equal Status and Equal Rights of Women and Men in 2008 (first passed in 1975) to include additional protections for workers at businesses with 25 employees or more. The revisions include: penalties on companies that do not develop and submit upon request gender equality plans; and that women must comprise 40% of national and local committees and boards, including those owned partially by the state or local municipality. Article 19 of the revised Act also protects the rights of workers to discuss their wages; it states that, "workers shall at all times, upon their choice, be permitted to disclose their wage terms" (Einarsdóttir, 2010). In 2010, the United Kingdom replaced the Equal Pay Act of 1970 with the Equality Act, which strengthened anti-discriminatory pay practices and enacted protection for employees to discuss and disclose their wages (Foubert et al., 2010).

Many European countries have taken pay transparency a step further by instituting some system for reporting pay data to government agencies or publicly. The data allows government authorities, employers, and employees to identify possible pay discrimination practices and promote wage-equitable workplaces. Austria, Belgium, Sweden, Denmark, and Portugal have passed some type of pay data reporting regulations to hold companies accountable for equitable pay practices. Germany, Luxembourg, and Switzerland collaborated on Logib, an online self-evaluation tool, designed for companies to analyze and verify the equality of their pay practices (European Commission, 2014). Others, with Spain, Denmark, and Belgium among them, have instituted mandatory, or encouraged voluntary, gender audits. These require companies to evaluate their operations, policies, and structures, not just their pay

practices, to determine the extent of gender equality in their workplaces (Holmes and Corley, 2017). In the UK a new wage gap disclosure regulation went into effect in 2017 requiring companies with more than 250 employees to publish data on the gap between men and women's earnings. The regulation also requires employers to report bonus pay data to calculate their gender bonus-gap. The gender wage gap and bonus-gap data is reported to the government online and is required to be made publicly available on the employer's website (Westover *et al.*, 2018).

Enacting pay reporting and data collection legislation in the U.S. during the past decade has stalled in Congress amid objections from business groups that claim the requirements are onerous and unnecessary.[1]

The museum field has voluntarily provided a level of pay transparency by conducting and publishing the results of wage and salary surveys. Both the Alliance for American Museums (AAM) and the Association of Art Museum Directors (AAMD) conduct salary surveys, publishing the results as a service to the field – AAMD's report is available for free, AAM charges for its National Museum Salary Survey. While not as rigorous as federally-mandated reporting, the wage and benefits information provided voluntarily may be useful to improve compensation awareness for those entering the field, establish a base-line for current employees to discuss wages, and to ensure museums are paying competitive salaries. The AAMD (2017) report reviewed salaries, benefits (housing and, in some instances, vehicle allowances) and established benchmarks by geographic region and demographics. The surveys could also encourage museums to undertake gender audits of their pay practices to

discover or prevent wage discrimination. Another initiative to build compensation awareness and transparency within the museum field include grassroots efforts to require employers to provide salary information in job advertisements.

The motherhood penalty

While the gender wage gap affects women at the start of their careers, across occupations, and by education level, the most striking wage disparity occurs during a woman's child-bearing years when the responsibilities for caring for children fall disproportionately on women's shoulders. Nearly all research examining pay between men and women concludes that women's responsibilities to care for children accounts for a significant portion of the gender-wage gap (Blau and Kahn, 2002). Childcare responsibilities cause a reduction in the number of hours women are employed in the labor market: either they never enter the work force, withdraw from it (temporarily or permanently), or seek employment with fewer hours than men. Women working full-time outside of the home spend on average 1.87 hours per day caring for children under age 18 while men spend 1.05 hours per day on average (Carnevale et al., 2018). This imbalance in primary responsibilities for child and household care translates into women working fewer paid hours then men (ibid.). In a 2016 Gallup poll of 323,500 salaried adults, women with children work the fewest number of hours on average: women with a child younger than 18 reported working 43 hours per week; women without a child younger than 18 reported working 44 hours; men with a child younger than 18 worked 47 hours; and men without a child younger than 18 worked 46 hours per week. The report confirmed that the need for flexibility to

care for children and perform domestic work is considered one of several factors explaining why women earn lower wages than men. Because women caring for children work fewer hours than men, the reduction of hours spent in the workplace affects an employer's perception of performance, can negatively impact career development, reduces a woman's opportunity for additional (often industry specific) training and mentorships and, can limit bonuses and promotions (Miller and Adkins, 2016).

This inequality at the onset of a woman's participation in the workforce is compounded from one employer to another if new employment offers take into consideration an employee's prior salary history. A recent U.S. legal decision overturned previous rulings using a woman's prior salary history as a reason for paying her less than a man, it being reasoned that calculating a woman's pay based on her salary history (recall that the gender wage gap begins as soon as a female enter the workforce and grows steadily overtime) is itself a form of gender discrimination (Watkins, 2018). U.S. Circuit Judge Stephen Reinhardt wrote in the majority opinion:

Although the Act has prohibited sex-based discrimination for more than fifty years, the financial exploitation of working women embodied by the gender wage gap continues to be an embarrassing reality of our economy... To hold otherwise – to allow employers to capitalize on the persistence of the wage gap and perpetuate that gap ad infinitum – would be contrary to the text and history of the Equal Pay Act, and would vitiate the very purpose for which the act stands. (Campbell, 2018)

The impact of the motherhood penalty is startling when viewed cumulatively over the span of a woman's lifetime earnings. Based on data of British women collected in the 1990s, researchers H. Joshi and H. Davies (2002) determined an average woman with a mid-level education and two children would forfeit about 50% of the earnings she might earn if she did not have children. The loss of earning was smaller for women with higher levels of education who returned to full-time employment after having children (ibid.). Having children compounds the gender wage gap by reducing women's wages while simultaneously raising men's. In a study of American household wage data from the 1990s, researchers found that, on average, a woman's income declined by 5% with the birth of her first child while resulting in a 9% increase in the father's (Lundberg and Rose, 2000). More recent research indicates the motherhood penalty has decreased in the U.S. and Europe for highly educated women in high-wage professions compared to non-mothers (Carnevale *et al.*, 2018).

Legislative efforts to support working mothers in the U.S. began in the late 1970s with the passage of the Pregnancy Discrimination Act of 1978 (an amendment to Title VII of the Civil Rights Act), yet stalled in the 1980s despite efforts by activists to enact work-family policies. The National Partnership for Women and Families (then known as the Women's Legal Defense Fund) worked for nearly a decade to pass legislation allowing employees to take twelve weeks' unpaid, job-protected time off to care for a child, spouse, or parent. Drafted in 1984, the legislation was proposed, and blocked in every session of Congress until 1991, when it passed with bi-partisan support only to be vetoed by President George H. W. Bush and again

in 1992 before being signed into law in 1993 by President Bill Clinton. Other than a 2015 revision to the definition of spouse in recognition of same-sex marriages, the Family Medical Leave Act has not been updated to protect or expand employee leave (U.S. Department of Labor, 2019). Currently, only 14% of U.S. employees are covered by paid family-leave policies. In the absence of federal legislation, three states, California, New Jersey, and Rhode Island have mandated paid family-leave benefits, New York State and the District of Columbia have each passed laws that go into effect in 2020. (Brainerd, 2017). The patchwork of legislation across the country leaves many workers who need time off to care for family members disadvantaged in the workplace and because care-giving falls disproportionately to women, also exacerbates the gender wage gap.

In a study of economically developed countries that have enacted family-friendly work policies, researchers find higher rates of employment for women compared to the U.S., although more women worked part-time and fewer women held executive positions (Blau and Kahn, 2013). The gains of paid parental leave may manifest over time. Countries with the smallest wage gap also have had some of the most progressive parental and family-friendly policies in place for decades. Iceland, for example, with a wage gap of 16% (Paddison, 2019) first enacted a law mandating paternity leave to fathers in 1998. Two years later it introduced the Icelandic Act on Maternity/Paternity and Parental Leave that mandated nine months of paid parental leave to workers at 80% of their average salaries. Based on research showing positive social benefits Iceland's lawmakers are considering extending the leave to ten months. In comparison to workers from member countries of the Organization for

Economic Co-operation and Development (OECD), American mothers and fathers lag woefully behind their peers, receiving the shortest amount of parental leave.

Mothers in France, for example, receive sixteen weeks paid leave for their first and second child, and if they have a third child, receive an additional ten weeks off. French families also receive child care subsidies and three years of free preschool (Carnevale *et al.*, 2018). OECD countries that have taken a pro-active approach to supporting working mothers and fathers also have higher rates of participation of women in the workforce. In 2015, 67% of women in the U.S. participated in the labor market, ranking eighteenth out of 32 OECD countries, with New Zealand leading with 85% participation. In terms of the gender wage gap, women from New Zealand, Belgium, and Luxembourg, where the percentage of women in the labor market is the highest, earn 94% as much as men (ibid.).

For many women, the responsibilities of care-giving may prevent continuous participation in the labor market or delay entry into it entirely (Sigle-Rushton and Waldfogel, 2006). Employment interruptions not only impact women's earnings in the short term, some law makers also recognize that unpaid care-giving reduces women's retirement security by decreasing lifetime earnings and retirement or pension contributions (Holmes and Corley, 2017). Economically developed countries including Sweden, Germany, Japan, France, and Norway adopted caregiver credit programs in the 1970s, the practice spread, and now nearly all European countries offer some type of caregiver credit (Jankowski, 2011). The effort to reform the Social Security system in the U.S. and adopt caregiver credits used throughout Europe have failed. The Social

Security Caregiver Credit Act (SSCCA) first introduced by Representative Nina Lowey (D-NY) in 2002 has died in every congressional session since, including 2018 (SSCCA, H.R. 6952, 2018).

U.S. legislative proposals

Currently, the EPA requires employers pay women and men for "equal work." Some feel this standard is too narrowly defined and should be interpreted to mean "comparable" jobs. The Fair Pay Act (FPA) first introduced in Congress in 1995 (but never passed) amends the EPA by redefining equal pay for equal work to mean comparable wages for comparable jobs by classifying those jobs as "equivalent":

> The term equivalent jobs means jobs that may be dissimilar, but whose requirements are equivalent, when viewed as a composite of skills, effort, responsibility, and working conditions. (FPA, H.R 2039, 2019)

On March 27, 2019, lawmakers in the House of Representatives passed the Paycheck Fairness Act, which is aimed at closing the gender wage gap by expanding and strengthening existing provisions under the EPA and Fair Labor Standards Act. The law would ban companies from asking job candidates their previous salary, prohibit companies from retaliating against workers for discussing wages, increase penalties for equal pay violations, and require companies to disclose reasons for salary discrepancies other than the basis of sex. Additionally, the law would provide funding for EEOC staff training to better address complaints. The legislation moved onto the Senate where its

passage is unlikely; the Republican-controlled Senate has blocked similar legislation four times since 2012 (Paycheck Fairness Act, 2019).

International approaches to closing the gender wage gap
Recognizing the limits of existing gender discrimination laws, some countries and states have taken steps to prevent it from occurring in the first place. For nearly twenty years France and Sweden have required employers to analyze their existing pay practices and develop plans for the coming year to address any gender wage disparities. Canadian MPs introduced the Act to Establish a Proactive Pay Equity Regime within the Federal Public and Private Sectors (Pay Equity Act) in 2018 to require employers to undertake wage audits to ensure women and men working in federally-regulated workplaces receive equal pay for equal work (Government of Canada, ESDC, 2018). The European Union called upon member countries to eliminate pay discrimination by applying existing rules or implementing new ones; the European Commission adopted in 2017 the EU Action Plan 2017-2019 Tackling the Gender Pay Gap, that identified 24 actionable items for member countries to put into practice (European Commission, 2017). Globally, the United Nations' 1995 Fourth World Conference on Women in Beijing, adopted gender-responsive budgeting as part of its platform. Australia first instituted gender-responsive budgeting in 1985 and continued to measure the impact of its national budgets on women and girls until 2013 (Holmes and Corley, 2017). The OECD (2017) reports that 90 countries (and cities – San Francisco) have implemented some form of gender-responsive budgeting, examining their national budgets and reporting

on their impact on gender equality. In addition to assessing national budgets and their impacts on women, Christine Lagarde, Managing Director of the International Monetary Fund, proposes countries revise their tax policies which, generally, disproportionately tax families at higher rates (European Commission, 2017).

Solutions

The United States is now lagging behind its industrialized peers in implementing federal legislation to support working families and end wage discrimination practices. In the absence of proactive policies enacted nationally, state legislatures and court rulings are advancing workplace wage discrimination protection. This piecemeal approach may not be enough. It may be time for corporations and nonprofit organizations to adopt workplace solutions to close the gender wage gap.

The lack of federally-mandated legislation to help close the gender wage gap presents an opportunity for museums in the U.S. to signal their commitment to ending pay inequity by instituting proactive initiatives. In an interview, Charlotte A. Burrows, former EEOC commissioner under the Obama administration, suggested three measures employers could take up voluntarily to help close the gender wage gap, specifically:

- First, make clear to their workforce that pay equity is a priority at the very highest levels by having top executives articulate a clear commitment to that goal.
- Second, make clear their house is in order. Employers can do this by examining payrolls (or statistical analyses for large employers) to determine whether pay disparities

exist between men and women doing the same job.
- Third, the proactive step every company should take is to let employees know that, if they wish, they can voluntarily share pay data with their co-workers. (Dorrian, 2016)

In addition to these voluntary steps, the Obama administration in January 2016 asked private employers to sign on to the The White House Equal Pay Pledge that states, specifically:

> We believe that businesses must play a critical role in reducing the national wage gap. Towards that end, we commit to conducting an annual company-wide gender pay analysis across occupations; reviewing hiring and promotion processes and procedures to reduce unconscious bias and structural barriers; and embedding equal pay efforts into broader enterprise-wide equity initiatives. We pledge to take these steps as well as identify and promote other best practices that will close the national wage gap to ensure fundamental fairness for all workers.

Perhaps a voluntary pledge to commit to ending the gender wage gap is needed for the museum profession. Could museum activists take this up as a next step toward pay equity? Or could it be initiated by any one of the regional, national, or international museum professional organizations? AAMD researchers recommend looking more closely at gender diversity among boards and hiring committees (Gan, et al., 2017). Museum Studies programs need to build awareness of the gender wage gap among their students, and museums must take proactive

steps to address the issue that affects the majority (60%) of museum workers (AAMD, 2018).

Systematic change is possible, but it will require work across the field. National professional organizations such as AAM and AAMD could expand the scope of their salary surveys to include the collection of pay-equity data and boardroom gender diversity. AAM could include gender pay audits as a component of its accreditation process. How many museums might voluntarily undertake gender-responsive budgeting? Or could this be a requirement imposed by federal grant-making agencies and private foundations? As museums move increasingly to serve their communities and make lasting, social contributions beyond their walls, they, as the most highly trusted civic institutions (Dilenschneider, 2017) should leverage their position as cultural influencers to promote and lead on the issue of gender pay equity.

NOTE

1. The Obama administration, in an effort to eliminate wage discrimination by gender, race, and ethnicity, mandated pay data reporting in 2015 through an administrative rule change. It required the U.S. Equal Employment Opportunity Commission (EEOC) to collect pay data, employee pay ranges, job categories, and hours worked from employers of 100 or more workers, all federal contractors and first-tier subcontractors with 50 or more employees and all financial institutions/government banks with 50 employees or more to assist the agency identify possible discriminatory pay practices. The rule change was approved in 2016 with the first reporting deadline scheduled to go into effect in 2018. On taking office, President Trump and his appointees have rolled back a number of Obama-era regulations (Eilperin and Cameron, 2017) including the EEOC pay reporting mandate which the Office of Management and Budget (OMB) suspended in 2017. After the OMB announced the suspension of the rule, it was sued by two worker's rights organizations, The National Women's Law Center and the Labor Council for Latin American Advancement. A federal judge ruled in favor of the plaintiffs and reinstated the rule in March 2019 ordering the EEOC to begin wage data collection in May 2019 (Smith, 2019). The Trump administration appealed the judge's decision asking the deadline be pushed to 2021. In April 2019, U.S. Circuit Court Judge Tanya Chutkan ordered the EEOC to collect the wage data by September 2019, calling the Trump administration's objections to the rule, "arbitrary, capricious, an abuse of discretion, or otherwise not in accordance with the law" (Campbell, 2019).

REFERENCES

Arnason, B.T. and Mitra, A., 2010. The Paternity Leave Act in Iceland: Implications for gender equality in the labour market. *Applied Economics Letters* 17: 677–680.

Association of Art Museum Directors, 2018. *Salary Survey*. Retrieved from: https://aamd.org/sites/default/files/document/AAMD%20Salary%20Survey%202018%20final.pdf

Bertrand, M., *et al.*, 2014. Breaking the glass ceiling? The effect of board quotas on female labor market outcomes in Norway. *National Bureau of Economic Research: Working paper No. 20256*.

Beyer, S., 2018. Low awareness of occupational segregation and the gender wage gap: No changes over a 16-year span. *Current Psychology*, 37,(1): 373-389.

Blau, F. D. and Kahn, L. M., 1997. Swimming upstream: Trends in the gender wage differential of the 1980s. *Journal of Labor Economics*, 15(1, pt. 1): 1-42.

Blau, F. D. and Kahn, L. M., 2000. Gender differences in pay. National Bureau of Economic Research. *NBER Working paper No. 7732*.

Blau, F. D. and Kahn, L. M, 2006. The U.S. gender pay gap in the 1990s: Slowing convergance. *Industrial Labor Relations Review*, 60(1): 45-66.

Blau, F. D. and Kahn, L. M., 2007. Changes in the labor supply behavior of married women: 1980–2000. *Journal of Labor Economics*, 25(3): 393–438.

Blau, F. D. and Kahn, L. M., 2013. Female labor supply: Why is the U.S. falling behind? *American Economic Review*, 103(3): 251-256.

Blau, F. D. and Kahn, L. M., 2016. The gender wage gap:
Extent, trends, and explanations. National Bureau of
Economic Research. *NBER Working paper No. 21913*.

Brainerd, J., 2017. Paid family leave in the states. *National
Conference of State Legislatures 25(31)*.

Campbell, A. F., 2018. 9th Circuit: you can't pay women
less than men just because they made less at their last
job." *Vox*, April 10. Retrieved from: https://www.vox.
com/2018/4/10/17219158/equal-pay-day-2018

Campbell, A. F., 2019. Trump tried to sabotage a plan to
close the gender wage gap." *Vox*, April 26. Retrieved
from: https://www.vox.com/2019/4/26/18515920/
gender-pay-gap-rule-eeoc

Government of Canada: Employment and Social Development
Canada, 2018. Government of Canada introduces his-
toric proactive pay equity legislation. Retrieved: https://
www.canada.ca/en/employment-social-development/
news/2018/10/government-of-canada-introduces-historic-
proactive-pay-equity-legislation.html

Carnevale, A.P., *et al.*, 2018. Women can't win: Despite making
educational gains and pursuing high-wage majors,
women still earn less than men. *Georgetown University,
Center on Education and the Workforce*.

Corbett, C., and Hill, C., 2012. Graduating to a wage gap.
American Association of University Women Educators.

Cornwell, C., and Kellough, J. E., 1994. Women and minorities
in federal government agencies: Examining new evidence
from panel data. *Public Administration Review*, 54(3):
265-70.

d'Hoop-Azar, *et al.*, 2017. Gender parity on boards around the

world. *Institutional Shareholder Services, Inc.*

Desta, Y., 2019. Michelle Williams says pay-gap contro-
versy 'paralyzed' her. *Vanity Fair*, April 3. Retrieved
from: https://www.vanityfair.com/hollywood/2019/04/
michelle-williams-wage-gap-paycheck-fairness-act

Dillenscheinder, C., 2017. People trust museums more than
newspapers. Here's why that matters right now (Data).
[Blog post, April 26]. *Know your own bone.* Retrieved from:
https://www.colleendilen.com/2017/04/26/people-trust-
museums-more-than-newspapers-here-is-why-that-
matters-right-now-data/

Burrows, C.A., (Interviewed by Patrick Dorrian) 2016. EEOC
striving to make equal pay for equal work the new norm.
The Bureau of National Affairs, Inc. 10 (1).

Eilperin, J., and Cameron, D., 2017. How Trump is rolling back
Obama's legacy. *Washington Post*, March 24, updated 2018,
January 20. Retrieved from: https://www.washingtonpost.
com/graphics/politics/trump-rolling-back-obama-
rules/?utm_term=.eae3898e39.pdf

Einarsdóttir, T., 2010. *The policy on gender equality in Iceland.*
Brussels: European Parliament. Retrieved from: http://
www.europarl.europa.eu/document/activities/cont/201107
/20110725ATT24624/20110725ATT24624EN.pdf

Equal Pay Act of 1963. (Pub. L. 88-33), EEOC.

European Commission, 2014. *Tackling the gender pay gap in the
European Union.*

European Commission, 2017. *EU action against pay discrimi-
nation.* Retrieved from: https://ec.europa.eu/info/poli-
cies/justice-and-fundamental-rights/gender-equality/
equal-pay/eu-action-against-pay-discrimination_en

Fair Pay Act. 2019. H.R. 2039, 116th Congress.

Farrell, S., 2015. Women in the Boardroom. *The Guardian*, September, 29. Retrieved from: https://www.theguardian.com/business/2015/sep/29/companies-with-women-on-the-board-perform-better-report-finds.

Foubert, P., *et al.*, 2010. *The gender wage gap in Europe from a legal perspective (including 33 country reports)*. Brussels: European Commission. Retrieved from: https://www.equalitylaw.eu/downloads/3862-the-gender-pay-gap-in-europe-from-a-legal-perspective-pdf-518-kb

Gan, A.M., *et al.*, 2014. *The gender gap in art museum directorships*. Association of Art Museum Directors.

Gan, A.M., *et al.*, 2017. *The ongoing gender gap in art museum directorships*. Association of Art Museum Directors. Retrieved from: https://aamd.org/sites/default/files/document/AAMD%20NCAR%20Gender%20Gap%202017.pdf

Gallup, 2016. *Women in America: Work and Life Well Lived.*

GuideStar, n.d. Retrieved from: https://learn.guidestar.org/products/nonprofit-compensation-solutions/guidestar-nonprofit-compensation-report

Holmes, K., and Corley, D., 2017. *International approaches to closing the gender wage gap*. Center for American Progress. Retrieved from: https://www.americanprogress.org/issues/women/reports/2017/04/04/429825/international-approaches-closing-gender-wage-gap/

Institute for Women's Policy Research, 2011) *Fact Sheet: The gender wage gap: 2010*. Retrieved from: https://iwpr.org/publications/the-gender-wage gap-2010/

Jankowski, J., 2011. Caregiver Credits in France, Germany, and Sweded: Lessons for the United States. *Social Security*

Bulletin, 71(4): 61-76. Retrieved from: https://www.ssa.gov/
policy/docs/ssb/v71n4/v71n4p61.pdf

Jones, J. M., 2005. *Gender differences in views of job opportu-
nity*. Gallup. Retrieved from: https://news.gallup.com/
poll/17614/gender-differences-views-job-opportunity.aspx

Joshi, H. and Davies, H., 2002. Women's incomes over a
synthetic lifetime. In: Ruspini, E. and Dale, A., (Eds.) *The
gender dimensions of social change* (111-31). Bristol: The Policy
Press.

Kerr, B., *et al.*, 2002. Sex-based occupational segregation in
U.S. state bureaucracies, 1987–1997. *Public Administration
Review*, 62(4):412–23.

Kumar, D. K., 2018. *California state law mandates female board
directors by 2019*. Reuters, September 30.

Lundberg, S. and Rose, E., 2000. Parenthood and the earnings
of married men and women. *Labor Economics*, 7 (2000):
689-710.

Mandell, A., 2018. *Exclusive: Wahlberg got $1.5M for 'All the
Money' reshoot, Williams paid less than $1,000*. USA Today,
January 9.

Miller, J. and Adkins, A., 2016. Reality and perception: Why
men are paid more: *Gallup*, October 26. Retrieved from:
https://www.gallup.com/workplace/236345/reality-percep-
tion-why-men-paid.aspx

Paycheck Fairness Act, 2019. H.R. 7, 116th Congress.

Paddison, L., 2019. Why Iceland is the best place in the
world to be a woman. *Huffington Post*, March 8. Retrieved
from: https://www.huffpost.com/entry/iceland-
women-world-best-place_n_5c7d39ace4b0614614dc
f2d4

Rabovsky, T., and Hongseok, L., 2017. Exploring the antecedents of the gender wage gap in U.S. higher education. *Public Administration Review*, 78(3): 375-385

Ruhm, C., J., 1998. The economic consequence of parental leave mandates: Lessons from Europe. *Quarterly Journal of Economics* 113 (1): 285-317.

Sigle-Rushton, W. and Waldfogel, J., 2006. Motherhood and women's earnings in Anglo-American, Continental Europe, and Nordic Countries, Luxembourg Income Study (LIS). *Working Paper Series, No. 454.*

Smith, P., 2019. EEOC's pay data collection reinstated by federal judge. Bloomberg Law: *Daily Labor Report*, March 4.

Social Security Caregiver Credit Act, 2018. H.R. 6952, 115th Congress.

Universum Global, 2018. *What is the current global cost of talent?* Retrieved: https://universumglobal.com/whats-the-current-global-cost-of-talent/

U.S. Bureau of Labor and Statistics.

Watkins, T. A., 2018. The ghost of salary past: Why salary history inquiries perpetuate the gender pay gap and should be ousted as a factor other than sex. *Minnesota Law Review*. 103: 1041-1088.

Westover, G., *et al.*, 2018. U.S. and U.K. changes in pay equity laws call for employers to look internally to avoid discrimination claims. Bloomberg Law: *Daily Labor Report*, August 8.

White House Equal Pay Pledge, 2016. Retrieved from: https://obamawhitehouse.archives.gov/webform/white-house-equal-pay-pledge

World Economic Forum, 2018. *The global gender gap report.*

Insight Report. Retrieved from: http://www3.weforum.org/
docs/WEF_GGGR_2018.pdf

A PROMISE TO THE WORKERS

Jaclyn J Kelly

THE MUSEUM INDUSTRY is changing from within. Prodded by thoughtful people, a societal push to understand the nature of privilege and basic financial need, museum staff from different parts of the field (management, staff, consultants, and others) have started to rethink the way our industry treats work, the people that do it, and the way it gets done. Ideas like, "we don't work here to make money," and the notion that working in a museum is a privilege workers must pay for through unpaid internships and expensive credentials, have been widely accepted, and even worn as a badge of honor and measure of sacrifice. These practices give people who do not rely solely on their own labor for money a head start and act as gate-keeping measures. They also devalue work and can prevent talented people who do not have access to other resources from starting or sustaining careers in museums. The question now becomes: what can be done?

People across our field have attempted to address this in a variety of ways: blog posts, social media accounts devoted to museum workers or new professionals, petitions, and calls to AAM or its affiliates to create accreditation-related solutions. These are all effective and necessary, but there is another solution that few museum workers seem to consider: unionization, also known as collective bargaining. Collective bargaining is negotiation between employer representatives and a labor union over wages, hours, working conditions, or other disputed issues. The result of collective bargaining is a contract: a binding, enforceable agreement between two parties. The contract is a promise to the workers about how the employer will treat them and value their labor. The workers' representative organization is known as a *local*. The local is often affiliated with larger

councils, which in turn may be affiliated with national organizations (known as an *international*) or labor federations. This allows them to pool resources in powerful ways. Internationals often represent workers who work in the same or similar industries, but not always.

How does collective bargaining help workers?

Collective bargaining generates leverage. This becomes particularly crucial in the museum industry where several disparate factors interact to exert a downward pressure on compensation. Some of these factors include unpaid internships and the oversupply of candidates due to the proliferation of museum studies programs. Internships are a rich and vital part of proper museum training, but unpaid internships can become a source of free labor for an employer. Unpaid work can impact or reduce the need to hire paid staff (perhaps even replacing the paid staff these unpaid interns hope to be someday), and can means that most workers' first jobs pay nothing and their next "entry level" job does not need to pay much more. Besides these market forces, the museum industry produces workers who are personally and professionally committed to museum work and are often, whether they realize it or not, willing to absorb the organization's unwillingness or inability to pay more because they believe the institution's mission and economic interests are one and the same. All these factors coalesce to perpetuate low levels of pay, particularly in entry-level positions.

Management's promises to the workers via the contract provide benefits and peace of mind to workers in unionized workplaces. One of the most important things a labor union does is negotiate base pay and raises. This is important for

several reasons. First, a union can secure higher pay for a position than the employer would likely have been willing to provide otherwise (Economic Policy Institute, 2012b). Second, it ensures that there is a "floor," a minimum, to how much money management must offer a candidate for the position. This floor is published in the contract, to which all workers have access; transparency is automatically increased. This is significant because some of the dynamics that often impact women applying for museum jobs disappear: the dreaded "salary history" issue, and inexperience or discomfort when negotiating for more money. This also means that management cannot devalue the work based on who is performing it: issues of pay discrimination are preempted. Locking in pay raises over the course of a contract benefits working families and households as well. When the worker knows what their pay is, and what their raises will be for the agreed-upon length of the contract, they can foresee their income and plan accordingly.

Labor unions also negotiate over healthcare. Similar to compensation, workers are likely to get a better healthcare package with union representation than the employer would have offered otherwise. Some employers do not offer healthcare to part-time staff. A labor union, based on the wishes of the membership, can choose to pursue this at the bargaining table and arrive at an agreement with management to get healthcare for part-timers.

A union can negotiate for contracts which require that work done by paid staff continues to be done by paid staff. This gives the local enforceable language in the event they feel management is siphoning away staff job duties and livelihoods to interns, volunteers, or contractors. Unions can also set up

enforceable parameters that govern the institution's use of contract workers. Again, this helps people maintain good, in-house jobs in museums.

Finally, labor unions negotiate with management on behalf of workers on a range of other things including, but not limited to, scheduling, uniform reimbursement, workplace safety, benefit time, clear job descriptions (which automatically entail a clear reporting structure), and general working conditions. These agreements set out what workers can expect from their managers and, in some instances, what managers can expect from their workers. For working families, having an agreement regarding, for example, how far in advance they will receive their schedule makes it easier to plan and hence easier to maintain a job in the museum industry.

Do unions cause conflicts?

Managers often complain that unions bring conflict and discontent to the workplace. But this is not really true. The collective bargaining process necessitates that management be up-front about the duties they need workers to perform and how much they will compensate a worker for completing them. If management is unwilling or unable to do that, the union is not creating conflict. It is simply exposing something that was already there, namely management's desire to maintain the latitude to alter job duties at a whim and probably with little or no additional pay. Negotiating a collective bargaining agreement can generate conflicts, but conflict is not something to fear. It can be a necessary step in resolving issues.

Conflict can also arise when the union offers a counternarrative to management's narrative about a situation in the

workplace. Management typically does not appreciate this, but it can allow workers to examine workplace situations from the employee's perspective and clearly assess how a situation in the workplace might affect themselves or their fellow workers.

There can be conflicts within unions, too. Decision-making in a union is totally different from the decision-making we often experience in the workplace. In the workplace, management maintains full control of any decision-making process. It is important to remember that even if management invites staff input, management maintains full control of the process. This includes deciding: at which point in the process to accept staff input; which questions to allow staff feedback on; and of course complete control over whether to use or discard staff input. If the staff do not like a decision, they have no recourse.

In a union, decisions are made by a quorum of members (usually designated by the union's constitution) voting on a resolution. This democratic process can create conflicts, which is natural and normal in a member-driven, horizontal organization. When deciding on a course of action, particularly if different types of workers are involved, some of the most intense conflict will be among members before management is even approached. While this can be difficult, robust debate is a sign of a strong and healthy democratic organization and not something to be avoided. Unions use rule-governed processes for making decisions, which ensures that there is a time for open debate before a final vote and a quorum must be present to take a vote. These decision-making processes allow workers, in a union context, to have far more power to determine their own course of action than

they do in the workplace as an employee. Their decisions carry more weight; the mantle of "worker/leader/decision-maker" can feel heavy sometimes.

Potential side effects of collective bargaining

Unionization has the potential to increase diversity in museums, an issue important to many people in this industry. As Nicole Ivy (2016) noted:

> The data reveal that museum studies graduate programs tend to attract people who can afford either to carry sizeable amounts of student debt or to finance a good portion of the cost through independent resources. First generation college students, students from... impoverished communities... may not be able to do either. [...] The prevalence of unpaid work – and work paying less than a living wage – in the field also affects museums' ability to attract professionals who don't have access to financial reserves.

Research indicates that income inequality often hits communities of color the hardest (Economic Policy Institute, 2012a). Working people coming together in a union have the power to negotiate higher wages on behalf on everyone in the workplace. If pay, raises, and healthcare costs are better as a result of a union contract, perhaps it will naturally allow more workers of color to start and sustain jobs in the museum industry. Unionization is an especially powerful tool to drive change because it is totally worker-driven. It allows workers to propose and implement solutions based on their understanding

of the issues that affect themselves. They do not need to wait for industry leaders to implement top-down solutions, on their timetable, while talented workers from under-represented demographics seek careers elsewhere. We can negotiate good contracts with decent pay and regular raises that make this industry a financially viable option for anyone that wants to be a part of it.

Unions have a long tradition of caucusing, which allows workers with common interests, goals, philosophies, or experiences to come together to discuss their shared interests and propose resolutions to the local. Workers can caucus any way they want, and workers often caucus along demographic lines. These structures allow workers with similar experiences in the workplace to discuss amongst themselves, design solutions, and act in solidarity with each other.

Another side effect of unionization is increased accountability, and this accountability flows in several different directions. First, a union shares authority and power. The leadership of a union is elected by the membership (in contrast to leaders in the workplace hierarchy, who are appointed). The membership share power between themselves, by virtue of the voting process, to make decisions for the local. The local leadership is subject to an election and must be re-elected every term if they want to continue. This creates a culture and practice of mutual accountability between workers and their leaders and between workers themselves. Unions are not a third-party organization, run by lawyers, who come into a workplace and dictate pay and working conditions. They are member-driven organizations governed by processes that authorize the membership and its leaders to make decisions and hold them accountable.

Collective bargaining also holds the museum account-able. The people that work at museums are also taxpayers and community members. When management and labor arrive at an agreement, management is making a promise to mem-bers of the community. This holds the institution account-able in enforceable ways to regular working people, who may not always have the same interests or vision as politicians or wealthy donors. In an industry in which institutions and the individuals who work in them often want to maintain a pro-gressive profile, a union contract helps ensure that the institu-tion's business practices bear out those values.

A worker identity – the power of solidarity
Most people in the museum industry, at least the white-collar staff, probably would not use the word "worker" to describe their relationship to their employment. They may use the terms "professional," or "museum professional," instead. However, layering on an identity as a worker has powerful implications both for creating financially sustainable careers and for creat-ing richer bonds with the communities we serve.

The word "professional," when used in the museum indus-try, often describes someone with a high degree of training, education, and experience, which they use to complete their job duties. The identity of "worker" does not override or remove professional identity, but simply denotes that the employee in question does not own or otherwise control the workplace. Furthermore, a worker identity helps us realize that we have shared interests as a working class, and that those interests do not always coincide with management's interests. Viewed through this class analysis, the museum professional has just

as much in common with the building custodian, if not more so, since both are subject to the decisions of the employer and neither control the workplace. Realizing that one's interests do not always coincide with management's does not mean that the professional is any less personally or professionally aligned with the museum's mission. The museum's mission and its economic interests are not one and the same. Conflating the two is probably one reason workers are so hesitant to demand more. Asserting one's interests as separate from the institution's is not a rejection of its mission.

Some professionals may bristle at the idea of being lumped into a local with people who do different kinds of work at the museum and prefer to be among workers of similar training or background. Differences in education and career path may make professionals feel that their many years of training, education, and sacrifice make them irreconcilably different from other types of workers, although it is worth noting that many types of workers have lifetimes of work and sacrifice too, often with little to show for it. I once heard a colleague from a unionized workplace, in reference to a dispute within their local, state angrily that, "maybe the professionals need our own union." A tired, divisive, and ugly sentiment resurfacing once again. One of the major themes in American labor history is the inherent tension between craft unionism and industrial unionism. Craft unionism is a labor organization based on members' possession of a common skill. Labor history teaches us that skilled laborers (frequently white men) often used this concept to exclude workers of other races, classes, and genders; it is a philosophy that, at times, has slipped into prejudice. In contrast, an industrial union is a labor union organized on the basis of common

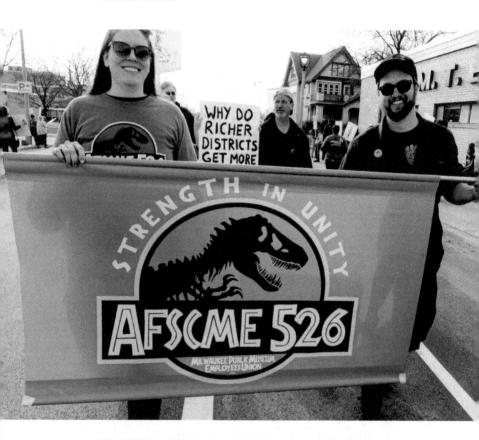

FIG. 1: AFSCME Local 526 stand in solidarity with students, families, and education workers in demanding good public schools and fair working conditions.
Photograph: Joe Brusky.

employment in a single industry, regardless of skill. This union-
ism includes workers of all kinds, which generates more lever-
age in the workplace. It also has the potential to benefit everyone
while addressing the needs of oppressed workers within its
ranks. In this model, a local based at a museum would include
everyone, whether they wear a lab coat, teach programs, push
brooms, or turn wrenches, united by their common interests
as a working class. They have a deep potential for progressive
goals and action and invite workers of different backgrounds
and experiences to stand in solidarity with each other. The
model also creates a rich pool of experiences to draw from when
designing contract demands and strategies.

An industrial structure combined with a shared worker
identity allows us to interpret and critique our institution from
a cross-departmental standpoint and invites us to understand
our fellow workers in new ways. For example, what does it
mean to be a worker, a woman, and a person of color? How
could those experiences differ from the way an employee who
is a worker, a man, and white moves through the workplace? Or
a person who is a worker and gender non-conforming? These
identities shape the way we interact with employers, the public,
and other workers. Layering on a worker identity allows work-
ers to simultaneously stand in solidarity and recognize shared
interests with other workers while fostering a deeper under-
standing of others' unique experiences. Our struggles are not
the same, but they are connected (Figure 1).

Finally, a worker identity has important implications for our
work in museums. The identity of *worker* is the only identity
that is almost universal; the overwhelming majority of people
in the world do not control their workplace. When we recognize

this identity in ourselves it creates a bond with the people in our communities. When we sit alongside fellow workers at regional labor council or state federation of labor and listen to workers address the delegate body about their struggle in the workplace or their latest contract negotiation, we are connecting with our communities simply as participants and comrades. This contrasts with interactions with the public as museum staff. There, we are the experts and possessors of information, with all the associated status and authority, which inherently alters the dynamic with the public. When we hear about the struggles of working people in our community and attend their rallies or walk alongside them in the picket line, we are standing in solidarity with the exact people we want to serve. Describing our community members in the time-honored language of the labor movement, as our brothers and sisters, has deep potential implications for the way we think about and serve the people.

Conclusion

A union brings together different kinds of workers to collectively pursue a more just and equitable museum industry, reflecting the full richness of our communities. A state AFL-CIO federation or local labor council can help find experienced organizers to help if staff wish to organize a union in their workplace. As workers, we are well-positioned to identify interests and issues affecting ourselves and our fellow workers, and design solutions. Workers of the museum world should unite under a broad banner that brings all museum workers together and looks forward to the diverse museum workers we will welcome in the future. We are the leaders, thinkers, and agitators we have been waiting for, and perhaps the communities we serve have been waiting for us too.

REFERENCES

Economic Policy Institute, 2012a. *The State of Working America*. Retrieved from http://stateofworkingamerica.org/chart/swa-income-table-2-5-median-family-income/

Economic Policy Institute, 2012b. *The State of Working America*. Retrieved from http://stateofworkingamerica.org/chart/swa-wages-table-4-37-union-wage-premium/

Ivy, N., 2016. The labor of diversity. *Museum*, 95, 36-39.

OMG WE WON! THE NEW MUSEUM UNION

Stefanie Jandl

ON A RAINY THURSDAY AFTERNOON in January 2019, the National Labor Relations Board conducted an election at the New Museum in New York City. Museum employees cast their ballots on a proposal to join Local 2110 of the United Auto Workers, which represents employees at the Museum of Modern Art and several other cultural institutions in the city. The museum leadership, which had been unaware of the union drive until just three weeks prior to the election, had engaged anti-union consultants to launch a forceful campaign to counter that of the well-organized union committee seeking fair wages. The votes were tabulated and announced before the end of the workday: more than 80% of voters approved joining Local 2110. The museum's new collective bargaining unit, known as the New Museum Union, now represents about one-third of the museum staff and as of April, 2019 is negotiating its first contract (Figure 1).

New art, new ideas

The New Museum is the only museum dedicated exclusively to contemporary art in the borough of Manhattan. It was founded in 1977 by Marcia Tucker, a Whitney Museum-trained curator with a progressive vision for a contemporary art museum that would embrace "the new" in every way possible – new art, new and emerging artists, new ways of presenting, interpreting, and collecting new art. Tucker eschewed the traditional notion of a permanent collection because it was inherently contradictory for a contemporary art museum to collect works that would soon cease to be contemporary. As the founding director, Tucker also employed a new kind of leadership model, "one based not on hierarchy and power, but on empowerment – communication,

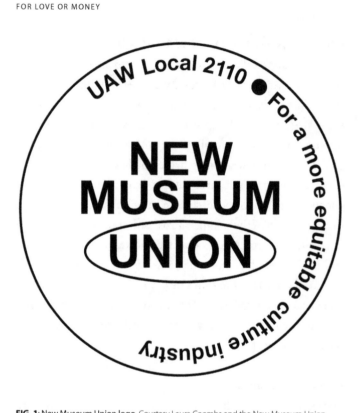

FIG. 1: New Museum Union logo. Courtesy Laura Coombs and the New Museum Union.

collaboration, listening, and consensus building." (Pachmanova, 2006: 116) She was a strong feminist and believed in fair wages and equal pay; in the first few years of the New Museum everyone, women and men alike, received the same salary – except Tucker herself, who didn't draw a salary until the museum's finances stabilized (Tucker, 2008: 126). Although she did not follow through on some particularly radical early ideas, like job-swapping, Tucker, who led the museum for 22 years, rejected top-down leadership models throughout her career.

Located since 2007 in the Bowery of Lower Manhattan, the New Museum is well known for its long-standing, influential exhibition program that fulfills its current mission of "new art, new ideas." The museum recently expanded its reach with the launch of several experimental initiatives. New Inc, described as "the first museum-led incubator," is a creative think-tank that nurtures art practitioners to become creative entrepreneurs. IdeasCity hosts dynamic annual conferences that bring together diverse people and perspectives to shape the cities of the future by positioning the arts at their core. The museum also offers school, youth, and family programs as well as public programming.

The New Museum is led by Lisa Phillips, who was hired in 1999. It has an annual operating budget of $13 million and a staff of 150 full- and part-time employees. The board of directors has been enlarged during Phillips' tenure and is now comprised of 42 people. Attendance, though not publicly shared, is about 400,000 per year. This year the museum breaks ground on a new adjoining building, designed by Rem Koolhaas's architecture firm, OMA, that will increase the museum's current square footage from 58,000 to just over 100,000. An $85 million capital campaign is underway to fund this expansion and enlarge the museum's endowment.

You can't eat prestige

While the museum has progressive roots and a dynamic outward facing persona, union organizers and other junior staff members – former and present – describe a different vibe within the museum. They portray a hierarchical organizational structure with little vertical connectivity and communication, a place where new staffers are unlikely to receive onboarding and existing staffers are often surprised by the departure of colleagues because email announcements are forbidden for such occasions. They discuss the frustration of ongoing high staff turnover, which disrupts projects and doubles the already intense workloads of remaining employees. Salaried staff, many describe, are expected to work long hours on demand, making it difficult to sustain much-needed side jobs.

But the central issue New Museum employees cite is unlivable salaries that are low even by New York museum standards. Some starting salaries, they shared, are as low as $35,000. According to the museum, the median salary for full-time employees who are eligible to join the union is $52,000 (P. Jackson, museum spokesperson, personal communication, April 8, 2019). This figure means that half of these employees earn salaries less than $52,000, which is at or below the 2018 living wage of $51,000 for New York City.

Beyond salary, employees cited unaffordable shared costs for healthcare and minimal defined benefits, such as paid time off, as factors for joining a union. Museum employees also described feeling pressure not to report overtime hours. According to state employment law that was drafted to maintain a living wage, salaried New Museum staff earning $50,700 or less in 2018 would have been legally entitled to overtime pay.

(This threshold increased to $58,500 for 2019.)

With no human resources department or director, personnel management has until recently been part of the job description of the Director of Finance and Administration – itself a recently vacated position. Junior staff members describe difficulties within this framework in seeking support and information (paid holidays, for example), and negotiating raises, benefits, titles and job descriptions. (As of April, 2019, the museum filled the newly-created position of Human Resources Manager, who will report to the Director of Finance and Administration – a position for which a search is also underway.)

Beyond these tangible issues, junior museum staff portray an unspoken but discernible attitude within the museum that a low-paying, entry-level job is something one suffers for future rewards: the prestige of the museum launches a career and opens the pathway to better-paying jobs in the field. But as one union organizer remarked, "you can't eat prestige." The only way for the museum's entry-level staff to live – and, for many, to pay off student loans – is through outside funds and people: family money, gainful side hustles, roommates, partners, or parents. And at the New Museum and elsewhere in the profession, such financial patches are considered normal: "it's just what you do to establish a career."

Getting what we deserve

In March 2018, the New Museum held a quartet of workshops on sexual harassment for cultural leaders and workers. Women from senior management organized the sessions and although they were aimed at the general public all museum staff were encouraged to attend. The final workshop focused on the

gender pay gap. Titled *Changing the Balance of Power and Getting What We Deserve: Salaries, Promotions, Mentorship*, the session leader noted that the gender pay gap was especially true in museums and focused on "how we value women's work, tactics for negotiating salaries and promotions, and what resources are available to benchmark one's economic status." Junior staffers in attendance were angered by the core message of the workshop since their own efforts to negotiate higher salaries in the museum had been difficult, lengthy, and largely unsuccessful. Further, the workshop's implicit "lean-in feminism" – a strategy for individual professional women to succeed by asserting themselves within existing structures – was at odds with their own feminist beliefs that an institution needs to be fundamentally reshaped to create actual equity. The session inadvertently shined a light on core issues in the New Museum workplace and galvanized staff into action.

The anger following the workshop broke social barriers amongst junior colleagues in a work environment that was largely siloed. Grass roots conversations began around non-living wages, unpaid overtime, formidable workloads, and out-of-touch senior leadership. They shared salaries. With the capital campaign bringing in millions of dollars and the Director's total compensation package at about $750,000 – more than 5% of the museum's annual budget – the junior staff felt that there was little concern for their economic and workplace well-being.

While the employees felt exasperation over their work environment, they also shared a belief in the museum and its mission, and they wanted to see it succeed. Many were inspired by Marcia Tucker's radical vision and her rejection of hierarchies, which made the present misalignment between the museum's

stated progressive values and workplace conditions all the more disturbing. And they were motivated to implement a long-term remedy, something that would benefit the people who would hold their jobs in the future.

By the fall of 2018 the New Museum staff conversations included most of the junior staff, both full- and part-time. Employees discussed possible remedies, including union representation. In order to consider this option more fully, they reached out to a union leader at the Museum of Modern Art and then to Maida Rosenstein, the president of Local 2110, which represents MoMA employees. In October Rosenstein met with the group and brought along MoMA union members to co-present and answer questions. The group shared salaries, benefits, and workplace conditions at their respective museums. After learning what the union could offer them, the New Museum workers reached quick consensus on their course of action: form a collective bargaining unit.

Win your quickie election!

Now a formal union committee, the group proceeded with a card campaign. Local 2110 required a supermajority of eligible staff to sign cards affirming their wish for union representation. The union organizers secured about 54 cards and on the morning of January 4, 2019 Local 2110 filed a petition with the National Labor Relations Board to conduct an election. That same day union organizers formally notified the museum leadership of their intention to hold a vote two weeks later. In a striking disconnect, this email – sent nine months after union discussions began – was the first time the senior staff and the board of directors heard of a union drive (Figure 2).

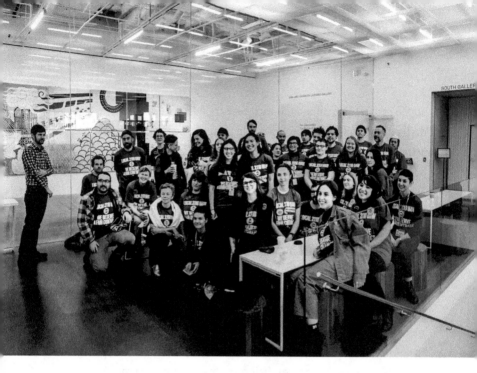

FIG. 2: Union organizers wear solidarity T-shirts in the New Museum lobby the day after filing their petition for a union vote. Courtesy New Museum Union.

Caught off-guard, the museum's leadership sought immediate professional advice on labor law and the process of union organization. A spokesperson said that while many staff members were interested in a union, others were unsure or opposed. The museum wanted to acknowledge the range of views and thus engaged outside expertise for one week to help staff make "informed decisions" (P. Jackson, museum spokesperson, personal communication, April 8, 2019).

But the firm retained by the museum, Adams Nash Haskell & Sheridan, specializes exclusively in "union-avoidance" – not informed decision-making. Their website states that they help companies keep their workforce from forming unions and promotes what they've trademarked as *the union-free privilege®*. They offer clients a menu of "urgent services," including one for the situation the New Museum faced: "Win Your Quickie Election!" (NLRB rules presently allow elections to be held as soon as twelve days after a petition is filed.) The engagement of a union-busting consultancy group triggered the New Museum union committee to issue a press release and go public with their drive. These tandem events led to considerable negative press for the museum and generated public expressions of solidarity with the union organizers from the MoMA union, artists, and others in the art sector.

The consultants quickly launched a suite of meetings to provide museum staff with "balanced information" about union membership. At this time some junior-level museum employees were surprised to learn that their jobs were "supervisory," a status that would make them ineligible for union membership. (The New Museum stated that no positions were reclassified in response to the union drive.) As such, these employees

were required to attend a supervisors' meeting, led by the consultants, that enunciated problems with union affiliation: unions are not for museums; they require hefty 2% dues; and they "build walls where there were none" (Day, 2019). Next, the consultants met individually with supervisors and department heads to discuss unionization, but some staff reported "being asked during these meetings to name names" (Resnick, 2019).

Finally, each staff member was assigned to one of four mandatory meetings that were led by senior staff. These sessions aimed to bypass the union campaign and address employee concerns directly by opening lines of communication between the senior and junior tiers. Museum leaders said they felt "hurt" and "betrayed" by the surprise union drive, and they urged staff to come to them directly with their problems rather than forming a union, which would cause "irreparable damage" within the museum. The Director and Associate Director emphasized that they were always available to talk with an employee over a cup of coffee. The meetings were adjourned with no time for questions from staff. Many employees found both the agenda and tone of the sessions patronizing, and some staff members who had been undecided left confident that unionizing was the path forward.

After the union vote was taken on January 24, 2019, the New Museum Union campaigners tweeted: OMG WE WON!! It was a decisive victory for the union committee: 38 Yes votes and eight No votes. (Ten additional ballots remain sealed and "under challenge" pending NLRB hearings to establish voter eligibility.) In a statement issued to the press, the museum said it respected the employees' decision to form a union and affirmed it would move forward in good faith to advance the mission of

the museum. As of this writing the New Museum Union - UAW Local 2110 and the New Museum management are negotiating their first labor contract.

Conclusion

The successful union campaign at the New Museum is notable in several respects. What began as open-ended conversations about workplace inequity grew into a well-organized, process-oriented initiative. The core committee, comprised of five or six employees, foregrounded inclusivity and open dialogue among colleagues to cultivate consensus. Over nine months they dedicated hundreds of hours to their work – several commented that the project was akin to a second (unpaid) full-time job. Some have parents in unions and therefore understood both the benefits of membership and the extensive work of campaigning.

Equally important, the union committee was strengthened by the millennial status and personal beliefs of its members. Highly educated, they are well read in labor history and political theory; some are activists. They are part of the first generation to enter the American workforce encumbered with significant student debt and handicapped by unaffordable healthcare and stagnating salaries. The New Museum Union organizers sought financial stability – not wealth – in their chosen field, and their millennial perspective on justice drove them to challenge the larger system rather than finding new careers or publishing open letters demanding fair wages. Further, this generation is typically drawn to flat organizational structures built on collaboration, transparency, and a free flow of feedback amongst all employees. Not surprisingly, the New Museum's hierarchical organizational structure felt outmoded and stifling to young

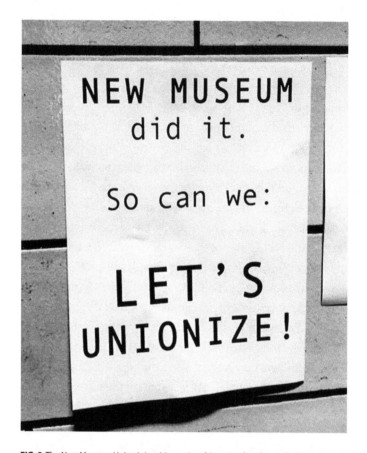

FIG. 3: The New Museum Union is inspiring union drives at cultural organizations elsewhere. Photograph taken in April, 2019.

staff, an aspect they found all the more shocking when considering Marcia Tucker's founding tenets.

The New Museum employees are not alone in their workplace concerns. Entry-level museum professionals are increasingly speaking out today about internal museum labor practices that form barriers to entering, and staying in, the profession (Figure 3). Museum Workers Speak, a collective of young museum professionals, held a rogue session on this topic adjacent to the 2015 American Alliance of Museums conference. In their manifesto the group wrote:

> Many museums have a stated commitment to acting as agents of social change, but we see an inconsistency between this mission and museums' internal labor practices. We believe that only once museums recognize and resolve their internal inequalities can they truly begin to act as agents as social change. (Museum Workers Speak, 2015)

MWS is no longer operating as a platform of social change – not surprisingly some members have left the museum profession altogether for financial reasons – but the group nonetheless succeeded in bringing much-needed attention to contemporary labor issues. The New Museum Union organizers successfully implemented one possible solution and museum employees elsewhere are watching closely.

Facts and opinions contained in this chapter, where not otherwise attributed, were provided by present and past employees of the New Museum. They have not been identified individually to preserve their confidentiality.

REFERENCES

Day, M., 2019. Fight at the Museum: An Interview
 with Lily Bartle. *Jacobin*, 23 January. Retrieved
 from https://jacobinmag.com/2019/01/
 new-museum-union-uaw-art-bargaining

Fox, O.K. and Jakubowski, J., (Producers), 2019. Episode
 29 New Museum Union. Audio podcast. *Art and Labor*,
 January. Retrieved from http://www.artandlaborpodcast.
 com

Kennedy, R., 2016. New Museum Plans Expansion After
 Raising $43 Million. *New York Times*, May 10, 2016.

Museum Workers Speak, 2015. *AAM 2015 Rogue Session.*
 Retrieved from https://museumworkersspeak.weebly.com/
 resources.html

Pachmanova, M., 2006. Interview with Marcia Tucker:
 Empowerment and Responsibility. *n.paradoxa*, online
 issue no. 19. Retrieved from https://www.ktpress.co.uk

Resnick, S., 2019. Issues & Commentary: Organizing the
 Museum. *Art in America*, April 01. Retrieved from https://
 www.artinamericamagazine.com/news-features/maga-
 zines/museum-unions-issues-commentary-organizing-
 the-museum/

Tucker, M., 2008 *A Short Life of Trouble: Forty Years in the New
 York Art World*. Berkeley, CA: University of California
 Press.

NEXT-GEN THINKING FOR MUSEUM RECRUITMENT

Micah Styles

IN 1966 ROBERT F. KENNEDY delivered a speech where he is quoted as saying:

> There is a Chinese curse which says, "May you live in interesting times." Like it or not, we live in interesting times. These are times of danger and uncertainty; but they are also the most creative of any time in the history of mankind.

The widely-held view is that there is no evidence of the Chinese origin of such a curse. The earliest clearly identified use was by Sir Austen Chamberlain, British Foreign Secretary in 1936, who likely stole it from his father, Joseph Chamberlain, who said something similar in a speech way back in 1898. (Shapiro, 2006: 669). Regardless of who ultimately can lay claim to it, the phrase's longevity of use can probably be attributed to its enduring applicability to "our times." The recurring mistake, of which even RFK was guilty, was to assume that we in the here and now have reached the pinnacle of creativity, underestimating the ability of human beings to continue to create new paradigms, reimagining and reshaping the future.

Every generation faces both opportunities and challenges that require increasing levels of creativity. The concept of "interesting times" provides a no less valuable lesson for museums today, which are often a useful lens through which to view broader perspectives. And it is not too much of a stretch of the argument to see how we do indeed function in a cultural, societal, commercial, operational and technological landscape that is unprecedented. Never before has the *now* for museums been so fluid (unstable) and the *future* been so exciting (unpredictable).

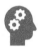	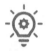		
NOW	REVIEW	PRIORITIZE	FUTURE
People strategy	Based on business objectives	Outcome-driven	People-centricity
Talent optimization	Broad and specific impacts	Range of initiatives	Maximized resource
Hiring process	Available resources	Phased approach	Next-gen processes
Unstable / Fluid	Disruptive landscape	Agile implementation	Unpredictable / Exciting

FIG. 1: Moving hiring practices towards a solution-oriented future.

The opportunity for a modern museum wishing to sustain its relevance within this context is inextricably linked to its people strategy, talent optimization and, in particular, its ability to attract, appoint and retain the very best staff. In these incredibly interesting times in which experience, commerce and scholarship are converging, it is our skilled and engaged staff, many of them digital natives, who will navigate our museums. Undercompensation in the sector, coupled with less-than-best practice at times, is making it hard for them to do this effectively, and it is our view that this will only increase over the short and medium term. If we are able to change how we recruit, we can also begin to make changes to who we recruit, and the way we pay them. This chapter will provide some principles and guidelines to introduce next-gen thinking into the sector that can be prioritized and progressively adopted by future-thinking museums (Figure 1).

Recruiting the best
Talent acquisition, selection and retention is not a single solution, it is an ecosystem that is expanding and evolving rapidly. So before we delve into what recruitment practices we believe will shape the future, it is worth spending some time reflecting on the principles that we see as best practice right now, as parts of them may be new ideas to some. Our recommended recruitment approach is built on four fundamental principles:

1. Build the brand
A recruitment program is a unique opportunity to engage with a wide and diverse audience. For many this may be their first real exposure to your museum. A recruitment program that capitalizes on this opportunity should primarily be driven by

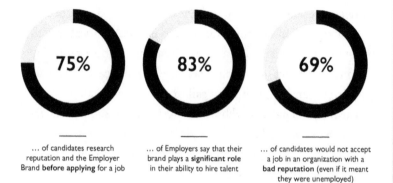

FIG. 2: The importance of the employer brand for attracting candidates. Source: LinkedIn.

development, promotion and engagement and integrated with the Human Resources (HR) process, not the other way around. HR departments often create reproductions of job descriptions for recruitment advertising and candidate information packs, which lack creativity, passion and enthusiasm. Museums can improve on this, and create something special – *the best candidates will have bigger, bolder, better aspirations!* Process is still important though and the "experience" should begin from point of first contact through to interview, selection, appointment, first day and beyond. Each touch point along this path should be carefully thought through to maximize goodwill, enthuse both public and professional sector, and convey the museum's vision and mission (Figure 2). Of paramount importance is an end-to-end process that is well planned, managed and delivered professionally.

Takeaway: Employer brand matters. First impressions last. Get it right: message, tone, information. First contact, process, feedback. Everything.

2. Start early

A museum's recruitment program should be aligned with business, financial and operational plans. As such, getting the right people with the right skills on board at the right time is imperative, otherwise compromises will be made, either in the timeline of projects or on the quality of staff that are recruited for the team. *The best people are the hardest to find* – and once you have found them, they are usually the least available. Understanding, accepting and accounting for this by building into the recruitment program hard deadlines, key milestones and intermediate steps, and ensuring these are all realistic is essential. Foresee potential issues (either internally with your

own process or externally with desired candidates for appointment) and seek to address them before they become problems.

Takeaway: Recruitment takes longer than you think. Plan well in advance. Allocate necessary resource and allow adequate time. Don't compromise.

3. Work backwards

It is proven that people can more easily be trained to develop skills than they can be trained to develop qualities. So, envisage the type of teams you want to create (welcoming, collaborative, flexible, cross-functional, high-performing etc.) and prepare personality profiles for each role (or for groups of types of positions). Prioritize matching people rather than skills, so that *the best can grow with their role*. Brief evaluation tests can be used as the starting point for filtering potential candidates. This can all be done simply, cost-effectively and swiftly online. Thereafter, the more traditional route of recruitment can be followed, although we suggest weighting attitude, aptitude and agility over ability – and soft skills over hard. Screening candidates in this way flips recruitment on its head, and initially can feel counter-intuitive – but it will produce much better results in the medium and longer-term.

Takeaway: Get people with the right qualities. Give them the chance to develop the right skills. Start with capability, develop competency and build capacity.

4. Mix it up

Using the right acquisition channels in the right mix is essential to attract the very best staff. If you chose to use *advertising* as a channel you must stand out from the crowd, or you will be

lost within it. Intrigue, enthuse and excite potential applicants. Design and content are both important. However, be aware that with advertising, and especially with online job boards, often quantity not quality of applicants is produced – so recruitment advertising can be used as part of an integrated program, but its limitations should be recognized and lessened, and it certainly shouldn't be your only route to market.

Everyone uses *social media* of some kind, and a recent study has shown that 73% of millennials (i.e. those currently in the 18-34 age group) found their last position through a social media platform (Venerri, 2018). However, social media can often be an ineffective element of a coordinated recruitment program. Why? Because before we recruit via social media, we need to understand it and the way our target demographic engages with it, and this is not always easy. Responsive campaigns are improving, so developing a strategy, determining the concept and content, implementing across multiple targeted platforms and evaluating using a variety of metrics will result in the most effective, optimized campaign.

The third stream often included in a recruitment program is a *targeted resourcing* initiative to supplement applications received from recruitment advertising or social media with a local, regional and international outreach. The very best candidates are not usually actively searching and applying for jobs; however, statistics show that 85% of people would be open to consider new opportunities when directly contacted. (LinkedIn, 2016). Whether working from a list of professionals you admire, or generating a list based on comparator and market research, such a proactive approach can widen the talent pool from which a museum will be able to select, especially for more

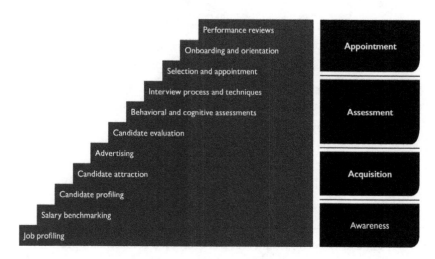

FIG. 3: Vital elements of all recruitment and retention strategies.
Source: Based on the 39 steps devised by Barker Langham Recruitment.

senior, specialist or difficult-to-fill positions.

Takeaway: Be creative. Try new attraction channels, techniques and touch points outside of the normal. Experiment. Invent. Fuse. Repeat.

The hiring process
The hiring process which is implemented will always vary, being tailored to individual circumstances and resources available, but there is a commonality amongst the most successful that includes the following processes (Figure 3).

- *Job profiling.* Being sure to understand the job and its requirements, using opportunities for multi-functionality within positions as a catalyst for creating collaborative, high-performing teams (and not simply as a cost-cutting exercise to get more bang for your diminishing bucks).
- *Salary benchmarking.* Not just within the sector but increasingly externally-focused, combatting the ever-downward spiral of peer-reviewed salary comparators, a self-perpetuating circle that has created the low salaries and high staff turnover that are prevalent in our sector.
- *Candidate profiling.* Reflecting on the list of key criteria for specific roles and how this translates into desired employee attributes, as each role has different characteristics which can be used for evaluation purposes, as well as defining a suite of common qualities that a museum will want all their staff to display.
- *Candidate attraction.* Successfully communicating, informing, educating and enthusing existing museum

professionals, established or emerging. And enticing new candidates to enter the sector from more diverse backgrounds – an important and under-emphasized part of the candidate acquisition process.

- *Advertising.* The museum sector has largely not bundled up its many attractions and offered them to a wide enough pool of people. Successful museums do this more effectively, and this bundle of attractions is used more positively and proactively in recruitment, appealing to both the basic and higher needs of future employees.

Other elements of the hiring process that also play a part in creating a comprehensive and solution-oriented recruitment process include:

- Candidate evaluation
- Behavioral and cognitive assessments
- Interview process and techniques
- Selection and appointment
- Onboarding and orientation best practice
- Performance reviews

Space does not allow us to develop all these elements in detail but suffice to say that an inclusive, results-driven hiring process that attracts, selects and retains the best staff will need to take the above into account. We have developed a process called The Thirty-Nine Steps for helping clients achieve results (Barker Langham Recruitment, 2019).

Trends

Richard Hannay, the protagonist and narrator in John Buchan's novel *The Thirty-Nine Steps* was also living in a time of change. War was looming large in Europe and he had to adapt to another "new reality" – quickly surrounded as he was by spies and their gadgets. Adapt he did and (spoiler alert) he lived to see another adventure in the second novel, *Greenmantle*. Being aware of the current and rising trends in the recruitment landscape and adopting the most beneficial and applicable of these is essential for modern museums that need to have half an eye on their day-to-day operation, whilst also looking around the corner to see what the future holds, and what impact this will have on their hiring and engagement process.

Below we summarize the major trends that will shape the next generation of recruitment practice. However, this is not an exhaustive list, and the iterations of change are happening at an increasingly rapid pace. Now, almost twenty years into the new century, we are seeing the results of an era that has been built on technology, from mobile phones to AI and machine learning. Whilst we are seeing these exciting, transformative tools being adopted by the museums sector, we don't always see the necessary adjustments and recalibration of process to use them well. For value to be created from the use of these tools there is a need to also create processes and guidelines for using them better and more effectively. Museum directors, departmental managers and especially human resource professionals within the sector therefore need to incorporate such adaptation and future-forward thinking into their hiring strategy.

Collaborative hiring

When it comes to recruitment, involving a wider team in the recruitment process can be of real value. There's a reason why they say two heads are better than one, and one example of this is the significant potential that can be derived from the combined personal networks of team members. This is one of the reasons we see an increase in the implementation and effectiveness of employee referral programs. Referred hires generally are more productive, more engaged and less likely to leave.

In fact, research (for example Jobvite, 2019) consistently shows four main reasons why employee referrals are one of the best ways to recruit:

- Faster to recruit – according to a recent study, on average it takes 29 days to hire a referred candidate, compared to 39 days to hire a candidate through a job posting or 55 days to hire a candidate through a career site.
- Cheaper to hire – you do not have to pay traditional recruiting costs to source them and, because they are faster to hire, it also means spending less on your internal process costs.
- A referred new recruit will onboard faster than a traditional hire – the referred starter feels like they have a friend that is not their boss to turn to and ask questions as they onboard so it helps to get them integrated into the culture much more quickly.
- A referred recruit will stay at their job longer than a traditional hire – another study found that 46% of referred hires were around for at least one year after they were hired, which was far above the 33% of people hired

through career sites and 22% hired through job boards. (LinkedIn, n.d)

Additionally, a culture of internal mobility can also be a great way to collaboratively meet skill shortages, decrease turnover and increase employee engagement. Not many organizations have a well-developed internal mobility program yet, but it is coming, as is another collaborative hiring tool – crowdsourced interviewing. Perhaps taking collaboration to its extreme level, crowdsourcing interviews could be a major trend in the medium term. If two heads are better than one, how good will 10,000 heads be at screening candidates, setting interview questions, or selecting the best candidates? The aggregated evaluation platforms that can facilitate such input are already being developed (such as Evalufy, Monjin and CrowdSourceHire). And as well as perhaps leading to faster, better decisions as a by-product, they are also helping to dilute the impact of biased prejudices and discrimination within the hiring process.

Takeaway: Recruitment is not the sole responsibility of a select few. Use both internal and external resource to make the hiring process a more collaborative (and thereby more effective) experience.

Attracting talent (and skills) from outside the sector

Museums are not alone in often struggling to find skilled people for vacancies and so, with a growing number of baby boomers retiring and fewer people to be found in the more traditional talent pools, forward-looking institutions are increasingly looking beyond their borders to find good people. Also, as business conditions become more complex, so do human capital

necessities, which means that hiring from within the sector may not always be the most effective approach. As a result, therefore, rather than prioritizing relevant previous experience and academic qualifications, there is a trend for greater focus on transferable skills sourced from a considerably expanded talent pool.

One of such cross-industry hiring's foremost advantages is that it encourages innovation. Someone who is seeing your museum from a different perspective can provide a much-needed new outlook on the way things are done. It also changes team mindset. Hiring someone from a different sector can reset the way a team works – if everyone has similar backgrounds, organizations should not be surprised that they keep seeing similar outcomes. Finally, cross-industry hiring also accelerates execution as cross-industry hires and the objective new perspectives they bring can give leadership teams the drive they need to move important projects and initiatives forward.

The skills we are recruiting for are also changing, and many of these can more readily be found by extending the talent pool outside the museum sector. For example, there is an increased focus on hiring people with future-proof skills such as complex problem-solving capabilities, critical thinking and cognitive flexibility (World Economic Forum, 2018). There has also been more attention on people's soft skills and, in our visitor-centric environment, museums are often struggling to find talent with good soft skills such as communication, listening or empathy. Soft skills are personality-driven and they are increasingly understood as what makes the difference between a good and a great candidate. Hard, tangible and technical skills can usually be taught, while teaching someone how to show empathy

is almost impossible.

Takeaway: Museum hiring processes that attract and engage with candidates that have transferable and future-proof soft skills will attract a wider talent pool and add significant institutional value.

Artificial intelligence

Applications of Artificial Intelligence (AI) in the hiring process are becoming more widespread, and whether we like it or not, the number of different uses of AI in recruitment just keeps growing. The tide for adoption appears to be turning, as more and more recruiters are embracing the technological advantages. A recent survey by Jobvite found that nearly 50% of recruiters feel positive about the effects of AI on their jobs while only 7% believe AI will have a negative effect. From automated candidate sourcing, recovery, and matching, to hiring remote workers and creating customized employee value propositions, the maturation and mainstreaming of AI functions across the recruiting lifecycle is happening, in particular, in the following three ways.

Recruiting functions: As recruiters begin to understand how AI can be leveraged to solve specific pain points, we are seeing a move away from the general idea of "AI for recruiting" to more specific applications such as "AI for sourcing candidates" or "AI for screening applications". As these AI products become more widely integrated and available in Applicant Tracking Systems (ATS) they are becoming a best-of-breed add-on that talent acquisition professionals are increasingly using, similar to how they choose to use recruiting software tools currently.

Chatbots: Recruiting sees a lot of trends and fads, some of

which become mainstream and entrenched. The last big trend that became mainstream was *mobile-friendly* functionality for career sites and job applications. If your museum's job application process isn't mobile-friendly for both candidates and the recruitment team, then your process is falling behind your peers and needs to be updated. Having an AI-powered chatbot to help pre-screen and pre-qualify candidates will likely be the new mobile-friendly function. Recruitment chatbots are getting so much attention because of the massive efficiency gains and improvements in candidate experience they can represent if used well. With 66% of candidates comfortable interacting with a chatbot, the market looks ready for greater adoption of this tool.

Onboarding and training: Currently, AI functions are focused on the early part of the hiring process, such as sourcing, screening, and initial candidate outreach. The trend is for AI to become more common later in the recruiting process, to improve activities such as onboarding and training. One of the main advantages is that AI can use large amounts of data to provide more accurate recommendations and suggestions to enhance the employee experience. That means AI can be integrated into onboarding and learning management systems to provide customized programs based on a new employee's skills, knowledge, and prior experience. We are still some way off this going mainstream, but early adopters will stand out from the crowd, adding real value to their employer brand.

Takeaway: Museums usually have a paucity of resource, either simply time, or often a breadth and depth of skills within a skeleton human resource department. AI is an emerging solution that is orientated to solving both and we believe it will be

a game-changer that will ultimately be adopted broadly across our sector.

Flexible workforces

In most organizations, the workforce already consists of a combination of full- and part-time employees, contractors and freelancers. In the U.S. alone, 36% of all workers (around 57 million people) are in the gig economy, a figure that is likely to grow even more in the coming years (Gallup Inc., 2018). In our sector, working with freelancers on initial short-term or fixed-term engagements was also often viewed as a good way for a museum to find out if they would like those people to become full-time employees. However, increasingly, professionals are choosing to freelance as a lifestyle choice: independent workers like the fact that they can work anywhere they want, when they want and are often happier than "traditional" employees. In fact, research finds that satisfaction levels for flexible working have never been as high as they are right now: 74% of independent workers say they are "highly satisfied" (McKinsey Global Institute, 2016).

Technology, of course, is a big enabler of this kind of freelance work, supported by platforms such as Upwork, PeoplePerHour or Fiverr which can quickly match freelancers with projects. This last point is especially relevant when a museum needs to find skilled people urgently – and in an industry where talent is scarce turning to freelancers or contractors to meet resource needs is an obvious solution. In a climate and future where museums are having to reflect more and more on their *raison d'etre* and re-focus their attention on core values and vision, a flexible, agile and responsive workforce is

something that all human resource and recruitment strategies should be looking to incorporate. The greater use of on-demand resource may also go some way to freeing up other resources to pay essential core staff better.

Takeaway: Rigid structures and engagement contracts are not flexible enough to meet the demands of the way we work today. Your workforce increasingly doesn't want them either. Be agile and responsive. Now.

Increasing diversity

The issue of diversity is rising up the strategic to-do list, and rightly so, as the need transcends merely meeting quotas or representation targets. Museums where boards and staff have different backgrounds and experience are more likely to encourage debate and to make better decisions. This is because diversity encompasses not only the identified characteristics enshrined in employment and equality legislation but also diversity of thought. Museums should try to recruit people who think in different ways, as well as those who have different backgrounds.

Achieving diversity is a perpetual challenge, especially for museums who are unable to attract as broad a demographic as other higher-paid sectors, and in theory virtually every organization needs to seek to increase or at least maintain diversity when recruiting new staff. This needs HR departments to think creatively and engage with parts of the population not traditionally reached, including young people, people with disabilities and members of minority or ethnic communities. The need is even greater at executive and trustee level where 97% of Trustee Chairs are white and seven out of ten are men. The UK

Charity Commission estimates that only 0.5% of the trustee population is made up of 18-24 year-olds and over a quarter of nonprofits feel that their leadership team lacks sufficient diversity, a problem exacerbated by the fact that 81% of charities practice recruiting of trustees by word of mouth or personal recommendation (The Charity Commission, 2017).

There are a number of simple, proactive initiatives being used to encourage a more diverse talent pool to enter the application and selection process, including:

- Scheduling interviews in the evenings or weekends, so that those on lower incomes do not have to take time off from work to attend, which can be a significant barrier to entry for some.
- Having arrangements in place, or being ready to put them in place, should you need to provide translators, sign language interpreters, audio, Braille or large-print versions of documents.
- Making sure the venue in which you hold your interviews is in a location which can be easily reached by all and is accessible for people with disabilities. Video interviews can break down the barriers of availability and accessibility.
- Using alternative methods of recruitment, not just the tried and tested channels that you have always used, which will always reach the same audience. A recruitment campaign targeted specifically at local communities or minority populations, for example, will require a break from the norm but will result in a greatly increased pool of diverse applicants.

Takeaway: Museums have it within their power to be more diverse and inclusive. Simple steps can be taken to achieve this, it just needs some creativity. The benefits are multitudinous.

Generation Z

Over 61 million Gen Z'ers (the cohort that comes after the millennials) will enter the U.S. market in the next few years. (Bridgeworks, 2018). They have in fact already been entering the global workforce for a while now, although so far mainly in internship and entry-level positions. These digital natives are now finding their way into the workplace proper and this will obviously accelerate in the short to medium-term. Museums therefore need to be aware of the different touch points and channels used by this future resource supply and adapt to their communication styles. The most apparent characteristic of Generation Z is that they and their smartphone are one. As a collective, their access to information, sharing of information, and reaction to information is instantaneous, and measured in seconds, not minutes or days as was the case just a decade ago. This also means that their attention span is relatively short and capturing their attention in the first instance whilst they are bombarded with sensory overload can be difficult. This is why video has become such an important part of the recruitment toolbox and is set to become an almost obligatory part of any recruitment strategy.

A museum will also need to adapt to Gen Z'ers' other needs. For example, health and wellness ranks as a high priority for them when evaluating employment opportunities, and a museum that does not accommodate these needs does so at its peril. Promoting workforce health can, not only help make your

organization an employer of choice, but also improve productivity and other broad-reaching benefits. Health and wellness programs have likewise become more wide-reaching, going beyond supporting gym memberships, to providing an holistic platform of care that covers both mental and physical health and encourages healthy lifestyles. One example of an employer doing this is a Wisconsin company that has blurred the lines between healthcare and workplace wellness through an innovative program that rewards employees for being healthy, or at least working towards better health. The largest financial rewards come via a health insurance plan, which includes a company-funded health savings account (HSA) with shared premiums, which calculates each individual employee's share of the premium based on a health assessment that measures tobacco use, blood pressure, and body mass index (BMI), plus laboratory blood tests for cholesterol and glucose levels.

Takeaway: Recruitment needs to adapt to the needs of the next generation. The hiring process, especially employee attraction and retention strategies, must respond to this large and increasingly diverse talent pool.

Project-based hiring

This is a result of several of the trends that we have considered above, like the growing gig economy and the shift from experience-based hiring to hiring based on transferable and soft skills. These developments are (or will) change the way museums manage their projects, so it follows that it makes more sense to start hiring for them in a different way. This has, among other benefits, the advantage of gathering those people who are the best in their field for each project. Instead of buying

labor, organizations will actually be more directly buying (and thus recruiting for) results.

Another related trend is the rise in more abstract or open-ended job descriptions. These are seen in vacancy adverts that are written in a less formal way and speak more to the type of person an organization is looking for, rather than the specific skills or experience they seek. This recruitment tactic encourages candidates to apply even if they may not have the exact credentials typically needed for a particular role. Many times, a candidate may have the perfect personality and ambition for a certain role but will be put off applying simply because of the strict requirements outlined in an overly-detailed job description. Writing open-ended descriptions is a great way to ensure that these potential golden nuggets are not missed, which links back to inclusion and diversity as well. Museums, with their programming, events and exhibition rotations are a natural environment for adopting this more fluid, project-based hiring approach, which can and should be extended into more general operations.

Takeaway: Think projects, and recruit resource that is aligned to their requirements. Use a nimble approach. And don't be too specific. Loosen up those job descriptions, and you'll be pleasantly surprised at the positive difference it will make.

Conclusion

We live in truly interesting times because our cultural, societal, commercial, operational and technological landscape around us is changing at an unprecedented pace. Never before have museums needed to be so aware of and respond to transformational change and this presents an opportunity to seize the momentum

and apply it to making parallel transformational changes in our sector. The environment is right for making changes to the hiring process (how we recruit) which can undoubtedly be used as a platform for attracting more diversity into our sector (who we recruit) and creating a more attractive, or at least fairer, remuneration structure (what we pay).

This is especially true for museums that are reconnecting, reintegrating, and reimagining the end-to-end hiring process, and adopting best practice principles from their peers and outside of the arts and culture sector. Many museums are already on this curve and recognizing: the value that building the brand adds; the benefits of starting early and investing in finding the best employees; the advantages of a non-traditional mind-set and recruiting based on qualities rather than skills; and the necessity in a crowded, noisy, competitive recruitment landscape to creatively optimize available budgets to attract applicants from a wider, more diverse talent pool.

The hiring process, from awareness of the need to appoint and beyond, also needs to be robust enough to support this approach. Whilst not every museum will, or needs to, implement our *Thirty-Nine Steps*, all museums do need to consider each stage of talent attraction, acquisition, selection and retention in an holistic way. The weakest link will always be exposed, and the quality of staff recruited will not meet the ever-increasing demands put upon museums, leaving the museum vulnerable to under-performance, or more simply, failing to live up to visitor expectations.

Finally, trends that are affecting the wider HR and recruitment community can be adopted by museums in a variety of ways (Figure 4). We do not expect to see museums

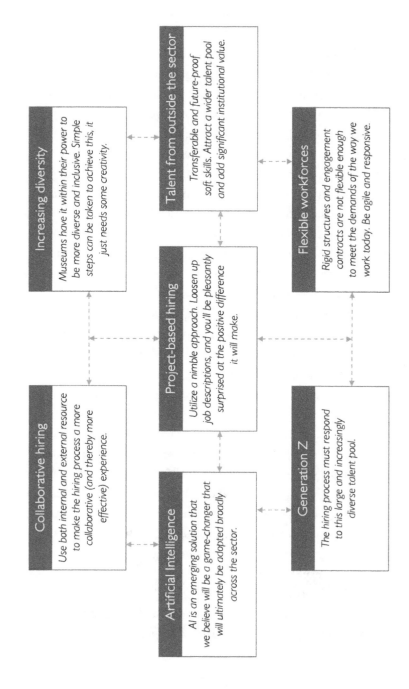

Increasing diversity

Museums have it within their power to be more diverse and inclusive. Simple steps can be taken to achieve this, it just needs some creativity.

Talent from outside the sector

Transferable and future-proof soft skills. Attract a wider talent pool and add significant institutional value.

Collaborative hiring

Use both internal and external resource to make the hiring process a more collaborative (and thereby more effective) experience.

Project-based hiring

Utilize a nimble approach. Loosen up job descriptions, and you'll be pleasantly surprised at the positive difference it will make.

Flexible workforces

Rigid structures and engagement contracts are not flexible enough to meet the demands of the way we work today. Be agile and responsive.

Artificial Intelligence

AI is an emerging solution that we believe will be a game-changer that will ultimately be adopted broadly across the sector.

Generation Z

The hiring process must respond to this large and increasingly diverse talent pool.

out-maneuvering Google or Apple with new products and processes within their hiring process, but we do recommend that museums review what they can do better, and how new technology and ways of working can support diversity, inclusion and fairer pay structures. Collaborative hiring, attracting talent from outside the sector with transferable skills, leveraging the use of AI, using flexible workforces, encouraging diversity, appealing to Gen Z'ers and implementing a more project-based approach to hiring are all elements that can be introduced. But introduced they must be. Salary inequalities and the lack of diversity in the museum's workforce is not an issue that will be resolved overnight, nor is it one that a single solution will eliminate – but redefining the hiring ecosystem with next-gen thinking for recruitment will certainly be an important part of moving hiring practices to a solution-oriented future.

FIG. 4: FACING PAGE – Hiring trends for future-thinking museums.

REFERENCES

BridgeWorks, 2017. *Generation Edge 101* (8 March). Wayzata:
BridgeWorks. Retrieved from: http://www.generations.
com/2017/03/08/generation-edge-101/

Gallup Inc., 2018. *The Gig Economy and Alternative Work
Arrangements*. Washington, DC: Gallup Inc.

Jobvite, 2019. *Recruiting Benchmark Report*. Retrieved from:
https://www.jobvite.com/wp-content/uploads/2019/03/2019-
Recruiting-Benchmark-Report.pdf

LinkedIn, 2016. *Talent Trends Report*. Retrieved from:
https://business.linkedin.com/content/dam/me/business/
en-us/talent-solutions/resources/pdfs/2016-global-talent-
trends-v4.pdf

LinkedIn, n.d. *LinkedIn Talent Solutions*. Retrieved from: https://
business.linkedin.com/content/dam/me/business/en-us/
talent-solutions/resources/pdfs/new_employee_refer-
ral_programs_FINAL.pdf

McKinsey Global Institute, 2016. *Independent Work: Choice,
Necessity, and the Gig Economy*. New York: McKinsey &
Company.

Shapiro, F. R., 2006. *The Yale Book of Quotations*. New Haven, CT:
Yale University Press.

Styles, M. J., 2001. *The Thirty-Nine Steps*. London: Barker
Langham Recruitment Ltd, 2019 edition.

The Charity Commission, 2017. *Taken on Trust: awareness and
effectiveness of charity trustees in England and Wales*. London:
The Charity Commission.

Venneri, A., 2018. Forbes.com: *Social Recruiting Is Growing. Are You Prepared?* (18 January). Retrieved from: https://www.forbes.com/sites/gradsoflife/2018/01/18/social-recruiting-is-growing-are-you-prepared/#66004d3b9cae

World Economic Forum, 2018. *The Future of Jobs Report 2018.* Geneva: World Economic Forum Centre for the New Economy and Society.

CHAPTER TWENTY-THREE

MAKING SALARIES A PRIORITY FOR MUSEUM BOARDS

Dawn Salerno and Mark Gold

MANY MUSEUM PROFESSIONALS feel underappreciated and underpaid by their employers, some to the point of leaving for positions outside of museums. The employers, led ultimately by museum boards, are faced with the challenge of balancing a budget, and as is often a solution, do not prioritize staff salaries and salary increases. The result is a field where salaries for highly qualified people remain low, staff size is as lean as it can be to sustain basic services or meet out-sized goals, and employees are asked to do more for less. Yet the prioritization of investment in the museum visitor, by way of quality museum programs, is rarely questioned. But what if, in this environment of low salaries and high staff turnover, that very quality was at risk, causing a downward spiral in attendance and revenue? The benefits of employee longevity, loyalty, and productivity are lost, and the goals of achieving diversity and addressing pay inequities become harder to achieve.

The solution to this dilemma lies in a paradigm shift so that governing boards perceive museum professionals as an asset, and therefore, a resource worthy of investment. So that they view them as a means of improving the quality of exhibitions, programming, and visitor experience, all of which result in increased revenue and support. So that they appreciate both the costs of under-compensation and the benefits of offering more generous salaries. A new paradigm for museum compensation might look like this:

> Compensation policies are designed to attract and
> retain the best employees in a competitive environment,
> and as being most likely to yield the best mission-
> fulfilling programming and visitor experience, while at

the same time meeting revenue goals. Equitable pay is, therefore, a mission-critical investment in, and ultimately the path towards, the museum's success.

Improving the compensation of museum professionals will attract and retain high quality employees who will develop and deliver the best programming and visitor experience, resulting in an increase in reputation, programs – and revenue to support the important goals of achieving diversity and eliminating pay inequities. Furthermore, an investment in museum profession-als is as powerful a move toward economic sustainability as any investment that can be made. The challenge is to convince those in charge of budget design and approval of the validity of this argument.

The power to make these changes lies with the museum's board of directors. Progress at a board level can be made in several ways – some of which are internal to the organization and some of which may be imposed or influenced by external sources.

Are museum professionals underpaid?
The Bureau of Labor Statistics' *Occupational Outlook Handbook*, includes a category for Archivists, Curators, and Museum Workers (Bureau of Labor Statistics, 2019). Most positions in that category require a master's degree. As of May, 2017, the median annual wage for workers in this category was $47,360.

BLS also identifies Similar Occupations for each category. For this category, three of the four occupations identified generally require master's degrees as well: Anthropologists and Archeologists, Historians, and Librarians. The Median

Pay for those categories, as of May, 2017, was $62,280, $59,120, and $58,520 respectively – 23% to 31% higher than museum professionals.

BLS breaks down the median pay for Archivists, Curators, and Museum Workers by the industries in which they work. For those employed by museums, historical sites and similar institutions, the median pay was $43,710:

- Educational services, state, local, and private: $52,960
- Government: $49,430
- Museums, historical sites and similar institutions: $43,710

It is difficult not to conclude that something is out of alignment when the BLS reports the average salary for Food Service Managers as $52,030 per year, and for Postal Service Workers as $57,260 – over $13,500 more than Curators and Museum Workers.

Why are museum professionals underpaid?
There are simply too many professionals vying for the same jobs, and too few jobs available for professionals looking for full-time employment. This is basic Economics 101. Price is determined by supply and demand. The greater the supply of a product or service, the lower the price will be.

In a response to the post Museums and the Salary Conundrum in the *Leadership Matters* blog (Baldwin, 2016), one respondent related the following experience, not all that uncommon:

When I post an entry level job for our historic site, I tend to get between 60-90 qualified applicants for the

position. That means that I can choose from a wide
selection of folks, most with similar degrees and
experience. We have a set salary for the position so there
is no opportunity for applicants to negotiate but even if
they did, I could probably just move down the list until I
found someone who would take the job at the salary
offered.

Imbalance between supply and demand

The following four factors contribute to an imbalance in supply
and demand.

Unpaid interns and volunteers: Volunteers play a crucial –
and appropriate – role in the operation of most museums.
They engage elements of the community and make valuable
connections between the community and the institution. The
2009 *Museum Financial Information* published by American
Alliance of Museums (AAM) included information on the ratio
of volunteers to paid full-time staff. For museums overall, it
was about six volunteers for each paid employee. For museums
with budgets of less than $250,000, the ratio was 18:1. Often,
the work performed by volunteers is work that would otherwise
be performed by museum professionals.

Museum studies programs: Many programs require intern-
ships, reducing the need to pay entry level professionals to do
that work. The irony is that the unpaid intern is paying for the
privilege of an unpaid internship, in the form of tuition. The
professional "promise" that these proliferating programs offer
– and that the credentials bestowed by them imply – contribute
to the supply of museum professionals as well.

Part-time positions: Employers often hire part-time

employees to avoid paying for full-time benefits. The downside is that part-time employees often mirror the institution's lack of commitment to them. Because they work less, they generally build fewer helpful relationships with other employees, visitors, donors, and partners. They know less about programs and services and give the appearance of a less-than-stable professional staff.

Outsourced and contracted services: This phenomenon can be seen in non-museum professional services like custodial, food service, and security, in entry level positions, and even in the most critical mission-related jobs. The same upside and downside that informs decisions on the use of part-time employees pertains here.

Beyond supply and demand imbalance

The reasons for systemic under-compensation beyond simple supply and demand include the following.

Sacrifice measure: There is value in the feeling of self-worth and prestige that comes from working in any organization that contributes positively to the betterment of society or the individual, and in a field that enjoys the respect and trust of the population at large. These intangible rewards increase the willingness of some individuals to work for less.

Preponderance of females: According to the Institute for Women's Policy Research, the ratio of women's and men's median annual earnings was 80.5% for full-time, year-round workers in 2017, resulting in a gender wage gap of 19.5%. In a field of mostly women, the causes of the inequities in the compensation of women are aligned with the causes of depression in the compensation of the field generally.

Salary surveys: Museum salary surveys are typically simply compilations of field-wide raw data and are not benchmarked against comparable external areas of work. If the museum field as a whole is underpaid, a salary survey will not demonstrate that. Unfortunately, salary surveys may even be used to justify low compensation: "We're going to pay you an average wage for your job and our budget." In which case under-compensation is perpetuated.

Museum hyperactivity syndrome: Many museums are quite ambitious about the reach of their collections, exhibitions, and programs. Many aim to do a lot and to make a significant impact in the community in order to attract, secure, or satisfy grant funding. Grantors want to see growth, innovation, and impact. These metrics can spur museums into taking on too much and cutting corners by freezing salaries, hiring part-time employees and contractors, and engaging volunteers. Museums do not want to seem stagnant or disinterested in reaching out to and engaging diverse audiences. The hyperactivity of simply taking on too much can sideline salary discussions and divert resources from full-time staff to part-time and temporary employees.

Reliance on individual earning history: Systemic under-compensation and salary inequities can be perpetuated, on an individual basis, by setting the salary of a candidate or employee based on what they are currently earning. Making this information unavailable is seen as a strategy to break the cycle. Laws prohibiting employers from asking for candidate salary information have been enacted in several states, including California, Oregon, Connecticut, Vermont, and Massachusetts.

What are the effects of under-compensation on museum professionals?

In a 2016 survey conducted by Sarah Erdman, Claudia Ocello, Dawn Salerno and Marieke Van Damme, 63% of the respondents who had left the museum field identified their reason for doing so as the pay being too low (Erdman, 2017). Further analysis provided the following results:

- A majority left the field within their first one to five years, 85% within ten years of entering it. The field is losing its youngest members and, likely, its most diverse.
- The average salary of these individuals increased by $10,000, or approximately 27%, when they left the museum and got their first job outside the field.

The effect of under-compensation is documented by innumerable personal stories, often posted as comments on blogs, about the struggles of museum professionals to make ends meet (including the repayment of educational debt) and the stress and frustration that result. Beyond the financial challenges, many museum professionals suffer from low morale and a sense of being overworked and exploited. The burden of financial obligations and the desire to achieve an improved lifestyle take their toll, and many leave the field they love in frustration.

What are the effects of more generous compensation on museums?

An increased level of compensation can have powerful effects across the museum, including a higher quality and more engaged workforce with positive effects on "production"

(including the quality of exhibitions and programing), and "sales" (including admissions, programs, events, and other points of engagement and sources of revenue). There will be less turnover, resulting in a staff that is more knowledgeable, familiar with the institution, and accustomed to working toward common goals as a team, with less money expended on hiring and training. A higher level of compensation will attract more qualified and capable employees.

There will be a sense of loyalty and improved morale, resulting in a staff with greater "buy-in" and a willingness to extend themselves. A higher level of compensation will allow groups with fewer resources to take these jobs rather than seek higher-paying positions in other fields, resulting in a more diverse workforce. And, finally, a staff that is not stressed about personal financial issues will be less distracted and able to focus more completely on their work.

In their chapter in this volume, Micah Styles and Ian Duckworth observe:

> With the concept of staff value at its heart, an institution can potentially set up a virtuous circle, attracting, engaging and retaining "better" staff which in turn leverages employee value and job satisfaction. Happier employees with rewards, recognition and career pathways are perfectly positioned to take advantage of the new skills and ways of working required in a museum of today.

> An institution which invests in their employees in this way is better equipped to get the most out of the way

museum staff structures have changed, are changing and will change further to create inclusiveness, accessibility, social networking, partnerships and community benefit...

Maybe the ultimate added value for museums comes from the recognition that all the staff within the institution add value. With this buy-in, the larger added value that only museums are equipped to deliver is revealed – to put a set of experiences into a visitor's head they didn't know were possible – and then get them to come back for more of something completely different. (Styles and Duckworth, 2019)

A fairer level of compensation is consistent with the values of the typical museum and of the museum community. Museums present themselves as repositories of trust and of the values of diversity, equity and inclusion. To exploit staff by paying, in many cases, less than a living wage is inconsistent with those values.

How do we get from talk to action?

As with any call to action, the essential starting point is to identify where the power to effect change resides. Whether in the context of adopting a budget or in setting institutional policies on salaries, the vortex of power resides with the Board of Trustees or equivalent governing body of the museum.

Changes in board perspective and policy can come as a result of influences internal to the museum as well those that are imposed on boards by external conditions and forces. Such

influences, conditions, and forces may not be a complete anti-
dote to the problem but can contribute in a positive way to a
solution. Internal sources of change include:

- educating the board about the benefits of adopting a new
 paradigm on museum compensation and/or the benefits
 of specific practices toward achieving that end, and
 effecting the adoption of specific policies or practices;
- achieving changes in board composition to make it more
 likely that any effort to adopt a new paradigm or make
 specific policy changes will be successful.

Internal sources of change

Adoption of institutional policies and practices

When Lawrence Yerdon arrived at Strawbery Banke Museum
in Portsmouth, New Hampshire, as its President and CEO in
2004, the museum had challenges with deficits, building main-
tenance, programming, and underpaid staff. A series of major
changes resolved most of those issues and, starting in 2016,
two years prior to the launch of a capital campaign, Yerdon,
the finance director, and the board chair used every opportu-
nity in board meetings to mention the staff salary issue. The
message was, "We can't get and keep good people unless we
pay reasonable salaries." They saw it both as a business argu-
ment and as a moral issue. Yerdon presented the board with a
formal analysis based on salary surveys, inflation calculations,
and other data and offered recommendations. In 2018, the board
included a line item in its endowment campaign sufficient to
generate enough revenue on an annual basis to bring salaries
in line with the recommendations.

Effecting change at a board level from within the museum generally starts with the executive director and/or one or more board members willing to take up the cause. It's not a cause likely to be embraced as a priority by a newly-appointed executive director. Financial sustainability, compelling programming, capital needs, and constituency satisfaction will get more attention and will consume less political capital than advocating for staff. But with a reservoir of trust and relationship built over time, as was possessed by Yerdon, the cause can be championed.

Changes at the board level can take at least two forms: first, the adoption of policies that will inform budget, recruiting, and compensation decisions; and, second, the implementation of specific practices.

An example of the former might be something as simple as a policy that the museum has a goal that its employees be paid in the top half, quartile, or tenth of field-wide salaries as reported in relevant salary surveys. If all museums committed to being in even the top half, the law of averaging will result in a field-wide increase in salaries.

Likewise, boards could voluntarily adopt specific practices such as including salary ranges in job listings, reconsideration of the role of volunteers, part-time employees, and contractors, and changes in recruiting and hiring practices.

Changing the composition of the board

Survey data reported in the AAM's *Museum Board Leadership 2017: A National Report* reveals that 89.3% of museum board members are Caucasian and an astounding 46% of museum boards are all white (BoardSource, 2017: 8). Females constitute 45% of board

members, but only 38% of board chairs (ibid).

The likelihood of a board embracing changes in policies around salaries may well depend on who is seated at the table where those decisions are made. Since systemic under-compensation may arise in part from the preponderance of females in the field and may impede progress to achieve diversity and pay equity, one could infer that by increasing diversity (including gender diversity) on museum boards, initiatives to improve compensation and address inequities would be more warmly received and more likely to succeed.

The presence of a museum professional (beyond the museum's executive director) on the board would offer a diversity of experience and perspective and benefit the museum not just on the salary issue, but also on policies relating to exhibition or education. While it might be problematic if those seats were occupied by professionals within the museum itself, real value could be added by professionals from other museums or even those retired from service, especially for small or mid-sized museums. Regional and state associations could consider creating an online clearing house to connect museums interested in such expertise at a board level and professionals willing to contribute their time as a board member.

External sources of change

While one way to raise salaries across the field is for boards to embrace better practices one museum at a time, there are external sources of change that can have the same result, but field-wide. External sources of change include legislative mandates, actions by professional associations, unionization, and social media.

Legislative mandates

There is a disinclination on the part of governments and legislatures to insert themselves into board-level decision making in the absence of strong public policy rationales. Prohibiting discrimination is perhaps the most obvious example where public policy overrides board prerogative. But there are examples of legislatures imposing requirements designed to achieve results consistent with public policy goals on the issues of under-compensation and inequity:

- The *Act to Establish Pay Equity* (G. L. c.149, s.105A) became effective in Massachusetts in 2018. The law makes it illegal for a potential employer to ask a candidate about their present salary and gives employees the legal right to disclose information about their own compensation to others. It provides a defense from claims of discrimination to those companies that undertake a good-faith evaluation of their pay practices and demonstrate reasonable progress to eliminate gender-based pay differentials.
- In 2007, Denmark required companies with over 35 employees to disclose pay data by gender. In a study reported by Rebecca Greenfield of *Bloomfield News* on December 5, 2018, researchers looked at salaries between 2003 and 2008 (before and after the law) and pay at companies that didn't have to comply. Women received bigger wage increases at firms that had to report their pay data, reducing the gender gap by 7%.

There is a role for legislation in the spectrum of strategies to address under-compensation and pay inequities. A possible

strategy for the field, including its individual stakeholders and professional associations that purport to speak for the field, is to advocate for legislation that can affect salaries and disparities, to include, perhaps, even an increase in minimum wage.

Actions by professional associations

There are several strategies that professional museum associations can deploy to influence the conduct of museums. They include: legislative advocacy as mentioned above; conditioning access to association resources on compliance with certain requirements; the establishment of professional standards and articulation of best practices; and setting requirements for accreditation.

In taking such actions, professional associations are faced with the dilemma of having two constituencies whose interests might conflict with each other. National, regional, and state museum associations (in contrast to profession-specific associations) generally have both institutional members and individual members. Whereas individual members may push for increased transparency, institutional members view the salaries as a critical component of their financial sustainability and wish to control their own hiring practices and compensation policies.

A current flashpoint for that dilemma is the issue of whether websites that post jobs (many of which are hosted by museum associations) should require that job listings include a salary range. The rationale for requiring salary information is that the listed salary will be one reflecting the fair value of the work involved and preclude employers from offering the position to a qualified candidate who might be willing or desperate

enough to accept less. The disclosure alone speaks to a value of transparent hiring practices.

On October 4, 2018, a blog post by Laura Lott, President and CEO of AAM, titled, *Leading by Example, Not by Mandate*, explained the decision by AAM not to require salary information on job listings as follows:

> It is not our practice to institute strict, national, one-size-fits-all requirements. The beauty and strength of our Alliance is the range of people and museums we represent. Even the core standards for museums are not prescriptive – they are broad, adaptable, outcome-oriented statements fulfilled by each museum in different ways based on its discipline, type, budget, governance structure, and other unique circumstances.
>
> After thorough consideration, we continue to believe that AAM should not mandate the specific actions a museum takes to demonstrate its commitment to providing equitable opportunities for all. So at this time, we do not plan to implement a requirement to list pay, which is often governed by myriad federal, state, and local labor laws; umbrella-institution policies; labor union contracts; and more. (Lott, 2018)

There was considerable blowback on social media. In the blog's comment section (ibid), Paul Orselli noted AAM's "outlier" status on the issue and accused AAM of "[giving] cover to 'bad actors' continuing to exploit museum workers and take advantage of rationalizations like the one AAM has just provided."

In another blog comment, Paul C. Thistle suggested that AAM's individual members should "question whether the AAM also champions the interests of its members who happen to be 'museum workers' as well as the interests of museums as institutions." He noted that "...the AAM *Code of Ethics for Museums* (2000) states in the same sentence that the governing authority of museum institutions commit themselves to protect and enhance not only the museum's collections, programmes, physical, and financial resources, but their 'human resources' as well." (ibid)

Taking a position contrary to AAM, The American Association for State and Local History, which also has institutional and individual members, states its policy as follows:

> Only job and internship postings that provide salary/ compensation information are permitted on the AASLH job board. In the case of internships or fellowships, non-monetary compensation must be explained in the body of the posting.

As of this writing, three of the six regional associations in the United States have imposed a requirement for the listing of salary. Two regional associations "encourage" the inclusion of that information, and one has taken no position.

Associations, especially the national associations, possess the ability to establish, articulate, and propagate professional standards and best practices for the field. Even if those standards are not enforceable, they operate as a statement of values that can at least influence boards. The areas covered by existing standards and best practices are broad, but there is little in terms of how a museum can or should value and care for its staff. Museum

associations that set standards can advance the cause by encouraging member museums to embrace specific policies and practices designed to treat employees equitably (both in the hiring process and thereafter), encouraging member museums to undertake the type of gender equity review described in the Massachusetts statute, and articulating a set of value-based principles associated with volunteers and unpaid interns. Even something as basic as a commitment to pay a living wage, as determined on a geographic basis and using several well-respected tools, would at least raise the profile of these important issues.

The Association of Art Museum Directors (AAMD) did just that by passing a resolution encouraging museums to pay their interns, noting that paid internships are essential to increasing access and equity for the museum profession (Association of Art Museum Directors, 2019). In the statement, Jill Medvedow, Co-Chair of AAMD's Professional Issues Committee, and Director of the ICA Boston, observed that:

> ...by failing to pay interns, we ensure that these experiences are only really accessible to those who are already financially secure and, often, people who have established career networks available to them.

The Museum Trustee Association (MTA) occupies a unique position in the US museum community. According to its website, it "supports and advises its members as they set policy [and] allocate resources." MTA could be positioned as a powerful convener of discussions around this important issue among the only people able to effect change.

Those associations, like AAM, that offer accreditation have

the power to set the criteria for that status. Why not build into the accreditation criteria some commitment – if not actual practice – on the part of museums to payment of a fair wage and the end of pay inequity? They could include a commitment to include wage ranges in job postings, delivery of salary data broken out by gender and race, and compliance with other best practices in hiring and compensation. In this way, employees are afforded the same attention that the accreditation process places on objects in the collection.

There are actions that professional associations can take to improve these conditions in their role of setting and maintaining field-wide standards. Associations can be proactive, setting a standard on their own initiative, or they can be reactive, responding to members advocating for change.

Advocacy by members can be individual or organized. A powerful example of the latter is the initiative by the National Emerging Museums Professional Network (NEMPN). Addressing concerns raised by its own members, NEMPN launched a campaign to encourage museum associations that hosted job postings to require the inclusion of salary information. The campaign, started in 2018, included personal outreach by NEMPN to 60 targeted associations, a Change.org petition, and a letter-writing campaign. According to Michelle Epps, President of NEMPN, of the 35 associations that NEMPM engaged with, fifteen now require salary information, seven strongly encourage it, and it is under consideration by others.

Unionization

It is beyond the scope of this chapter to analyze the reasons why museums professionals might unionize – or decline to do

so – and beyond the scope to analyze the effectiveness of union-ization in achieving it goals. Suffice to say that it is becoming one of the strategies of response to inadequate salaries and, in a social media environment, a response that is getting more attention than a decade ago. Examples include Museum of Modern Art, The Tenement Museum, and the New Museum.

Unionization can result from the failure or refusal of museum management to deal with its employees and salaries as an investment instead of an expense like any other – or per-haps the financial inability to do so. Once in place, however, the process of addressing salaries (and, indeed, all conditions of employment) becomes one of negotiation through collective bargaining, usually with each party seeking to persuade key constituencies of the virtue of their position and seek their sup-port to achieve the desired outcome. When the process breaks down, job actions (including picketing and strikes) may follow.

Social media

Social media can be a powerful tool for change. It serves as a platform for sharing research and opinions, for debate, for advocacy and, in some cases, for shaming.

The *Leadership Matters* blog of Anne Ackerson and Joan Baldwin has long been a source for thought leadership on work-place issues, among others (Baldwin, 2016). The Gender Equity in Museums Movement is a repository for "raising awareness, affecting change, and championing transparency about gender equity in the museum workplace. Museum Workers Speak described itself as a "collective of activist museum work-ers interrogating the relationship between museums' stated commitments to social value and their internal practices."

These platforms and others like them are invaluable contributors to aggregating the data and leading and facilitating the discussion.

Social media can also serve as a powerful advocacy tool. One need look only to recent negotiations at Museum of Modern Art and unionization efforts at the New Museum to see how effective it is at sharing news and garnering support. When organized and orchestrated, social media messaging can affect policy decisions within an institution, including both individual museums and professional associations. Fair Museum Jobs, located in the UK, defines itself as follows:

> Fair Museum Jobs is a grassroots, collective movement. Our objective is to establish a better standard ("The Manifesto") for museum job recruitment that is based on the principles of fairness, transparency, equity and inclusivity. We believe recruitment based on these principles is fundamental to creating a museum sector that is resilient, relevant and representative of all society.
>
> Fair Museum Jobs will take collective action to urge employers to improve their recruitment practices when they fall short of the established standard. We will also celebrate best practice, and champion examples as models for emulation. (Fair Museum Jobs, n.d.)

Their model is to identify job postings in which individual institutions have deviated from what they consider best practices such as the inclusion of a salary range or the option of

equivalent experience to substitute for a specific degree in appropriate cases. They contact the institution and express their concern. Through their website and Twitter account, they identify the institution, the concern, and the outcome of contact. They are not successful with every encounter, but they are successful in many to get postings changed or, at a minimum, bring the issue to the attention of the employer.

A similar initiative titled Salary Transparency Alerts was started in the US in March of 2019 by the National Emerging Museum Professionals Network. Members are asked to report job postings that do not include salary and fill out an online form. NEMPN then reaches out to the museum. According to Michelle Epps, its President, "We don't want to compel museums to switch. We want them to come to that conclusion on their own based on a presentation of logic, facts, and discussion."

Museum professionals can organize advocacy efforts through social media and take advantage of the medium to advocate within an institution, within professional associations, and within the field.

How do we pay for it?

A common response to this question is to ask, "What expense line item can we cut to fund an increase in salaries?"

It is rare that any museum budget isn't already lean. Compensation is likely the largest line item and so much of the rest of the operating budget is fixed in the sense that there is little ability to reduce such items as insurance premiums or utilities, so that there is little ability to shift among those items. In those situations where the operating budget results

in a surplus, there is an opportunity to make the case that some of that surplus can and should be used for this purpose. Increased salaries can also be funded by increased revenue – such as ramping up fund-raising efforts or shop sales goals. It's probably fair to assume, however, that if a museum could do these things, it already would have.

A budget is an institutional statement of priorities. When staff and salaries are treated as the go-to line item to balance revenue and expenses, they are given the lowest priority of all. In her recent presentation at Museums and the Web, Claire Blechman characterized the issue this way:

> I don't care what your mission statement says. Where you spend your money tells me what your institution really cares about. Do you pay your interns? Does your education department have money for supplies? Does your director live in a rent-free penthouse? Your museum's budget is a moral document. (Blechman, 2019)

Rather than merely shifting dollars among expense categories, the museum could choose to build a resource to support increased compensation levels through permanent endowments.

A targeted and designated endowment could support a specific position in the same way in which they have been used to support galleries and facilities. Colleges and universities have long embraced the concept of endowed administrative and faculty positions. Museums have embraced a similar strategy, primarily with named directorships and curatorial positions. If a museum can generate endowed support for a specific position

to which donors may wish to affix their names, it frees money otherwise in the compensation expense line item to be applied to other positions.

An endowment could also support staff compensation more generally. Many capital campaigns have multiple purposes. Why not include an appropriately worded and justified component of the larger capital campaign to support equitable pay for staff – with the goal of supporting the museum's mission with the best possible human resources?

Of its recently launched $13 million capital campaign *Building Community: The Campaign for Strawbery Banke*, $4.5 million was designated for general endowment, with three purposes: support of a program to preserve buildings with both exhibit and income-generating space, a program to provide access to economically disadvantaged children, and a fund to "offer more competitive salaries to attract and retain the most talented staff."

Ethical guidelines established by AAM prohibit the use of the proceeds of deaccessioning for anything other than acquisition or the direct care of collections. But some recent discussions have asked the field to consider if or when a loosening of those standards might be appropriate. Some, including Glenn Lowry, Director of the Museum of Modern Art, have proposed that the proceeds from a deaccessioning that complies with the standards of the field could be used to fund an endowment restricted to purposes other than collections – public programs, exhibitions, and publications.[1] Presumably any expansion on the use of proceeds to activities of the museum would also include the compensation of those museum professionals engaged in those activities.

In his essay, *Museums Can Change – Will They?*, Michael O'Hare notes that, "Big museums have long refused to recognize their unexhibited collections of duplicates and minor works as a financial resource." (O'Hare, 2015) Taking the Art Institute of Chicago (AIC) as an example, O'Hare posits that selling just 1% of its collection:

> ...would endow $17 million a year of operating budget, a fifth of the institute's current "instructional and academic" staff costs, which would enable it hire to something on the order of 200 more full-time researchers, educators, designers, and people studying the audience to understand what really goes on when people get up close to art... In business language, we could say that the AIC has drastically misallocated its... resources between production (the staff) and capital (the collection). (ibid)

The museum field easily accepts the practice of using endowments to fund at least key staff positions. Funded by traditional capital campaigns or otherwise, here lies one path to funding a more equitable level of compensation for all museum employees.

Summary

The issue of systemic under-compensation makes for an interesting and passionate discussion among museum professionals. But, like so many topics, it has remained just that – interesting and passionate, but with little effect. And as with so many topics, there will be no effect until the field identifies where

the power to make change resides and embraces strategies to provide a presence where and when those decisions are made.

The common thread is advocacy. At the individual museum level, this can take the form of an executive director and/or board leader making the case for why a well-paid work force is in the best interest of the institution. It can take the form of professional associations advocating within their membership by establishing best practices, accreditation standards, or job posting requirements. It can also take the form of social media campaigns and unionization.

Professional associations are perhaps the most powerful arrow in the advocacy quiver. One need only look at the role they have played on the issue of diversity. The extent to which they are willing to play that role on this issue will depend on how they resolve the tension between the legitimate interests of their individual members and their institutional members. The resolution may well depend on the extent to which their individual members, either individually or through formal or informal groups, advocate for – or demand – change.

The power to adopt a new paradigm for compensation of museum professionals and to adopt policies in support of that paradigm resides with the board – led, influenced, or supported by their executive directors. Boards are vested with the legal and fiduciary duty to make decisions in the best interest of the institution they serve, and of its mission. Many trustees come from the business world and embrace (sometimes to a fault) the principles and priorities that drive business organizations. The decision to address systemic under-compensation and inequities and to carry out financial responses to support that effort is both founded in sound business thinking and is consistent with

the shared values of the museum community. The challenge is to get the board to focus on those benefits to their own institutions. That challenge can be met by the education of the board, along with a host of strategies to advocate for equitable salaries.

NOTE

1. http://www.artagencypartners.com/podcast/episode-22-glenn-lowry/

REFERENCES

Association of Art Museum Directors, 2019. *Association of Art Museum Directors Passes Resolution Urging Art Museums to Provide Paid Internships*. AAMD: 20 June. Retrieved from: https://www.aamd.org/for-the-media/press-release/association-of-art-museum-directors-passes-resolution-urging-art-museums

Baldwin, J., 2016. Museums and the Salary Conundrum. *Leadership Matters*, 26 January. Retrieved from: https://leadershipmatters1213.wordpress.com/2016/01/26/museums-and-the-salary-conundrum/

Blechman, C, 2019. Everything is on Fire: How to advocate for the arts with your elected officials. Powerpoint presentation, MuseWeb Conference, Boston, 2-6 April 2019. Retrieved from: https://docs.google.com/presentation/d/1OwpIkRyXSENI4Sp968tEoJ8vYYakAmMaxhS8HwfzS1Q/edit#slide=id.p1

BoardSource, 2017. *Museum Board Leadership 2017: A National Report*. Washington, D.C.: BoardSource.

Retrieved from: https://www.aam-us.org/2018/01/19/
museum-board-leadership-2017-a-national-report/

Bureau of Labor Statistics, 2019. *Occupational Outlook
Handbook*. Washington D.C.: U.S. Bureau of Labor
Statistics. Retrieved from: https://www.bls.gov/ooh/educa-
tion-training-and-library/curators-museum-technicians-
and-conservators.htm

Erdman, S., *et al.*, 2017. Leaving the Museum Field. American
Alliance of Museums: *Alliance Blog*, 22 September.
Retrieved from: https://www.aam-us.org/2017/09/22/
leaving-the-museum-field/

Fair Museum Jobs, n.d. Retrieved from: https://fairmuseum-
jobs.wordpress.com/about-us/

Lott, L., 2018. Leading by Example, Not by Mandate.
American Alliance of Museums: *Diversity, Equity,
Accessibility, and Inclusion*, 4 October. Retrieved
from https://www.aam-us.org/2018/10/04/
leading-by-example-not-by-mandate/

O'Hare, M., 2015. Museums Can Change - Will They?
Democracy, 36, Spring 2015. Retrieved from:
https://democracyjournal.org/magazine/36/
museums-can-changewill-they/

Styles, M., and Duckworth, I., 2019. How to Enhance Your
Value. In: Salerno, D. E. *et al.* (Eds.) *For Love or Money:
Confronting the State of Museum Salaries*. Edinburgh &
Boston: MuseumsEtc.

FINANCIAL RESOURCES FOR PAY EQUITY, VISITOR EXPERIENCE, AND PUBLIC VALUE

Michael O'Hare and Jodi Kovach

PROPERLY COMPENSATING the staff that make an art museum function is within the financial grasp of any large art museum. In this chapter, we discuss how releasing a small part of a collection – typically comprising work of lower quality or importance, and of which only a tiny fraction is, or can be, displayed – can be the key to a significant upgrading of human resource practices. Furthermore, redeploying existing resources this way is not only good for the staff, but also good for the public and for art, because it creates conditions for improving educational programming and integrating the museum, its resources, and the cultural experiences it can offer, into different facets of public life.

Because it's so easy to see a museum as an institution that just "hangs paintings on the wall for people to look at", we need to back up, and first describe the value museums create so we have some criteria for institutional decision making; and second review the tools and resources with which a museum creates this value.

The museum's "product"

The overarching principle we adopt, in effect the objective function for optimizing museum management, is that the purpose of a museum is engagement with art. This formulation is already broader than hanging pictures and opening the doors, because (for example) it requires people to actually come in and look, and so puts issues like the admission tariff, open hours, and publicity on the table. It is not vacuous nor self-evident, especially in the present context, because it is different from (for example) "the purpose of a museum is to collect art" or "... to afford wealthy collectors social status". Our "mission statement" is readily expanded into engagement by more people

with more art, but what about the quality of the engagement itself? Which people? And when?

Art engagement is much more complicated than looking and more active than seeing. It occurs inside the head of someone looking at a work (and not only when he is in front of it) and more broadly across social and political groups for whom that engagement is a mechanism of communication and identity formation. It is also much more socially constructed (Becker, 2008), or at least collectively determined, than one might think.

The degree to which the viewer collaborates in building this experience cannot be overestimated, and involves much more than taste differences. Even before interpretation and engagement begins, just "seeing" a work involves extremely complex analysis of a visual field in an active process, and the brain does a lot of work before consciousness has access to the retinal image. Indeed, a full-color perceived image can be constructed with only two close wavelengths of "chartreusish" light, in which a tomato looks red despite reflecting no red light at all, because the brain processes the whole image's distribution of wavelengths statistically before deciding what this or that pixel is "supposed" to look like. This is why a lemon is yellow on a cloudy day and also indoors in incandescent lighting (Ebner, 2007).

Audience engagement is an active, partly conscious, reorganization of prior and novel experience, including experience not "contained in" a single work. This activity is not unique to the plastic arts: art in other media like music is also perceived with similar holistic analysis, so a note or a chord only has meaning in the context of what comes before and after.

Looking forward instead of backwards, it follows that every current engagement with art now is also an investment that

enriches engagements in the future. Economists have modeled this investment as a "beneficial addiction", interpreting evolution of taste as a process by which a viewer becomes more and more adept at creating better engagements through successive experiences of art (Stigler and Becker, 1977). The richness, complexity, and depth of the experience a museum visitor constructs in response to a displayed work and its explanatory context are therefore quality measures not only for the moment of engagement, but of such moments in her future.

Finally, all this engagement is not only extended in time but also in space: people are engaging with the museum's art outside the building: on television, through the web, in other museums in loan exhibitions, in books, and even in memory: walking the dog or washing the dishes.

For a college conference about teaching, Jennifer Roberts has provided a striking illustration of how much of an engagement is brought to the occasion from "outside" the work, including general knowledge and also expert art-historical background. Describing her experiment of spending three hours in front of a single familiar Copley portrait, as an example of "slow teaching" for a faculty seminar, she goes back and forth across the canvas, and back and forth in time and history, adding insights from zoology, the symbolic and critical conventions of the painting's time, and pure formal analysis, until this single work takes as long to engage as a full symphony concert (Roberts, 2013).

Resources

The "product" of the museum, engagement with art, is thus made by a collaboration between the institution and the visitor, assisted by silent partners like the visitor's parents and

FOR LOVE OR MONEY

her high school art teacher. The visitor provides attention and presence, but also her own prior experience with art and with everything else. The museum participates partly through exhibition of specific works but also through a whole complex of explanatory and educational materials and choices. To do its part, the museum relies on both specialized and general resources that can roughly be divided into capital, labor, and consumables like electricity. The main capital resources are the collection, the building, and the endowment; labor includes workers for whom the museum competes with the economy as a whole (gardeners, office staff, managers, cleaners) and teams of highly trained and specialized staff (curators, conservators, educators, designers) whose employment options outside a museum are few. Whether artists, at least for a contemporary museum, should be thought of as part of the museum's non-employee labor force, as volunteer docents certainly should, is an interesting and important question that we have to put aside to another context, noting however that the economic welfare of artists, both those who have, and those who have not, made it into superstar status, has a lot to do with museums' exhibition policies (Abbing, 2008; Thompson, 2014).

Major museums are not isolated enterprises, but part of a larger art-world network, composed of well-established academic institutions, auction houses, museum networks, gallery systems, and media outlets that are eager to support and promote art in a global market (Thornton, 2008). The networks for the promotion, sale, and exhibition of contemporary art span the globe, and include wealthy U.S. and Western European cities: New York, London, Los Angeles, and Berlin, as well as major East Asian cities like Beijing and Tokyo. As art historian

and sociologist Sarah Thornton has shown in her exploration of the many facets of the contemporary art world, the few artists who actually achieve international success in the highly mercurial art market, which is often influenced by the whims of abundantly wealthy collectors, do so through self-advancement strategies such as earning affiliation with prominent MFA programs, many of which are in the United States, by winning prestigious awards, and by attracting the attention of art critics and the protection and support of dealers in the United States and Europe. Having work in a museum collection, not to mention receiving a solo exhibition is especially valuable. Each distinction plays a role in upgrading the perceived cultural value of an artist's work among collectors, dealers, museums, critics, and audiences (Thornton, 2008; Thompson, 2008: 85-94; Graw, 2009: 108-112).

In the current discussion, we are most concerned with management of capital and labor, where the characteristic decisions concern how to allocate fungible resources among the large categories (particularly the collection), and, that settled, how to manage each to maximize value creation. As an example of the first decision, a large cash gift can be placed in the endowment to generate ongoing income, spent right away on a building renovation or hiring a specialist curator, or used to buy a work of art for the collection. Examples of the second are whether a given work should be placed into storage or put on display (displacing a different work into storage), or how much of this year's endowment yield should be cashed in and spent for operations and how much left in investments to grow for future use.

Inescapable questions like these (it is not possible both to buy a painting and to not buy it) require recognition that each

choice has an opportunity cost that must be balanced against its benefits. Displaying painting X over the next year means some painting Y will not be on the wall for visitors to see; buying more works means less money will be available to expand the building and show more art, or to hire an educator who will enable rewarding engagement. In abstract terms, these decisions are not unique to museums, but the typical museum's existing allocation of resources between its collection and everything else makes that particular set of choices especially salient, and creates opportunities for more value creation that other arts institutions lack.

What is important about the museum's labor force is that these experts and specialists are the mechanism by which the works on display create the kind of complex, high-value engagement we describe above. More, better-trained, and more experienced curators, designers, and educators directly generate better engagement with art – and more engagement as visitors who benefit from the experience return for more of it.

What is important about the collection are four facts that apply to all major museums:

- The collection far exceeds the building's display capacity and therefore nearly all of it is out of public view in storage, costing real resources to care for but creating minimal value.
- It is extremely valuable in purely market terms, and therefore an enormous financial resource; typically a large museum will have about 95% of its wealth invested in art.
- The two preceding facts are concealed by museum financial accounting policy, wherein museums simply do not recognize the collection as an asset in financial reports.

- Museum codes of ethics, to which museum professionals choose to bind themselves and which they created, forbid selling from the collection except to buy more art.

How much money are we talking about here? For any normal enterprise, a large asset like a museum collection, central to the firm's business and objectives, would be evaluated and reported in its financial statement balance sheets. Remarkably, museums systematically omit these assets from any financial reporting (more on this below). We have estimated the value of the collection of two large museums by comparing their operating budgets and collection size by number of objects to the two museums whose collections have actually been appraised, the Berkeley Art Museum and the Detroit Institute of Arts. Such estimates are extremely rough but considerable even if we only regard the number of zeroes in the result (Figure 1). For comparison, the endowment of each of these museums is about $1 billion.

The large part of the collection that is not displayed bears emphasis. We credited undisplayed minor works with "minimal value" above, not "no value", and indeed, any stored work might at some time figure in a scholarly publication or be brought out for a special exhibition. But for the bottom strata of study collections, the odds of these happening are vanishingly small, and equally important, neither of these uses requires that the works be in the possession of any particular museum.

Opportunity and direct costs of current practice

To understand what it means for museums to keep (in our examples) between 90% and 97% of their wealth in the

INSTITUTION	ESTIMATED COLLECTION VALUE	
	BY OBJECT COUNTS	BY OPERATING BUDGET
MUSEUM OF MODERN ART New York	$12 billion	$42 billion
ART INSTITUTE OF CHICAGO	$18 billion	$41 billion

FIG. 1: Estimated value of the collections of two large museums based on operating budgets and collection size.

collection, we have to construct hypothetical alternatives. For example, either of our example institutions could, by selling 1% off the bottom (by quality or importance) of their collections:

- endow free admission forever (currently more than $20);
- or increase its instructional and academic staff budget by a fifth;
- or increase its gallery space and therefore the amount of art displayed by almost a third.

Any of the options would also greatly reduce storage costs. At the same time, the works sold off would mostly go to small museums or private collectors that would show them (O'Hare, 2015b).

While it's obvious how showing more art or having a larger staff improves and increases art engagement, the admission price is equally important and deserves special comment. Economic theory teaches us that the correct admission price for any non-congested[1] museum is zero, as at the British national and Smithsonian museums. The reason for this is that if I go to the museum, there's no less of it for you (unlike attending a concert and occupying a seat). If the admission price is any higher than "free", economic waste will result, in the form of people who would value the visit more than it costs to provide, but less than the price than they have to pay, and therefore don't attend. In technical language, museum attendance should be priced to consumers, like everything else, at its marginal cost, the value of the resources used up by the next visitor – which is zero, like walking on a sidewalk.

Economic theory aside, though, charging the right price

also leads to a better art experience. No-one spends eight hours straight at a concert or a play, but if it costs $25 to go to a museum, visitors are strongly pressured to stay all day, rather than going home and coming back another day and paying again. Art engagement at the end of a day spent trudging around a museum trying to see it all is profoundly degraded. Finally, high admission prices are counter to the aim of delivering art engagement down the economic ladder.

All in all, our core proposition is that the opportunity cost of keeping everything is less and lower-quality art engagement, by fewer people – less of precisely the value museums are charged by society to create. The behavior the AAMD code of ethics demands systematically violates the public trust museums claim to serve. Nor is the cost spread evenly across the public: not only are high admission prices a real obstacle for the poor, but skimpy or arcane labelling and explanation is differentially off-putting to visitors whose schools could not afford art courses, as public schools in poor neighborhoods typically cannot. Museums create very little engagement for the 80% of the U.S. population that does not attend an art museum in a typical year.

Until recently, conjecture of this kind was unrealistic in the extreme. However, a couple of high-visibility debates about deaccessioning (what museums call selling from the collection, perhaps because buying and selling has such a grubby, *déclassé*, common feel to it) and a spreading realization that storage costs are growing ruinously without limit, have put the "deaccessioning debate" back on the art world agenda. Even the director of MoMA would favor selling judiciously, and spending the proceeds (via the endowment) on programming (Burns,

2018). More recently the issue has been aired in *The New York Times*, apparently without the firestorm of indignant outrage that might have been expected (Pogrebin, 2019).

The larger deaccessioning controversy is long-standing and too complex for us to review completely here (see, for example Cirigliana, 2011) but in a separate section below, we discuss the obstacles to deaccessioning for better programming and more humane treatment of staff, and finally recommend specific reforms.

Underfunding professional staff in a wider context

Museum management and policy is not just about art, even art taken as broadly as we have argued above. Museums face expectations (not always coherent or synoptic) rooted in social justice, political, and both distributional and efficiency economic effects, so management decisions about their resources have resonance broadly across society. Amassing collections in storage does not practically align with the 21st-century priorities and practices of museum professionals working in major art museums (Dewdney, *et al.*, 2013) but these professionals do not act alone to define the missions of prominent art institutions, to make decisions about the allocation of funds to uphold or reshape our cultural heritage, or to determine how it's managed.

Curating, collecting, and programming staff at large institutions must bend in many directions to satisfy the conflicting expectations of wealthy collectors, donors, and board members with those of grant funding institutions from whom museums seek support. Depending on how museums respond, the institutions can reinforce existing socio-economic inequalities, or

create spaces for real public dialogue and cultural advancement, making the expertise of qualified staff, and their freedom to implement their ideas about promoting more and better engagement, crucial to the decision-making processes. Better HR policies are thus consequential broadly across the society that supports the museum. Significant impediments to progressive practices that make art meaningful to a broad public include the ongoing expense of managing and preserving overgrown encyclopedic collections, and competing demands placed on museum professionals to meet expectations and satisfy the differing interests of donors, collectors, and funding organizations.

These external pressures and influences are not miscellaneous or random, but are heavily tilted towards the interests of donors (of money and artworks) from the very highest income strata. Freeing the museum's existing wealth that is trapped in the under-used part of its collection could provide an invaluable counterweight to the influence of inexpert or self-serving donors.

This influence is not incidental or marginal. An exhaustive documentation of campaign financing and contributions to special interest lobbies made by board members of 128 nonprofit arts organizations in every state in the USA in 2015 found that, "most [major art museums] operate with little or no democratic input, oversight, or recognition of government support." (Fraser, 2018) Of combined total revenue of over $4.2 billion in 2015, 10% of this sum came from the public sector, and 15-30% more came from indirect government subsidies due to their tax-exempt status, but these sums are overshadowed by those made by private donors who often sit on museum

boards and who govern museum processes in support of their interests. Furthermore, the tax subsidy for charitable giving is directed and conditioned by the donors whose gifts trigger the deduction. (Feld *et al.*, 1983) These interests, Fraser argues, are reflected in the ostensible fact that "many art museums have become prominent public showcases for highly concentrated private wealth, identifying that wealth with generosity, creativity, and cultural accomplishment." Linking cultural patronage with campaign finance in our current political climate, Fraser's exposé scrutinizes the conflict of interests that arise among the missions and responsibilities of our cultural institutions to educate, enlighten, and – yes – entertain, and those of politically powerful, wealthy board members who are making decisions about the collections and assets of so many of the country's major nonprofit, charitable organizations (Fraser, 2018).

Today's global museum is more than ever a project of an economically élite private sector. Billionaire collectors shape the market value of art through aggressive collecting practices that can make or break the career of an artist – and museums, as part of broader art-world networks, participate in this volatile market system in catering to the tastes of wealthy donors in building collections and curating exhibitions .

In his 2014 anthropological study of Chicago's Museum of Contemporary Art, Matti Bunzl, now director of the Wien Museum in Vienna, described neoliberalism's effect on the nonprofit world as "marketizing" it. The "imperative for growth" is driving the agendas of museums, transforming them into glamorous, high-profile tourist destinations and obfuscating programs that cultivate public discourse on the cultural value of artwork. (Bunzl, 2014) The expectations of many institutional

grant funders such as the National Endowment for the Arts and the National Endowment for the Humanities respond to this impending crisis by paying for program development to ensure that a museum's collection is used to enrich the cultural education of the public. The incentive for proving the viability and success of these programs is the prospect of receiving more funding from endowments committed to making collections open and usable. Again, these relatively modest influences (by dollar value) could be greatly amplified by the resources museums already have, were they freed from the collection. Increased circulation of collection objects through collaborations with art museums and other public institutions such as libraries, parks, and health services democratizes governing processes and shifts policy decisions about asset allocation to the interests and needs of diverse and lesser served audiences

A model example of this kind of resource sharing is Public Knowledge, a two-year collaboration between the San Francisco Museum of Modern Art and the San Francisco Public Library. Through this partnership, museum and library professionals curate and sponsor artist and publishing projects, public programs, research, and exhibitions mounted in different spaces and institutions around the city, all geared toward reaching underserved audiences who may not have access to the museum because of the price of admission, transportation costs, or lack of education. The goal of Public Knowledge is to break down institutional hierarchies through collaboration, and to use museum and library resources and professional expertise to engage new audiences in real discourse about the effects of recent urban change on socio-economic inequality (Public Knowledge, n.d.).

The roles of professional staff in the 21st-century museum are increasingly expanding to reach more, and different audiences, and to negotiate the not completely congruent goals of increasing attendance and enriching engagement. Marketing staff are tasked with bolstering and sustaining attendance among a broader range of communities, attracting these audiences through celebratory openings, family festivals, late-night events, and parties targeting different demographic groups – events and programs whose success require skills far outside traditional curatorial training or experience and which must be obtained in competition with commercial enterprises prepared to pay MBA salaries for them. Yet, while marketers want to use the collection and the exhibitions to make the art museum a centerpiece of contemporary event culture, the responsibility of curators is to focus on presenting and preserving the artwork to uphold cultural heritage and its integrity. Curators at large public museums have to create exhibitions that are accessible to as many audiences as possible, but that also distinguish the institution for producing new knowledge and making intellectual contributions to art historical fields, while keeping in mind the collecting interests of, and relationships with, existing and future donors to attract and promote buy-in (Bunzl, 2014: 91). Meanwhile, the education department must navigate these competing priorities to focus on better engagement with the art, making collections in storage accessible to teachers, for example, and developing programming and materials targeting the interests, learning levels, languages, and physical limitations of different audiences.

When attendance rates drop, institutions are willing to acknowledge the crucial role professional staff play in making

museums a vital part of the community. The Dallas Museum of Art (DMA), for example, when faced with consistently low visitor numbers, launched a long-term research initiative to learn about how and why audiences engage with art in order to improve its programming. Between 2003-2009, the DMA partnered with a private museum planning and research firm to conduct six qualitative studies to understand the range of preferences among audiences concerning museum visits and ways of engaging with and talking about art. The data collected from this research inspired the *Framework for Engaging with Art*, a methodological approach to programming that enables the institution to appeal to different audiences in meaning-ful ways, and to increase and sustain attendance (Pittman and Hirzy, 2010). The data showed four clusters of audiences that the researchers identified, as follows:

- Observers seeking clear explanations.
- Participants who want to learn about art and enjoy the social aspects of the museum experience.
- Independents, with an art or art historical background, who want to view artwork on their own.
- Enthusiasts who are well-versed in art discourse and enjoy talking about it with others.

The programs developed from this research target each of these groups in different ways, and range from late-night social events to technology-based educational tools, demonstrating that the art museum can be a place for people of many differ-ent interests, personalities, and demographics. The DMA's new mission demonstrates that the social events and promotional

parties offered by museums are not at odds with connoisseur-ship and intellectualism, but in fact complement them to build a sense of community in a public institution.

The numerous demands placed on museum professionals to attract buy-in raises the question whether or not art institutions and their professional staff ever have curatorial freedom from the restraints of market, donors, and tradition – or at least how much. Whether this notional freedom is actually absolutely desirable is a matter for legitimate debate, as art and its audience exist in the real world and require real economic resources but also, in the view of many, need to be protected from pure market influence. Composer Milton Babbitt argued a half-century ago that the contemporary artist's responsibility was exclusively to an élite handful of other artists and analogized his role to a physicist, supported by public funding to do research only a half-dozen peers could understand (Babbitt, 1958). Dictatorships have traditionally demanded that artists toe a party line, of course in the name of "the people", but Soviet socialist realism didn't leave a memorable inventory of great works. Tom Stoppard captures a lively and unsettled debate about the duties of the artist among Lenin, Joyce, and Tzara in *Travesties* (Stoppard, 1975).

Wherever the balance of this debate lies, it's certain that the economic power of Bourdieu's money élite (Bourdieu, 1984) should not displace the expertise (and values) of museum staff as it has, for example, when museums accept gifts with conditions on display or retention. Models of institutions in which staff are afforded creative freedom are the state-funded museums in Europe. For example, the small non-collecting institutions of contemporary art, *Kunsthallen*, freed from the burdens

and politics of collecting, have greater latitude in creating and implementing their programming.

A guiding principle for these alternative programs is that by focusing on art of the present, the institution can imagine new modes of collecting, sharing resources, and curating exhibitions that resist the outdated practice of creating authoritative narratives of art movements. The New Museum in New York, for example, began in 1977 with the concept of maintaining a "semi-permanent collection" to distinguish it from MoMA and the Whitney Museum of American Art. The museum would show and keep works from their exhibitions, and then deaccession these after ten years to make room for new pieces. Such innovative practices have been in place for more than two centuries by institutions intent on distinguishing their focus on the present: initially by the Musée du Luxembourg in Paris in 1818, and later by Alfred Barr at the Museum of Modern [sic] Art, whose policy until 1953 established that works would be deaccessioned after 50 years or given to the Metropolitan Museum (Bishop, 2013). A European collaborative network known as *L'Internationale*, for example, challenges conventional collection ownership laws by enabling seven European partner museums and cultural institutions to share their collections. A study of radical new practices in public museums of contemporary art shows that such alliances strengthen the voices of museum professionals in shaping institutional missions and programming. (Bishop, 2013)

Obstacles and opportunities

The foregoing pages make the case for selling thoughtfully, from an enormous and mostly unused collection, in order to

fund greatly-increased value creation of many kinds and by many means, especially including properly funding the professional staff. Why are museums so reluctant to do this?

At bottom, opposition probably lies deep in the professional culture of an industry managed, like most industries, for the comfort and in the traditions of its managers and funders. Museum directors and curators for the most part peer-score each other by judging:

1. the collections they have managed to gather (whether displayed or not);
2. exhibitions and display by how they look to art specialists, rather than how their publics are looking at (and engaging with) the art on offer;
3. the money they have been able to raise as gifts.

Tunnel-vision focus on the objects rather than their use by viewers (1 & 2) partially explains why museum directors and trustees tolerate visitor engagement that averages between six and ten seconds per work.

Formally, displacement of art engagement by endless accumulation is embodied in the AAM and AAMD codes of ethics, in which museum directors agree to quarantine any of their number that sell works to increase or improve art engagement. Debate over the practice is stifled in its crib by the accounting convention of simply not recognizing the latent wealth on hand in balance sheets. Ignoring – actually, hiding – the collection's value, allows Glenn Lowry to claim absurdly that museums are systematically undercapitalized (Burns, 2018) while his own museum (MoMA) is sitting on tens of billions of dollars' worth of art.

Less formally, rigid refusal to deaccession (or to relax the AAM and AAMD code restriction) is usually justified by bromides related to institutional strategy. The first of these is that, "if we ever sell anything, no-one would ever give us anything again." The second is that, "we might find in years or decades that we had sold a masterpiece; Vermeer was unappreciated for two hundred years!" The third is that deaccessioned works are "lost forever".

The last is probably the most intellectually careless: buyers of art do not lose it or trash it; they buy it intending to display it and care for it; when they or their heirs don't want it any more, they sell or give it to someone who does. When a painting is sold it does not leave the planet or go in a landfill; it goes on a wall whose proprietor believes it will create more value than the seller thinks it will. There is nothing "lost", from society's perspective when a work of art goes from hidden storage in city A to a small museum's (yes, or a private owner's) wall in city B; quite the opposite.

Not parting with a given work for fear of future regret misunderstands the real risks such a decision must analyze. There is a small probability – not zero, but small – that the Jane Doe landscape whose merit has heretofore been invisible (despite the careful review it received before sale) will be judged to be a great work after it is sold. But museums cannot avoid bets like this; acquiring new objects is just as risky as deaccessioning them. In 1973, Jules Olitski received a retrospective that filled several galleries at the Museum of Fine Arts in Boston and the Whitney in New York (Kramer, 1973), the kind of send-off most artists can only dream of. Museums everywhere paid top dollar to acquire these very large color-field canvases, expensive to

store and move, in the decade or so afterwards. But Olitski works now sell for mere tens of thousands of dollars; the Whitney has three but does not currently display any of them. Much better to make intrinsically risky decisions thoughtfully than to pretend there is a way to avoid risk.

Selling a work in hand entails a small risk of future regret, but this bet has another side, and the cost there is not possible but certain. Foregoing the money that could be obtained by a sale ensures not delivering the enhanced art engagement discussed in the first section of this chapter, enhancement that sale price could pay for. Retaining everything out of fear of making the first kind of mistake is intellectually equivalent to not crossing a street to a dinner date because you might be run over doing so.

As regards donor influence, two different issues present themselves. If an earlier administration unprofessionally and rashly accepted a work with an agreement against deaccessioning that current management now wishes to sell , it may be necessary to get a judge or the state attorney general (who oversees nonprofits) to declare that selling to (for example) another museum that will display it is close enough (cy près in legalese) to the donor's expectation to allow the sale. Alternatively, the museum may offer to simply buy the restriction back from the donor's family and still come out ahead, or simply ask permission to sell the work on grounds explained here.

As regards accepting new gifts, it may be the case that donors can play museums off against each other, like firms demanding ruinous tax exemptions from cities as a condition of locating a new factory, especially as long as restricted gifts are tax deductions for the donor at full market value. But those

restrictions, including conditions of display and retention, violate the same AAMD ethics code that forbids deaccessioning, because they substitute the taste and pride of wealthy collectors for the expertise of curators. Museums need to develop some serious spine in these negotiations to defend their real mission from corruption, and exhibit professional responsibility.

More generally, remaining in input mode forever as a practical option in a world in which the stock of art is growing faster than the capacity of the population to engage with it (O'Hare, 2015b) is itself questionable (Pogrebin, 2019). Each museum has to ask itself how much more of the world's stock of art, that it has no space to show and can't afford to conserve properly, does it really want to possess?

Recommendations

Existing formal rules like the codes of ethics, and informal understandings and donor power, have nailed museums' feet to the floor, preventing them from properly funding professional staff, admission pricing, and bricks and mortar that would greatly increase and improve engagement with art. The situation can be improved with better practices by all the players in the art and museum system. We recommend the following:

1. Museum managers and leaders

- Amend the AAM and AAMD code of ethics to allow the sale of art from the collection not only to buy more art, but to invest in an endowment whose safe yield can be spent on programming and related purposes like conservation and outreach.
- Take the ethical prohibition against accepting restricted

gifts seriously, and support each other in refusing donated art which has restrictions, or is without an endowment to fund conservation and storage.

- Recognize your audience as partners in creating art engagement: allow museum members to elect a couple of trustees.
- Estimate the value of your collection and report it.
- Identify the least-used, lowest-quality, most redundant tenth (by money value) of your collection and explore opportunities to sell from it. Put the proceeds into the endowment and use the increased yield to correct your professional pay scale and initiate programs to increase and improve art engagement.

2. Donors and trustees

- Do not give money to any art museum that has not estimated the value of its collection and reported the result in its balance sheet. Until things improve, give to your local theater or symphony; they don't have a Golconda of unused scripts or scores in the basement to sell.
- Do not ask for restrictions on use or display when you give art.
- If you are on the board, demand that the museum be as tough-minded and result-oriented as you are in your own business, starting with recognizing the collection in its financial reports.

3. Government and regulatory bodies

- Amend the tax code to discount the charitable deduction for gifts of art with restrictions on use.
- State Attorneys General and the Financial Accounting

Standards Board should require recognition of the collection as a financial asset.

Conclusion

In early 2019, students in a Behavioral Public Policy class at Kenyon College responded to the question of how, and whether or not, to better allocate resources to improve visitors' engagement with art. Prior to the first class meeting, students went to the art museum on campus (for many of them, the first time) to view one exhibition and then focus on one work of art for an extended period of time. For the majority of the students, this was the first time they had considered the ineffable value of contemplating artwork, especially in economic terms, and had thought about practical ways of expanding and deepening this experience for more people. The majority of the class agreed that conversations initiated by museum staff about the exhibition enriched their engagement with the artwork more than any other aspect of the visit, and concurred, having consulted the literature on the topic, that they would support selling off 1% of the value of a collection at a major museum in order to hire more staff to engage with visitors and potential audiences inside and outside the museum. Anecdotally, this is validating for the authors, but the more salient point that this experiment suggests, in accordance with our argument, is that increasing, and better compensating professional staff recalibrates longstanding, institutional priorities to provide the public with the fundamental human need to appreciate art, individually and communally.

NOTES

1. A few museums (the Louvre, the Museum of Modern Art in New York, and the Uffizi in Florence for example) are over-attended to the point that an additional visitor imposes real costs on others, or excludes someone else from entering. Rationing access by price in these cases is economically efficient, though socially deplorable, but it is also an irrational response: if public schools (for example) are overcrowded, a sane society doesn't exclude poor kids, it builds more schools and hires more teachers!

REFERENCES

Abbing, H., 2008. *Why Are Artists Poor?: The Exceptional Economy of the Arts*. Amsterdam: Amsterdam University Press.

Babbitt, M., 1958. Who Cares if You Listen? *High Fidelity*, February 1958.

Becker, H., 2008. *Art Worlds (25th Anniversary)*. Berkeley, CA: University of California Press.

Bishop, C., 2013. *Radical Museology, or What's "Contemporary" in Museums of Contemporary Art?* London: Koenig Books.

Bourdieu, P., 1984. *Distinction* (R. Nice, trans.). Cambridge, MA: Harvard University Press.

Bunzl, M., 2014. *In Search of a Lost Avant-Garde: An Anthropologist Investigates the Contemporary Art Museum*. Chicago & London: University of Chicago Press.

Burns, C., 2018. Authority and Anxiety with MoMA director Glenn Lowry. *Art Agency Partners*. Retrieved from https://www.artagencypartners.com/episode-22-transcript-glenn-lowry/

Cirigliana, J. A., 2011. Let Them Sell Art: Why a Broader Deaccession Policy Today Could Save Museums Tomorrow. *Southern California Interdisciplinary Law Journal*, Vol. 20, 365–394. Retrieved from https://heinonline.org/HOL/P?h=hein.journals/scid20&i=369

Dewdney, A., et al., 2013. *Post Critical Museology: Theory and Practice in the Art Museum*. New York: Routledge.

Ebner, M., 2007. *Color Constancy*. New York: John Wiley & Sons.

Feld, A. L., et al., 1983. *Patrons Despite Themselves: Taxpayers and Arts Policy*. New York: NYU Press.

Fraser, A., 2018. *2016 in Museums, Money and Politics*. Cambridge & London: MIT Press.

Graw, I., 2009. *High Price: Between the Market and Celebrity Culture* (N. Grindell, trans.). Berlin: Sternberg Press.

Kramer, H., 1973. Art: Jules Olitski Retrospective. New York Times, September 8, p. 27, Retrieved from https://www.nytimes.com/1973/09/08/archives/art-jules-olitski-retrospective.html

Message, K., 2006. *New Museums and the Making of Culture*. Oxford & New York: Berg.

O'Hare, M., 2015a. Malthus und der Maler. *Brooklyn Rail*, October. Retrieved from http://www.brooklynrail.org/2015/10/art/malthus-und-der-maler

O'Hare, M., 2015b. Museums Can Change – Will They? *Democracy*, (36). Retrieved from https://democracyjournal.org/magazine/36/museums-can-changewill-they/

Pittman, B., and Hirzy, E., 2010. *Ignite the Power of Art: Advancing Visitor Engagement in Museums*. New Haven and London: Dallas Museum of Art and Yale University Press.

Pogrebin, R., 2019. Clean House to Survive? Museums Confront Their Crowded Basements. *New York Times*, March 12.

Public Knowledge, (n.d.). Retrieved April 2, 2019, from SFMOMA website: https://www.sfmoma.org/artists-artworks/public-knowledge/

Roberts, J. L., 2013. The Power of Patience: Teaching students the value of deceleration and immersive attention. *Harvard Magazine*, 40-43.

Retrieved from https://harvardmagazine.com/2013/11/
the-power-of-patience

Rostami, M., 2018. Creating Visual Poetry: An interview with
Mary Zimmerman. *Berkeley Rep Magazine*, 2018–19 (4),
17–19.

Stigler, G. J., and Becker, G. S., 1977. De Gustibus non Est
Disputandum. *American Economic Review*, 67 (2), 76–90.

Stoppard, T., 1975. *Travesties*. London: Faber and Faber.

Thompson, D., 2008. *The $12 Million Stuffed Shark*. New York:
St. Martins Press.

Thompson, D., 2014. *The Supermodel and the Brillo Box*. New
York: Palgrave Macmillan.

Thornton, S., 2008. *Seven Days in the Art World*. New York:
W.W.Norton.

ABOUT THE EDITORS

KRISTINA L DUROCHER is the director and curator of the Museum of Art of the University of New Hampshire in Durham, NH. Previously, she was curator at the Fitchburg Art Museum, Fitchburg, MA. She has nearly twenty years' experience with civic and academic art museums, creating innovative programs and leading organizational change. Her curatorial program embraces one-person and group thematic exhibitions that promote experiential student learning and faculty instruction and facilitate teaching with art as a primary source for academic and social engagement. Her interests include artists who synthesize new media, technology, and modes of presentation to address social issues and aesthetic concerns. She is an experienced museum director with a demonstrated commitment to advancing the study of art in higher education; a proven leader with a history of public service and advocacy for the profession.

Kristina serves on the board of directors of the New England Museum Association and as the New England Region Representative for the Association of Academic Museums and Galleries. She has reviewed grants for the New Hampshire State Council on the Arts and the National Endowment for the Humanities. She holds an MA in Art History from the University of Massachusetts, Amherst with a concentration in contemporary art. She received a dual BFA in Art History and Painting from the Massachusetts College of Art and Design, Boston. She was selected to attend the Getty Leadership Institute in 2017.

MARK S GOLD is a partner in the law firm of Smith Green & Gold, LLP, Pittsfield, Massachusetts. He holds a degree in Economics and International Studies from The American University, a law degree from Georgetown University, and a Masters in Museum Studies from Harvard University. His practice includes business and corporate law, venture capital and traditional financing, and non-profit and museum law. He has served on numerous nonprofit boards, including New England Museum Association, and, currently, Community Legal Aid, Inc. He also serves as a Hearing Officer for the Massachusetts Board of Bar Overseers. In 1992, he received the Massachusetts Bar Association's Community Service Award.

Mark has written extensively and participated in panels at meetings of the AAM and regional associations on deaccessioning, legal issues for museums, non-profit governance, and under-compensation in museums. He contributed to *Museums and the Disposals Debate* (2011) and co-edited and contributed to the three-volume *Handbook for Academic Museums* series (MuseumsEtc, 2014-15). He authored the chapter, Monetizing the Collection: The Intersection of Law, Ethics, and Trustee Prerogative, in *The Legal Guide for Museum Professionals* (Rowman & Littlefield, 2015) and has contributed two chapters to *Is it Okay to Sell the Monet? Responsible Deaccessioning for Museums* (Rowman & Littlefield, 2018). Most recently, he co-edited *The State of Museums: Voices from the Field* (MuseumsEtc, 2018).

DAWN E SALERNO is Executive Director of the Rotch-Jones-Duff House and Garden Museum in New Bedford, Massachusetts. She serves on the Cultural Coalition Council and the Education Foundation of New Bedford. In her previous roles as Deputy Director for Public Engagement and Operations and Acting Director at Mystic Museum of Art in Connecticut, she oversaw a strategic planning process, increased visibility for the organization via social media, and engaged over 6000 yearly attendees through public programming. She has held positions in the education departments of the Wadsworth Atheneum and Lyman Allyn Art Museum.

Dawn has been a grant reviewer for the Institute of Museum and Library Services and for Connecticut Humanities and served on the board of the latter until 2018. Since 2009, she has been a member of the Board of Directors of New England Museum Association, serving on the Program, Nominating, and Advocacy committees and, most recently, as its President. Dawn was recipient of the Connecticut Art Education Association's Museum Educator of the Year award in 2009. She has published articles about the museum field in various blogs, magazines and online publications as well as co-editing *The State of Museums: Voices from the Field* (MuseumsEtc, 2018). She earned her Masters degree in Museum Education Leadership at Bank Street College and her BA in Classical Studies and Religion at Boston University. She completed the Getty Leadership Institute program in 2017.

ABOUT THE AUTHORS

MATHEW BRITTEN has worked as a museum educator for the last five years. He is proud of his working-class roots and is a member of Museum as Muck. Mathew graduated from the University of Leicester in 2018 with a Masters in Socially Engaged Practice in Museums and Galleries. He is currently the Museum Manager at Bury Transport Museum, Manchester.

JESSICA BRUNECKY is President of the Colorado–Wyoming Association of Museums' board of directors, and Director of Visitor Experience for the University of Colorado Art Museum. In 2018 she co-authored two white papers for the University of Colorado's Academic Futures Initiative: *Is It An Art? A Case Study of Teaching at the CU Art Museum* and *Informal learning at CU Boulder's museums and the impact on student experience: now and for the future.* Her paper *Enticing and Engaging the Millennial Audience* was included in the *University Museums and Collections Journal* (2015).

KELLY CANNON is a museum educator in New York. She works collaboratively with curators, educators, and others to produce and maintain online courses and develops digital content including audio tours, podcasts, and videos. As a Fulbright Fellow in Budapest, she researched modern and contemporary photography as well as digital humanities approaches for the arts. She holds an MA in the History of Art from the Courtauld Institute of Art, London, and a BA in the History of Art from Yale University. Her academic research focuses on artistic strategies in the context of nationalism, post-socialism, and digital networks.

IAN DUCKWORTH is Associate Director of Research at Barker Langham Recruitment. He has 30 years' museum experience and is recognized for his work in building capability, competency and capacity for some of the most iconic museums in the world. He supervises all research and deep resourcing activity that supports Human Resource, Recruitment and Training consultancy and advisory work across international markets. His first degree was in History at King's College London, followed by a Museum and Art Gallery Diploma. Ian worked for fifteen years in senior roles in museums, art galleries and sculpture parks in the UK and USA. For the last six years he has been based in Catalonia.

MICHELLE EPPS is the President of the National Emerging Museum Professionals Network (NEMPN), having been involved with NEMPN since 2011 and serving as President since 2015. She currently works as the Community Engagement Coordinator at SPACES, Cleveland, and is currently the interim Museum Educator at the Lakewood Historical Society. Much of her professional work involves creating access to the arts for vulnerable individuals such as incarcerated youth, low income seniors, kids living in public housing, and homeless women and children. She holds a Masters in History with a Specialization in Museum Studies and a Certificate in Nonprofit Business Management from Case Western Reserve University. Michelle also serves on the advisory committee for Kent State University's MuseLab and the Education and Museum Outreach Advisory Council for the Federal Reserve Bank of Cleveland.

MICHELLE FRIEDMAN is Head of Education and Academic

Initiatives at The Aldrich Contemporary Art Museum, CT and has worked with audiences, restructuring programs, and the establishment of whole school, district and institutional partnerships. She designs museum-wide assessment systems to track engagement, gauge program effectiveness, and identify opportunities for strategic growth. Michelle holds a bachelor's degree in Art History from Purchase College and is a Master's candidate in Art Education at Boston University. She is a Trustee-at-Large with the New York City Museum Educator Roundtable and presents at museum and art education conferences. She holds the 2019 Outstanding Art Museum Educator from the Connecticut Art Education Association.

KERRY GRIST is an Open University graduate with a working-class background, and a member of Museum as Muck. She started her museum career in 2017 after having a variety of volunteering roles whilst studying. Kerry is a Collections Assistant at the Science Museum, London, working on the regeneration of the Medicine Galleries.

TOM HOPKINS is a Curator at a national museum in the United Kingdom. Prior to his current role, he worked in collections management and research positions at the History of Science Museum, University of Oxford, Christ's Hospital, Guildford Museum and Worcester Cathedral Library. Tom established and edits a careers blog. Initially a platform by which to give advice to emerging museum professionals, he is also interested in ways to make recruitment in the UK museums sector more equitable. https://museumcareers.wordpress.com/

JON INGHAM is Associate Organizational Development Consultant with Barker Langham Recruitment, where his role is that of an insight-based human resources and organization development consultant. He focuses on developing innovative approaches to people management in order to create competitive advantage, often through the development of human and social capital. Jon previously worked as an international HR Director for EY and a Director in human capital and reward consulting for Buck. He is the author of *The Social Organization* (2017) which describes how employers can invest in the relationships between their people, and has previously written on reward innovation for the Association of Talent Development.

STEFANIE S JANDL is an independent museum professional with over twenty years' experience with academic museums, exhibition planning, and collections management. She is co-editor of the three-volume *A Handbook for Academic Museums* (2012-15) and co-author with Mark Gold of the paper *The Practical and Legal Implications of Efforts to Keep Deaccessioned Objects in the Public Domain* (2011). She has written for *Gastronomica* and has also published on Man Ray, cuisine, and museums. She holds a BA in Political Science from the University of Southern California and an MA in the History of Art from Williams College.

MELODY KANSCHAT is an energetic arts professional with broad experience in management, communications, fundraising, and master plan development. She was appointed Executive Director of the Getty Leadership Institute at Claremont Graduate University in 2013. Melody had recently concluded

a 22-year career with the Los Angeles County Museum of Art (LACMA) where she served in a variety of executive capacities. In her final six years at LACMA, she was the President and Chief Operating Officer, responsible for the day-to-day operations of the museum and overseeing a total annual expense budget of over $60 million. She holds a BS degree in Radio, Television, and Motion Pictures from Ball State University in Muncie, Indiana.

JACLYN J KELLY has been with the Milwaukee Public Museum (MPM) for over eleven years and in her current role of Educator for over eight years, and holds an MA in Public History and Museum Studies from the University of Wisconsin-Milwaukee. At MPM, she has initiated several successful projects to communicate history, including innovative uses of social media. She also has experience in object-based learning for early learners and helping students conduct and then communicate original research through exhibits. Jaclyn is also heavily involved in representing museum workers' interests through her work with AFSCME Local 526, AFL-CIO and she has served as an executive board member, vice president, shop steward, and is currently president. She has also expanded her involvement in organized labor by becoming a delegate to the Milwaukee Area Labor Council, joining the Young Workers Committee, and co-managing the digital communications of the Wisconsin Labor History Society.

JODI KOVACH is the Curator of Academic Programs at the Gund Gallery, Kenyon College, OH. In this role, she partners with faculty across disciplines to integrate art into their curricula. In the fall of 2018, she conducted a seminar series for

social science faculty through which they explored the politics and economics of contemporary art museums. She holds a PhD in Art History from Washington University in St. Louis. Jodi's research interests focus on contemporary art from Mexico City. She has also taught art and design history, and has contributed to exhibition catalogues on topics of international modernism and global contemporary art.

SARAH MALDONADO is the Membership Coordinator of the New York City Museum Educators Roundtable (NYCMER), and an educational consultant, focused on curriculum development and education management systems – and specifically supporting adult-child conversations, both in and out of the classroom. She has previously worked for the American Museum of Natural History, the Queens Zoo (part of the Wildlife Conservation Society), New York State Parks, the Montezuma Audubon Center, Beaver Lake Nature Center, Alley Pond Environmental Center, AmeriCorps NCCC, and the NYC Parks Department. Sarah holds a Master of Professional Studies in Environmental Education and Interpretation from SUNY College of Environmental Science and Forestry, and a BA in Secondary Math Education from CUNY Queens College.

CHARLOTTE MARTIN is President of the New York City Museum Educators Roundtable (NYCMER) and previously served as Trustee-at-Large, Secretary and Peer Group Liaison, and Intern. She has worked in, and consulted on, education and accessibility at a wide range of museums in New York City, Washington, DC, and New Haven, CT. Currently, she is Senior Manager of Access Initiatives at the Intrepid Sea, Air & Space

Museum. Charlotte holds an MAT in Museum Education from George Washington University and a BA in the History of Art from Yale University.

STEVEN MILLER has been in the museum field since 1971. Having directed three museums, he has also served as a trustee, curator, writer, media commentator, and consultant. He taught for sixteen years with the Seton Hall University MA Program in Museum Professions. Steven is the author of *The Anatomy of a Museum: An Insider's Text* (2017), *Deaccessioning Today: Theory and Practice* (2018), and *How to Get A Museum Job* (2019). He holds a BA in sculpture from Bard College, and a Graduate Certificate in the Principles of Conservation Science from ICCROM, Rome.

TARYN R NIE graduated in 2017 with an MA in Museum Professions from Seton Hall University and is currently the Membership and Grants Manager for The Rockwell Museum in Corning, New York. Throughout her career in the arts thus far, she has had the opportunity to intern with a handful of wonderful entities – from mid-size regional museums like the Cedar Rapids Museum of Art, to daring arts organizations like CreativeTime, and nationally renowned institutions including the Smithsonian and Princeton University Art Museum. She originally hails from Alaska.

MICHAEL O'HARE, an architect and engineer by training at Harvard, has taught public policy analysis, including arts and cultural policy, at MIT, Harvard's Kennedy School of Government, and currently at UC Berkeley's Goldman School of Public Policy. With and between academic appointments, he

worked as a consultant at Boston's Museum of Fine Arts and at the assistant secretary level in Massachusetts state government, and has had visiting positions at Université Paul Cézanne Aix-Marseille, the National University of Singapore, and Universitá Bocconi in Milan. His principal research interests are public management, environment and energy policy (most recently biofuels and climate stabilization), and government policy toward the arts. He is an author of *Patrons Despite Themselves: Taxpayers and Arts Policy* (1983) and numerous publications analyzing tax and accounting issues, stock-flow problems in music and plastic arts, and related arts policy and management topics.

PURVI PATWARI has over twenty years' experience designing and transforming Human Resources departments. She has a successful track record of building structure, implementing policies and programs, and executing strategic changes for organizational improvement. During the last eleven years, she has served as Director of Human Resources for three prominent Boston-area art museums, bringing her passion and commitment to strengthening capacity in talent acquisition and management, employee relations, operations administration and policy design. Purvi is currently an independent consultant doing business as Segovia HR Solutions. She holds an MA in Museum Studies with a focus in Education from Tufts University and a BA in Political Science and Anthropology from the University of Vermont.

SEEMA RAO is the Principal and CEO of Brilliant Idea Studio (BIS), a consulting group which helps museums, non-profits, and libraries. BIS specializes in content development and

strategy, change facilitation, and inclusive community. With nearly twenty years' museum experience, Seema has led interpretative and programming content development for all audiences, including the innovative Gallery One, Studio Play, and Asian Odyssey. She holds a Master's degree in Art History from Case Western Reserve University, Cleveland and a Master's in Information Science and User Experience Design.

NATALIE SANDSTROM graduated from Smith College, where she studied English and Art History and completed a concentration in museum education, in 2018. She is the Program Coordinator at the Institute of Contemporary Art at the University of Pennsylvania, where her mission is to make people feel welcome through dynamic and accessible experiences with the art. Natalie also runs the blog *Beyond Art*, and writes contemporary art criticism for various publications including *Philly Artblog* and artcritical.com.

ANTHEA SONG is the Event and Job Listings Coordinator with the New York City Museum Educators Roundtable (NYCMER). Passionate about effective communication and audience engagement, she has previously worked on public and multigenerational programs in education at the Guggenheim Museum and Seattle Art Museum, respectively. As Manager of Programs and Communications at the Alliance for Young Artists and Writers, she now works with educators across the country to identify and recognize creative youths with the annual Scholastic Art & Writing Awards. Anthea holds an MA in Museum Studies from Leiden University and a BA in Art History from University of British Columbia.

MICAH STYLES is Director of Human Solutions at Barker Langham Recruitment. For two decades he has had the opportunity of working with museums and clients across the cultural and creative industries on local, regional and international recruitment campaigns, organizational design and transformational capacity building. His work has encompassed collaborating with national museums through to supporting smaller independent and private museums. Each experience has provided valuable insight into the way institutions approach the hiring process, the variety of tools available to a modern museum to attract, engage and retain staff, and how this approach can successfully be used strategically to address the issues of salary inequalities and diversity in the workforce.

LIAM SWEENEY is a senior analyst with the Libraries, Scholarly Communication, and Museums program at Ithaka S+R. His work focuses on issues of diversity, equity and inclusion among cultural organizations, applying quantitative and qualitative research methods to issues of demographic change, institutional culture, strategic leadership, and organizational structure. He holds a Master of Arts in Liberal Studies from the CUNY Graduate Center.

AMELIA TARACENA holds a Master's degree in Art History and Heritage from the Université Toulouse II – Jean Jaurès and a Master's in Museology from the National School of Conservation, Restoration and Museography (ENCRyM). During a stay in Europe, she collaborated in the Augustins Museum, International Art Festival of Toulouse and the Salzillo Museum in Murcia. And while in Mexico, she worked at the Museum

of Mexico City as an exhibition coordinator, in Buró-Buró as coordinator of the *Catálogo Contemporáneo*, and in the National Museum of Art in the Press and Publishing Department. Ameila has published in magazines such as *Camino Blanco*, *Arte y Cultura* and *Discurso Visual* and currently works as an Independent Museums Lecturer.

PAUL C THISTLE has 26 years of mission and management work in museums and archives. He has published articles in periodicals such as *Curator*, *Muse*, *Journal of Museum Education*, *Material Culture: The Journal of the Pioneer America Society*, an essay in *Care of Collections: Leicester Readers in Museum Studies* (1994) and others in the field of Indigenous history including the award-winning book, *Indian-European Trade Relations in the Lower Saskatchewan River Region to 1840* (1986). Since 1990, Paul has been writing about the overwork culture in the museum field and currently blogs on *Solving Task Saturation for Museum Workers* and *Critical Museology Miscellanea*. He has taught Museum Studies at Beloit College, WI.

EMILY TURNER is a Seattle-based museum educator and creative historian who strives to infuse joy and creativity into the museum experience and encourages visitors of all ages to think critically about objects and their stories. Through writing and comix, Emily explores issues of representation and labor in art and history museums. An officer for the Museum Educators of Puget Sound, she is active in her community as a mentor and an advocate for emerging museum professionals. She holds a BA in history from New York University and an Advanced Certificate in Museum Studies from the University of Washington. Her

writing has recently appeared in the *Museums Journal* (2019) and in *The Care and Keeping of Museum Professionals* (2019).

JOHN WETENHALL is founding director of the new George Washington University Museum and serves on the faculty of the university's Graduate Program in Museum Studies. As Executive Director of The John and Mable Ringling Museum of Art for nearly ten years, he led a $150 million capital and endowment campaign that re-established the estate as a prominent cultural attraction in Southwest Florida. John previously participated in major renovations at the Cheekwood Museum of Art in Nashville and the Birmingham Museum of Art, having also held positions as President of the Carnegie Museums of Pittsburgh and as Interim Director of The Miami Art Museum (now Perez Art Museum). He is an art historian, educated at Dartmouth (BA), Williams (MA) and Stanford (MA, PhD), with an MBA from Vanderbilt. He has served on the boards of AAM, ICOM-US and AAMG and has received the lifetime achievement award from the Florida Association of Museums.

TARA YOUNG is an experienced museum professional and a Professor of Museum Studies at Tufts University. Currently an independent consultant, she has held positions at museums on both coasts. Most recently, she served on the founding staff of the Museum of Russian Icons, in Clinton, MA, which received AAM accreditation in 2015. Tara holds degrees in the History of Art and Architecture from Harvard College and the University of Pittsburgh, as well as a Certificate in Nonprofit Management and Leadership from Tisch College of Civic Life at Tufts University. She is the author of *So You Want to Work In a Museum?*.

ALSO FROM MUSEUMSETC

Museum Participation
New Directions for Audience Collaboration

Edited by Kayte McSweeney and Jen Kavanagh

MuseumsEtc

The State of Museums
Voices from the Field

Edited by Rebekah Beaulieu,
Dawn E Salerno and Mark S Gold

MuseumsEtc

Feminism and Museums
Intervention, Disruption and Change
Volume One

Edited by Jenna C Ashton

MuseumsEtc

Interpreting The Art Museum
A Collection of Essays and Case Studies

Edited by Graeme Farnell

MuseumsEtc

The Caring Museum
New Models of Engagement with Ageing

Edited by Hamish L Robertson

MuseumsEtc

CODE | WORDS
Technology and Theory in the Museum

Edited by Ed Rodley, Robert Stein and Suse Cairns

MuseumsEtc

Exhibitions and Education
A Handbook for Academic Museums
Volume One

Edited by Stefanie S Jandl & Mark S Gold

MuseumsEtc

Beyond Exhibitions and Education
A Handbook for Academic Museums
Volume Two

Edited by Stefanie S Jandl & Mark S Gold

MuseumsEtc

Advancing Engagement
A Handbook for Academic Museums
Volume Three

Edited by Stefanie S Jandl & Mark S Gold
With a Foreword by John R Stomberg

MuseumsEtc

THE MUSEUMSETC BOOK COLLECTION

10 Must Reads: Inclusion – Empowering New Audiences

10 Must Reads: Interpretation

10 Must Reads: Learning, Engaging, Enriching

10 Must Reads: Contemporary Photography

10 Must Reads: History of Photography from Original Sources

10 Must Reads: Strategies – Making Change Happen

A Handbook for Academic Museums, Volume 1: Exhibitions and Education

A Handbook for Academic Museums, Volume 2: Beyond Exhibitions and Education

A Handbook for Academic Museums, Volume 3: Advancing Engagement

Advanced Interpretive Planning

Alive To Change: Successful Museum Retailing

Contemporary Collecting: Theory and Practice

Collecting the Contemporary: A Handbook for Social History Museums

Conversations with Visitors: Social Media and Museums

Creating Bonds: Successful Museum Marketing

Creativity and Technology: Social Media, Mobiles and Museums

Engaging the Visitor: Designing Exhibits That Work

Feminism and Museums: Intervention, Disruption and Change

For Love or Money: Confronting the State of Museum Salaries

Inspiring Action: Museums and Social Change

Interpreting the Art Museum

Interpretive Master Planning

Interpretive Training Handbook

Museum Participation: New Directions for Audience Collaboration

Museum Retailing: A Handbook of Strategies for Success

Museums and the Disposals Debate

Museums and the Material World: Collecting the Arabian Peninsula

Museums and Visitor Photography: Redefining the Visitor Experience

Museums At Play: Games, Interaction and Learning

Narratives of Community: Museums and Ethnicity

New Thinking: Rules for the (R)evolution of Museums

On Food and Health: Confronting the Big Issues

On Sexuality - Collecting Everybody's Experience

On Working with Offenders: Opening Minds, Awakening Emotions

Oral History and Art: Painting

Oral History and Art: Photography

Oral History and Art: Sculpture

Reimagining Museums: Practice in the Arabian Peninsula

Restaurants, Catering and Facility Rentals: Maximizing Earned Income

Rethinking Learning: Museums and Young People

Science Exhibitions: Communication and Evaluation

Science Exhibitions: Curation and Design

Social Design in Museums: The Psychology of Visitor Studies (2 volumes)

Sustainable Museums: Strategies for the 21st Century

The Caring Museum: New Models of Engagement with Ageing

The Exemplary Museum: Art and Academia

The Innovative Museum: It's Up To You...

The Interpretive Trails Book

The Museum Blog Book

The New Museum Community: Audiences, Challenges, Benefits

The Power of the Object: Museums and World War II

The State of Museums: Voices from the Field

Wonderful Things: Learning with Museum Objects

VERTICALS | writings on photography

COLOPHON

Published by MuseumsEtc Ltd.
UK: Hudson House, 8 Albany Street, Edinburgh EH1 3QB
USA: 675 Massachusetts Avenue, Suite 11, Cambridge, MA 02139

www.museumsetc.com
twitter: @museumsetc

Edition © 2019 MuseumsEtc Ltd
Texts © The Authors

MuseumsEtc books may be purchased at special quantity discounts for business, academic, or sales promotional
use. For information, please email specialsales@museumsetc.com or write to Special Sales Department,
MuseumsEtc Ltd, Hudson House, 8 Albany Street, Edinburgh EH1 3QB.

A CIP catalogue record for this book is available on request from the British Library.
ISBN: 978-1-912528-12-7

The paper used in printing this book comes from responsibly managed forests and meets the requirements of
the Forest Stewardship Council™ (FSC®) and the Sustainable Forestry Initiative® (SFI®). It is acid free and lignin
free and meets all ANSI standards for archival quality paper.

Dolly Pro, the typeface in which the main text of this book is set, is designed by Underware, a
specialist type design studio founded in 1999 and based in The Hague, Helsinki and Amsterdam.
The font is "a book typeface with flourishes", designed for the comfortable reading of long texts.
The asymmetrically rounded serifs give the type a friendly but contemporary look - and it uses
old-style numerals, which we love.